Wild Science

Wild Science investigates the world-wide boom in "health culture." While self-help health books and medical dramas are popular around the globe, we are bombarded with news reports and images of DNA and cloning, the fight against AIDS, cancer and depression. With popular culture the principal means by which the non-scientific community understands illness, health and science, what are the implications of this for national health policies and for what gets funding for research?

The contributors to this innovative volume consider the new visual technologies which make the human body into a virtual territory; popular representations of genetics and identity, the diagnostic and medical practices centered around women's bodies, and debates around the practice of "feminist science studies." Individual chapters engage with scientific phenomena and controversies such as the Visible Human Project, the supposed existence of a "gay gene," cosmetic surgery, breast cancer media activism, HIV testing, and medical abortion. *Wild Science* argues that science is an everyday practice bound in values and institutions, and calls for a responsible engagement with the public cultures of science and health.

Contributors: Anne Balsamo, Anne Beaulieu, Lisa Cartwright, Kathy Davis, Lisa Finn, Ursula Franklin, Janine Marchessault, Maria Nengeh Mensah, Kim Sawchuk, M. Mehdi Semati, Jennifer Daryl Slack, Bonnie P. Spanier, José van Dijck, Catherine Waldby, Angela Wall.

Janine Marchessault is Associate Professor in the Department of Film and Video, York University, Ontario.

Kim Sawchuk is Associate Professor in the Department of Communication Studies, Concordia University, Montreal.

Writing Corporealities

Series Editor: Elspeth Probyn

This series seeks to encourage innovative writing about corporealities. It takes as a leading premise the fact that writing and studying embodied forms of sociality are intricately mutually informing. The type of work presented under the rubric of this series is therefore engaged and engaging, as it understands that writing itself is an embodied and social activity. The range of theoretical perspectives privileged may be wide but the common point of departure is a certain *parti pris* to study the materiality of contemporary corporeal processes and realities. Beyond discrete description, through different forms of writing, bodies, discourses, forms of power, histories and stories are put in play in order to inform other relations, other corporeal realities.

AIDS AND THE BODY POLITIC
Biomedicine and Sexual Difference
Catherine Waldby

Wild
Science

Reading Feminism, Medicine and the Media

Edited by

Janine Marchessault and Kim Sawchuk

London and New York

First published 2000
by Routledge
11 New Fetter Lane, London EC4P 4EE

Simultaneously published in the USA and Canada
by Routledge
29 West 35th Street, New York, NY 10001

Routledge is an imprint of the Taylor & Francis Group

Typeset in Galliard by Taylor & Francis Books Ltd
Printed and bound in Great Britain by TJ International Ltd, Padstow, Cornwall

British Library Cataloguing in Publication Data
A catalogue record for this book is available from the British Library

Library of Congress Cataloging in Publication Data
Wild Science: reading feminism, medicine, and the media / edited by Janine Marchessault
and Kim Sawchuk.
p.cm – (Writing corporealities)
"Published simultaneously in Canada."
Includes bibliographical references and index.
1. Medical innovations –Social aspects. 2. Feminist theory. 3. Health in mass media.
I. Marchessault, Janine. II. Sawchuk, Kim. III. Series.
362.1–dc21 RA418.5.M4 W54 2000 99–055545

ISBN 0–415–20430–5 (hb)
ISBN 0–415–20431–3 (pb)

Contents

PART THREE
Clinical practices

PART FOUR
Feminist science studies

Illustrations

Contributors

Anne Balsamo is a member of the research staff at Xerox PARC, and part of the RED Studio whose research charge is to study emergent document types. Her first book, *Technologies of the Gendered Body: Reading Cyborg Women* (Duke, 1996) discusses the cultural implications of new body technologies. Her next book will investigate the relationship between cultural theory and the design of mass culture.

Anne Beaulieu has written a dissertation entitled "The Space Inside the Skull: Digital Representations, Brain Mapping and Cognitive Neuroscience in the Decade of the Brain." She is Lecturer in Psychology at the University of Bath.

Kathy Davis is Senior Lecturer at the Faculty of Social Sciences in the University of Utrecht in The Netherlands. Born in the United States, she has taught psychology, medical sociology, and women's studies at various universities in The Netherlands. She is the author of *Power Under the Microscope* (Foris, 1988), *Re-making the Female Body* (Routledge, 1995) and editor of *Embodied Practices: Feminist Perspectives on the Body* (Sage, 1997), as well as several books on gender, power and discourse. She is currently working on a book about masculinity and plastic surgery.

Lisa Cartwright is Associate Professor of English and of Visual and Cultural Studies at the University of Rochester, Rochester, New York. She is the author of *Screening the Body: Tracing Medicine's Visual Culture* (Minnesota, 1995), co-editor with Paula A. Treichler and Constance Penley of *The Visible Woman: Imaging Technologies, Gender and Science* (New York University Press, 1998), and co-author with Marita Sturken of *Practices of Looking* (Oxford, forthcoming in 2000).

Lisa Finn is a doctoral candidate in the Visual and Cultural Studies Program at the University of Rochester, in Rochester, New York. She is currently completing her dissertation, titled "Risky subjects: constructions and categorizations of women in health care."

Ursula Franklin is University Professor Emerita, University of Toronto, Canada. She holds a Ph.D. in experimental physics from the Technical University, Berlin and taught in the Faculty of Applied Science and Engineering for more than two decades. She served as a board member of the National Research Council of Canada and the Science Council of Canada, and is a companion of the Order of Canada. She is the author of *The Real World of Technology* (House of Anansi, 1999).

Janine Marchessault is Associate Professor in the Department of Film and Video at York University, Toronto. Her writings on visual culture have appeared in various publications, including *Public, CineAction!, New Formations* and *Screen*. She is the editor of *Mirror Machine: Video and Identity* (YYZ Books, 1994) as well as the author of a forthcoming book on Marshall McLuhan. Her art videos include *The Act of Seeing with Another Eye* (1991) and *Numerology of Fear* (1999), both of which are distributed in Canada through V-Tape.

Maria Nengeh Mensah is currently completing her Ph.D. in Communication Studies at Concordia University, Montreal. Her thesis deals with the media discourse on women and AIDS in Quebec. She has been involved with HIV/AIDS work since 1989. She has worked as a volunteer with community-based AIDS organizations; as an editor of clinical practice guidelines for national medical associations; and as a part-time faculty and lecturer in Communications, Sexology, and Women Studies.

Kim Sawchuk is Associate Professor in the Department of Communications at Concordia University, Montreal, Quebec where she teaches courses on communications theory, research design, semiotics and feminism and the media. She is the co-editor of *When Pain Strikes* (University of Minnesota Press, 1999).

M. Mehdi Semati is Assistant Professor of Communication at Michigan Technological University, Houghton, Michigan. He teaches in the areas of mass communication theory, film and television theory and criticism, theories of visual representation, international communication, and audio and visual production.

Jennifer Daryl Slack is Associate Professor of Communication and Cultural Studies at Michigan Technological University, Houghton, Michigan. She is the author of *Communication Technologies and Society: Conceptions of Causality and the Politics of Technological Intervention* (Ablex, 1984), co-editor of the *Ideologies of the Information Age* (Ablex, 1987), and co-editor of a special issue of *Cultural Studies*, "Cultural studies and the environment" (8:1, 1994).

Bonnie P. Spanier is Associate Professor in the Women's Studies Department, State University of New York, at Albany, US. Her research interests include the effects of gender, race-ethnicity, class and sexual preference on the content and process of science. She is the author of *Im/partial Science: Gender Ideology in Molecular Biology* (Indiana University Press, 1995). She received her doctorate in microbiology from Harvard University.

José van Dijck is Associate Professor of Literature at the University of Maastricht, The Netherlands. She teaches and lectures on the popularization of science and visual culture and is the author of two books, *Manufacturing Babies and Public Consent: Debating the New Reproductive Technologies* (1995) and *ImagEnation:*

Popular Images of Genetics (New York University Press, 1998). She is currently working on a collection of essays titled "*The transparent body. Medical imaging in media and culture.*"

Catherine Waldby teaches in the areas of science and technology as culture, feminist theory and theories of sexuality in the School of Media, Culture and Communication at Murdoch University in Perth, Western Australia. She has published in the areas of feminist theory, sexuality, social aspects of AIDS, and the biopolitics of medicine. Her most recent book is *AIDS and the Body Politic* (Routledge, 1996). She is also the editor of *BioFutures, BioCultures*, a series published by Routledge intended to foster the theorization of new biotechnologies and developments in the biosciences. Her new book, *The Visible Human Project: Informatic Bodies and Posthuman Medicine* (Routledge), is forthcoming in 2000.

Angela Wall is an Account Planner for Red Sky Interactive, an experience oriented interactive design shop in San Francisco. She has contributed articles to *afterimage* and the recent collection *Playing Dolly*, ed. E. Ann Kaplan and Susan Squier.

Acknowledgments

We wish to express our gratitude to Sheryl Hamilton for all her painstaking work in helping to organize early drafts of this anthology, and to Pablo Cantero and Jen VanderBurgh who helped to bring the manuscript to completion. Thanks are also due to Communication Studies at Concordia University and to the Department of English at McGill University for administrative support.

The copyright holders of all the images reproduced in the book are acknowledged beneath the images themselves. All reasonable efforts have been made to contact copyright holders. Any omissions brought to the attention of the publisher will be remedied in future editions.

For their faith, energy and interest in this project, we would like to thank Elspeth Probyn and Rebecca Barden at Routledge. Finally, our thanks to Frances Leeming for agreeing to alter her image.

Introduction

■ Janine Marchessault and Kim Sawchuk

THE JUXTAPOSITION OF the words "wild" and "science" in the title of this anthology is not intended to speak to some new form of feminist anarchy. Rather, we hope to call attention to an ideology and an epistemological framework in which "wild" and "science" are typically oppositional terms. Since the end of the eighteenth century, Western science has been directed towards taming nature: nature has been conceptualized as something wild, unruly and changing. This opposition takes hold with the professionalization of science and medicine in the nineteenth century and extends to a set of distinctions between science and culture, rationality and the imagination, masculinity and femininity, and so on. These distinctions have been, and continue to be, upheld by institutional formations and disciplinary methodologies, separating the humanistic studies from the sciences. As the romantic dictum goes, science creates facts, art produces ambiguity.

As we enter the twenty-first century, however, stories of illness, medical cures and scientific discoveries have taken on a powerful and less than ambiguous currency in popular culture. Television channels, such as the *Life* channel, regularly tell us how to care for ourselves and for others. In American sitcoms, women characters who were concerned previously with careers and family are now dealing with their health: Ellen has a mammogram, Murphy Brown has breast cancer, Sibyl considers hormone replacement therapy. Medical dramas are popular around the world: *ER*, *Dr Quinn Medicine Woman*, *Chicago Hope*, *L.A. Doctors* (US), *Urgence* (Quebec), *Casualty* (UK), and the surrealistic Danish series *The Kingdom*, to name but a few. Self-help health and homeopathic lifestyle books sell in numbers comparable to the romantic fiction market. We are bombarded daily with media images of DNA, news reports about cloning, representations of the fight against AIDS, cancer and depression. It is no coincidence that the explosion of health cultures in industrialized nations correlates directly with the erosion of health care systems – the less access people have to health care, the greater the consumption of health culture. Health cultures are fueled by a central contradiction: spectacular advances in medicine's diagnostic technologies

and treatments are putting modern health care beyond the financial reach of most people and placing health firmly in the sphere of consumerism. Even in Canada, where a socialist health care system has been a distinguishing feature of its national identity, pharmaceutical industries are thriving while hospitals are being closed.

Wild Science is motivated by a feminist, political imperative to actively and critically engage with the public meanings of science, to assert the frictions and contradictions within popular renditions of what medicine can and should do. Recent interdisciplinary work in the field of science studies has foregrounded the need for researchers in the humanities to engage with the common sense meanings and popular conceptions of science. The title of our book, *Wild Science*, seeks to reference the culture of science, to foreground the fact that science is made up of practices that belong to culture. As feminists, we have a special interest in the way science, and in particular medical science, has come to care for and make sense of human bodies, the way scientific evidence has impacted on gender, racial and class identities. We are concerned with the blurring of biomedical research and industry. This anthology is motivated by the belief that research which encourages media literacy around popular representations of medicine also makes possible a public discourse around ethics. More than ever it is crucial to analyze how common purposes and knowledges are being imagined in the sphere of the everyday. From a variety of disciplinary perspectives, *Wild Science* asks the following questions: what does it mean for the biological sciences to render the body visible? How are illness, health, science and medicine depicted in popular culture – that place where most of the non-scientific population encounters science? What kinds of public bodies are being constructed by new medical practices? What types of agency and action are transforming these practices?

Science acts as a screen for the hopes and fears of communities. In studying its cultures, we study science but we also study ourselves and our expectations of science. Public images of science have a direct impact on health education and popular perceptions of the limits of science. They influence public opinion on national health policies and, ultimately, help to determine which projects are funded for research.

It is important to remember that while there is an increase in reports and narratives about health, these discourses have a history. By providing historically grounded analysis of textual conventions in science, by relating medical images to real bodies, and by foregrounding the political economy in which certain images of science are promoted above others, *Wild Science* makes a unique contribution to the growing field of feminist science studies. It also owes a great deal to a generation of feminist scientists and cultural theorists who have sought to understand the social influences on and of science. In particular, the works of Ursula Franklin, Ruth Hubbard, Evelyn Fox Keller, Ann Fausto-Sterling, Katherine N. Hayles, Sarah Franklin, Donna Haraway and Sandra Harding have raised important questions about the limits of science and the specificity of scientific enterprises. We have learned from them that truth claims and objectivity are complicated and indispensable. They have taught us that feminist politics and scientific practices are not oppositional terms; and finally, that ethics, value and agency have a place in scientific research.

In organizing this anthology, we sought to include the work of scholars whose research addresses the cultures of science and medicine across a variety of sites. Looking to locate some of the cultural influences on and of science within different social and economic formations, we invited contributors from The Netherlands, Australia, the UK, the US, and our own country, Canada – countries whose moder-

nity and democratic structures are intricately tied to health care and science. The essays collected here address a range of topics: popular autobiographies and literature, television science programs, talk shows, medical dramas, science journalism, public health education, artistic and activist media. What unifies the essays in this book is their focus on the visual culture of medicine. Contemporary forms of imaging play a central role in the way medicine understands the human body and disease. Popular images of medicine, whether in literature, the cinema, television or print media, draw upon these visual conventions as ichnographies to construct meanings and metaphors that are readily understandable, that translate complex theories for general consumption. We have divided the contributions into four sections which can be read progressively as a movement from abstract visualizations towards more concrete engagements with medical practices and the media.

The first section, "Corporeal Maps," explores the new visual technologies that are not only mapping bodies but making the human body into a virtual territory, inaugurating new forms of knowledge and popular fantasies of travel through the body itself. In "Biotourism, *Fantastic Voyage*, and sublime inner space," Kim Sawchuk examines the pleasures and liabilities of the movement of a technologically assisted gaze into inner-body space. She looks at the new subjectivity being created for the medicalized subject of the late twentieth century, the biotourist. This new mobility is extended in Catherine Waldby's investigation of the social and epistemological implications of the Visible Human Project, an anatomical imaging project based in the US that has created an interactive corpse from a real male cadaver. The body is scanned and transformed into three-dimensional representations whose depth and volume can be manipulated and made available as "data sets" on the Internet. Waldby seeks to delineate the biopolitical consequences of transforming flesh into data. In "The brain at the end of the rainbow," Anne Beaulieu analyzes the way in which images of brain scans (CT, MRI, PET) are interpreted differently by neuroscientists, patients and the general public. Beaulieu highlights the different understandings of what brain scans can reveal about intelligence, memory and consciousness. Like Sawchuk and Waldby, she seeks to analyze the popular expectations associated with the metaphor of the map, and the limits of what can be known about the human brain through scans.

The second section of the anthology, "Genetic Codifications," focuses on the popular discourses and representations of the human body in terms of genetic codes. In Chapter 4, Janine Marchessault examines the images of the human genome in *The Secret of Life*, a popular television series designed to introduce audiences to the wonders of genetics. Here, bodies are represented as filing cabinets, integrated communications systems and film stock, giving the impression that they can be easily programmed for health. Similarly, José van Dijck in "The language and literature of life" is concerned with the metaphors used to translate the abstract and complex theory of genetics for a general audience. The most popular metaphor is that of language. She compares two diverging criticisms of the genome metaphors and assesses proposals to construct new metaphors borrowed from literature and music. In Chapter 6, Bonnie Spanier examines the popular belief that homosexuality is determined by genes. Her chapter applies a feminist critique to the media coverage of the Ellen DeGeneres (star of the TV show *Ellen*) and Anne Heche love story which featured scientific claims that homosexuality is biological. Spanier, a molecular biologist by training, is concerned with the way this belief, which has been unsubstantiated in recent scientific studies, functions to essentialize homosexuality. She argues that the lessons garnered from a scientific history of racist and sexist claims about biolog-

ical difference need to be heeded; biological explanations for social differences are always deeply entrenched in structures of power.

While the first two sections of this volume address visual maps, metaphors and popular images of medical science, part three, "Clinical Practices," brings together five essays which analyze the diagnostic and medical practices around women's bodies. Instances of patient and media activism have challenged the way medicine is practiced in some circles and the manner in which healthy bodies are represented in popular culture. In the first essay, "Pygmalions in plastic surgery," Kathy Davis contends that if women's decisions to undergo cosmetic surgery can be linked to the practices and discourses of femininity, then men's decisions to perform cosmetic surgery should also bear a connection to the practices and discourses of masculinity. As an illustration, she looks to the popular autobiography by a male plastic surgeon, titled *Doctor Pygmalion*. The self constructed in *Doctor Pygmalion* is a professional self: the ideal plastic surgeon. Lisa Cartwright's contribution, "Community and the public body in breast cancer media activism," offers a crucial survey of media activism around breast cancer. The media techniques and strategies of breast cancer activists have made a significant impact on health policy. Moreover, they have radically challenged and altered the new biological configurations of the natural female body. Rather than contesting the place of fashion and beauty, many media producers working in either medical or art practices have forced the public to confront the bodies of women with breast cancer, forwarding a new biology of sorts – that is, a new configuration of the natural body as one that has experienced breast cancer. In Chapter 9, Maria Nengeh Mensah examines the technology of HIV testing in terms of social and discursive practices which visualize HIV-seropositive sexed bodies in Canada. HIV infection is understood as a permanent form of hybridity where once fixed categories are confused and boundaries are no longer clearly visible. The biomedical strategy to solve this problem of uncertainty and (in)visibility uses naturalizing notions of sexual identity to explain and thus control the natural virulent transmission into the social body. Biomedicine reaffirms the Nature/Culture distinction by identifying the infected subject as a viral sexual agent. In the next chapter, "Complications: an analysis of medical abortions in the US," Lisa Finn seeks to understand decreased access to abortions in the United States. While sterilization is still publicly funded, abortion availability has significantly decreased. With the passing of the Hyde Amendment, abortion in the US has been constructed within the problematic terms of "choice," the Federal and State governments see themselves as not having any responsibility to guarantee the accessibility of abortion. Extending the discussion about control over reproduction, Angela Wall (in Chapter 11) looks to the kinds of ethical questions and popular ideologies that arise in the popular media over older women who seek to have children through assisted reproduction. Wall reviews the contradictory imaging and textual narratives that arise in the discussion of women who choose to engage in assisted reproduction.

The final section of the book is devoted to feminist science studies. This section describes some of the epistemological and institutional frameworks that are influencing the development of the humanistic studies of science. Anne Balsamo's chapter, "Teaching in the belly of the beast," suggests new ways for teaching technoscience studies that re-imagine learning science by way of science fiction. Balsamo stitches together science fiction with the pedagogical possibilities hinted at in Neal Stephenson's *The Diamond Age*, appropriating the Victorian notion of the "lady's primer" from the author. Balsamo explores numerous pedagogical strategies for

teaching feminist technoscience to future engineers and scientists in ways which open up dialogue and interdisciplinarity. Jennifer Daryl Slack and M. Mehdi Semati make a similar argument for interdisciplinary research in their analysis of the science wars. They analyze the discursive logic at work in the now infamous Sokal affair as a kind of "intellectual hygiene." Interdisciplinary work on science was presented in both the popular and academic media as an infiltration of muddy or fuzzy thinking into pure science, as a harrowing threat to standards of truth. Slack and Semati argue that the distrust of interdisciplinary research, reflected in the way the affair was reported, is an indication of an intellectual conservatism that needs to be challenged. They foreground the political implications of science studies and argue that research which locates science within a cultural context is crucial to fostering responsible scientific research.

Finally, we conclude with one of Ursula Franklin's letters. Franklin's work, well-known within Canada, but less known internationally, defines the aims of this book: science and technology are distinct but interrelated practices; science is a practice, bound in values and institutions. Science is not perfect but it matters. Women must intervene in science to transform its goals. In "Letter to a graduate student," Franklin writes to a young feminist considering a career in science. She advocates working in the neglected area of organic materials (blood, tissue, cells or bone), areas of research that are "messy" and "less amiable to reductionist simplification." While this kind of research will have very few military or industrial benefits, it will change the lives of "mere people." Franklin encourages the meeting of feminism, science and culture. The analysis of science fiction and the critical examination of scientific reductionism are equally crucial areas of research if we are to understand the possibilities and limits of science. This is wild science, not as anarchy, but as a direct challenge to political, cultural and economic interests that have been setting research agendas since the end of the First World War.

As a critical social discourse, feminism's contribution is greater than any single issue. Feminist critiques of the political economy of science look at how over-investment in medical instruments depletes funding and resources from other types of medical research. A feminist analysis of high technology medicine asks how these purchases may act as a smokescreen for less investment in medical personnel, and the movement away from medicine as the art of healing with a patient emphasis, into a business where patients are shuffled through the system, fifteen minutes each, like so many hamburgers in a fast-food outlet. A feminist analysis of science seeks to know who the shareholders are in laboratories, research centers and government that will profit from these technologies in the globally integrated investment markets. A feminist analysis of science must also acknowledge when these technologies and scientific know-how can be used to assist in diagnosis, care, and lead to better health and life for all, not only for those who can afford private treatment and costly health insurance. Finally, a feminist investigation of the relationship between science, popular culture and our everyday life interrogates philosophical questions about ethics, subjectivity and agency. The contributors to this book go beyond ideology critique to facilitate a responsible engagement with the public cultures of science and health, locating political energies that are creative and powerful.

Corporeal maps

Kim Sawchuk

BIOTOURISM, *FANTASTIC VOYAGE*, AND SUBLIME INNER SPACE

It is too little to call man a world; except God, man is a diminutive to nothing. Man consists of more pieces, more parts, than the world; than the world doth, nay than the world is. And if those pieces were extended, and stretched out in man as they are in the world, man would be the giant, and if the world the dwarf, the world but the map, and the man the world. If all the veins in our bodies were extended to rivers, and all the sinews to mines, and all the muscles that lie upon one another to hills, and all the bones to quarries of stones, and all the other pieces to the proportion of those which correspond to them in the world, the air would be too little for the orb of man to move in, the firmament would not be enough for this star; for, as the whole world hath nothing, to which something in man doth not answer, so hath man many pieces of which the world hath no representation.

(John Donne, *Devotions*: 23)

The medieval philosophers were right. Man is the centre of the Universe. We stand in the middle of the infinite between outer and inner space and there is no limit to either.

(Dr Duval in *Fantastic Voyage*)

Imaging the inside

CONTEMPORARY MEDICAL TECHNOLOGIES such as microscopes, X-ray machines, endoscopes, and most recently positron emission tomography (PET) and magnetic resonance imaging (MRI) have made it possible for medical scientists to peer into the body without cutting through the skin. Though their technical procedures and machinery are distinct, these devices visualize and enlarge somatic space, rendering our most infinitesimal cells, molecules and genetic structures into images on a scale that we can more easily comprehend.

Images of interior body space come to us through major capital investments in high technology medical instruments, but they are not only encountered in a hospital or doctor's office. The representations of the body produced within medical culture have intersected with representations in popular culture since their invention. The

1897 film *X-ray Fiend*, for example, satirized the recently discovered X-ray machine, revealing a pair of lovers embracing to be no more than a pair of skeletons. In the post-war era, images of the human interior have become regular features of photo-journalism, television documentaries and CD-ROMs. The Visible Human Project, first developed to train surgeons and medical doctors, is now available to a general-ized audience on the World Wide Web (for more on this project, see Chapter 2). It is with the recurrence of the theme of inner space and these anatomical entertainments within popular culture that biotourism has its genesis.

By biotourism, I refer to the persistent cultural fantasy that one can travel through the inner body, a bodyscape which is "spatialized" and given definable geographic contours. Rendering the interior of the body as a space for travel is contingent upon the representation of the body as a frontier with glorious vistas that can be visited – perhaps not by a real body, but at least by the human eye. Just as tourism relies upon the production of glossy images and pamphlets to beckon potential tourists to visit a site, the scientific images produced by the medical biotourist industry seduce us into exploring our own internal regions. In this complicated tangle of political, economic, cultural and technological discourses a new facet of human subjectivity is being spawned – the biotourist.

This chapter explores the phenomenon of biotourism by way of a close reading of the 1966 film, *Fantastic Voyage*. Directed by Richard Fleischer, whose previous credits included *20,000 Leagues under the Sea*, *Fantastic Voyage* is the story of a team of human beings who, along with their nuclear submarine *The Proteus*, are miniaturized to the size of microbes. This is done so that the team can carry out a delicate opera-tion to remove a blood clot from the brain of a Czechoslovak scientist, injured in a KGB ambush while attempting to defect to the United States. Fortunately for the "Free World" (the film is saturated with Cold War themes) this miniaturization tech-nique has been developed by a top secret branch of the American military. Unfortunately, however, the procedure can only be sustained for an hour, the approximate length of a feature film. As the publicity blurb on the back cover of the video of *Fantastic Voyage* exclaims: "There's danger in every heart beat, from attacks by the body's immune system, to attacks of sabotage from within the sub. The opera-tion must be completed in one hour. It's a race to save the scientist's life and their own." The film was released amidst great hype because of its (then) considerable US$5 million budget, and won two Academy Awards: for best Special Effects and for best Art Direction.[1]

Despite its status as "fiction" the film is of interest because of its persistent centrality; for instance, a recent special issue of *LIFE* magazine on the Visible Human Project was entitled "The Fantastic Voyage."[2] These new images which simulate travel through *real* human bodies have of course precursors in the film *Fantastic Voyage*, but also in past issues of *LIFE* magazine itself, which has regularly featured "inner space." The 1962 issue of *LIFE*, entitled "The Human Body," included an article accompanied by original paintings which imaginatively illustrated a different type of tour – "The Phenomenal Digestive Journey of a Sandwich." Following the fictive tale of an adolescent boy's eating habits to explain the transformation of "food into fuel," the narrative is complemented by a series of illustrations of the body. In one image the boy is shown supine, his ribcage is open so that we can see his intes-tinal tract which is displayed as a vast range of mountains and valleys, flanked by his arms which contain rivers of arterial veins, his muscles and organs depicted as hills (see Figure 1.1).[3]

FIGURE 1.1 "Down a Long Canal"
Source: Illustration by Arthur Lidov, *LIFE* (3 November 1962).

This image, a kind of cross between Swift's Gulliver and Donne's poetic rendering of body and landscape (quoted at the beginning of this chapter), links the desire and impetus to conquer external nature with our increasing management and desire to control the wilderness of our own inner nature, a drive forcefully described in Horkheimer's and Adorno's *Dialectic of Enlightenment*.[4] This is precisely the tendency within humanist thought that came under vehement attack by feminism and structuralism for its assumption of man's dominion over all, including all those bodies that were "not-man."

Fantastic Voyage is a key text because it incorporates the essential aesthetic features typical of biotourism. First, it involves the transposition of scale, turning the minia- ture into the gigantic. Second, it transforms anatomy into a space, more significantly a type of landscape with analogous geographic features which can then be "mapped." Third, it narrates this voyage in allegorical terms as a journey from light into dark- ness. Fourth, like most biotourist narratives *Fantastic Voyage* invokes the pictorial and discursive rhetoric of the sublime. My intention here is to outline the essential discur- sive features of the fantasy of biotourism and to indicate its permutations and cultural significance, particularly for future feminist studies of subjectivity and corporeality in our present conjuncture.

The scale of things

In a discussion of the literary legacy of the miniature and the gigantic, Susan Stewart notes that the secret of the microscope is its transformation of the miniature, which

can be viewed with a single perspective, into the gigantic, which can only be taken apart piece by piece (Stewart 1993: 54). This question of scale and the inversion of the microscopic and the macroscopic is a central feature of the fantasy of biotourism, and its accompanying theme of corporeal expansion and reduction has a long history in Western literary tradition. Such books as Jonathan Swift's *Gulliver's Travels* and Lewis Carroll's *Alice in Wonderland* render – in words – the vertiginous, hallucinogenic feeling that one can shrink or conversely become an entity larger than life.

The tension between the miniature and the gigantic is also a recurring visual trope that utilizes the monumental potential of the movie screen in two areas of film production: science fiction films and films targeted at children. Such movies as *Honey I Shrunk the Kids* (1989), *Toy Story* (1995), *Mouse Hunt* (1997) and *The Borrowers* (1998) exploit the terrors of the very big and the very small, thrilling children and adults with the imaginary possibility of being devoured in a bowl of cereal, eaten by a trusted pet, lost in the jungles of the suburban lawn, or chased in the walls of a decrepit old house. In a world in which counters and chairs are designed for adults, these films make the everyday ominous through tricks of visual hyperbole, exaggerating the contours of the adult world that rarely fits a child's proportions. It is my belief that the popularity of toys like Polly Pocket or Dinky toys can be attributed to the sense of control they impart to children who can hold these miniature folding universes and objects in the palm of their hands.

The extremes of large and small are a staple visual feature of the science fiction genre. The 1903 film *Under the Microscope* by Percy Stowe explores the horrors of a cheese sandwich through a microscope revealing all manner of hideous creatures which are ingested. In Jack Arnold's 1957 classic *The Incredible Shrinking Man*, the hero shrinks after traveling first through a nuclear cloud while on holiday, and then as a result of bug spray upon his return home. Although by the end of the film his body is reduced to nothing he is saved spiritually by becoming "One with the universe." As he says in his pithy, final lament: "I realized that it was nothing and that I was nothing too … the infinite and the infinitesimal." In many of these films, the macrocosmic world of the stars, the infinite, is linked with the microcosmic miniature, the infinitesimal. Indeed, the quest for a galaxy that is contained within a bauble on a cat's collar drives the action of the 1997 film *Men in Black*.[5]

Vivien Sobchak notes that science fiction films often derive their power to induce wonder "not from the imaginativeness of their content, but from the imaginativeness of their stance and scope" (Sobchak 1987: 101). In the examples given above, it is not the intricate complexity of the narratives that compel but "the scale of things" and the ability of this transposition of scale to engage the viewer so that s/he lets go, escapes, or feels like s/he is swallowed up by the image.[6]

Films like *Fantastic Voyage* are a hybrid of the science fiction-adventure-spy genres, and the film effectively capitalizes on the possibilities of stance and scope as described by Sobchak. In the second major sequence in the film we are treated to the miniaturization process in three distinct stages. In stage one, the cast enters the hive-like antechamber, taking their place on one of the hexagonal grids that make up the tiles of the floor. There is silence, except for the vague sound of machinery and instruments. This technological whir and buzz is punctuated by the barking of commands emitted from within a control tower. In the second stage, the ship and its occupants are "miniaturized" and inserted into a giant needle. A shot taken from within the submarine shows a pair of human eyes peering in – thus emphasizing the vessel's reduction in size; eyes that to the film spectator in a theater are twenty feet in

height. The needle, the capsule and its inhabitants are once again reduced and the ship and crew are injected into the neck of the scientist.

Throughout this sequence sound provides important cues: a deafening roar follows as the machine is propelled forward, the crew members holding on for dear life as they race towards the subcutaneous depths of inner space at a frightening incline. Suddenly all noise stops: tranquillity ensues followed by the movie's theme music. We have passed the ultimate threshold and are inside the blood stream, in "the middle of the infinite between outer and inner space," as Dr Duval (one of the scientists on board) comments. We watch the crew as they look at the inside of the body. The miniaturization of the humans in their submarine makes possible a panoramic point of view of a vast multi-hued vista from within. They are shown gazing in awe and wonderment at the floating blobs of fluorescent psychedelic plasma. This transposition of scale, the first component of the biotourist experience, prepares us for the second moment within the fantasy: the spatialization of the inner body and its transformation into landscape.

Bioscapes: spatializing the body

Throughout the film the relationship between the inside space of the body and the outside space of the control room, which is of course connected to the security of the nation, is maintained through the use of maps and charts depicting different parts of the scientist's body. The headquarters of the military-industrial corporation entrusted with the task of the rescue operation is replete with images and maps of the circulatory system. A huge line drawing of the various routes through the bloodstream is pinned to the wall of the central control station. This map is updated with minute by minute reports of the submarine's location.

The maps refer back to the scientist's body which is laid out on a table, his dormant figure surrounded by radar tracking equipment which picks up the signal from the miniaturized submarine – that is until the ship loses contact because of a saboteur on board. The scientist's body, the head shaved and the skull marked out in blue lines, is itself partitioned into manageable zones. There is continuous movement between the world outside of the body and the world inside it. Inside the submarine, the crew has replicas of the body maps. The camera moves between these registers in order to confirm that the crew is indeed inside the scientist's body and to show where they are at all points. Through the use of these corresponding representations of corporeal space, we, the spectators, have the thrill of occupying all positions yet knowing where we are at all times from the purview of inside and outside.

Parker Tyler comments that he sees in the film "a great microcosmic/macrocosmic tension":

> The space within exists – and must exist however consciously it be avoided – equally, coextensively, with the space outside. The science-fiction type of film, therefore, was bound to get around to viewing the interior of the body as an artificially constructed inner space corresponding with the real body's inner space, which in turn would be a trope for actual space: The "out there" space shared with all other men.
>
> (Tyler, cited in Sobchak 1987: 95, 96)

The maps transform the body as space into a series of known places that are intercon-

nected and can be charted in the same way that a geographic atlas maps land, or in the way that anatomical atlases originally marked the skeletal, muscular and organic systems. In so doing, an ordering is imposed upon the "ensemble of possibilities" of a volatile and unstable organism (de Certeau 1984: 98). However, it is not merely a spatial ordering – a management of territory – that is at stake, but the rendering of this space into a landscape, or more precisely a *bioscape*.

In an extended analysis of the film in the 1966 edition of the journal *Films and Filming*, Raymond Durgnat, a self-confessed science fiction fan, defended *Fantastic Voyage* as one of the most imaginative film ideas to have occurred in years on precisely these grounds. His description of the "scenery" of inner space captures the merging of terrestrial and aquatic images in the film.

> Vast in Cinemascope (and the microscope) its vistas of the body's interior have a lunar strangeness: the heart's arteriole branch work is as intricate as coral caverns; corpuscles float by like something between a patch of light and a jellyfish. … Even in the eerie outer space and underwater effects of the pleural cavity or arterial canals is the mountainous scales of recognizable fleshy or muscular masses.
>
> (Durgnat 1966: 12, 13)

The creation of a bioscape makes sense because there is a pre-existent discourse that ties geography and the body. This chapter's opening quote from John Donne's *Devotions* expresses the dimensions of this homology: "Man is a world unto himself, and as such he is diminutive to nothing." The veins of our bodies are like rivers, our sinews like mines, our muscles like hills, our bones like quarries of stone; this is all man and "Man" is greater yet than the sum of all of these representations.[7] While the inner-body space depicted in the film is an underwater vista, the confrontation of "man" and "nature" is a trope that owes part of its ancestry to the tradition of landscape painting.

Theorists of landscape painting have argued that "landscape" is a cultural and aesthetic category and always a part of a social formation and political conjuncture.[8] Landscapes, whether cultivated actual territories, carefully manicured gardens, or representations, are never purely natural phenomena. As Deborah Bright writes, "whatever its aesthetic merits, every representation of landscape is also a record of the human values and actions imposed over land over time" (Bright 1989: 125). Thus art historians have looked to the paintings of John Constable and W.F. Turner in an attempt to understand the civilizing mission of the white European bourgeoisie or to the photographs of Walker Evans to unravel the heroic frontier mentality which is so much a part of American culture. These representations of our place within the landscape indicate our imaginary relation to these spaces; in particular, our awe, fear and wonder of a natural world that was being brought under territorial dominion. And here it is necessary to turn to the pictorial uses of the sublime.

The landscape paintings of the nineteenth century tried to render in art the feeling of the sublime found in man's encounter with nature. They often included a small figure of a human being who is shown looking upon a scene, obviously overshadowed by its enormity and implied power. While the figure in the painting is enveloped by these forces, the viewer who looks at this transformed nature in the work of art is once again made triumphant. It is *we* who look upon both the landscape and the tiny human figure, giving us as spectators a gratifyingly omniscient,

omnipotent point of view. The awe we feel standing next to these paintings is surmounted by our relationship, in scope, to them.

Fantastic Voyage plays upon this convention and spectatorial point of view. As cinemagoers we occupy much the same position *vis à vis* the travelers in *The Proteus*, who like the human figures in nineteenth-century landscape paintings are there to remind us of the potentially destructive power of our corporeal inner nature, and in so doing raise the possibility that nature – usually a terrifying "She" – must be tamed. This kind of anthropomorphic thinking, which typically places "man" at the center of the Universe, is a sentiment expressed by Dr Duval in *Fantastic Voyage*. But a consideration of the body as landscape has even more immediate relevance to the epoch and culture that produces its representations.

If the body as landscape can be used to trace the movements of human activity over time, then the activity recorded in the fictional narrative of *Fantastic Voyage* is the 1960s geopolitical discourses of Cold War rhetoric about the new frontier as espoused primarily by President John F. Kennedy. This rhetoric believed faithfully in technology's ability to bring progress, prestige and wealth to the US through medical advances into the body and outward expansion into space. Kennedy liberalism, as C. Wright Mills (1958) noted at the time, was not benign; rather it fostered interventionist US policies internally and externally through the threat of a communist invasion of the US body-politic.

Stanley Kubrick's 1963 classic spoof on this ideology, *Dr Strangelove: or How I Learned to Stop Worrying and Love the Bomb*, satirized what Mills called the "crackpot realism" of the American military (Mills 1958: 89–97). A fear that his body fluids will become contaminated is one of the obsessions that causes the paranoid military commander in the film to set in motion the dropping of the bomb on "the Ruskies." *Fantastic Voyage*'s own paranoid fantasy of invasion, however, is not satirical; instead it feeds directly into the Cold War ethic. The film obscures the details of the history of Eastern Europe after the Second World War, conveniently portraying Czechoslovakia as dupes within the Soviet orbit. Like so many Hollywood depictions of Eastern Europe during this period, differences within communism and socialism are erased and any ethical or intellectual sympathies with the left are explained away as "brainwashing" (Chomsky 1993) – another reason for the crew of *The Proteus* to travel to "the brain of our defecting, injured Czech scientist."

Journies of light into darkness

In her analysis of the processes of documenting the inner body, Barbara Marie Stafford notes how the extension of vision permitted a new form of "travel."

> Opaque depths were opened up, becoming transparent without the infliction of violence. The veil of the invisible was gently and non-invasively lifted. The eye could easily voyage through and beyond the densities of a plane, or silently journey beneath the stratified level.
>
> (Stafford 1991: 343)

While these technical transformations in microscopy and imaging technologies are important, it is arguable that the most important precursor to contemporary renditions of the biotourist tale is cultural rather than technological. The eventual lifting of the prohibition on anatomical dissections in the fifteenth century soon led to the

drawing of atlases of the body, the most famous of which are those by Vesalius. These atlases were published to enhance the hegemony of scientifically-based medical knowledge of the body throughout the Enlightenment.[9] This makes possible the idea of movement into this space as a type of journey into the darkness, just as the search for bodies to dissect, analyze and document was often accomplished by cover of night because of the clandestine nature of the activity. Following the Enlightenment trope that frames the movement of the surgeon's scalpel into the body as the journey of the enlightened educated male doctor into the underworld, biotourism, too, is discussed as a voyage of "light into darkness" (Good and Del Vecchio Good 1993: 81–107). And here we need to reconsider just what form of travel is depicted in *Fantastic Voyage*.

In *Fantastic Voyage*, the nature that is offered to the traveler/spectator is the inner nature of the human body. Jody Berland argues that when we conceptualize "nature as separate from ourselves, and as an unchangeable, autonomous, and pristine, as a place where we can visit to find some sort of freedom, then we commit ourselves to the vantage point of the tourist" (Berland 1992: 12). I would augment these provisional definitions by saying that the vantage point that *Fantastic Voyage* allows us reveals a longing for a return to a pre-industrial order that we are rendering ever more inaccessible and obsolete: it is a journey, a pilgrimage, and not a tour or a mere voyage. A journey, as Susan Stewart explains, "marks the passage of the sun through the sky, the concomitant passage of the body's labor through the day, and the pilgrimage or passage of life" (1993: 60). The journey is an allegorical notion that links lived experience to the natural world, while the idea of the trip as a pilgrimage into inner space connects *Fantastic Voyage* to a religious world view.

In pilgrimage, one goes to learn and experience in order to transform oneself through contact with a place; it is a return to what Benjamin called the idea of the aura (Benjamin 1968: 222, 23). One passes through different sites as part of a rite of passage; one travels beyond a threshold for a spiritual experience – often to be healed either emotionally, physically or spiritually. In the bringing together of the language and imaging of travel and discovery, the sacred and the scientific makes the scientific enterprise into a spiritual experience. Like modern-day pilgrims we are invited to travel in search for the secret of life through the interior landscape of the body. Through the wonders of high-tech sub-aquatic miniaturization, biotourism is linked in *Fantastic Voyage* to the so-called pre-industrial experience of travel through sacred space to a particularly spiritual place.

This concept is key to understanding the privileged position of Dr Duval in the film's narrative and the way that the goals of science, technology and religion are reconciled within the film. The discourse of biotourism maintains "the sacred" within the technological experience. This intervention is thus reinterpreted and redeemed through the idea of the journey as a kind of pilgrimage and the invocation of the language of the sublime. It is in this respect that the passages through the body parts, which become like place names on a tour, function as liminal zones. Movement through and beyond each "station of the cross" – the heart, the lungs, the brain – is complete with conflict and resolution in order to move on to the next stage. And it is here that we again encounter the uses of the sublime in the film.

Narrating the sublime

The Proteus travels through the blood stream to each major corporeal landmark: from the heart, to the lungs, up the lymphatic system to the inner ear, where it then proceeds to "Mecca" – the brain. Each stage of the journey is demarcated by a reflection, offered by Dr Duval [Arthur Kennedy] on the infinite, underscoring the significance of our passage into another threshold that reveals the wonders of inner nature. At each point of the journey, Dr Duval as philosopher-surgeon looks out the window of *The Proteus* to comment on the expanse before him. Duval's spiritual discourse, however, is countered by the scientific reductionism of Dr Michaels.

The story of *Fantastic Voyage* turns on the tension between the two lead characters, Dr Michaels and Dr Duval. Duval uses science for the humanitarian cause of confirming the perfection of a God-created universe. His association with the sublime is important precisely because he is imaged as the prototype of the good scientist, replete with a lovely young technical assistant, Cora Peterson (Raquel Welch), whom he educates and protects throughout the film.[10] Peterson, the sole female character in the film, voices childlike wonder at the unveiling of life's mysteries.

Dr Michaels, who turns out to be a communist traitor, is depicted as the cold and calculating scientist who consistently denies the presence of the divine at work behind creation. Played to perfection by Donald Pleasence, Michaels is a bald, slightly portly figure who contrasts with the rugged masculinities of Duval and the military agent Mr Grant (Stephen Boyd) who has been assigned to watch over the medical crew. On the one hand, Grant expresses the point of view of the lay person unacquainted with the intricacies of the body. On the other, in his role as protector of the ship's mission, he is clearly aligned with the values of the military and the state. Dr Michaels' unpleasantness as a character is a sign of his later seditious intents. He is claustrophobic, and although the explanation given is that he was buried in the trenches during the war, this weakness signals his sniveling masculinity and cowardice. It also makes his punishment for his treachery – he is swallowed by a giant lymphocyte – even more righteous.

Dr Duval is most clearly associated with the language of the sublime. Dr Michaels, the Soviet spy, consistently deploys the purely rational language of science, numbers and calculations in describing the processes of life and the biology of the body. As they reach the heart, for example, Grant interprets the sounds in militaristic terms, "It sounds like heavy artillery fire." Dr Michaels in turn supplies the technical information: "40,000 beats per year," to which Dr Duval replies, "… and every beat separates a man from eternity."

Every passage into a different body part acts as a site of potential danger and a problem to be resolved. In the lungs, they must transfer oxygen from the body into the oxygen tanks of the ship, which have been sabotaged by someone on board. Cora Peterson looks out the window and in an awestruck tone says: "Just think. We are the first ones to see it happen …" Her mentor, Dr Duval, completes the sentence for her: "The living process." When they reach the lungs and "witness oxygenation" they are again divided on its meaning. For Dr Michaels "it's just a simple exchange, corpuscles releasing carbon dioxide for oxygen." Duval counters that this is not just a question of science; it is a miracle, confirmed by their witnessing of the event: "We've known that it existed for a long time, yet to actually see the structure of the atom, for the first time. To see one of the miracles of the universe: the cycle of breath." When Michaels insists that it is not a "miracle" but "a simple exchange,"

Duval replies that it is not all "accidental" but that such a harmonious display of "engineering" must have been made possible by a creative intelligence of a higher order. It seems as if this quasi-religious, humanist language is meant to quell fears that in a technological age life is no longer a miracle, a wonder. But it also serves an ideological purpose in distinguishing American free-enterprise entrepreneurial science, guided by religion, from the godless vocation of communist state-sponsored science. And here it is necessary to return to the centrality of the brain and the concept of brainwashing.

In the 1960s the "brain" was seen as an icon whose inner workings needed to be discovered so as to unlock the mystery of what it means to be human. In the film, mind, brain and consciousness are not clearly distinguished from one another, for the medical paradigm popular at this time was behaviorism. The brain was considered the key to understanding all of human experience in a hierarchy of the senses that placed the other organs in a position of lesser value. It is when the submarine reaches the brain that the most violent argument over the relationship between the finite and the infinite takes place.

Dr Duval: Yet all the suns that light the corridors of the universe shine dim before the blazing of a single human thought …

Grant: … proclaiming an incandescent glory that is the mind of man.

Dr Michaels: Very poetic gentlemen. Tell me when we pass the soul.

Dr Duval: The finite mind cannot comprehend the infinite; the soul that comes from God is infinite.

The brain in both scientific and popular discourses of the 1960s is Mecca, and I would argue that at that time it occupied the same semiotic space now held in the 1990s by DNA.

Within the film's narrative, tensions over the sublime and the scientific are a means to address these contemporary debates in fictional form. But here we must be attuned to intricacies of the sublime. The discourses of the sublime in *Fantastic Voyage* are used to bolster *man's* humanity and a spirit of triumph within an attitude of respect. As such, these popular renderings of philosophic debates are not aligned with the Burkean sensibility of "agreeable horror" in which nature ultimately triumphs over humankind. Rather, the sensibility of the film is aligned with the views of Kant and Schiller in their expression of the belief that it is the mind that ultimately triumphs over nature (Modiana 1985).[11]

The sublime, science fiction and feminism

Fantastic Voyage, as I have argued, plays with scale and transposes the inside of the body into a landscape (a bioscape) that can be traveled through by the miniaturized human beings in *The Proteus*. Like other landscapes, its revisioning of the bioscape can be read as part of a particular historical and political conjuncture. *Fantastic Voyage* blends aesthetic conventions of the period with other representational forms: the optical art sensibility of its opening sequence, costumes and special effects are punctuated by the emergence of the romantic sublime – the play of light and dark in

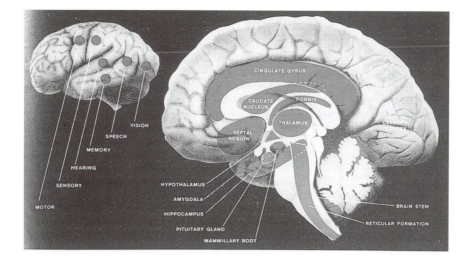

FIGURE 1.2 "The New Geography of the Brain"
Source: *LIFE* (8 March 1963).

a panoramic landscape. Like the final sequence of *The Incredible Shrinking Man* and its monologue about the conjoining of the infinite and the infinitesimal, in *Fantastic Voyage* wonder and awe at the universe beyond our human competency to comprehend it rationally is a key discursive device.

Scott Bukatman (1996) argues that the discourse of the sublime is often used in contemporary science fiction to explore anxieties about nature and technology by offering a form of visual mastery and sense of wonderment to the spectator who is invited to partake in this journey. Bukatman speculates that cosmic displays and technologically advanced optical effects of science fiction cinema, like those found in *2001: A Space Odyssey* (1968) and *Close Encounters of the Third Kind* (1977), simultaneously acknowledge our anxiety over a "perceived loss of cognitive power experienced by the subject in an increasingly technologized world" while at the same time "producing a sense of cognitive mastery" (Bukatman 1996: 255). In his recounting of science fiction films which use the rhetorical form of the sublime, Bukatman highlights the special effects work of Donald Trumball (the man behind such works as the Stargate sequence of *2001*) as a kind of *auteur* of the genre.

Bukatman's brilliant analysis of the sublime in science fiction engages in arguments with visual theorists such as Jonathan Crary, taking Crary's Foucauldian position to task for stressing that the body is placed under the domination of the eye with the advance of optical technologies. Bukatman shifts theories, drawing upon phenomenology to assert that the question is not one of power and domination, but the transformation of our corporeal sensibility. While Bukatman's work is pivotal for the inquiry on the sublime, my own reading of the sublime in science fiction differs from and builds upon Bukatman's ideas in four respects.

First, Bukatman considers the issue of the body in his reading of cinema science fiction and the depiction of movement through space. In Bukatman's work, however, it is the body of the film spectator that is analyzed, not the bodies in the films. His work does not analyze the body in the representations of the sublime and science fiction. Second, Bukatman focuses on discourses of the sublime in science fiction that are centered around large technological objects and displays. *Fantastic Voyage* does not

erect the sublime around a massive technological object or environment (such as the city in Ridley Scott's 1982 film *Blade Runner*). Instead, inner space is depicted as a terrifying natural landscape that can be traveled through. This film, like the science fiction comedy-adventure *Inner Space* (1987), is constructed around the technological invasion of a "natural environment," that of the interior human body. Third, Bukatman does not want to read all power as domination, but he is surprisingly judgmental towards popular cultural renditions of the sublime. He comments that these contemporary versions of the sublime are "tamed, popular, commercial" versions of the sublime and not a "truly awe-inspiring transcendental vision." Bukatman takes these popular versions of the sublime seriously but he is still concerned with drawing a line between the "fine art of painting" and the popular cinema. Finally, Bukatman offers a rather selective reading of phenomenology, one that neutralizes its critical potential for understanding the ways these imaging procedures are transforming our sense of inner and outer self *as* nature. And here feminist phenomenological work has been an important component of the creative and critical uses of this tradition and deserves acknowledgment.

There is a rich feminist tradition that looks at the personal and political impact that such fetal representations have for women. Iris Marion Young (1990), for example, uses phenomenology to describe the mediation of the body and its implications for the experience of pregnancy; she suggests that a splitting takes place between our inner and outer selves. For Rosalind Petchesky (1987), seeing images of the fetus is at once about establishing a me and not me that does not only bond mother and child as some research suggests, but separates mother from fetus. In contemporary fetal rights discourses such images have been used to privilege the autonomous personhood of the fetus separate from the mother. Women are obliterated from the picture leaving as the focal point the fetus floating in a vacuum rather than a body, like a little tiny spaceman.[12] Any consideration of biotourism and inner space needs to take into account the tradition of feminist work that places the body at the forefront of philosophical and cultural investigation (Probyn 1992).

Inside out

Subjectivity, our sense of who we are as human beings and of our capacity for agency and action in the world, is marked in the twentieth century by the proliferation of technological possibilities. One significant aspect of the growth of scientific devices for imaging the interior of body space, and making the inside of the body into a landscape for imaginary travel, is the transformation of our corporeal sensibility. Our bodies have been medicalized, and in this medicalization of the body as an administrative unit of control a new identity and sensibility has been forged – the biotourist. As our bodies are increasingly mediated and surveyed by technologies that render them transparent and visible, the lived relationship of the body to the phenomenological world is replaced by the nostalgic myth of contact and presence with inner space. *Fantastic Voyage*, like the other byproducts of the biotourist industry in art, science and medicine, is culturally located at the cusp of this longing for an unattained "natural" corporeal existence in the twentieth century which has obliterated this possibility. This desire and longing is a paradox of our culture. It is fueled by the desire to know what is happening inside and to see the inner body at work, yet it is predicated upon technological intervention.

But this idea that representation can be without intervention is itself a wish, a fantasy. As Ian Hacking (1995) has stated, every representation is an intervention into corporeal space. Technological innovations such as the microscope in the 1600s aggrandized the miniature into shapes that were not brought into clear focus until better lenses could be constructed. Most importantly, these shapes could not be clearly examined until the discovery of aniline dyes that could be injected into organisms without killing them. Because most microbes are transparent, these dyes rendered their contours visible to us (Hacking 1995: 192). Even if we do not need to cut into the body to see, we must make visible through some kind of transformation, whether it be by making a patient swallow barium to reveal the contours of the stomach, inserting an encilloscope into an anus, bouncing back frequencies to create an ultrasound image, or jostling the subatomic protons in a body to create the process of MRI. Biotourism depends upon the optical capacity to see the inner recesses and contours of the body, which can be accomplished either by cutting through the epidermal layer and peering directly inside or by the use of less invasive technical devices. Biotourism is the fantasy that one can voyage into the interior space of the body *without* intervening in its life processes, with silent footsteps, without leaving a trace.

If the discourse of the sublime in the eighteenth century articulated a sensibility towards first nature and second nature, then these new rhetorics of the sublime update these concerns as they operate towards first nature in the transformation in an era of "technomorphism" to borrow a term from Elizabeth Fox Keller (1995). The trade-off is that our body becomes a technical object under human control in exchange for knowledge of its internal operations and increased longevity. When our technologies fail to bring us good health, when our doctors must admit that no matter how many machines there are we must accept that we are doomed to our own mortality.

Popular images and narratives of inner sublime space concretize our continuing faith in the phantasmagoria of progress and the body as the new frontier for high-tech exploits and interventions that try to augment "life" and put death into abeyance. This attempt to reconcile science and spirituality is one of the main themes explored in *Fantastic Voyage*. The task of re-imagining how science may improve lives in *this* world, on the other hand, is one of the many tasks of a feminist analysis of science and technology.

Notes

1 The veracity of these special effects was at the centre of controversy among film critics of the period. Pauline Kael (1966), for instance, penned a scathing review for *The New Republic*, criticizing the hygienic, psychedelic interior landscape portrayed in the film.

2 This issue of *LIFE* featured the computer-generated image work of Alexander Tsiaras (1997), the artist who conceived the images for the Time-Warner interactive CD-ROM *Body Voyage*, subtitled *A Three-Dimensional Tour of a Real Human Body*. The CD-ROM is only one of several educational-entertainment spin-offs from the Visible Human Project, discussed by Catherine Waldby in this section (see Chapter 2).

3 "How food becomes fuel: the phenomenal digestive journey of a sandwich" (1962). The paintings are by Arthur Lidov. The February 1997 issue of *LIFE* picks up on the trope of "the fantastic voyage," with its title, "A fantastic voyage through the human body."

4 M. Horkheimer and T. Adorno (1972), see in particular, "Excursus I: Odysseus or myth and enlightenment," pp. 43–80.

5 Within this sub-category of science fiction films based on expansion and reduction, a whole treatment could be made of the central place of "the bug" who becomes the size of a

human, beginning with George Méliè's' 1898 film *Un bon lit* and continuing through to *The Fly* (1958 and 1986). In the former, giant bugs transformed into monsters roam the earth's surface, while in the latter a human merges with an insect. In both films the bug is enlarged while humans remain the same size, under threat from a species we normally dominate. We routinely squash bugs, usually without remorse, so it is no wonder that we fear insects seeking revenge; and bugs, like monsters, are usually depicted without reason or a higher moral purpose. In this respect, the French film *Microcosmos* (subtitled *The Little People of the Grass*, 1997) is distinct in its sympathetic depiction of the bug world. By reducing the entire scale of their habitat through clever editing and the judicious use of music and sound, the bugs in the film are anthropomorphized and given human qualities.

6 For an analysis of the fantasy of being swallowed see M. Morse (1994).

7 John Donne, *Devotions*. Walter Raleigh's accounts of his journey into the Brazilian Amazon are fascinating for their similar use of language. For an account of Walter Raleigh's travel diary see S. Shama (1995), p. 308.

8 The idea of landscape as a historical and cultural process was first advocated by John Brinkerhoff Jackson, often referred to as the godfather of landscape studies; see J. Brinkerhoff (1994). Other important works on landscape include M. Wanke (1995). For work on the symbolic dimensions of landscape see D. Cosgrove (1988). And, finally, P. Groth's and T.W. Bressi's (1997) *Understanding Ordinary Landscapes* is an excellent compilation.

9 The exigencies, goals and practices of science differ from the writing of science fiction but there is an interesting interchange between the two realms on this level. Both are dependent upon representation: one for the creation and exchange of knowledge, the other for the entertainment and pleasure and speculation. As well, both science and science fiction have been caught up in debates concerning realism and representation.

10 Welch's own sublime figure, in a tight white wetsuit, like the other crew members, was commented on by more than one film critic. See, for example, J. Parish and M. Pitts (1974), p. 172; and B. Crowther (1970), p. 3631.

11 R. Modiana (1985), *Coleridge and the Concept of Nature*. Modiana's book is an excellent overview of theories of the sublime.

12 Rosalind Petchesky (1987) analyzes this phenomenon in her reading of the *Silent Scream* in "Foetal images: the power of visual culture in the politics of reproduction," pp. 57–79.

References

Benjamin, W. (1968) "The work of art in the age of mechanical reproduction," in H. Arendt (ed.) *Illuminations*, trans., H. Zohn, New York: Schoken Books, 222–3.

Berland, J. (1992) "Fire and flame, lightning and landscape: tourism and nature in Banff, Alberta," Banff, Alberta: The Walter Phillips Gallery, 12–17.

Un bon lit (*A Midnight Episode*, 1899), dir. Georges Méliè.

The Borrowers (1998), dir. Peter Hewitt, Polygram Films, 91 min.

Bright, D. (1989) "Of Mother Nature and Marlboro Man: an inquiry into the cultural meanings of landscape photography," in R. Bolton (ed.) *The Contest of Meaning: Critical Histories of Photography*, Cambridge, Mass: MIT Press, 125–42.

Brinkerhoff, J. (1994) *A Sense of Place, a Sense of Time*, New Haven: Yale University Press.

Bukatman, S. (1996) "The artificial infinite: on special effects and the sublime," in L. Cook (ed.) *Visual Display: Culture Beyond Appearances*, San Francisco: Bay Press.

de Certeau, M. (1984) *The Practice of Everyday Life*, trans. S. Rendall, Berkeley: University of California Press.

Chomsky, N. (1993) *Rethinking Camelot: JFK, the Vietnam War, and US Political Culture*, Montreal: Black Rose Books.

Cosgrove, D. (1988) *Social Formation and Symbolic Landscape*, Madison, Wisconsin: University of Wisconsin Press.

Crowther, B. (1970) "*Fantastic Voyage*," *The New York Times Film Reviews*, 1913–1968, vol. 5, New York: The New York Times and Arno Press, 3631. Crowther's review originally appeared in 1966.

Durgnat, R. (1966) "*Fantastic Voyage*," *Films and Filming* 13, 2 November: 12–13.

Fantastic Voyage (1966) dir. Richard Fleischer, 20th Century Fox, 100 min.

"A fantastic voyage through the human body" (1997) *LIFE*, February: 33–76.

The Fly (1958), dir. Kurt Neumann, 20th Century Fox, 94 min.

The Fly (1986), dir. David Cronenberg, 20th Century Fox, 96 min.

Fox Keller, E. (1995) "Situating the organism between the telegraph and the computer," in M. Bal (ed.) *The Point of Theory*, Amsterdam: University of the Netherlands Press.

Good, B. and Del Vecchio Good, M. J. (1993) "Learning medicine: the constructing of medical knowledge at Harvard Medical School," in S. Kindenbaum and M. Locke (eds) *Knowledge, Power and Practice: The Anthropology of Medicine and Everyday Life*, Berkeley: University of California Press, 81–107.

Groth, P. and Bressi, T. W. (1997) *Understanding Ordinary Landscapes*, New Haven: Yale University Press.

Hacking, I. (1995) *"The Microscope," Representing and Intervening: Introductory Topics in the Philosophy of Natural Science*, Cambridge: Cambridge University Press.

Honey I Shrunk the Kids (1989), dir. Joe Johnston, Disney, 101 min.

Horkheimer, M. and Adorno, T. (1972) *The Dialectic of Enlightenment*, trans., J. Cumming, Boston: The Seabury Press.

"How food becomes fuel: the phenomenal digestive journey of a sandwich" (1962) *LIFE* 3 November: 78.

The Incredible Shrinking Man (1957) dir. Jack Arnold, Universal Pictures, 81 min.

Kael, P. (1996) Untitled review, *The New Republic* 8 October: 34, 35.

Marion Young, I. (1990) "Pregnant embodiment: subjectivity and alienation," in *Throwing Like a Girl and Other Essays in Feminist Philosophy and Social Theory*, Bloomington: Indiana University Press, 160–77.

Men in Black (1997) dir. Barry Sonnenfeld, Columbia Pictures, 98 min.

Microcosmos: le peuple de l'herbe (1997) dir. Claude Nuridsany and Marie Perennou, Galtée Films, 75 min.

Mills, C. W. (1958) *The Causes of World War Three*, New York: Simon and Schuster.

Modiana, R. (1985) *Coleridge and the Concept of Nature*, Florida: Macmillan.

Morse, M. (1994) "What do cyborgs eat?: oral logic in an information society," in G. Bender and T. Druckery (eds) *Culture on the Brink: Ideologies of Technology*, Seattle: Bay Press, 157–89.

Mouse Hunt (1997) dir. Gore Verbisnski, Dreamworks, 98 min.

Parish, J. and Pitts, M. (1974) *The Great Spy Pictures*, Metuchen, N.J.: The Scarcrow Press, 172.

Petchesky, R. (1987) "Foetal images: the power of visual culture in the politics of reproduction," in M. Stanworth (ed.) *Reproductive Technologies: Gender, Motherhood and Medium*, Minneapolis: University of Minnesota Press, 57–79.

Probyn, E. (1992) "Theorizing through the body," in Lana Rakow (ed.) *Women Making Meaning: New Feminist Directions in Communications*, New York: Routledge, 83–9.

Shama, S. (1995) *Landscape and Memory*, Toronto: Vintage Canada.

Sobchak, V. (1987) *Screening Space: The American Science Fiction Film*, New York: Ungar.

Stafford, B. M. (1991) *Body Criticism: Imaging the Unseen in Enlightenment Art and Medicine*, Cambridge, Massachusetts: MIT Press.

Stewart, S. (1993) *On Longing: Narratives of the Miniature, the Gigantic, the Souvenir, the Collection*, Durham, North Carolina: Duke University Press.

Toy Story (1995) dir. John Lasseter, Disney, 81 min.

Tsiaras, A. (1997) *Body Voyage: A Three-Dimensional Tour of a Real Human Body*, New York: Time Warner Electronic Publishing.

Wanke, M. (1995) *Political Landscape: The Art History of Nature*, Cambridge: Harvard University Press.

Catherine Waldby

THE VISIBLE HUMAN PROJECT
Data into flesh, flesh into data

Man makes man in his own image.

(Norbert Weiner)

THE RELATIONSHIP BETWEEN technology and the body is one of the defining concerns of contemporary intellectual and ethical practice in both the sciences and the humanities. It is a concern at the forefront of the much vaunted move from a humanist to a post-humanist theory/normativity of the subject, as biotechnologies make the humanist distinctions between human and machine, nature and culture, life and non-life increasingly difficult to sustain. Such projects as IVF, cryogenics, genetic engineering, the Human Genome project, and the various productions of digital artificial life, not to mention an increased dependence on more and more sophisticated prosthetics, involve the biotechnological manipulation and management of the borders between such distinctions, and the prospect of their eventual redundancy. As Braidotti (1994) points out, the management of living matter has always been a priority for our culture, and the development of these biotechnologies indicates the emergence of new use values for the human body, new forms of knowledge, productivity and exchange, which must always have consequences for the meaning of subjectivity, conditioned as it is by forms of embodiment.

Many of these new techno-bodily economies have developed out of the late twentieth-century's conceptualization of the body as an effect of codes, flesh specified through/as information. The ramifications of this form of specification are only gradually being realized, both in the sciences and the humanities. While the idea of the living body as a system of information is most familiar to us from the field of molecular biology, it has also, perhaps indirectly, conditioned the understanding of the body and its identity in many other domains, from that of science fiction to the disciplines which Fox-Keller (1994) terms "cyberscience" – information theory, cybernetics, operations research and computer science, the sciences which have been responsible for the development of the new digital technologies.

In this chapter I wish to focus on a particular, quite startling development that summarizes and plays out some of the implications for our understanding of the body as data: the virtual anatomy "atlas," the Visible Human Project (VHP). The VHP takes advantage of the ever increasing capacity of super-computers to deal with large quantities of rich visual data, enabling the creation of a three-dimensional "recording" of actual human bodies whose depth and volume can be manipulated in the field of the computer screen. The VHP creates complete, anatomically detailed, three-dimensional representations of the male and female human body and makes these representations available on the Internet.

The project's method for recording bodies is as follows. First a suitable cadaver is located, one which is free of pathological tissue or prostheses so that the imaged body can circulate as an example of "normal," that is normative, anatomy.[1] Once such a body is located, it is imaged through a number of different media. It is placed in a magnetic resonance imaging (MRI) machine and scanned. This first imaging process provides a template for the intact body which is to be digitally "copied." Next, the body is frozen in gelatin at -85°C. Once suitably solid, it is cut into four sections and each section is scanned by computed tomography (CT) and MRI technologies.

After this, the body is systematically and very finely sliced into oblivion, the slices falling at the same points at which the CT scan had optically "dissected" the body. Beginning with the feet, the frozen sections are fitted into a dissection device, a cyromacrotome, described by its creators as a "milling device," which planes the corpse at very fine intervals, between .3 and 1 millimeter. This technique effectively obliterates the body's mass, each planed section dissolving into sawdust due to its extreme desiccation. After each planing the cross-section of the remaining body section is digitally photographed, so that each photograph registers a small move through the body's mass. Each of these photographs is then converted into a computer data file, and their position in the overall body registered according to the initial template.

In this way the fleshly cadaver is converted into a visual archive, a digital copy in the form of a series of planer images. This archive can be downloaded via the Internet after payment of a licensing fee. The files can be viewed one by one, showing highly resolved transverse cross-sections through the body in realistic, photographic color (see Figure 2.1). Due to the animating and volume rendering capacities of computer vision this archive is not merely an inert series of images: the slices can be re-stacked so that the appearance of volume and solidity is restored to the virtual body (see Figure 2.2). This re-stacking capacity enables unlimited manipulation of the virtual corpse. As one commentator describes it:

> The … data set allows [the body] to be taken apart and put back together. Organs can be isolated, dissected, orbited; sheets of muscle and layers of fat and skin can lift away; and bone structures can offer landmarks for a new kind of leisurely touring.
>
> (Ellison 1995: 24)

Blood vessels can be isolated and tracked through virtual space, users can "travel" the entire length of the spinal cord or the esophagus, and the body can be opened out in any direction, viewed from any angle and at any level of corporeal depth. Users can move around the body using hypermedia links and "fly-throughs" which allow navigation through different points of the body from a vantage point similar to that of a

FIGURE 2.1 Visible Human Male: cross-section of the skull

Source: Courtesy of the Institute of Mathematics and Computer Science in Medicine, University Hospital
 Eppendorf, Hamburg, Germany.

tiny spacecraft. The body appears like a terrain which moves beneath and past the
viewer, blood vessels are traversed as if they were tunnels, the colon as if it were a
cave. The skeleton can be traveled as if flying at low level through a forest of bones.
The body's interior appears as if it were a hollow, extensive space, populated by
organs, bone and connective tissue, Gulliver's body as it might appear to Lilliputian
explorers.

The virtual corpse can also be animated and programmed for interactive simula-
tions of trauma, of human movement, of fluid dynamics and of surgery. The heart
can be made to beat, the veins to bleed, the flesh to bruise and lacerate. At present,
programmers are working to give muscles and bones different degrees of resistance
and density in relation to haptic data transmitted to a surgical data glove, to be used
by a surgeon performing simulated surgery. Obliterated in real space, the cadaver is
magically reformulated in virtual space, to act as a surrogate for real bodies in the
space of the screen.

The VHP is thus the most recent, and certainly the most exhaustive of medicine's
attempts to render the human body visualizable, as the project's name implies. The
project's aim of representing the body is of course shared by the whole history of
medicine, and one of the intriguing things about the VHP is its dual status as the
newest and most spectacular technology for the representation of the body, yet at the
same time as an atavistic object that recapitulates within itself an entire history of physio-
anatomical technologies, practices and meanings. It realizes the three hundred-year-old

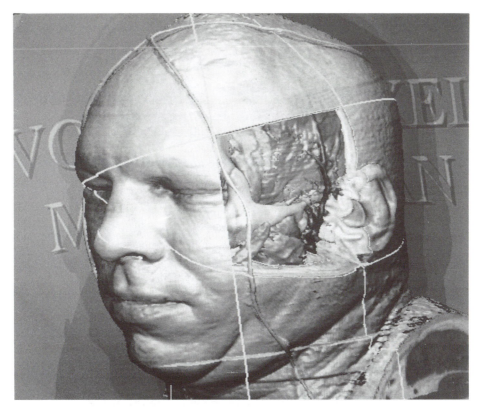

FIGURE 2.2 Visible Human Male: volume rendering of the head

Source: Courtesy of the Institute of Mathematics and Computer Science in Medicine, University Hospital
 Eppendorf, Hamburg, Germany

anatomical dream of perfect, exhaustive visual access to the body's inherently patho-
logical interior, and of that interior's perfect representation (Stafford 1993). This
visual access to the interior is combined with the capacity to visualize simultaneously
the body as a totality and a dynamic field of action, a mode of visualization which
Cartwright (1995) identifies as specific to nineteenth- and twentieth-century physi-
ology, the science of the living body. In short, it brings together capacities to render
simultaneously the body as surface and depth, action and object, and in the process
realizes a series of medicine's historical desires – for the body's visibility, for its stan-
dardization, and for mastery over life processes through their simulation.

 The VHP is atavistic in another sense, too, an unsettling recapitulation of the
often grisly history of anatomical knowledge. At the time of writing (1999) two
human bodies have been fully imaged for the project, while a third is in preparation.
The first cadaver was made available because a convicted murderer, Joseph Jernigan,
donated his body to science before his death by lethal injection at the hands of the
Texas penal system. Jernigan has thus become a member of the centuries old frater-
nity of criminals whose sentence included anatomical dissection after execution
(Forbes 1981). Criminalized male bodies have furnished the raw experimental mate-
rial for the generation of anatomical knowledge since dissection became legal in the
seventeenth century, dissection acting in their case as an epistemologically productive
form of punishment (Barker 1984). The second cadaver is that of a 59 year-old

woman who died less spectacularly of a heart attack. Jernigan and the as yet unnamed woman have been dubbed Adam and Eve by their technicians and the popular science press, the first couple in the virtual garden of cyberspace. The third body will be that of an embryo, constituting the VHP as a kind of digital nuclear family.

The VHP is, then, a medical object strongly continuous with the history of medical visualization. Its novelty, and its epistemological and biopolitical significance, is found in the way that this history has been transformed by being taken up in a new economy of representation. This economy is specific to the new digital technologies, with their capacity for visual modeling and simulation, and for the global replication and communication of visual data enabled by the Internet.

These technologies effectively render the human body, or more precisely the appearance of the body, into digital information, decomposing the body's fleshly complexity into the simple on/off logic of binary code. The VHP is certainly not the first body to be imaged digitally: virtual imaging using data from CT scans, positron emission tomography (PET), MRI and sonography have regularly been used for medical diagnosis over the last ten years. However, the VHP is distinguished by its exhaustiveness, its attempt to image two entire bodies in a complete fashion and to circulate them through the Internet as standardized diagnostic and pedagogical benchmarks. Cyrosection transforms the depth and opacity of the body into a series of visible planes, of cross-sectioned flesh and bone, which then can be made to yield up detailed visual information in light spectra, unlike the ghostly, low resolution spectra involved in MRI, PET and the other modes of visualization that "see" through the body's tissues and surface. These latter modes of visualization produce images which have no straightforward relationship to the way the body looks to unaided eyes, and demand considerable interpretive skill and training for technicians and specialists before they can be reliably used for clinical purposes. The VHP, however, reproduces the "look" of the body in the space of the computer screen much more naturalistically, thus minimizing the sense of an object mediated by technical vision.

What the VHP attempts to do is to create a virtual clone of the body, a visual double which reproduces, perfectly and uncannily, the "look" of the fleshly body as it could only be seen by an unlimited power of vision. Like the fleshly clone which maps cell to cell, the VHP tries to map cell to voxel, to transubstantiate flesh into data, with maximum density and minimum loss of flesh, understood as visual information. The exhaustiveness and high resolution of this mode of imaging means, however, that the VHP forms an extremely large and unwieldy data set, a sign of the body's excess to this mode of technical containment. To access the VHP it requires at least two weeks' downloading time and about 50 gigabytes of storage capacity, and the images can only be completely manipulated by a super-computer.

This digitalization of the flesh yields multiple effects in the fields of medical knowledge formation and the biopolitical field of the social that such knowledge regulates. An esoteric, scientific and also increasingly popular object, the VHP seems destined to transform the ways in which medical imaging is used and imagined, and the way that non-scientific subjects consider their own bodies and their relations to biotechnologies. In my opinion, one of the most important biopolitical consequences of the VHP is a further development and reinforcement of the conceptualization of "Life" – the iconic object of biomedical practice – as an economy of information or data. This very specific understanding of Life has profound consequences; and the VHP, as the newest visual text for modeling the living body, plays out a number of

these consequences, in particular the desire to manage the human body through its digital simulation.

This form of management, the digital "reproduction" of bodies as a means of specifying the way that bodies work, also locates the VHP as an object of feminist concern. The VHP serves as a demonstration of biomedicine's mastery over technical forms of reproductive power, its ability to replicate bodies through their transformation into code. In this regard it forms one of several new biotechnologies – IVF, cloning – which seek to abstract the power of reproduction from specifically feminine bodies and arrogate it to medical techniques. In the following section I will try and tease out some of the ways in which translations of flesh into data condition the meaning of living matter, and some of the feminist and more general biopolitical implications of this process.

The virtual corpse

I suggested above that the VHP is of interest to the biomedical establishment because it presents a highly flexible, complex and information-rich method for rendering the human body as a demonstrative visual text. Among others, Latour (1990) has argued that this movement from living object to visual text *about* the object characterizes the entire scientific enterprise. Latour contends that the purpose of science is to transform masses of natural objects into standardized trace representations, for example graphs, tables, formulae, and so on, which summarize objects in ways that are intelligible to scientists, and which can easily be reproduced and manipulated. The object of the scientific gaze is not the natural object but the visual text produced about the object, which does the crucial work of acting as a standardized, cooperative surrogate for the object under consideration. Daston and Galison (1992) term these surrogates "working objects."

> Working objects can be atlas images, type specimens, or laboratory processes – any manageable, communal representatives of the sector of nature under investigation. No science can do without such standardised working objects, for unrefined natural objects are too quirkily particular to cooperate in generalisations and comparisons.
>
> (Daston and Galison 1992: 85)

In this sense, anatomy, the science of the body's organization, is concerned to produce working objects which both visually demonstrate *and* simplify the individual complexity of the human body. Historically anatomy has been quick to seize upon emerging forms of visual technology to aid this task – moving from the craft technologies of the draughtsman artist to the more "objective" technologies of the camera obscura and the camera. The VHP represents the most recent innovation in these methods for producing anatomical working objects, a dramatic development in what Foucault (1975) calls "the techniques of the corpse," the methods used to extend the medical gaze into the dead body and hence discover the hidden secret of the body's life.

The corpse, rather than the living body, is central to the production of anatomical working objects, and hence to anatomical knowledge more generally. Anatomy, which produces visual texts about the living body's organization, does so through the analysis of dead bodies, often, as I mentioned earlier, the bodies of dead male criminals. This

paradox is sustainable I would argue because of the way in which biomedicine conceptualizes Life. As Foucault (1970) suggests in *The Order of Things*, the concept of Life reified in biomedical discourse is an historical rather than a natural concept, emerging only in the nineteenth century as the object of the new sciences of biology.

Life is here conceptualized as the force and animation of living bodies, as an abstract, elusive force which exceeds its location in any particular body. Like the forces of magnetism, gravity and entropy found in physics, it can be conceptually abstracted from any particular body which it might animate, and hence can be analyzed, quantified and controlled irrespective of these bodies. As Cartwright (1995) puts it,

> No longer concerned with the body as such, medicine is interested in isolating life – in regulating and extending it, and in gaining control over death in the process. The observed body came to be viewed as a vehicle, a site of living processes.
>
> (Cartwright 1995: 82)

At the same time, the force of Life is expressed in the organization of organic matter, just as the forces of physics reside in the organization of inorganic matter. However, the organization of Life is not to be found on the body's surface but inheres in the relationship between visible surface and concealed depth (Foucault 1970: 228). Consequently, for anatomy, the depth and volume of the living body is an obstacle to its desire to see and analyze the processes of Life. Anatomical dissection seeks to overcome the body's depth and opacity, the "tangible space of the body, which at the same time is that opaque mass in which secrets, invisible lesions, and the very mystery of origins lie hidden" (Foucault 1975: 122).

Thus in order to see the general vivifying principles of the body, in order to open it out in a complete fashion to the analytic gaze of anatomy as a set of visualizable surfaces rather than an opaque volume, the particular body must be dead. A particular body must die in order that biomedicine can see and analyze the organization of life understood as a *biocentric field of force*. The bodies visualized by the VHP donate their life force to the visual text.

As Leder (1990) points out, the corpse also lends itself to reductive and quantifiable forms of explanation that are compatible with the conceptualization of Life as an abstract quanta of force. The living body is excessive, non-predictable, organized through non-quantifiable forces of meaning and desire, as well as organic drives. Because the living body operates as a subjective, phenomenological and erotic, as well as an organic totality, it defies conceptual dismemberment and reduction. Only the corpse can be treated as the uncomplicated object of an analytic logic.

> While the body remains a living ecstasis it is never fully caught in the web of causal explanation ... Its movements are responses to a perceived world and a desired future, born of meaning, not just mechanical impingements. This bodily ecstasis constitutes an absence that undermines attempts to analyse the body and to predict and control its responses. Only the corpse seems to render such a project triumphant. The dead body is at last self-contained. It is a sheerly material and predictable thing.
>
> (Leder 1990: 147)

Hence the corpse is the privileged object of the anatomical gaze, both because it can readily be opened out and reduced to its component parts, its organs, limbs, cells and molecules, and because it can easily be interpreted as a simple organic object once caught up in the force field of Life. It lends itself to the production of anatomy's working objects because it is in itself a simplification of the living body.

The VHP utilizes the corpse in this way too, but through digitalization and the production of a virtual corpse it has overcome the problematic relationship between surface and depth encountered in the fleshly body. Rather than producing flat, sequential images of a corpse in various stages of dissection, as analog technologies like photography, cinema and scientific forms of drawing do, the VHP effectively creates a digital replica, reproduced as rugged data instead of fragile flesh. The cyrosection slices are, as I described earlier, imaged in various spectra and the images are converted into mathematical codes through scanning technology which allocates a set of quantitative values to different qualities of color, lightness and darkness, texture, density, and so on. Once the data has been scanned into a computer, these mathematical codes can be reconstituted as visual text through visual interface software which reverses the process, transforming quantitative codes into pixels and voxels, the light units of the virtual screen. This means that the "look" of the body can be reformulated in the virtual space of the screen.

Through this conversion of flesh into data the paradoxes of surface and depth, of Life and the violence which medicine must do to see it, are suspended. The VHP data-body can be manipulated in ways which the fleshly body cannot, cooperating seamlessly with the desire to see its interior. The virtual body can be both dismembered and re-membered. The data set can move from individual cyrosections to virtual integrity, each virtual section re-stacked in order so that a complete body is made up. The integrated body can then be dismembered again, this time according to the logic of classical dissection, where flesh, sinew and bone are laid out in an orderly way using a cursor as a scalpel. One of the primary uses envisaged for the data is simulational dissection for medical students, who will be able to reformulate their cadaver at will. Unlike Dr Frankenstein, who must suture together mismatched body parts in the clumsy world of physical space and material bodies, the VHP can cleanly dismember and re-member its virtual bodies with a flick of the cursor. While the VHP is produced through an inaugural act of violence, the execution (in Jernigan's case) and cyrosection of the body, the visual text so produced has expunged any trace of violence, that is resistance, from within its frame.

In this dense conversion of flesh into data the VHP creates a parallel realm of virtual anatomy, a controllable world of anatomical demonstration set apart from the world of everyday bodily life. As an extremely complex, flexible and information-rich working object, it acts as a heuristic device, setting out and enabling certain kinds of thought, experimentation, visual projection and fantasy about the operation of the human body and its technical surrogates. This *aide-pensée* works in this fashion both for the esoteric biomedical imagination and for the public imagination, which is directly addressed by a number of commercial projects – CD-ROM hypertext products which use the VHP data to produce popular visual narratives about the body's interior. The crucial point about this working object, however, is that it is simultaneously a visual text of the body and a mathematical structure of data. Methodologically speaking, it is a visual text of the body produced through mathematical structures of data. This has crucial implications, both for the forms of mastery which can be exercised over the VHP and for the concepts of Life which are implicit in it, the concepts of Life it can be used to fantasize and speculate about.

Biodigital economies

The attractiveness of the VHP for biomedicine derives precisely from the forms of mastery enabled by digital technologies over virtual objects. Because virtual objects are produced through binarisation, the rendering of all qualities as quanta, they are amenable to complex forms of exchange, replication, scale manipulation and transmission – made possible only when a common code and a standard value are in play. Braidotti (1994) argues that medicine has always strived for forms of representation which standardize and quantify the body, an argument which recalls Heidegger's (1977) propositions about the scientific world view and its drive to mathematicize its objects. Heidegger suggests that the mathematicization of nature is a form of conceptual practice which makes the world over as a use value, a set of calculable causes and effects which are amenable to technical intervention and instrumentation.

Braidotti makes an analogy between this mathematicization of the body and the realm of pornographic representation, describing medicine's standardizations of the body as medical pornography. She defines pornography here as: "a system of representation that reinforces the commercial logic of the market economy. The whole body becomes a visual surface of changeable parts, offered as exchange objects" (Braidotti 1994: 25). In other words medicine seeks to standardize the flesh in order that it can be rendered into an economy, able to be prostheticized along lines which make flesh productive within the terms of our biopolitical order. As Haraway (1991) expresses it, the codification of the flesh is a strategy for rendering the body completely within the domain of technical mastery, for forcibly cutting across qualitative differences in bodily meanings and capacities and making them equally available to technical intervention. She writes that

> the translation of the world into a problem of coding [is] a search for a common language in which all resistance to instrumental control disappears and all heterogeneity can be submitted to disassembly, reassembly, investment and exchange.
>
> (Haraway 1991: 164)

This standardization ensures that, as Braidotti (1994) discusses, body parts and bodily substances can be exchanged in practices like organ donation and trade, and IVF technologies, and flesh can be replicated, at least theoretically, without recourse to the other, the body of the mother. Replication of bodies outside of sexuality and maternity represents for medicine the promise of final and complete control over Life, control realized when the force of Life can be technically simulated through simulating bodies. A fully realized techno-economy of the body would bypass sexual reproduction altogether, proceeding through commodified forms of replication (Baudrillard 1994).

In the case of the VHP, the flesh has been standardized and quantified according to the logic of digital code, and hence the visual text of the VHP is a productive working object for biomedical knowledge precisely because of these "economic" qualities – the ability to be replicated, rapidly transmitted, dismembered, circulated – that is, available to all digital objects in the global digital communication infrastructure. Some of the knowledge effects of these abilities include:

1 Replication: as a digital data set the virtual corpse can be perfectly replicated without loss of quality. Just as in the biomedical imagination a fleshly body can be "cloned" through the activation of its organic DNA information, so too can the virtual body be cloned, because it is specified through digital information. This ability to be infinitely reproduced ensures that different teams of scientists can work on the data set secure in the knowledge that their sets are absolute standardizations, each a perfect replica of the other. This perfect standardization is highly desirable within the framework of biomedical practice because it facilitates medical pedagogy and the formation of professional knowledges more generally. It allows, for example, for standardized notions of normalcy and pathology to be disseminated throughout the medical profession. One of the uses envisaged for the data set is as a diagnostic benchmark for images of healthy tissue, which can be used in pathology labs and clinics throughout the world as a point of comparison with histological sections of unhealthy tissue.

2 Transmission: the VHP is a data-body which can be transmitted and downloaded via the technologies of the Internet to a computer anywhere in the world. This compatibility clearly lends the VHP to international forms of commercial and academic collaboration. It enables research teams to collaborate on the same object in different locations and to pool and combine experimental results.

3 Segmentation: the traditional anatomical practice of analyzing bodies into their component parts can also be simulated on the virtual body. Visual digital data can be infinitely segmented without loss of quality, and consequently different segments of the data-body can be treated as detachable modules which can be worked on independently by research teams. This subdivision of the data has proved a very popular attribute, with a team at Stony Brook specializing in the colon and another at the University of Pennsylvania producing an interactive knee program. In this way the VHP can be segmented according to the traditional concepts of the body's organization represented by the existing anatomical subdisciplines, but it seems to me that the infinite plasticity of the visual data, its endless ability to be manipulated and opened out, might contribute to new concepts of anatomical organization that exceed such mechanical subdivisions.

Bio-simulation

Each of these effects of digital economy listed above makes the VHP a working object around which new forms of pedagogical, commercial and collaborative knowledge relations can be formed. The most important digital effect of the VHP, however, resides in the simulational and modeling capacities of digital visual data. The VHP data set is not an inert working object but something more like a field of anatomical, simulational possibility. The operation of the VHP involves not only the "visual data" derived from the body but also its manipulation in the virtual space of the screen. The VHP is an object whose heuristic value derives from the particular ability of virtual space itself to be manipulated. It is not so much the representation of a body *in* space as a representation *of* virtual bodily space, rendered as a depth and volume which can be moved through and refigured at will. As a digital visual object the VHP also exploits the peculiar flexibility of computer imaging. As Wark (1993) notes, digital images have the quality of limitless mutability without loss of information density. They can be repeatedly changed, modified and manipulated without a loss of quality and without limits.

These qualities of virtual vision make the VHP a peculiarly potent, propositional mode of visualizing the body. As a virtual body it takes on all the attributes of the speculative, imaginative and experimental medium which is virtual space. It also takes on the quality of a perfectly mastered body, a body which complies with the whim of the operator who presides over the space of the screen. As Edwards (1990) notes, the space of the virtual screen is a micro-world, a surrogate world under the control of the programmer. The world of the screen, like the world of a chess game, sets out complexity and non-predictability within strictly confined parameters. It creates the conditions for very complex, yet none the less simplified, working objects.

> Problems of simulation are essentially problems of representation – of creating symbolic entities with properties and rules of interaction that correspond to real entities and their interactions. ... Computer simulations are ... by nature partial, internally consistent but externally incomplete; this is the significance of the term 'micro-world.' Every micro-world has a unique ontological and epistemological structure, simpler than that of the world it represents. Computer programs are thus intellectually useful and emotionally appealing for the same reason: they create worlds without irrelevant or unwanted complexity.
>
> (Edwards 1990: 109)

Just as the corpse excludes complexity from the biomedical model of Life, so too does the VHP. The VHP presents a virtual body which is fully contained within the parameters of biomedical imaging and explanatory frameworks, and which is hence fully cooperative as a clinical, commercial and experimental object. It is a model of the body and corporeal space in the sense that a model is a systematic visual field which is consistent in its own terms, a field from which all heterogeneity, non-predictability and qualitative difference has been excluded.

These qualities of controlled complexity and detailed mastery enable new and highly complex forms of bodily modeling to be enacted. Current practices or future proposals include surgical simulations, with randomly introduced complications for the training of medical students; the modeling of war wounds for military research; use by radiologists to plan cancer therapy and surgeons to plot the path of a bullet before surgical intervention; and the creation of diagnostic models for sports injuries. The VHP will also be used to create complex models of human movement, useful for the design of prosthetics, ergonomic furniture and tools, athletics training programs, and the like. Another form of simulation involves the production of animation "fly-throughs," that is animations which represent the body as a terrain, above and through which the virtual point of view moves as if in a miniature spacecraft.

The VHP's modeling capacity is of central interest in assessing the biopolitical effects generated by this mode of visualization. The power of virtual space to model a complex virtual world has profound implications in all domains of knowledge for the engendering and management of the real. Wark (1993) indicates the particular abilities of virtual images to anticipate and lay out realizable models, using architecture as his example.

> An interactive, walk-through model may simulate a building prior to its construction. This may not sound like much: so could a drawing or plan. But drawings or plans, like photographs, are surfaces ... [Computer graphics

are] more than a mere surface, it is a mathematical structure, which in this instance could be drawing, plan and model all in one, in anticipation of the referent building which has yet to be built. More than an analog, it is a homolog. Where one might plan a building, build it and photograph it, in that logical order, one can now plan a building, computer-graph it, and then build it – having disturbed the logical order of sign and referent.

(Wark 1993: 147)

Simulations, as Baudrillard (1994) notoriously argues, make the real over in their own image, force its compliance.[2] In the realm of biomedicine a forced compliance of bodies with their medical representations is arguably the very methodology of medicine, its means of effecting cures and therapies. The purpose of working objects for clinical medicine is to specify visually the distinctions between normal and patho-logical bodies and to use these visual texts as diagnostic and prognostic models, to which particular fleshly bodies are made to conform (Waldby 1996). One of the most important uses proposed for the VHP is that of a clinical benchmark, to act as a universal visual norm of the body's organization which can be disseminated in medical schools, clinics and laboratories.

To put it slightly differently, the VHP is such an attractive working object for medicine because of the complex ways it can simulate the organization of the living body, a capacity which allows medicine both to refine its own technical interventions into fleshly bodies and to use the VHP in more speculative ways as an experimental object. And it can do this because it is both a detailed visual text and a complex digital, that is mathematical, structure which is open to unlimited forms of manipula-tion within the space of the screen. Its modeling of the body involves programming in various kinds of limits and contingencies – simulated densities of bone and tissue, random fluctuations in blood flow and pressure, and so on. These are nevertheless limits which work within the terms of the program, rather than limits which arise out of the non-predictability and non-systematicity of embodied subjectivities. While the project programs in qualitative differences, these can never have the excessive effects of differences among and within embodied subjects; differences of resistance and idiosyncrasy, of the personal meaning of illness and its psychosomatic consequences, of the abjection and vulnerable mortality of fleshly bodies. While the VHP seems to take sexual difference into account through its treatment of both a man's and a woman's body, at the level of the technology's operation this gesture to difference seems to me to be effectively negated by its elimination of heterogeneity *as such*.

Techno-life

In this aspect as a mathematically-coded visual text, the VHP does not merely illus-trate the operation of the living body as biomedicine understands it. Rather it enacts within its own technology the organization of Life as data, which can be abstracted from the individual body and transmitted to and reformulated at another site. Here I am following arguments made by Cartwright (1995) and Diprose and Vasseleu (1991), who in different ways demonstrate that the technical modes that biomedicine uses to illustrate the processes of Life are themselves constitutive of this Life. They suggest that the conventional distinction between living matter and the technical models of Life that science creates to model it is precisely what enables biomedicine to generate material effects in living matter while seeming only to illustrate or analyze

them. This power of demonstration underpins medicine's manipulation of "life itself," the purposive motivation of matter.

> In science, various forms of 'calculated error' are employed to help concep-tualise the separate sphere of physical reality. These 'calculated errors' are used as figurative substitutions in the sense that objects and images which are not actually part of the matter being described are substituted in its place. ... Technical animation, used to convey physical mechanisms, can be included in the practice of 'calculated error' or substitution of alternative material to convey the ideas of science. ... The animation is regarded as no more than a formal demonstration of matter or mechanisms to which both it and its supporting commentary refer. ... Thus, scientific animation relies on the distinction between the metaphoric 'illusion of life' it generates and the elsewhere 'real-live' action which is its subject matter.
>
> (Diprose and Vasseleu 1991: 148–9)

Diprose and Vasseleu suggest that this separation of "life" and the "illusion of life" is not sustainable because biomedicine's imaging practices do not leave the fleshly body untouched, but rather exercise prosthetic effects. Such biotechnologies are implicated in the constitution of material bodies and hence of the forms that material Life, bodily motivation and motility, can take. If we accept that medicine's demonstrative texts exercise such constitutive effects, it follows that the VHP is not merely a screen through which speculations about the organization of the living body can be enter-tained. Instead, it is in itself a simulation of Life, where the force of Life is understood as a transmittable code.

Translation of bodies into a transmittable code clearly yields medicine new and flexible protocols for intervention into living bodies. It motivates the developing practices of tele-medicine and tele-surgery, terms which designate a range of diag-nostic and interventionist practices where the patient is at one site and the doctor or surgeon is at another, their encounter mediated by complex visual and haptic communications technologies which transmit symptoms, vital signs, visual access and surgical procedures as data.

Reciprocally, if the force of Life is understood as informational code, the program of Life itself can be rewritten. Data can be manipulated and transubstantiated into flesh, a conceit which informs the growing number of biotechnologies which seek to manipulate genetic code – those of recombinant DNA, nucleotide sequencing, and polymerase chain reaction. The biotechnical manipulation of genetic codes treats organic bodies as fields of simulation. They become objects for technical forms of replication, doubling, segmentation, hybridization and "morphing," producing species like the Onco-mouse through rewriting part of its genetic code. In these capacities the virtual corpse anticipates medicine's desire for more productive, modular, flexible and compliant bodies, whose reproduction can be rerouted away from the uncertainties and resistances of feminine sexuality and maternity and towards the reliable procedures of the laboratory. As Braidotti (1994) states, any technique which seeks to replicate living matter involves the effacement of the maternal body as point of origin, even when, in practice, no technique has been able to dispense with maternal bodies completely.

For me, the significance of the Visible Human Project considered as a biopolitical object arises from its lending a mode of visualization to the conceit. Its limitless

capacity to decompose and recompose the virtual corpse lends it to biomedical fantasizing about human life, and Life in general, as an informational economy which can be animated, reproduced, written and rewritten, through biomedical management. It is, to extend Braidotti's claim, an icon of medical pornography. It is a field of visual fantasization which plays out certain forms of mastery over a completely compliant, imaginary body, whose morphology has no integrity of its own, but is completely at the disposal of the master.

Notes

Acknowledgements:
I would like to thank Ien Ang, Alec Mchoul, Elizabeth Wilson and Peter Stuart for their help and comments. The research for this chapter was supported by a grant from the School of Humanities, Murdoch University. The author would like to thank Thomas Schiemann and the staff at the Institute for Mathematics and Computer Science in Medicine at the University Hospital Eppendorf, Hamburg for the use of their VHP images and for their generosity in demonstrating the Visible Human Project to me. Further demonstrations of their VHP modeling may be seen at http://www.uke.uni_hamburg.de/institutes/ IMDM/IDV/IDV_ HomePage.html.
I would like to thank the National Library of Medicine at the National Institute of Health for the use of their image of the cross-sectioned skull. I would also like to thank Brian Molinari, Paul Mackerras and David Hawking at the Department of Computer Sciences at the Australian National University for their assistance.

1 I have argued elsewhere that concepts of normalcy in biomedicine always carry normative weight. For an extensive treatment of the relationship between the normal and the normative see Waldby (1996, Chapter 2).
2 The strict Baudrillardian concept of the simulacra is that of a self-authorizing, replicatable model, copies without originals, which owe no debt to a referent. However, to take this general argument about simulacra and deploy it in the case of the VHP seems to miss a serious ethical and political point which is that the VHP could not have been inaugurated without the sacrifice of a life – in this instance, Jernigan's life. In this case the representation's precedence over the referent is bought through the murder and dismemberment of the referent, a murder which underwrites the representation's claims to the status of digital homolog. The circulation and exchange of virtual anatomies has only been made possible by taking life from a fleshly anatomy.

References

Barker, F. (1984) *The Tremulous Private Body*, London and New York: Methuen.
Baudrillard, J. (1994) *Simulacra and Simulation*, Ann Arbor: The University of Michigan Press.
Braidotti, R. (1994) "Body-images and the pornography of representation," in K. Lennon and M. Whitford (eds) *Knowing the Difference: Feminist Perspectives in Epistemology*, London and New York: Routledge, 17–30.
Cartwright, L. (1995) *Screening the Body: Tracing Medicine's Visual Culture*, Minneapolis and London: University of Minnesota Press.
Daston, L. and Galison, P. (1992) "The image of objectivity," *Representations* 40: 81–128.
Diprose, R. and Vasseleu, C. (1991) "Animation – AIDS in science/fiction," in Alan Cholodenko (ed.) *The Illusion of Life: Essays in Animation*, Sydney: Power Publications, 145–60.
Edwards, P. (1990) "The army and the micro-world: computers and the politics of gender identity," *Signs* 16(1):102–27.
Ellison, D. (1995) "Anatomy of a murderer," *21.C* 3: 20–5.
Forbes, T. (1981) "To be dissected and anatomised," *Journal of the History of Medicine and Allied Sciences* 36: 490–2.

Foucault, M. (1970) *The Order of Things: An Archaeology of the Human Sciences*, London and New York: Tavistock Publications.

—— (1975) *The Birth of the Clinic: An Archaeology of Medical Perception*, New York: Vintage.

Fox Keller, E. (1994) "The body of a new machine: situating the organism between telegraphs and computers," *Perspectives on Science* 2(3): 302–23.

Haraway, D. (1991) *Simians, Cyborgs and Women: The Reinvention of Nature*, New York: Routledge.

Heidegger, M. (1977) *The Question Concerning Technology and Other Essays*, New York: Harper and Row.

Latour, B. (1990) "Drawing things together," in Michael Lynch and Steve Woolgar (eds) *Representation in Scientific Practice*, Cambridge, Mass. and London: MIT Press.

Leder, D. (1990) *The Absent Body*, Chicago and London: University of Chicago Press.

Stafford, B. (1993) *Body Criticism: Imagining the Unseen in Enlightenment Art and Medicine*, Cambridge and London: MIT Press.

Waldby, C. (1996) *AIDS and the Body Politic: Biomedicine and Sexual Difference*, New York and London: Routledge.

Wark, M. (1993) "Lost in space: in the digital image labyrinth," *Continuum* 7(1): 140–60.

Anne Beaulieu

THE BRAIN AT THE END OF THE RAINBOW
The promises of brain scans in the research field and in the media

In a *New York Times* article, titled "Truth Scan," accompanied by a series of images of brains showing "accurate" and "false recall," Dr Schacter is quoted as saying that "this is just a first glimpse of the physical activity underneath the creation of false memories," and further confides: "I've had people ask me whether this could be used as a lie detector – you know, just hook them up and see whether the memory is real. But … it's all far too complicated, not to mention expensive" (quoted in Hilts 1996: D8). Yet, the article goes on to affirm that "researchers are producing pictures of the brain at work that clearly distinguish false memories from those that are true," and that "scientists may have captured snapshots of a false memory in the making." The context given for this research is the McMartin case in California in the 1980s, part of a growing trend of accusations of (ritualistic) child abuse based on "recovered memories," where no physical evidence can be found (Hilts 1996: D8). Given this presentation of the technology, it is perhaps not surprising that Dr Schacter, author of *Searching for Memory*, is asked about the potential use of positron emission tomography (PET) as a lie detector.

Elsewhere in the popular press, brain scans are mooted not only as potential brain-based polygraphs, but also as potential "diagnostic scanners" for a wide variety of conditions which have traditionally been considered medical matters. It has even been suggested that brain scans could be used as a tool for determining who has been abused as a child and who is likely to become violent or addicted.[1] Not only are most of these postulated uses of brain scanning technology still far from being concretized in the form of screening programs or services available at local hospitals, but there are ongoing major debates in the scientific research community about their feasibility. Just what these images mean and how results of studies done on specific groups can be extended to the population in general are but two questions currently under discussion in the research community. Nevertheless, in popular accounts brain scans are frequently presented in a direct, objective manner as a concrete possibility for acquiring knowledge about a range of widely different phenomena. A feminist methodology which calls for a contextualization of scientific knowledge and a concern for understanding how and why some bodies are "marked" as being different, a long-standing item on the feminist agenda, subtend the approach to the material presented in this chapter. I will demonstrate the usefulness of considering

the two settings – the research field and the popular media arena – for discussions of brain scanning as related but distinct cultures. Rather than seeing differences as the result of a "dumbing-down" of scientific work for lay consumption, the meaning of brain scans in each setting will be shown to be embedded in different understandings of what can be learned from images and what can be expected of technology. As well, concepts of technological mastery, such as "directness" of the brain scanning approach, and metaphors conveying the desirability of mapping the territory of the brain will be shown to be shared by both settings, with important consequences for the diagnostic promises of brain scans.

The possibility of mapping the brain

At the present time, some brain scanning technologies do have a number of clinical applications: in neurology for evaluating patients before brain surgery; in oncology for monitoring the progress of therapies in the case of brain tumors; and in psychiatry there is some diagnostic value for detecting Alzheimer's disease.[2] The focus of this chapter, however, is on the use of brain imaging in activation studies which are performed to examine the functions of the brain. While a number of approaches can be used to study function in brain mapping – from the microscopic study of cells to the study of behaviors in individuals – the main approaches are the imaging technologies, better known by their acronyms: PET, MRI (magnetic resonance imaging) and fMRI (functional magnetic resonance imaging). The possibility of assigning particular functions to areas of the brain is an old idea that has long been vying for dominance with the more holistic school which de-emphasizes the degree to which the brain is made up of differentiated regions.[3]

Brain mapping relies on the possibility of finding the neuro-anatomical substrates of behavior; in the case of Dr Schacter's research, "the physical activity underneath the creation of false memory." A central concept in this type of research is that mental activity can be *mapped* on to the structures of the brain. Familiar instances of the mapped brain from the nineteenth and twentieth centuries include the phrenological maps, showing labeled surfaces, Penfield's drawings of how our brains parcel out motor control and sensation, and photographs of slips of paper laid on to the cortex during epilepsy surgery.

Brain mapping has grown considerably as a scientific endeavor in the 1990s, the "Decade of the Brain,"[4] with the birth of a large-scale international mapping project (the Human Brain Mapping Project), the establishing of a professional association which holds annual meetings, a database accessible through the Web called BrainMap, textbooks with eminently bold foundational aspirations such as "*Brain Mapping: the Methods*," and at least two journals primarily dedicated to the publication of brain mapping articles. The interest of the popular press in the brain and brain mapping has also been noticeable during this period, with special issues and cover stories dedicated to the topic, consistently illustrated by imaging results.

The notions proposed by the new brain mappers also travel across the porous boundaries between these spheres. The distributed nature of brain function, the possibility of having (a more) direct access to the organization of brain function as "networks" and the feasibility of gathering physical evidence about the mind have been incorporated into popular discourse. In popular accounts, the mappable brain of the 1990s has some continuities with earlier efforts, but it is presented as having particular value in its use of imaging. Two features are central: first, there is the

proclamation of a new era in brain mapping, through a rejection of the more suspect part of the tradition – phrenology. Second, intertwined with the involvement of various areas is the notion of direct access to the brain's functions enabled by the imaging technology. Technical superiority and cognitive insight are coupled into a new view of the brain, and set in opposition to the methods and insights of phrenology.

Phrenology, which is based on the assumption that single areas are responsible for particular brain functions, was rejected as being overly simplistic by neuroscientists in the nineteenth century. Even today some neuroscientists fear that the memory of this scientific project still endures, and that they will be associated with it. While there are competing theories about how various areas of the brain interact (as building blocks, modules, or connected systems), the reference to networks and systems and connectivity of the brain prevails. In an article written for the *Scientific American*, and destined for a lay audience, one of the pioneers of brain mapping, M. Raichle, makes the following observation:

> I hasten to point out that the underlying assumptions of current brain mapping are distinct from those held by early phrenologists. They posited that single areas of the brain, often identified by bumps on the skull, uniquely represented specific thought processes and emotions. In contrast, modern thinking posits that networks of neurons residing in strictly localised areas perform thought processes.
>
> (Raichle 1994: 36)

The brain is understood through metaphors of communications and integrated systems which collapse the images of the brain as territory, and the brain as machine. Accordingly, the strengths and weaknesses of the brain are played out in terms of parallel processing, or network breakdowns, and the brain's development as the process of building up connections. While some metaphors endure (the brain is a "wired" instrument), the current approach is described as much less cumbersome than earlier attempts. The experiments of electric brain stimulation in the 1950s were described in *Newsweek* as follows: while "the UCLA cat manipulators are far from drawing circuit diagrams of the brain's electrical pathways" they are "mapping" the process of memory (quoted in Sconce 1996: 284). In one recent account, mapping "emotion" with brain imaging techniques is compared to lesion studies, which consisted "in analysing what was missing in patients who had brain injuries or strokes. The technique is like drawing a diagram of a house's electrical wiring by pulling out fuses one by one" (Goleman 1995: C9). The "wiring" can be seen at once through the use of imaging technologies, thereby enabling the mapping of the brain areas involved.

Being able to study the brain directly, to visualize complex interactions between brain areas, enables brain mappers to peer "inside the black box" (Raichle 1994: 36). Speculations to do with output and input are giving way to the authority of a direct approach:

> Psychologists and philosophers have long examined emotions and their impact on behaviour, but they have done so by observing what people do and say. Few have ventured into the so-called "black-box" of the brain. But advanced imaging techniques that can look inside the brains of subjects

while they talk about feelings and experiences are beginning to lead to a
neurobiology of emotions.

(Blakeslee 1994: C3)

The direct approach to the human brain and the complex understanding of the
brain's functioning enable brain mappers to ask new questions about the brain:

It seems too easy to ask subjects to feel something and then take pictures of
their brain ... It's almost a psychological barrier. Other scientists say "hey
you shouldn't be able to do that ... it shouldn't work." We've gotten used
to not being able to ask that kind of question about the mind.

(McCrone 1995: 34)

Even topics that once constituted scientific taboos, or less dramatically, seemed flaky
or too vague to be addressed, such as "intelligence" or "consciousness," are now the
subject of imaging research: "Enough is known about the brain to be sure that there
is no single 'consciousness centre.' But at least three cortex structures seem regularly
to light up whenever something enters awareness" (McCrone 1995: 34).

The metaphors used to present the brain and the new brain mapping approach
based on imaging technologies contribute to creating expectations about what can be
known about the brain: the metaphor of "mapping" evokes the concrete quality of

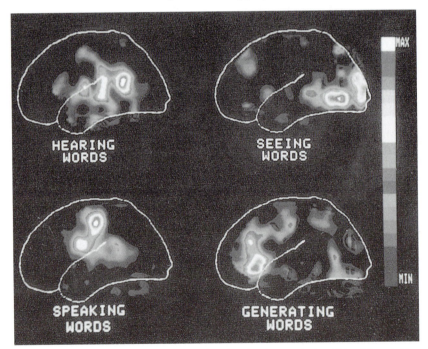

FIGURE 3.1 Computerized PET images showing the changes in local blood flow in the
brain, associated with local changes in neuronal activity, that occur during
different states of information processing. Based on research pursued with
PET in the second half of the 1980s, this image has become an icon of
activation studies.

Source: Courtesy of Marcus Raichle, Department of Neurology, Washington University School of
Medicine, St. Louis.

this terrain, the need for exploration and progressive refinement of the areas explored. In this new era of brain mapping, the access is direct and the project is benign; the brain is eminently mappable, and the maps are best conceived as road maps – rather than political ones that show the borders of countries. Cartography is a task that is possibly huge, but finite. If the mapping metaphors and claims to direct access tend to overlap in the research field and popular settings, the use of images is, however, sharply contrasted.

Reporting on brain mapping: say it with pictures

If the brain can be mapped, then this has been made possible through being "imaged" – and the visual impact of the bright PET images on a black background has often been credited with (at least) some of the popularity of the technique.[5] In this section, I shall address the way in which the promises of the technology are reinforced by the use of brain scans, in other words, how they function as visual arguments. As well, I will demonstrate how a context for understanding these arguments, a visual culture particular to a group, can be analyzed. This is to be understood to include various cognitive, organizational and material elements for creating and understanding images for particular groups. By contrasting two cultures of scientific understanding, I hope to shed light on each, though the emphasis here will be on the popular accounts. This does not question the argument that all scientific discourse also makes use of rhetoric in general (Latour and Fabbri 1977) and of metaphor and figurative language in particular (van Dijck 1995), but rather takes the argument one step further and shows how discourses vary between sites of production.

Many visual technologies have been shown to participate in the creation of new forms of social control or of new objects of study.[6] While the growth in the importance of visualization has succinctly been identified by a number of cultural analysts and historians, this growth is not of an undifferentiated, unitary kind, a single phenomenon entirely analyzable within the Foucauldian paradigm of the deepening medical gaze. To cite one well-known instance, Barbara Stafford has argued that while visual understanding was placed at the bottom of the totem pole of modes of scientific understanding around the time of the Scientific Revolution (far below the more rational forms of the number and the word), this situation is changing rapidly, requiring a renewed expertise in the understanding of images (Stafford 1996). What the following analysis will make clear, however, is that the visual component of the brain mapping technologies is valued and used in many ways, so that there is a mosaic of understanding of images rather than a single overarching new paradigm.

The images discussed in this chapter are the "brain scans" that originate in the lab or are taken from scientific publications (a small number of the articles I discuss also include artists' illustrations).[7] The shaping, labeling and transformation of these images, as they move from the lab to the pages of newspapers and magazines, involve "complementary processes of suppression and creation [which] lead to the construction of both novel objects and of relations between those objects" (Law and Whittaker 1988: 162).[8] Various dynamics suggested by Law and Whittaker (1988) arise in the use of images in popular contexts. "Simplification" is the presentation of more simple objects, in much the same way that scientists simplify their object of study by representing it.[9] At least two further transformations occur in the use of images for popularization: the process of discrimination, where new objects are

brought into being, and interrelation, where new relationships are drawn between these objects.

The neuroscientific context: the scan as graph

Neuroscientists involved in brain mapping have a very specific understanding of the images which they use. In the course of my fieldwork, simply raising the topic of the visual proved difficult. On a few occasions during interviews with neuroscientists, the momentum of the conversation was lost when I failed to translate my interests into acceptable terms and candidly asked about the visual aspects of PET, with the strongest reactions being elicited by my un/fortunate use of the phrase "PET as a visual technology."[10] For neuroscientists involved in brain mapping, images have a strict role – though they will sometimes allow that the visual aspect of the technology was part of their initial attraction to the field, or that performing the first scan of the distribution of a particular neurotransmitter was an impressive sight in itself, for example, dopamine distribution in the brain of a patient suffering from Parkinson's disease.

Typical of such discussions is the following description of PET scans, which sets up a clear division between what I suggested was an image of the brain and what my informant insisted was a representation of a statistically validated measurement: "They're non-pictures, they're statistical maps. So you're showing hard scientific evidence!" (interview, principal investigator, February 1997).[11] The idea of having a picture of the brain is strongly rejected. The following description of "visualization," taken from one of the textbooks on mapping, is one of the few instances where allowance is made for a role to the visual in brain mapping:

> The most profound use of computers in mapping is in the field of visualisation. Computerised visualisation of data that has been converted into a cartographic image of a spatial domain best communicates the meaning of quantitative information. Some people can see in their mind's eye the beauty and structure in mathematical or statistical relationships, but most require a visual representation to best appreciate these dependencies.
>
> (Toga and Mazziotta 1996: 6)

Note here that visualization is to assist in understanding measurements, but the investigation is not visual, scanning is not making pictures. This distinction is crucial in understanding neuroscientific vision. It is further reinforced by an emphasis on the work that leads to the production of the images. The image refers to a set of numbers, of measurements, and it is the production of these measurements which is stressed:

> You have to be careful not to be seduced by the images. You have to understand, from the scientific point of view, that the paper you write, you are not writing for *Psychology Today*. You are not writing for *Newsweek*, you are writing for the journals. You have to have statistics, and I have often said that, as fancy and compelling as the PET scan is, you still need a good solid research design, with an adequate number of subjects and the right statistics.
>
> (Researcher, quoted in Dumit 1995: 106)[12]

Neuroscientists also frequently insist on the importance of statistics, setting the statistical validation as the referent of the image, and emphasizing that the statistically validated measurements, and not simply the measurements of brain activity, are what appear on an image:

> To the uninitiated, they will see an SPM[13] as an activity in the brain ... and they will forget to take into account that that is not the activity, it is a coloured representation of a set of statistical values ... they've been through all kinds of crunch and in setting out to simplify, the picture can to some extent deceive.
>
> (Interview research fellow 1997)

This insistence on the quantitative is one of the strategies that prevents the "proliferation of meaning," prized by artists but not by scientists (Bastide 1990: 208), narrowing the possibility of interpretations that can be made of the results. Joe Dumit (1994) calls this monosemy, a quality of the information provided by scans, but it is also one of the main features built into the neuroscientific understanding and production of brain maps.

The visual culture of neuroscientists, therefore, can in no way be characterized as having overcome the distrust of the image as potentially misleading "reason" through its appeal to the "senses" identified by Stafford (1996). Neither has the hierarchy of number/text/image been inverted. Rather, these neuroscientists see brain scanners as enabling measurements of what goes on in the brain, and these measurements as being further warranted by statistical validation. This version of brain imaging is not necessarily incompatible with that found in popular accounts, and in some popular accounts neuroscientists will speak of "seeing" what goes on in the brain or of obtaining images of what a brain process "looks like." But in so far as the images are to be useful, that is understood in scientific terms, then neuroscientists rely on a quantitative definition.

The popular context: the scan as photograph

Many of the differences between neuroscientific and popular presentations of images result from a basic distinction in the role of images in each setting. Images are an epistemically new approach to the brain ("we can now see it") in popular accounts, while they have a heuristic role for neuroscientists ("we can now make measurements of it"). The importance of images and the manner and extent to which they can inform the viewer derive from this distinction.

Thus underlying the popular discussion of images is a different type of objectivity which rather than being quantitative, is based in effacing human, subjective intervention and the technology of the scanner. This kind of objectivity has been termed "mechanical objectivity" (Daston and Gallison 1992: 96). Assumptions about the impartiality of a technological representation are at the heart of this concept, the rise of which has been traced to the mid-nineteenth century. Mechanical objectivity is tied to notions of automatic representation, and the possibility of bypassing human intervention and its unreliability (Daston and Gallison 1992: 102). In the construction of mechanical objectivity, the process of representation is given over to the mechanical means which work consistently, tirelessly and remain free of human bias.

With its promise of one-to-one correspondence, photography is the archetypal

technology of mechanical objectivity, and in presenting brain scanning technology, magazine and newspaper headlines and descriptions make ample use of words associated with the camera, for example terms such as "snapshot" and "picture": "The new advances are made possible by fast imaging methods that allow researchers to take snap-shots of the brain in action" (Goleman 1995: C1). Also, the images themselves are presented as though they were photographs, transparently rendering the brain's activity. This strategy relies on the assumption of photographic realism, and insists on the fact that the representation is a record of what was simply taking place. Albeit transformed, the object does not undergo apparent distortion (Law and Whittaker 1988). In addition, the images reproduced in the popular press are usually free of the further notations found in scientific journals which supply further information about the subject or the statistical tests performed. (This will generally include information to do with technical specifications of scanner type; scanning protocols – how many times each condition was scanned and the duration of each session; the software used for the construction of the image; the method of administration and type of radioactive tracers, the amount and location of brain area being shown; the correlations between functional and anatomical images that have been performed, and so on.) Thus what remains is simply the colorful brain on a black background. Sometimes a color key to the images, representing levels of activity, is also included. This rainbow key shows the gradation of activity thresholds in qualitative terms (high/low), providing a simple interpretative tool for looking at the scans (see Figures 3.1 and 3.2).

By simplifying the images, new objects come into view; a condition is suggested by a label, and made apprehensible for the viewer. Furthermore, an exegesis of the image becomes possible once the technological intervention is presented as purely enabling and without interference. This tendency towards photographic realism is so strong that colors on the scans are discussed as though they originated in the brain: the process consists simply of "injecting the subjects with a radioactive tracer and scanning colour images of their brains. As normal subjects processed the emotion-laden words, their brains lit up with activity" (Kaihla and Wood 1996: 5). The interpretation of scans is elaborately constituted in this context. While MRI and CT scanners have made views of the brain as "slices" a familiar sight, and thermographs have shown the body's (albeit exterior) "hotspots," these scans offer a dynamic and internal view of brain activity. Whereas the reception of X-rays was marked by the evocation of death in skeletal revelation (see Cartwright 1995; Kevles 1997), brain activation images do not show bones and are images of life not death – in contrast to the X-ray, they convey "dazzling activity." The colors of the scan take on an iconic role: a scan of a patient with Alzheimer's disease is labeled as "a picture of confusion," the image shows "a patch of darkness in the brain of a 57 year old man. Reflecting a decrease in blood flow ... the darkness symbolises the agony of Alzheimer's disease" (Sochurek 1987: 34). Also common to the discussion of brain scanning is the description of brain activity as light-emitting: "In both sexes, the front of the limbic system glowed with activity" (Begley 1995: 51). Furthermore, the variations in brightness are interpretable: "How to tell if you're smart: see your brain light up" (Begley 1988: 64). "[T]he red glow of fear" in the brain (Lemonick 1995: 44) is directly visible. Even the black "background" is important in shaping the aesthetic of the images, "in contrast, brains of those who tested as less intelligent lit up like Times Square" (Begley 1988: 64), or another night-time scene: "In all 19 men, one region ... lit up like Las Vegas" (Begley 1995: 50). Note also how the

directness, the visible response of the brain to a task, and the metaphor of the wired brain are superimposed in these descriptions.

Given the presentation of these images as standing in for the state of the brain with an identified condition, or a particular kind of brain, what new types of relations are posited? Besides appearing in articles with simplified labels, scans are often shown in contrasting pairs, in both popular and neuroscience journals. There is a possibility of collapsing the label and the image, in texts illustrated by PET scans:

> When two images obviously distinguishable are put side by side with different labels, even though the text describes the data as forbidding going from image to label, the possibility of reading the image as providing the label is manifestly present.
>
> (Dumit 1993)

In popular magazines, the prescriptions against going from image to label are even weaker, as the text or label which appeared in the original article is simplified. The image has been loosened from its technical context and is set within a different narrative, about health and illness, about normality and pathology, and about how to tell which is which. Dumit has likened this practice of pairing images to the "before and after" of the popular magazine's "make-over" or self-improvement story.[14] And recently, this process has appeared in *Newsweek*, in an article in which PET scans showed the differences in brain function brought on by therapy for people suffering from obsessive-compulsive disorders, with scans labeled "before" and "after" (Begley 1996: 60). In this instance, PET tracks the possibility of change, of (self-)improvement, so that therapeutic effects are now locatable on the plane that brain scanning has opened up.[15] Many other dichotomies are also charted by brain maps, with popular articles showing the differences through contrasting pairs of rainbow-coloured brains, for example:

* left/right hemispheric differentiation
* high/low intelligence
* true/false memories
* normal/abused
* violent/non-violent
* addicted/non-addicted
* men's/women's recognition of emotion
* men's/women's math skills
* men's/women's neutral states of mind (thinking of nothing)[16]

While eliding the process of construction of these new representations, this mode of comparison emphasizes the visible difference between brains. Many crucial aspects of the work involved in imaging are not part of these stories, which focus on the differences built upon the scanning evidence (see Figure 3.2). For instance, there are no "blind" imaging studies where the neurological, psychological and medical status of the subjects have not been assessed prior to the scanning. In imaging settings, the label is known before the scanning begins; popular accounts show the images as providing the label. This is not a simple reversal attributable either to a lack of scientific sophistication on the part of journalists or to an unavoidable and necessary paring down of technical vocabularies, but is instead a complex process involving the

Healthy Brain

This PET scan of the brain of a normal child shows regions of high (red) and low (blue and black) activity. At birth, only primitive structures such as the brain stem (center) are fully functional; in regions like the temporal lobes (top), early childhood experiences wire the circuits.

Front

Temporal lobes

Back

An Abused Brain

This PET scan of the brain of a Romanian orphan, who was institutionalized shortly after birth, shows the effect of extreme deprivation in infancy. The temporal lobes (top), which regulate emotions and receive input from the senses, are nearly quiescent. Such children suffer emotional and cognitive problems.

Front

Temporal lobes

Back

MOST ACTIVE LEAST ACTIVE

FIGURE 3.2 "Healthy brain" and "abused brain" are shown to be visibly different. Note the indications for looking: white circles and the colour bar.

Source: Reprinted from *Detroit News* and *Newsweek*, by permission (Dr H. Chugani, 1997, Newsweek Inc., all rights reserved).

dynamics of simplification, discrimination and finally, interrelation, using culturally available symbolic and rhetorical resources.

Conclusion

In conclusion, I want to reflect briefly on the larger context of these recent popular accounts. The accounts discussed in this chapter invoke brain imaging as providing access to a basic level where pathological difference originates, beyond murky social factors, beyond "moral" judgments about violent, addicted or "abusive" kinds of people. These categories are not solely the fruit of brain mapping research, and arise from already existing streams of research which focus on some form of biological or physical basis of human behavior. But the powerful visual rhetoric and the formulation of the research as a mapping endeavor have been crucial in drawing attention to the "neurobiological substrates" of difference – as disease, abnormality or pathology. The promises of brain scanning evoke a technological fix to some of our greatest current social anxieties (child abuse, the rising level of violent crime and the use of drugs), as well as to perhaps more perennial sources of anxiety: aging, health and the differences between the sexes. Popular narratives about brain mapping are shaping expectations about the increased ability of neuroscience to finally explain ourselves to ourselves biologically, via the powerful objectivity of technology.

The coverage given to brain mapping has been markedly positive, evoking promises, not threats, with only a very few instances of reporting on the potentially exaggerated aims of brain mapping (see Wolf 1997) and on the immaturity of some aspects of the field (see Watzman and Aldhous 1996). Besides the inclusion of PET evidence in a few criminal court cases in the US, where the reception of this type of evidence was mitigated but largely positive (Dumit 1994; Kulynych 1996), there have been few inclusions of brain mapping into medical or social institutions, in the form of screening programs or diagnostic tests. The territory of the mapped brain has not (yet?) been used as a battlefield, but this may be imminent: the rhetorical uses of brain scans in popular accounts discussed above fall within a trend towards medicalization and a particular type of biological reductionism which are still far from resolved and involve multiple decisions and reorganizations, many of them about allocation of resources, professional arrangements and the already established diagnostic uses of brain scanners. With more riding on the results of brain scans, there may be greater questioning of the basis for the contrasting visions of the brain that appear in the media, and this may give rise to a different type of exchange between these cultures, making the technological transformation and internal debates about the meanings of brain scanning more apparent in popular reports than has been the case up to now.

Notes

1 I wish to thank Abby Lippman, Gérard Beaulieu and Sébastien Beaulieu for their help in gathering some of the materials from popular sources, and Trudy Dehue and Gerard de Vries who provided valuable comments on an earlier version of this chapter, presented as a paper at the Progress Conference of the Department of Science and Technology Dynamics, University of Amsterdam, September 1997.
2 The American Blue Cross/Blue Shield has extended the coverage to the use of PET for the differentiation of recurrent brain tumors and the localization of epileptic focus in patients considered for surgical treatment (Hoffman *et al.* 1993), and the Food and Drug Administration approved of PET for clinical purposes in 1995 (Kevles 1997).

3 See, for example, Young (1970) and Harrington (1987) for historical accounts of these debates.

4 Proclaimed by the US in 1990, and by Italy, Japan, Canada, the Netherlands and the European Community in the early 1990s. A "Year of the Brain" was also proclaimed in Denmark in 1997.

5 *Newsweek*'s science writer Sharon Begley recounted the following to Joe Dumit: "In the case of the PET cover [story], there was a paper presented at the Society for Neuroscience … for which they used a PET scan. The editors saw that and thought 'Well gee, the pictures are gorgeous, Maybe more can be said of this'" (Dumit 1995: 93).

6 See, among others, Cartwright (1995) and Marchessault (1993) on the use of film; Sekula (1986) on photography; and Pasveer (1992) on the early use of X-ray; as well as the special issue of *Camera Obscura*, 28 January 1992.

7 The two discourses that I compare here are largely concurrent, though some of the popular texts predate the beginning of my fieldwork (January 1995). The boundary drawn between the two relies on a number of features: the form of these texts, the institutional settings for the production of texts, and my own understanding of the intended audience of these discourses. Of course, there are a number of links between the two discourses, besides their thematic unity, their being "about" the same technology of brain scans. The use of the neuroscientific understanding of these images as a background to highlight the features of the popular discourse is also warranted by the common practice of reporting scientific news in newspapers and magazines upon the publication of a paper in one of the scientifically prestigious journals (for example in *Science* or *Nature*) or a presentation at a congress. This may be because scientists or university press officers are more pro-active around the time of particularly prestigious publications. In any case, the outright references or allusions to particular scientific publications further highlight the dynamics of exchange between the two domains.

8 These transformations involve a similar type of work as that which has received much attention in studies of science and technology and are a central and recurring theme in many ethnographic analyses of scientific work. See in particular Lynch (1985; 1990) and Amann and Knorr-Cetina (1990).

9 Law and Whittaker (1988) label this as political because it involves a process of representation, because "one" speaks on the behalf of "others." I would also call this political, but would rather focus on a different level of political implications – the circulation of knowledge and the creation of new subject positions.

10 Images certainly play an important role in brain mapping circles: witness the number of slides used in presentations, greater than any I have seen in an art history or film studies lecture. The deep ambiguity of mappers towards the images will be further explored in a chapter of "The Space Inside the Skull: Digital Representations, Brain Mapping and Cognitive Neuroscience in the Decade of the Brain," Anne Beaulieu, Ph.D. dissertation, University of Amsterdam, 1999 (forthcoming).

11 The interviews presented here were done as part of fieldwork conducted in a leading brain imaging laboratory between January and March 1997.

12 This quote also illustrates that researchers are aware of the existence of different conventions for different kinds of presentations of their work. Neither journalists nor researchers are naïve about the cultural exchanges in which they are involved.

13 An SPM is a statistical parametric map, produced using software that run sets of statistical tests on data detected by the scanner.

14 This comparative strategy to establish normality and pathology has also occurred in scientific contexts, but as discussed above, in terms of measurements and quantification. From the earliest use of X-rays, cinematography and chronophotography in the study of physiology, an emphasis has been placed on the measurable difference between images. In the imaging lab, as in physiological and anatomical contexts, the image functions like a marker of quantitative knowledge, a record of change (Cartwright 1992; Pasveer 1989).

15 In this instance, PET was not only used to image change, but was also part of the cognitive therapy for these patients. In the course of the therapy, patients were led to reinterpret their obsessive-compulsive behaviors as being due to a biochemical imbalance in their brains, thus incorporating a new level in the definition of the disorder. This might be described, for lack of better concepts, as being asked to differentiate between their sick

brains which affected their healing minds. Dumit (1994) mentions the fostering of this distinction for patients with schizophrenia and depression.

16 See on sex differences, Kolata (1995), Begley (1995) and Kinoshita (1992); on violence Gibbs (1995) and Kaihla and Wood (1996); on abuse, Goleman (1995) and Begley (1997).

References

Amann, K. and Knorr Cetina, K. (1990) "The fixation of (visual) evidence," in M. Lynch and S. Woolgar (eds) *Representation in Scientific Practice*, Cambridge, Massachusetts and London: MIT Press.

Bastide, F. (1990) "The iconography of scientific texts: principles of analysis," in M. Lynch and S. Woolgar (eds) *Representation in Scientific Practice*. Cambridge, Massachusetts and London: MIT Press.

Begley, S. (1988) "How to tell if you're smart," *Newsweek* February: 64.

——(1995) "Gray matters," *Newsweek* March: 48–54.

——(1996) "For the obsessed, the mind can fix the brain," *Newsweek* February: 60.

——(1997) "How to build a baby's brain," *Newsweek* Special Edition Spring/Summer: 28–31.

Blakeslee, S. (1994) "Tracing the brain's pathways for linking emotion and reason," *New York Times* 6 December: C1, C14.

Cartwright, L. (1992) " 'Experiments in destruction': cinematic inscriptions of physiology," *Representation* 40 (Fall): 129–52.

——(1995) *Screening the Body: Tracing Medicine's Visual Culture*, Minneapolis and London: University of Minnesota.

Daston, L. and Gallison, P. (1992) "The image of objectivity," *Representation* 40 (Fall): 135–56.

van Dijck, J. (1995) "Reading the human genome narrative," *Science as Culture* 5(23): 217–47.

Dumit, J. (1993) "A digital image of the category of the person: PET scanning and objective self-fashioning." Paper presented at the American Anthropological Association meeting, December 1993, Washington, DC, to be published in *Cyborgs and Citadels: Anthropological Interventions in Technoscience* (forthcoming).

——(1994) "Desiring a beautiful image of the brain: a cultural-semiotic inquiry." Paper presented at the conference on Visual Representation in Scientific Practice, Institute for the Medical Humanities, Gavelston Texas, 28 April–1 May.

——(1995) "Twenty-first-century PET: looking for the mind and morality through the eye of technology," in G. Marcus (ed.) *Technoscientific Imaginaries: Conversations, Profiles and Memoirs*, Chicago and London: University of Chicago Press.

Gibbs, W. (1995) "Seeking the criminal element," *Scientific American* March: 76–83.

Goleman, D. (1995) "The brain manages happiness and sadness in different centers," *New York Times* March 28: C1, C9.

Harrington, A. (1987) *Medicine, Mind and the Double Brain: A Study in Nineteenth Century Thought*, Princeton University Press: Princeton, New Jersey.

Hilts, P. (1996) "Truth scan: unscrambling the mosaic of memory," *Globe and Mail* 13 July: D8.

Hoffman, J., Hanson, M., Coleman, W. and Edward, M. (1993) "Clinical positron imaging," *Radiologic Clinics of North America* 4: 935–59.

Kaihla, P. and Wood, C. (1996) "No conscience, no remorse," *MacLean's* January: 50–1.

Kevles, B. Holtzmann (1997) *Naked to the Bone: Medical Imaging in the Twentieth Century*, New Brunswick, New Jersey: Rutgers University Press.

Kinoshita, J. (1992) "Mapping the mind," *New York Times Magazine* 18 October: 44–54.

Kolata, G. (1995) "Man's world, woman's world? Brain studies point to differences," *New York Times* 28 February: C1, C7.

Kulynych, J. (1996) "Brain, mind and criminal behavior: neuroimages as scientific evidence," *Jurimetrics: Journal of Law, Science and Technology* 36: 235–44.

Latour, B. and Fabbri, P. (1977) "La rhétorique du discours scientifique," *Actes de la recherche en sciences sociales* 13: 81–95.

Law, J. and Whittaker, J. (1988) "On the art of representations: notes on the politics of visuali-sation," *Picturing Power: Visual Depictions and Social Relations, Sociological Review Monograph 35*, London and New York: Routledge.

Lemonick, M. (1995) "Glimpses of the mind," *TIME* 17 July: 44–7.

Lynch, M. (1985) *Art and Artifact in Laboratory Science: A Study of Shop Work and Shop Talk in a Research Laboratory*, London: Routledge and Kegan Paul.

——(1990) "The externalized retina: selection and mathematization in the visual documenta-tion of objects in the life sciences," in M. Lynch and S. Woolgar (eds) *Representation in Scientific Practice*, Cambridge, Massachusetts and London: MIT Press.

McCrone, J. (1995) "Maps of the mind," *New Scientist* January: 30–4.

Marchessault, J. (1993) "The naked eye redressed: invisibility and redemption," *Public* 7: 21–37.

Pasveer, B. (1989) "Knowledge of shadows: the introduction of x-ray images in medicine," *Sociology of Health and Illness* 11(4): 360–81.

——(1992) *Shadows of Knowledge: Making a Representing Practice in Medicine: X-ray Pictures and Pulmonary Tuberculosis, 1895–1930*, Ph.D. Dissertation, University of Amsterdam.

Raichle, M. (1994) "Images of the mind," *Scientific American* April: 36–42.

Schacter, D. (1996) *Searching for Memory; the Brain, the Mind and the Past*, Dunmore: Harper Collins.

Sconce, J. (1996) "Brains from space: mapping the mind in 1950s science and cinema," *Science as Culture* 5(23): 277–302.

Sekula, A. (1986) "The body and the archive," *October* 39: 3–64.

Sochurek, H. (1987) "Medicine's new vision," *National Geographic* January: 2–41.

Stafford, B. (1996) *Good Looking: Essays on the Virtue of Images*, Cambridge, Mass: MIT Press.

Toga, A. and Mazziotta, J. (1996) *Brain Mapping: The Methods*, San Diego: Academic Press.

Watzman, H. and Aldhous, P. (1996) "Have the mind mappers lost their way?" *New Scientist* 4 May: 12.

Wolf, T. (1997) "Sorry, but your soul just died," *The Independent on Sunday* 2 February: 6–10.

Young, R. (1970) *Mind, Brain and Adaptation in the Nineteenth Century*, Oxford: Clarendon Press.

PART TWO

Genetic codifications

Janine Marchessault

DAVID SUZUKI'S *THE SECRET OF LIFE*
Informatics and the popular discourse of the life code

THIS ESSAY GREW out of my response to a television series hosted and written by Canadian broadcaster, environmental activist and geneticist David Suzuki. I first viewed the four-part program in the UK, where it was called *Cracking the Code* (BBC2, 1993), and then again upon my return to Canada where it was aired on PBS as *The Secret of Life*. While recognizing the need to devise packaging strategies for diverse national markets, the interchangeable titles also reflect a conflation of the cybernetic and the organic, of code and life inherent to the informatic basis of genetics. Indeed, a recurring image throughout *The Secret of Life* visualizes this to perfection: the camera tracks-in on a room lined with filing cabinets stacked with spreadsheets of DNA's coded instructions or "molecular software," it then tracks-out to Suzuki who explains, "all this to spell out you or me." This "life code" defines the new frontier upon which Suzuki's enlightenment drama and companion book *Redesigning the Living World* (1993) is played out.

Evelyn Fox Keller has observed that the problematic opposition between culture and biology challenged by genealogies and critical epistemologies not so long ago, has disappeared into a new modality, one which perhaps is more difficult to ascertain, *culture as biology*. In her well-known essay, "From the secrets of life to the secrets of death" (1990), Keller describes this new modality as arising from a desire to bridge the gap between life and death. The Baconian narrative of nature as a secret to be penetrated is tied to an understanding of mortality as merely an obstacle to be overcome. This was given a textual body almost two centuries ago in Mary Shelley's *Frankenstein; or The Modern Prometheus* (1818), whose enduring relevance lies in its refusal to oppose essence to construction or nature to history, probing instead the cultured boundaries of scientific knowledge and human identity. The monster who speaks and who feels, whose body has a history but no identity, troubles the Cartesian division by failing to find meaning in his own existence. In effect, Shelley's work foregrounds and foreshadows the ethical dilemmas, the relation between use value and exchange value, that pervade the new vistas of molecular biology and its highly lucrative biotechnical industries.

Unlike the body of Frankenstein, constructed out of recycled parts which never add up to a seamless whole, the new regime inaugurated by molecular biology conceives of the body in bits, as an archive of interconnected codes to be deciphered.

The Human Genome Project which involves the scientific community around the globe in piecing together a genetic map of the human body (based on the bodies of four men), in its aim to have the one stand for the many, provides a neat inversion of Frankenstein's monstrous heterogeneity. The book as body thematic that was such a fundamental part of Shelley's self-reflexive creation is not only inverted but no longer metaphorical. The DNA body is not simply a book but a library of information whose textual production extends backwards to the origins and totality of creation, what Suzuki calls "the immortal thread."

The story of molecular biology, historians of science tell us, can be read as the ultimate quest for the secret of life; the construction of the DNA model, the "golden" or "master" molecule is said to enable us to spell the connectivity of all life. According to Max Delbruck's oft cited Nobel address of 1970, molecular genetics has allowed "the riddle of life" to be solved (Fox Keller 1990: 180). What should concern us about Suzuki's very popular series, or any of the recent media discourses promoting DNA research generally, is the process by which the representation of life is reduced to the molecular mechanics of DNA, to a language or program shared by all life. As Ruth Hubbard (1995) has underlined, life is far more complicated and unruly than the double helix would lead us to believe. Obviously, the reduction of life to a model, or the body to a program, carries severe implications for social identities and political agency. In order to think through these implications more concretely, I intend to consider two tropes: *the body to be programmed* and *the body as program*. These can be seen to characterize an epistemological shift in biology that Georges Canguilhem has described as a move from mechanics to information and communication (1994a: 316–17). My intent is not only to bring an historical dimension to the popular representations of the human genome, but to draw out some of the differences and similarities between the old and the new biology, the distinctions between eugenics and genetics that Suzuki's television series insists upon.

The body to be programmed

In 1902 a small group was organized by the Psychological Institute of Paris to study psychic phenomena, to "explore that region, situated at the intersection of psychology, biology and physics where manifestations of forces not as yet defined might be more clearly delineated" (Bergson 1972: 510). The group included Etienne-Jules Marey, Henri Bergson and Marie Curie, all of whom shared a common but highly differentiated interest in time and the invisibility of a universal life force or energy. During this first year, while Marey continued to explore *l'écriture de la nature* in his time-motion studies of human locomotion, Bergson would begin work on his great treatise *Creative Evolution* to theorize an *élan vital*, a mystical force driving evolution. Also that year, working on radioactive bodies, Marie Curie succeeded in preparing a decigram of pure radium. Indeed, in this group we find a rich intersection of scientific specularities and the kind of interdisciplinary collaboration essential to the new science of biochemistry some decades later. Using Marey's graphic and chronophotographic inscriptors, the "Groupe d'études de phénomènes psychiques" conducted rigorous scientific experiments, measuring levitation and mental suggestion, charting the radioactive and electrical discharges produced by hysterics and by Paris' most renowned mediums. Marey's measuring devices were intended to procure visual evidence of the uncharted and invisible contours of the pathological, to dispel superstition by making its phenomena accessible to scientific quantification and explanation.

It is easy to situate this project within the rationalist and positivist norms of the period that Canguilhem summarizes as: "reason is superior to mysticism; noncontradiction is superior to participation; science is superior to myth; industry is superior to magic; faith in progress is superior to the progress of faith" (1994b: 367). This meeting of science, technology and the afterlife was not uncommon in the nineteenth century but can be understood as part of positive science's growing dominion over the natural world – a world generally conceived in the feminine (Didi-Huberman 1982). For our purposes, it is important to note that the group's interest in the invisible life of life, in the way the past works on the present, was heavily influenced by discoveries in thermodynamics and chemistry in the middle of the previous century. The division between life and death, the inanimate and the animate, between bodies and machines was transformed by the discovery that energy could not be augmented or destroyed but was a force subject to conversion, transmutation and exchange, the first law of thermodynamics. As many historians of science have observed, thermodynamics had a decisive impact on the scientific conception of nature as a single, indestructible and invisible force (Serres 1968: 36; Kuhn 1977: 66–10).

In his important study of the human motor and the invention of "fatigue" in the nineteenth century, Anson Rabinback argues that thermodynamics altered the very concept of corporeal labor, "at once modernizing it according to the precepts of industrial technology and naturalizing it in accord with the new laws of physics" (1990: 47). The distinctions between nature, technology and the human body, between beings and things, were obliterated by the concept of an energy force, an engine, that drives all aspects of life. Body power was no longer generated but processed. Consequently bodies and their labor power became a fluid, malleable mass that, given the second law of thermodynamics (entropy) needed to be managed in order to be conserved. It is precisely these new physical realities, the idea that energy was subject to degeneration, that Social Darwinists would seize upon to justify racial hygiene and the need for scientific management in the new industrialized nations.

The conception of the body as a mass to be programmed can be understood to reference a history of Western science in which a mathematical model of the body serves as a matrix to which all other bodies are made to measure. In the nineteenth century, and in the aftermath of the Napoleonic wars, European states created institutions specifically designed to collect statistical data on all aspects of life. An avalanche of printed numbers between 1820 and 1840 would come to serve what Ian Hacking has called "the taming of chance" (Hacking 1990). In France and England, scientific knowledge, engineering and management came to be based on innovative approaches to statistical data that would transform numbers into laws, and laws into images. Adolphe Quetelet's *Treatise on Man* (1835) sought to construct a mathematical mean of human behaviors – his norm, *l'homme moyen* would always choose to preserve the social order, the deviant would not. Thus, for Quetelet the average was an ideal that needed to be understood and preserved by social policy in the face of modernization. Social engineering should seek to decrease "the limits within which the different elements relative to man oscillate. The more Enlightenment is propagated, the more will deviation from the mean diminish" (Quetelet 1969: 345; quoted in Porter 1986: 104). According to Hacking, *l'homme moyen* represents both a new kind of information about populations but also a new conception of how to control them (Hacking 1990: 108).

Marey's use of chronography to study physiology from the late 1860s onwards, provides a good encapsulation of this new conception. With the use of chronography

and later chronophotography, his objective was to photograph bodies and translate movement into graphic inscriptions, to discover the fundamental and invisible laws of movement that would then come to define "the body" in terms of limits and potentiality. By linking physiology and photography, as François Dagognet has asserted, Marey would develop an *éducation physique* that quite literally would seek to make bodies conform to the economy of the film strip (Dagognet 1987).

Like Quetelet before him, Marey's emphasis on the norm reflected the influence of August Comte's scientific positivism. Hacking has remarked upon a "fundamental tension" expressed in Comte's idea of the normal: "the normal as existing average, and the normal as figure of perfection to which we may progress" (Hacking 1990: 168). This double meaning, Hacking maintains, stems from Comte's appropriation of François-Joseph Victor Broussais' theory of the normal and the pathological. Broussais maintained that all diseases could be understood in terms of degrees of variation and disturbances to the normal state, either above or below a figure set by the norm (Hacking 1990: 167–9). Broussais conceives of the normal and the pathological as relational, medical treatment of disease is directed toward a return to a normal state. Comte takes Broussais' idea that the pathological arises out of the normal state, and applies it to the political sphere where it takes on another dimension. One the one hand, the "normal ceased to be the ordinary healthy state," writes Hacking, "it became the purified state to which we should strive, and to which our energies are tending." On the other hand, there is "the idea that normal is only average, and so is something to be improved upon" (Hacking 1990: 168).

Hacking maintains that at the core of Francis Galton's eugenics (selective breeding for racial perfection) is a concept of the normal as mediocre. In contrast to Marey's inscription of averages aimed at maximizing energy expenditure and predicting or detecting a state of unhealth, Galton's obsessive anthropometry (the measure and correlation of body parts) would introduce a hierarchy into the category of the pathological, esteeming the exceptional or above average over that which is below the norm or simply average. Thus, for Galton, the pathological is not a variation that needs to be returned to a normal state, rather it is a reflection of the dynamic processes of Darwin's "descent with modification" formulated in *Origin of Species* (1859). Galton, and along with him Herbert Spencer, would reformulate Darwin's non-teleological conception to conform to an evolutionism that would equalize social, cultural and biological spheres along the lines of progress, or as Spencer put it in *Principles of Biology* (1864) "survival of the fittest."[1] Statistics, demographics and of course photography were useful tools for quantifying, predicting and most importantly according to Hacking, *explaining* patterns of reproduction and identity. Not only did Galton devise fingerprinting as a means of identifying criminals, but he was concerned to discern "average types" – officers, soldiers, criminals, Jews – by measuring body parts and sometimes using multiple photographic exposures of random samples of faces. For Hacking, Galton's statistical generalizations go one step further than Quetelet's *l'homme moyen* which was always an abstract ideal, by making these the basis for explanatory arguments. In short, Galton transforms statistical laws and probability claims into actual social reality (Hacking 1990: 186).

Galton coined the term "eugenics" (well born) in 1883 defining it through the category he had explored in *Hereditary Genius* (1869), an inherited intelligence determined on the basis of social accomplishment and profession. The fear for Galton was the general tendency for a race to regress to a mean, for the exceptional variation to be washed out:

the ordinary genealogical course of a race consists in a constant outgrowth from its centre, a constant dying away at its margins, and a tendency of the scanty remnants of all exceptional stock to revert to that of mediocrity, whence the majority of their ancestors originally sprang.

(Galton 1889: 406)

Galton was concerned that the mediocre, the poor (or mentally defective) and the "inferior" non-white races he had encountered on his many trips to Africa were reproducing faster than the "superior" strains of blood found among the white civilized races of Europe (he himself never had children). Evolution needed to be aided if exceptional stock was to survive. Thus, Galton focuses on the variation from the normal distribution to uncover the laws of progress, to map in statistical terms an evolutionary and hereditary trajectory that eugenics would secure.

Thus far we have looked at mechanistic discourses of the nineteenth century focused on social reproduction (material and biological). The norms upon which these discourses are based reside in numbers, what Marey called *l'écriture de la nature* or Galton's statistical laws. Normative function here depended on and took on meaning through a scale of value determined by national and imperial interests, the production of superior bodies. Both the science of work and eugenics gained currency in Europe and North America with the rise of nationalism. The difference between Marey and Galton resides in their views of normality. Marey conceives of the average as a law which is static and unchanging, an image which can be imposed on a body and a body which can be made to conform to an image. In contrast, Galton focuses on the variation in a nature that is evolving, and therefore conceives of norms in a much more forward looking and creative way. This is not to say that he is any less teleological than Marey but rather that eugenics has far vaster implications for the lifeworld. For Marey there was no question of going beyond or expanding the corporeal limits of expenditure. But for Galton, much like the imperial expansion of the Empire or the capitalist enterprise, the process of breeding for racial purity was implicitly an endless and progressive movement. As we shall see, the body-machine model of progress and the instrumental version of intelligence would remain very much a part of the science of genetics in the age of biotechnology.

The body as program

Evelyn Fox Keller (1993) maintains that the biological determinism at the heart of eugenics continues to thrive in molecular biology today. The problem we encounter in trying to situate the values and assumptions underlying genetic research is in establishing the norms upon which research is conducted, upon which notions of health and disease are being formulated. If Comte appropriated a model of the normal from biology to understand the social order, molecular biology has in turn appropriated discourses from the social sciences to understand reproduction. *Understanding DNA and Gene Cloning* (1984), an introduction to genetic engineering written by geneticist Karl Drlica,[2] provides a good example of the convergence between the life and communication sciences:

An explosion of knowledge is shaking the science of biology, an explosion that will soon touch the life of each one of us. At its center is chemical information – information that our cells use, store, and pass on to subsequent

generations. With this new knowledge comes the ability to manipulate chem-
ical information, the ability to restructure the molecules that program living
cells. ... The new biology is also telling us how the chemicals in our own
bodies function; we may soon be programming ourselves and writing our
own biological futures.

(Drlica 1984: v)

Life's instructions locked away since time began are now being extracted and deci-
phered with the aid of powerful computers. Like the end of the Cold War as the end
of history, the DNA body dissolves temporal and spatial boundaries, it is a fully inte-
grated circuit ready to be programmed for the future. The body as information,
along with the Cold War imagery of intelligence and secret instructions that is so
prominent in much of the language used to describe genetic research, reflects post-
war applications of war-time technologies (especially computers) in genetic research.
Donna Haraway has traced a shift in the discourses of biochemistry at the end of the
Second World War from thinking about cellular relations between and inside organ-
isms to a more mechanistic and reductionist approach drawn from information
theory: instructions, codes, messages, control and feedback mechanisms. This shift
was brought on largely by the flow of biologists into operations research during the
war, and the post-war flow of physicists into biology (Haraway 1979: 206–37).
According to biologist François Jacob, the molecular-informatic image of human
reproduction particular to the post-war period emphasizes the ability to retain and
transmit the past which is of course the definition of cybernetic systems: "The
programme is a model borrowed from electronic computers. It equates the genetic
material of an egg with the magnetic tape of a computer" (Jacob 1973: 9). The
concept of the program as a model for explaining evolutionary processes combines
two notions: memory and design. Reproduction is understood as communication
transmission, and intelligence is no longer relegated to the mind (as with eugenics)
but is an inherent part of the molecule.

Armand and Michele Mattelart have commented on the way nineteenth-century
notions of progress tied to evolution have been substituted by a new link between
communication and evolution (Mattelart and Mattelart 1992: 33). This link,
according to Jacob, "makes an honest woman of teleology" (Jacob 1973: 9).
Communication not only defines the new telos of the life sciences but also a new
interdisciplinarity between the life and the human sciences. In the late 1960s, the
concept of the code and the emphasis on communication led to what the Mattelarts
see as excessive exchanges between structural linguistics and biology. Roman
Jakobson, for example, would embrace the similarities between the signs and linear
structures of coding and decoding studied by linguistics and genetics (Mattelart and
Mattelart 1992: 29).[3] Responding at that time to such analogies, Jacob would
caution: "Linguistics studies messages transmitted from a source to a receiver. In
Biology, however, there is nothing of the kind – neither source nor receiver"
(Mattelart and Mattelart 1992: 29). Such analogies, Jacob explains, provide biology
with the conceptual framework in which to analyze generalizations; mathematically
grounded theories are rare in this field which is "why there is such a frequent
tendency to confuse the model with an explanation and analogies with identities"
(Mattelart and Mattelart 1992: 29).

While the simple symmetries between linguistic and genetic systems have been

largely discounted by biologists over the past decade, a new reductionism seems to be gaining momentum. Bonnie Spanier has observed that:

> recent developments have cemented the growing domination of a reductionist and DNA-centered form of genetics as *the* (rather than *a*) new molecular biology of all cells, the most powerful and, therefore, the most correct view of life. This hegemony can be recognized in reorganized biology curricula as well as in the daily newspaper.
>
> (Spanier 1995: 150)

The new hegemony of the gene as *the* life code is supported by the new recombinant DNA technologies that are fostering the massive economic explosion in the biotech industries (an explosion exemplified by the privatization of parts of the Human Genome Project and recent attempts to patent human genes). Writing on the cusp of this explosion, Drlica's *Understanding DNA* exemplifies the new reductionism. Taking the analogy of DNA as the "ribbon of life" into a new discursive field which grew out of structural linguistics, Drlica brings gene splicing to film theory:

> Imagine a film editor who feels that he can make a profitable new motion picture by clipping out a scene from a John Wayne film and sticking it into a short Mickey Mouse cartoon. The spliced film will be longer than the original Mickey Mouse cartoon and, depending on which John Wayne scene was moved and where it was placed ... [a] new motion picture will be created. In this same sense, gene splicing creates new forms of life.
>
> (Drlica 1984: 75)

If Marey's bodies were meant to conform to a film strip, then the DNA body is a film to be spliced. The frontiers opened up by genetic engineering are perfectly commensurate with the generic and animated world of the Wild West. Here an almost parodic gun-slinging constructivism uses the language of film, and a concomitant theory of montage, as an analogy for the way the language of life can be manipulated, replicated and recombined to create new biotechnical commodities.

While the Russian constructivist Sergei Eisenstein theorized a language of film that would reflect a synthesis between art and science, the shot as "brick," or as building block, was always intended to produce a language, intellectual montage, made over by history. A film language which, like the body of Frankenstein, would make visible the temporal seams of its construction (Eisenstein 1975). The recombinant film of John Wayne and Mickey Mouse presents us with a strange and yet logical heterogeny, a hybridity of masculinity and imperialism, of memory and design that leaves women out of the picture entirely. This is predictable for as Barbara Maria Stafford has asserted, the "final stage in the historicizing of nature sees the products of history naturalized" (Stafford 1979: 109). In *Understanding DNA* the process of naturalizing history conflates image and body in a curious inversion of cinematic realism, not film as life but life as film.

The spatialization of time in the processes of representation forged by Marey's positive science is what Henri Bergson would deplore in *Creative Evolution*. Modern scientific knowledge, Bergson would contend, depends on a cinematographic consciousness, on a fragmentation, recomposition and leveling of experience that reinforces the instrumental view of time and body as images modifiable at will

(Bergson 1944: 332–3). For his part, François Jacob asserts that the conflation of the computer program and the genetic program is misleading precisely because "one can change at will, the other cannot" (Jacob 1973: 9). Yet it is this difference that a new age of mechanism is obscuring by leaving environmental factors by the wayside.

For those familiar with David Suzuki's work as an environmental activist, his popular account of genetics in *The Secret of Life* is perhaps most astounding for the way in which the environment is reduced to the cell. Mimicking the autogenesis of cybernetic systems, the genetic code, he tells us, is "responsible for making and operating living organisms," it "passes on ancient messages," it "tells the body how and where to build an arm." The body conceived as information socializes a new biotechnical agent, the code. No longer an analogy, norm or average matrix outside human bodies, the code is the foundation of all life. The DNA model, seen so often as a computer-generated image in *The Secret of Life*, is what reproduction looks like in the age of information. Its boundaries are fluid, global and decentralized, automated and intelligent. It is a hermetic system where the regime of the gaze no longer holds sway, a derealized space where we see life from the perspective of a molecule, at once nowhere and everywhere, inside and out.

Moving seamlessly in and out of images of nature, bacterial cultures, computer-generated models and even the mosquito from the film *Jurassic Park* (1993), *The Secret of Life* provides a visual intertextuation that approximates Drlica's film as life analogy. One sequence, for example, provides a series of dissolves from a spider's web to a translucent strand of DNA to a computer-generated model of DNA to a computer print-out of "molecular software." This kind of sequencing splices together, equalizes and naturalizes a multiplicity of inscriptions and imaging technologies to create a continuity that is meant to signify the single thread of life: "the letters it takes to spell out you or me." It is impossible to locate the origin, the truth or objectivity of these images in relation to a reality that is external to them. Rather, abstract electronic images exist as a new visual language in a space founded on what Bruno Latour has called "optical consistency"; it is this internal consistency that allows very different kinds of inscriptions (from statistical graphs to MRIs) to be combined. Latour asserts that the current trend in science, towards simpler inscriptions that mobilize larger numbers of events, functions to make scientific knowledge less confusing and more convincing. For what is not apparent in the images are the calculations that went into making them or the actual material realities upon which they are based (Latour 1990: 41).

While the fingerprinting techniques that Galton devised for the British criminal system were intended to guarantee positive identification, DNA fingerprinting is far more ambiguous in terms of delineating biological identities. The taxonomy of sameness (the human species) and difference (absolute individuality in the form of the genetic print) is undermined by the fact that species differences are difficult to discern; by the gender problem, according to genetic studies not all women are women (some women carry the male chromosome); and by the reality that race is not a category of biological identity. This ambiguity is given a utopian dimension when Suzuki locates his own aspirations for a new biocracy (very similar to McLuhan's technocracy) in the new biology that will unify the diversity of the earth by combating disease and linking all living organisms. Relating the eugenics movement in Canada to the internment of his family and all Canadians of Japanese descent during the Second World War, he explains how he was drawn to biology and genetics because of the way these stress our inter-relatedness rather than our differences.

Between 1905 and 1935 a negative eugenics movement gained momentum in Britain, Europe and in North America.[4] In Canada, many provinces legalized sterilization and immigration policies were clearly slanted to support British and Northern European immigration.[5] This was supported by the ideology of an essential Canadian identity derived from the special character of the Northern land. In 1892 George R. Parkin, under the influence of Galton and Spencer, would claim that Canada's special Anglo-Saxon character resided in its cold climate, a climate that excluded the weaker races of the South, the "Negro" or "the Italian organ grinder." The "democratic spirit" of Canada's dominion was white and this is what needed to be preserved and protected (Parkin 1892).

It is this purity, whiteness and ahistoricity that finds expression again and again in *The Secret of Life*. The reoccurring image of an infant child whose white body appears to float in a black and empty space is the choice baby, the right to a healthy body quality controlled before conception, who will "leave its imprint on the future." A child that is the antithesis to Mary Shelley's monster whose history, written on its body, haunts its maker like a nightmare. As Keller argues, *choice* is the keyword for the positive eugenics envisioned by the Human Genome Project which is directed toward "the use of genetic information to ensure that each individual has at least a modicum of normal genes." This "eugenics of normalcy" distinguishes itself from its earlier incarnation by underlining that its goals will be achieved "through technological rather than social controls" (US Office of Technology Assessment 1988: 84–6; quoted in Keller 1993: 295). The earlier management of human populations by means of external social programs gives way to a new logic which avoids the anthropomorphic characteristics of purpose and control. In reducing living systems to information systems, the mass social program is internalized as the individual human program. Yet the older teleology continues to exert its influence: individual health replaces racial perfection but means the same thing because it depends on standards of normalcy, standards defined according to a norm signified by the singularity of *the* human genome and against an ever-growing list of genetic diseases (Keller 1993: 295). New categorical identities of disease are being conceived as genetic profiles that need to be wiped clean. Increasingly, these are diseases that are being collapsed into the behavioral sciences: manic depression, alcoholism, crime, homosexuality, shyness and the latest, "novelty seeking" (Horgan 1993: 92–100). The matrix which determines normalcy, according to Keller, escapes scientific scrutiny "not simply by oversight but by the internal logic of the endeavour" (Keller 1993: 297).

The DNA body is a cybernetic organism replicating the very structures of identification and consumption enabled by the new information technologies upon which its existence depends. And indeed the DNA body promises the same kind of agency: interactivity, freedom and individual choice. The field of the social, and with this the construction of what is normal and healthy need to be firmly materialized alongside the discursive power of a scientific apparatus that, like the great Parisian mediums Marey's chronography set out to record, claims to be doing nothing more than reading the signs.

Notes

1 For an interesting discussion of the relation between Darwin and Spencer, see P. Bowler (1989) *The Invention of Progress*.
2 I am indebted to Chris Byford for drawing my attention to this text.

3 As the Mattelarts point out exchanges between Jakobson, Jacob and Claude Lévi-Strauss
 were originally published in *Critique* (March 1974) and in *Linguistics* (November 1974).
4 See D. Kevles (1985) *In the Name of Eugenics* and M. B. Adams (1990) *The Wellborn
 Science*.
5 See A. McLaren (1990) *Our Master Race*.

References

Adams, M. B. (1990) *The Wellborn Science: Eugenics in Germany, France, Brazil and Russia*,
 New York: Oxford University Press.
Bergson, H. (1944) *Creative Evolution*, trans. A. Mitchell, New York: The Modern Library.
——(1972) in A. Robinet (ed.) *Mélanges*, Paris: Presse universitaire de France.
Bowler, P. (1989) *The Invention of Progress: the Victorians and the Past*, Oxford: Basil Blackwell.
Canguilhem, G. (1994a) "The concept of life," in F. Laporte (ed.), trans. A. Goldhammer,
 A Vital Rationalist, New York: Zone Books, 303–19.
——(1994b) "Normality and normativity," in F. Laporte (ed.), trans. A. Goldhammer, *A Vital
 Rationalist*, New York: Zone Books, 351–84.
Dagognet, F. (1987) *Etienne-Jules Marey*, Paris: Hazam.
Didi-Huberman, G. (1982) *Invention de l'hystérie: Charcot et l'iconographie de la salpetriere*,
 Paris: Macula.
Drlica, K. (1984) *Understanding DNA and Gene Cloning: A Guide for the Curious*, New York:
 John Wiley & Sons.
Eisenstein, S. (1975) *Film Form: Essays in Film Theory*, trans. J. Leyda, New York and London:
 Harcourt, Brace, Jovanovich.
Fox Keller, E. (1990) "From the secrets of life to the secrets of death," in M. Jacobus, E. Fox
 Keller and S. Shuttleworth (eds) *Body/Politics: Women and the Discourses of Science*, New
 York: Routledge, 177–89.
——(1993) "Nature, nurture and the Human Genome Project," in D. Kevles and L. Hood
 (eds) *The Code of Codes*, Cambridge, Mass.: Harvard University Press, 281–99.
Galton, F. (1889) *Natural Inheritance*, London: Macmillan.
Hacking, I. (1990) *The Taming of Chance*, Cambridge: Cambridge University Press.
Haraway, D. (1979) "The biological enterprise: sex, mind and profit from human engineering
 to sociobiology," *Radical History Review* Summer: 206–37.
Horgan, J. (1993) "Eugenics revisited," *Scientific American* June: 92–100.
Hubbard, R. (1995) "Genetic Testing," talk given at McGill University, Montreal, November.
Jacob, F. (1973) *The Logic of Life: A History of Heredity*, trans. B. Spillman, New York:
 Pantheon Books.
Kevles, D. (1985) *In the Name of Eugenics: Genetics and the Uses of Human Heredity*, New
 York: Knopf.
Kuhn, T. (1977) *The Essential Tension: Selected Studies in Scientific Tradition and Change*,
 Chicago: University of Chicago Press.
Latour, B. (1990) "Drawing things together," in S. Lynch and D. Woolgar (eds) *Representa-
 tion in Scientific Practice*, Cambridge: MIT Press, 19–69.
McLaren, A. (1990) *Our Master Race: Eugenics in Canada 1885–1945*, Toronto: Oxford
 University Press.
Marchessault, J. (1993) "The naked eye redressed: invisibility and redemption," *Public* 7:
 20–37.
Mattelart A. and Mattelart M. (1992) *Rethinking Media Theory*, trans. J. Cohen and M.
 Urquidi, Minneapolis: University of Minnesota Press.
Parkin, G.R. (1892) *Imperial Federalism: The Problem of National Unity*, London and New
 York: The Modern Library.
Porter, T. M. (1986) *The Rise of Statistics*, New Jersey: Princeton University Press.
Quetelet, A. (1969) *A Treatise on Man*, facsimile edition of 1842 translation, Gainesville, FL:
 Scholars Facsimiles and Reprints.
Rabinback, A. (1990) *The Human Motor: Energy, Fatigue, and the Origins of Modernity*, New
 York: Basic Books.
Serres, M. (1968) *Hermes*, Paris: Editions du minuit.

Spanier, B. (1995) *Im/Partial Science: Gender Ideology in Molecular Biology*, Bloomington and
 Indianapolis: Indiana University Press.
Stafford, B. M. (1979) "Toward romantic landscape perception: illustrated travels and the rise
 of 'singularity' as an aesthetic category," *Arts Quarterly* 3: 35–60.
US Office of Technology Assessment (1988) *Mapping our Genes.*

José van Dijck

THE LANGUAGE AND LITERATURE OF LIFE
Popular metaphors in genome research

"FRANCIS [TOLD] EVERYONE within hearing distance that we had found the secret of life," boasts James Watson towards the end of *The Double Helix* (1968: 126). Watson's famous autobiography, which relates the story of his and Francis Crick's discovery of the structure of DNA, is still considered a milestone in the popularization of the "new genetics." Fifteen years after the discovery, Watson significantly chose the autobiographical format to boost the field of DNA research which was then still in its infancy. The popularity of the new genetics was haunted by faint images and compromised memories of formerly prevalent eugenic theories. Watson's book has undoubtedly added to the myth that the double helix, in 1953, signalled the beginning of genetics – an origin story aimed at wiping out all continuities between eugenics and the "new" genetics. Watson, Crick and other molecular biologists managed to popularize the genetic paradigm in the 1950s and 1960s by addressing a large and general audience using easily accessible formats, images and icons. The widespread dissemination of genetic thinking is symbolized particularly by the popular use of the helical model, which was originally presented as an analogue model for the structure of DNA. Outside the domain of science, the double helix rapidly acquired the metaphysical meaning that Watson had so eagerly ascribed to it when he equated the molecular structure to the essence of life. Somewhat similar to the staff of Aesculapius, the helical design can be seen in everything from jewelry to advertisements to logos of biotechnology firms. The double helix is probably the most famous analogue model in science to have achieved the status of icon.[1]

Besides the helical model, scientists and journalists have particularly mobilized two metaphors in the dissemination of the abstract and complex theory of genetics for a general audience. The most popular metaphor for DNA is that of "language" or "alphabet." The four bases of DNA (adenine, quanine, thymidine and cytosine) are labeled as the letters in the alphabet (A, G, T and C) and the combinations of letters constitute "sentences" in a "book." All the letters of our DNA combined form the instructions for our genetic make-up, and knowledge of this structure may lead to more control of heredity. The equation of molecular "language" and the "essence of life" originates in the idea that once we understand the structure and function of the smallest organic units (molecules) humans can intervene in the process of evolution. Out of the language metaphor an extensive web of semantically related images

emerged, such as the "book," the "library," "reading" and "writing." Naturally, this semantic frame was not exactly new in the 1960s; ideas like the "legibility of nature" or "the book of life" have been traditional topoi in literature and science.[2]

Neither was the second metaphor introduced in the 1960s new or original; biologist Erwin Schrödinger had already introduced the term "code" in relation to DNA in 1944 (Schrödinger 1967). The code metaphor generated a string of semantic labels – terms like "encoding," "decoding" and "deciphering" – culminating in what Edwin Chargaff has dubbed "the grammar of biology" (Chargaff 1970: 810–16). The metaphorical idiom seriously caught on after the discovery of the double helix. The extended "code" metaphor by far exceeded the function of exemplification proper. Chargaff has convincingly argued that the de-metaphorization of the "code" and "language" metaphors eventually fed a new dogmatic biology based on the assumption that "life" can be explained by, and reduced to, its molecular structure. The popular genetic metaphors signaled a definite shift from the phenotype to the genotype; the idea of an underlying code or grammar enabled scientists to think of heredity as a general pattern that, once it is known, can be used as an explanatory model for countless phenotypical variations – commonly deviations or diseases.

It may not be a coincidence that the "code" and "language" metaphors gained wide acceptance in the 1960s, the decade in which Noam Chomsky's transformational generative grammar revolutionized linguistics and Marshall McLuhan mesmerized the world with magical mantras involving the medium and the message. The new molecular paradigm exhibits a remarkable parallel with innovative theories in both linguistics and communications, and appears to borrow its popular metaphors from these disciplines. Chomsky's transformational generative grammar centered on finding an abstract, universal coding system that served as an explanatory model for the endless variations in languages and individual linguistic development. It has even been argued that in the 1960s linguistics came to the rescue of biology, offering it a structured analysis.[3] The code metaphor – and, by extension, related terms like "sender," "receiver" and "message" – resonated clearly in McLuhan's popular theories which were very influential in sociology and emerging communication departments at that time. In the years after Watson's and Crick's discovery, the model for the structure of DNA had been worked out by the French molecular biologists Jacob and Monod. They explained the working of DNA as sending a string of coded information ("messages") from RNA ("messengers") to protein ("receivers"). Characteristic of this model and its metaphors is the assumed one-way flow of information from sender to receiver. What the new genetic paradigm and McLuhan's theory had in common was their determinist assumptions: in McLuhan's view, the medium determined the (content of the) message, in molecular biology genetic make-up constituted (the "life of") human beings.

In the past two decades, however, this relatively simple view of DNA as loci of information and RNA as its messengers or transmitters has been replaced by more complex interactional models. According to Evelyn Fox Keller, the working of DNA is increasingly understood in terms of complicated networks in which flows of information are not always predictable or rule-governed (Keller 1995). Since the mid-1980s, genetics research has focused primarily on inventorizing the correct order of nucleotides on the human chromosomes. Geneticists predict that before the year 2005 we will have a complete map of the genetic constitution of human beings. The genetic "map" or "chart" rapidly equaled other metaphors in popularity. Genetic maps show the relative positions of thousands of genes on the chromosomes, yet in

popular discourse the map is commonly figured as a colorful chart displayed on the physician's wall hanging next to the graphical illustration of skeletal parts and organs. The axiomatic implication of this metaphor is that the "map" enables the location of specific genetic aberrations or diseases. Ingrained in this configuration of the genome is the idea that disease can be "localized" as a defect or an irregularity in the gene sequence. A "map" is programmatic in a sense that it figures the human body as a predetermined route, a methodical arrangement of fixed DNA-fragments.

The Human Genome Project, as the effort to map three billion human genes is called, would never have succeeded without the introduction of the computer as a research tool. With the help of computer hardware and special database programs, DNA sequences are "translated" into digital codes. Whereas before the word "*code*" was an abstract term, in the context of genomics it takes on a digital materiality in addition to its referential function. Besides its material meaning in the business of genome research, the "computer program" also offers a new metaphor for the configuration of the genome. The notion of a "genetic program," however, entails a paradoxical loop: the program requires the very proteins that it generates in order to go on generating them. Rather than a linear flow of information we should identify circulation as the vector for the dissemination of meaning. In line with these new insights into the working of DNA one would expect new or adjusted metaphors and images to account for its complexity and the often contingent two-way traffic of genetic information. In the past five years, many popular non-fiction accounts have been published by geneticists who rely on extensive figurative language to explain the importance of genome research to a general audience. Yet despite the obvious update of molecular biology into the digital era, conventional notions like "reading" the genome still appear in its meaning of "deciphering" or "decoding."

The complex nature of our molecular constitution continues to be represented in terms of linearity rather than circularity, and the most popular contemporary metaphors for genome research are still derived from linguistics or its assumed computerized equivalent. The inventory of three billion gene sequences, for instance, is often represented as a "blueprint," and genetic information is digitally inscribed and stored on a "compact disk." While the human genome is increasingly *figured as* a "blueprint" it has *de facto* become a collection of digital units, stored away efficiently on a compact disk. Walter Gilbert, one of the co-founders of the Human Genome Project, has proposed the idea that the complete sequenced human genome, inscribed on a compact disk, will contain all our essential information: "One will be able to pull a CD out of one's pocket and say 'Here is a human being, it's me'" (Gilbert 1992: 96). In Gilbert's evocative and appealing image of the CD containing an inscription of a person's genetic make-up, we can notice an unproblematic convergence of the digital, organic and metaphysical signifieds of the body. "Me" refers simultaneously to digital units as a representation of the genetic body, an electronic inscription, and an immaterial "essence" – an identity or soul. Gilbert's metaphor of the CD does more than "update" the familiar equation of "life" with molecular structure, propelled by Watson and Crick. The parallel between "life" and digits materializes in a palpable, digital artefact – almost a household product.

Metaphors like "language" and "code," introduced in the 1950s and 1960s to popularize genetics, re-emerge three decades later in a revamped electronic coating. In spite of new insights into the working of DNA and the human genome, the dominant paradigm remains remarkably unchanged; the emergence of computers does not automatically lead to metaphors that express complexity and circularity of genetic

information. On the contrary, in popular magazines and books we find a persistent invocation of familiar, conventional metaphors that connote linearity and predictability. The "map" implies an uncomplicated one-to-one relation between representation and a fixed physical reality. The idea that the human body can be coded as a decipherable sequence of four letters, and hence as a finite collection of information, is based on the epistemological view that computer language – like molecular "language" – is an unambiguous representation of physical reality. As we may derive from Gilbert's famous dictum, the metaphors of genome research are borrowed from the domain of computer science, but they reappear in their old linguistic meanings. "Reading" or "understanding" the essence of life, even in a digitized context, still means to "decipher" or "decode" a prepackaged message.

In recent years, several scientists and non-scientists have criticized the images prevalent in the popularization of genome research, and they particularly object to the essentialist assumptions these metaphors reflect.[4] Traditionally, scientists have marginalized such criticism because metaphors, they insist, have merely an illustrative function; metaphors and models, in their view, have no other function than reflecting scientific reality. Some biologists, however, have pointed at the conceptual and ideological power of metaphors, and have objected to the inaccuracy and deceptiveness of some popular genome metaphors. The function of metaphors, in this latter view, is constitutive rather than ornamental: metaphors may actually change our concept of reality instead of merely providing convenient translation tools.[5] It is particularly this constitutive function of metaphors that forms the heart of criticism. These two diverging views on the function of genome metaphors can be illustrated by two recent publications: Robert Pollack (1994), in his popular non-fiction book *Signs of Life*, and Richard Powers (1991), in his novel *The Gold Bug Variations,* critically evaluate dominant images of the new genetics; both the molecular biologist and the novelist find metaphors like "language" and "code" deceptive and inadequate. In addition, both authors question the genetic essentialism underlying these metaphors derived from linguistics and communication theory. Yet their criticism proliferates very differently. Pollack proposes the introduction of a new metaphor to explain genetics: "literature," he argues, acknowledges the inherent ambiguity and contingency of the genetic constitution better than the term "language." Powers' critique is more profound; according to the novelist, we need not simply adjust our metaphors, but change our way of thinking about the relation between science and culture, and between reality and representation, in order to reshape our concepts of the human genome.

The literature of life

In *Signs of Life*, Robert Pollack severely criticizes the common configuration of the genetic structure as a language – an image that defines language as a static set of coding rules. Instead of taking linguistic concepts as a model, he proposes transferring the analytical apparatus of literary criticism on to genetics. To view genetics as literature rather than language allows recognition of the complexity of DNA. Taking advantage of the elaborate set of meanings this expansion brings along, Pollack tempers unmitigated biophoria and takes on the Human Genome Project's underlying determinist assumptions. In line with prevailing metaphorical preferences, he describes DNA as a "long, skinny assembly of atoms, similar in function, if not form, to the letters of a book" (1994: 5). His notion of reading, however, involves more

than deciphering: "The cells of our bodies do extract a multiplicity of meanings from the DNA text inside them, and we have begun to read a cell's DNA in ways even more subtle than a cell can do" (ibid.). The inherent polysemy of DNA texture enables multiple interpretations of the same letters; this infinite potential of meanings generated by a DNA text should be acknowledged by geneticists as a great asset rather than a disadvantage. Reading, according to Pollack, is an activity not directed at intellectual closure, but geared towards intellectual exposure. Therefore, the scientist suggests that geneticists borrow the analytical apparatus from literary theorists to raise a different set of questions: Are cells reading or are they merely decoding? Will there be a "canon" of DNA texts? What can we learn about the language these DNAs share, the dialects they produce, and the arguments they articulate? The discourse of literary criticism, in other words, propels questions of polysemy and multi-interpretability.

Pollack pursues his interdisciplinary reconnaissance by disassembling some of the most exploited images in genome sequencing, such as the "library," "translation" and the "book of life," to put a twist to their dominant meanings. Explaining the structure and function of the twenty-three pairs of chromosomes, he likens them to the two replicating towers of the World Trade Center ("an odd sort of library") where each stack holds a duplicate set of books. Library staff take down one volume, photocopy an article and put it back on the shelves. Human mistakes in the process of copying and reshelving are only as common as genetic mistakes, which we have come to know as mutations. Pollack proposes reading human DNA as "a work of literature, a great historical text," but he immediately points out that such a text can never have a single meaning; the human genome is not a "sacred text" with only one valid version. The value of literature lies in its potential to generate endless meanings – meanings that are contingent on the specific (historical) context of its readers. Comparing three translations of a paragraph from the New Testament, taken from different historical periods, Pollack shows that each version yields a profoundly different interpretation of the same words. Transposed on to genetics, this implies that meanings will multiply with time, and no single allele is ever going to be the sole "correct" version. The idea that there is a single, canonical interpretation of the human genome, whose precise alleles we might hold up as a perfect mirror, is not an innocent misconception but a dangerous tenet shared only by fundamentalists. The purpose of expanding the language metaphor into the realm of literature is to show that DNA opens up whole new worlds of interpretation; the leap from DNA to protein is as arbitrary as the relation between signifier and signified.

Pollack further deconstructs the concept of "translation" to unnerve popular comparisons of the human genome to historical events. Geneticists often liken their goal to "crack the code" to deciphering the Rosetta Stone, the code of which was "broken" by Champollion in 1821. But the word "translation," in common usage, is as much a misnomer in the context of the historical discovery as it is in relation to genetics. The Rosetta Stone was a rebus, a hieroglyphic sculpture that carried different language inscriptions of the same text. When geneticists talk about "translating" the human genome they talk about transposing a three-dimensional language (DNA) on to a linear representation of alphabetic units. Translation thus intrinsically entails a change of meanings; just as in ordinary translation, a word never means the same in another linguistic or representational context. Deciphering the "meaning of life," as Pollack argues, is the production of a "consensus trans*literation*" but never a translation (1994: 90). A transliteration of a string of four letters is no more likely to

reveal multiplicity in a gene than "the transliteration of a poem by Pushkin from Cyrillic into English would enable an English speaking person to see layers of meaning in a poem" (Pollack 1994: 12).

Technological upgrading of the language metaphor into digital information offers a new and exciting view of the possibilities of genetics. Once we have ordered and stored library fragments, we can start to edit existing genes. Pollack's introduction of the "molecular word processor" signals the potential of gene therapy as the "revision" or "re-authoring" of life:

> To use the molecular word processor is to write in the language of DNA freed from the constraints that natural selection has placed on the possible meanings a cell can put into or draw from its genomic texts. With it we can insert or read new meanings into existing genes, and construct new contexts in which gene sentences can take on new meanings. … As our tiny vocabulary of protein meanings grows, we will inevitably be drawn to the idea of a molecular literature entirely of our own creation.
>
> (Pollack 1994: 96)

Gene manipulation ("the recycling of microbal swords into molecular plowshares") puts scientists in the position of authors. Pollack evaluates the prospect that humankind can edify its own book of life with mixed feelings. Transgenic mice already populate the laboratories, and experiments with transgenic people may not be far away. "Transgenic," however, does not necessarily imply the creation of monstrous hybrids; a child born without a congenital disease passed on by its parents is also a transgenic product. Pollack's point is that mutations are never predictable, so the consequences of "improving" the genetic texture are impossible to calculate: "Single genes may one day be totally understood, but the overall meaning of the genome will not be a predictable sum or product of these separate meanings" (Pollack 1994: 152).

The very indeterminacy of the human genome should seduce scientists to see DNA as literature, rather than as language, and to treat its texts accordingly; they should abandon the hope for intellectual closure and rejoice in the pleasure of endless, multiple interpretations. By transplanting the apparatus of literary theory onto the life sciences, Pollack assumes that the narrow view of scientists will be expanded by the humanities' perspectives. Molecular biology should be appreciated as a creative art as well as a science. Adopting the popular metaphor of genetics as language, but expanding its figurative range to include literature, Pollack forges an ideological and conceptual shift in dominant genetic thinking. He reclaims analytical frameworks common in the humanities and reappropriates them for a double purpose: to change the conceptual model prevalent among geneticists, and to explain a highly abstract scientific theory to non-scientists. His tactic seems aimed at bridging the gap between the two cultures and at criticizing the essentialist rationale underlying the Human Genome Project. Pollack deconstructs for us, by means of analogy, genetics *in terms of* literature, and hence serves as an "interface" between the seemingly incommensurable worlds of science and culture. Scientists, after all, are also sort of artists – they modify genetic material just as sculptors mould their clay – and literary approaches may yield valuable insights into genetics.

Although he proves himself a staunch critic of the reductionist tendency in genome research, Pollack's rather static view of culture is marked less clearly.

Paradoxically, the molecular biologist defines literature as a collection of precious books laid down in a canon of texts and projects that on to science: "Once we finally see that all genomes are a form of literature, we will be able to approach them properly, as a library of the most ancient, precious and deeply important books, only then can the new biology be born" (Pollack 1994: 177). Besides viewing culture as a canon of texts, he also assumes a self-evident split between representation and reality. Metaphors, despite their potential power to affect conceptual frames, have an ornamental rather than a constitutive function. The idea that metaphors are representational models that do not really affect reality, for instance, is evident from his argument that the advance of computer science has yielded new figurative language that enables conceptual adjustments – geneticists can now be viewed as creative writers – but it has not really changed our concept of how DNA works. The word processor and the notion of information processing serve to illustrate the intricacy of genomics. Yet he never addresses the fact that the digitization of genome research is actually inscribed in its practices, and that information processing is no longer a mere figure of speech, but crucial materiality in genome research. One important consequence of the new digital practice of DNA research, for instance, is that geneticists have begun to talk in terms of "copyrights" rather than "patents" on discovered gene sequences. "Editing" genes not only sounds different than "manipulating organisms"; in the practice of DNA research, the digital representation of gene sequences seems to be the organic reality that serves as its referent. This can be retraced in the autonomy of the digital sign system: genetic information – the digital imprint of DNA – can be used in totally different contexts, such as life insurance or health insurance. In these new contexts, the digital code no longer functions as representation, but has become a material entity: a code that provides information about a human body and which can be coupled with other digital information systems.

Pollack transposes the conceptual frame of literature on to biology, but the traffic appears to move unidirectionally. In his double mission to explain the principles of genetics to laypersons and to criticize these principles, the molecular biologist projects his static concept of culture on to science. According to Pollack, we can read genetics *as* language or *as* literature. The metaphor of literature could change dominant determinist views on the structure of DNA by forcing geneticists to ask different questions. His concept of literature betrays a modernist view on the distinction between reality and representation. He assumes a basic separation between science and culture, and the author himself serves as an interface, a bridge between the two cultures that C. P. Snow (1959) envisioned. In Pollack's view, science can be explained in terms of literature; there seems to be a vector of meaning transfer but no sign of reciprocity. What counts as metaphorical language in one field can never transcend its ornamental function and become a shaping factor of scientific materiality.

The circulation of information

Whereas Pollack borrows the conceptual framework of literary criticism to explain genetics, Richard Powers carries the conceptual frameworks of genetics over into literature. In *The Gold Bug Variations*, the inherent polysemy of language and the human genome is reflected in its intricate narrative plotting. Simultaneously, the novel subverts some of the fixed plots usually associated with genetics. In its title the novel reflects the intertwining of three different disciplinary fields: music, science and

literature. *The Gold Bug Variations* is modeled after Bach's *Goldberg Variations*. The thirty chapters of the book, framed by an opening and closing aria, exactly correspond to the format of Bach's composition.[6] All of Bach's variations derive from the same basic notes, as they are all variations on a theme.

Interwoven in this design, Powers' narrative plotting borrows its structure from a scientific model: the double helix. Two love stories, one set in 1957, the other in 1983, converge to constitute a double stereo effect. Stuart Ressler, a geneticist who in 1957 is "one of a new breed who will help uncover the formula of life," falls in love with his colleague Jeanette Koss. Their team of molecular biologists sets out to crack the genetic code, a few years after Watson and Crick have discovered the helical structure. Gradually, Ressler comes to understand that the "secret of life" will never be cracked unless scientists choose a different way of looking at the coding problem. Listening to Bach's *Goldberg Variations*, the young geneticist realizes that the core of the problem is not finding the universal genetic code, but acknowledging its endless potential variations. Ressler provides this key when he finds a way of reconceptualizing the coding problem as a problem of musical theory. The essence of music is not the standardized sign system, inscribed in notes and staffs, but the infinite variations generated by these notes; subsequently, he exchanges the biological paradigm for the theoretical apparatus of music. As Ressler listens to Bach's *Goldberg Variations*, the music triggers a philosophical discernment that changes his career: "No wonder this Bach fella is so great a composer; he anticipates Watson and Crick by two hundred years" (1991: 191). For the outside world, the geneticist quits a promising career in science, though Ressler himself is convinced he has merely changed his direction of thinking about molecular biology. Bach's *Goldberg Variations* not only mean a radical change in Ressler's conceptualization of genetic research, but also in his professional life.

Twenty-five years later, Stuart Ressler works at Manhattan Online (MOL), a giant data-processing company where he shares night shifts with Todd Franklin, a graduate student in art history. Intrigued by the geneticist's peculiar career change, Franklin tries to reconstruct the facts of Ressler's life. While searching for information in the library, Todd gets help from librarian Jan O'Deigh. In their joint effort to collect and put together the details of the molecular biologist's life, the two become romantically involved. The two love stories, separated twenty-five years in time, spiral into a double helix – the two strands braided together by Jan O'Deigh, who attempts to reassemble Ressler's *vita*. O'Deigh's reconstructive journey forces her to look simultaneously for biographical facts and scientific theories, as the key to the secret of Ressler's life is ultimately locked in the genetic "secret of life."

The Gold Bug Variations is thematically composed around the three metaphors prevalent in genetics: language, the library and computer processing. The genetic code, in Powers' novel, is not *like* language: it *is* language, but language in all its facets, including polysemy – its intrinsic potential to generate infinite meanings in different compositions. The mistake most scientists make is that they are looking for the underlying rules of language formation, whereas the essence of language lies in its various enunciations. To elucidate this point, Powers reverts to Edgar Allan Poe's story *The Gold Bug*. *The Gold Bug Variations* subverts the traditional treasure-hunt plot, which is cogently summarized by Jeanette Koss as "simple letter frequency and word pattern trick leads scholar to pirate's treasure" (76). Most scientists take a conventional approach to the coding problem: if they only decipher the riddle, the decoded message will lead them to the treasure. Yet Ressler realizes the genetic game is immensely bigger and the stakes are higher:

> The treasure in Poe's tale is not the buried gold but the cryptographer's flicker of insight, the trick, the linguistic key to unlocking not just the map at hand but any secret writing. ... Not the limited game of translation but the game rules themselves.
>
> (Powers 1991: 77)

Ressler's solution to the problem is not to find the universal genetic code but to reconceptualize the problem. Just as the essence of music lies not in its standardized sign system consisting of notes and staffs, the essence of literature cannot be found in a meaning "engraved" in the text. The essence of music and literature lies in the infinite performances and interpretations these signs generate.

The parallels between different coding systems induce a meta-reflection on the notion and function of metaphors. The genetic code, as Ressler becomes aware, is itself a figure, a metaphor, "the code exists only as a coded organism" (Powers 1991: 271). Empirical research and representational theory, in this way of reasoning, have collapsed beyond distinction. When Jan O'Deigh, decades later, tries to reconstruct Ressler's scientific argumentation by studying the basics of both genetics and musical theory, she realizes that almost her entire understanding of science depends on the use of figurative language:

> It hurts to discover how much my understanding relies on analogy, pale figurative speech. ... Scientific method itself – from diagrams to symbolic formulae to phenomenal descriptions – relies on seeing things in reflected terms. Will I ever get it? Code is itself a metaphor.
>
> (Powers 1991: 166)

The "code of codes," the human genome, fails in its representation of reality, yet we lack another instrument to communicate its meaning or call it into existence. By the same token, it is impossible to transmit one system of knowledge into another without losing some of its meaning in the process – translation can never be the same as transliteration. Translation of the genetic code is unattainable because the human genome defies univocal interpretation: "The closest he would ever get is simile, literature in translation, the thing by another name, and never what the tag stood for" (Powers 1991: 516). Representation, in other words, is always distortion, yet at the same time it constitutes reality: the "code" – musical or genetic – is not merely a representation of the human genome, but its very condition. In contrast to Pollack's view, Powers' novel reveals a postmodern view of science and literature. The code, besides being a representation of a gene sequence, also functions as a new materiality.

The translation of "life" into digits has not only transformed genetics, but digits have become the universal currency in a postmodern world which capitalizes on processable information. In his novel, Powers shows how people's physical and social conditions and desires are digitally coded in order to be categorized and quantified. One of Ressler's friends, for instance, works for the Social Service where she processes job applications by attaching a numerical code to applicants with risky health conditions. She knows by heart the codes for all types of illness – heart disease, high blood pressure, chromosome deviations. Genetic and other deviations are reduced to digital codes. The giant knot of digital information that encodes all of people's financial, physical and personal data is symbolically represented by Manhattan Online (MOL), the data-

processing firm where Stuart Ressler and Todd Franklin work night shifts to keep an eye on the flow of billions of bits and bytes.

The fact that voluminous streams of data do not just represent, but actually define people's lives in the "real" world is clarified by two telling events. Ressler and Franklin witness that one temporary hitch in the computer system one day causes financial markets to fluctuate the next day, as digital subsystems are all interconnected. And when the two colleagues tinker with the processing system in order to procure their co-worker Jimmy a financial bonus, he ends up losing his health insurance due to an unforeseen mutation in the digital order. Two days later, Jimmy suffers a stroke and the two perpetrators of this computer crime desperately try to locate the processing mistake to get him back on coverage. Illness and health are regulated by the computer, not only through genetic inscription but also through their interconnectedness with other digital systems, such as insurance and banking. Digital systems show the same "bugs," or unpredictable mutations, as organic systems. Life, in all its manifestations, is regulated through "the absurdity of a language that made oncology and ontology differ by a single mutation" (Powers 1991: 636). The reciprocity between technologies of representation and archaeologies of information is ubiquitous; genetic algorithms are no longer mere registrations of the organic, but the representational system itself has substituted the biological system it once signified. Genetics and digital information systems have imploded, and terms like "virus," "bugs" and "evolution" now equally apply to both. Form, structure and images of *The Gold Bug Variations* upset the modernist hierarchy between empirical grounding and representation; the digital code is not a representation of the genome but has come to function as an autonomous signifier in another context.

The library also plays a crucial role in *The Gold Bug Variations*, both as an image and as a symbolic setting. Jan O'Deigh, the female protagonist, is a librarian – an archivist searching for an algorithm in the labyrinth of information. As a professional navigator in the ominous flow of facts and numbers, O'Deigh observes that information is never quite the same as knowledge. Librarians are also interpreters: they have the power to steer information, to retrieve and reassemble facts of life from obscurity. O'Deigh conscientiously manages the reference desk and the "Question and Answer board," where she pins up a daily notecard highlighting a long forgotten fact in history. The library, as a symbolic space, is a mental labyrinth that contains an endless number of possible routes to enter and exit. A map of such a place, even though it would help you find your way through the labyrinth, will never adequately represent the multiple potential routes: "The map is never quite the place, nor the place as navigable as its image" (Powers 1991: 368). Along the same lines, a map of the human genome, despite its projected potential to mirror the sequences of DNA strings exactly, will never reflect the varieties of "life" that may come out of this basic structure. Geneticist Ressler is predictably skeptical about the value of the Human Genome Project: "Even the complete library, unattainable, will never begin to hint at the books, the stories the string might have produced" (Powers 1991: 606).

In her attempt to reconstruct Ressler's scientific catharsis, his epistemic shift in genetic thinking, Jan O'Deigh ties in his new conceptual frame with her own experientially based frame of reference, when she compares the genome to a huge library: "If this business is a business at all, it must be a lending library – huge, conglomerate, multinational, underfunded, overinvested. ... The word I'm looking for, the language of life, is circulation" (Powers 1991: 326). This new metaphor replaces the old unidirectional model in which a sender (RNA) sends a message (DNA) to a

receiver (protein). The word "circulation" refers concurrently to the flow of genetic information and to the library lending system. Circulation is an image that ties in a conceptual model for the genome with a model for the structure of knowledge: the contingency and interaction between producers, receivers and resources of knowledge mirrors the structure of molecular information. It is indeed the circulation of ideas from a variety of representational systems – music, literature, science – that insures the generation of new knowledge, yet this flow is never predictable. *The Gold Bug Variations* reflects the contagiousness and creative potential of the mutual infection of disciplinary ideas.

The story defies strict genre boundaries just as the genome does not lead to a definition of "life." In the end, the entire novel turns out to be a vain attempt by Jan O'Deigh and Todd Franklin to write Ressler's biography. Just as the search for the human genome does not lead to discovering the "secret of life," O'Deigh's and Franklin's quest does not result in a perfect reconstruction of Ressler's life. While O'Deigh focuses on his scientific and intellectual development, Franklin concentrates on his personal life. Both "editors" of life realize that a biography is a heterogeneous knot of ideas, theories, facts, images and experience, not only Ressler's but also their own and others'. Beyond the biographical level, the fallacy of "writing life" is reflected in the novel's juxtaposition of discourses, resulting in a Bakhtinian dialogic imagination: scientific theories – Jacob's and Monod's messenger theory for instance – are paired off with literary theories and metaphors to the extent that makes it hard to distinguish science from fiction. Textual features that signal distinctive discourses disappear beyond recognition; allusions to scientific publications – Watson's and Crick's famous *Nature* article – poems or theories acquire meaning only if one is alerted to the possibility of endless connections via extratextual and intertextual references. Readers of *The Gold Bug Variations* are forced to act as librarians, always deriving their own knowledge from basic information, producing their own compositions from the same basic notes.

Whereas Robert Pollack's *Signs of Life* urges a unilateral transposition of literary theory on to genetics, Richard Powers' *The Gold Bug Variations* invites border crossings in both directions. The novel creates a discursive universe in which science, fiction, biography and real life reverberate in the productive circulation of ideas. Empirical problems become problems of representation and vice versa. The two cultures, which Pollack tries to interface in the humanistic tradition, have simply ceased to exist in Powers' novel. Knowledge, as the structure and content of *The Gold Bug Variations* imply, is derived from the infinite concatenation of signs, ideas, methods, models and theories from all disciplines. Circulation and variation seem the proper metaphors for both genomics and the dissemination of genetic knowledge into culture – a technoculture in which image and referent, genes and bytes, organic and digital systems, compete within the same domain, and where both body and image are subject to the vagaries of narrative manipulation.

The reciprocity between science and literature

Both Pollack and Powers manifest themselves as detractors of conventional genome metaphors derived from linguistics and communication theory. Both writers therefore propose new or adjusted metaphors which borrow their images from other domains, such as literature or music. Theoretical frames from the humanities, they seem to suggest, may be held up as models to science. Yet despite their superficial

commonalities, Pollack's and Powers' views diverge profoundly. While biologist Robert Pollack proposes to project literary theory on to genetics, *The Gold Bug Variations* invites us to cross boundaries in both directions. Whereas Pollack wants to replace one semantic field (language) by another one (literature) to explain a scientific concept, Powers' novel argues that concepts from one domain (literature, music) necessarily affect our understanding of concepts from other domains (genetics, molecular biology). The structure and content of his novel reflect this two-way traffic, while Pollack's non-fiction book appears more a "translation" of genetics in terms of literature.

In fact, Powers and Pollack formulate similar objections to genetic essentialism, yet Powers shows that in order to convey the complexity of genetics, a simple readjustment of its popular metaphors does not suffice; rather, we should also revise our concepts of metaphors. In contrast to Pollack, Powers does not stop after criticizing "language" as a misleading metaphor for genetics: instead of assuming that genes are *like* language he argues that (digital) language is the very condition of the human genome. However, Powers does not fall into a Derridian epistemology by defining all reality as language. His position corresponds to N. Katherine Hayles' "constrained constructivism." According to Hayles, there is a necessary reciprocity between representations and the disciplinary domains in which they are produced:

> The difference between a representation consistent with reality and one that depicts reality is the difference between a metaphor and a description. Constrained constructivism thus implies that all theories are metaphoric, just as all language is. Metaphorics, defined as the systematic study of metaphoric networks as constitutive of meaning production, presents a view of scientific inquiry that enriches and implies the figure of representation presented here.
>
> (Hayles 1993: 28)

Occupying this postmodern stance, Powers favors the image of the "network," a metaphor which thematizes rather than solves the complex relation between language, representation and reality. *The Gold Bug Variations* reconceptualizes the digital encoding of human DNA by showing how digits representing human gene sequences can take on a material meaning in a different context. Besides a criticism of conventional popular metaphors of genetics, the novel offers a critique of conventional thinking about metaphors.

Finally, Powers and Pollack exhibit profoundly different views on the relation between science and literature. Pollack intends to change scientists' one-dimensional and determinist view on genetics by transposing literary theory that foregrounds polysemy and interpretation on to the field of genetics. In doing so, he replaces one monolithic view by another. "Literature," in Pollack's view, consists of a historically variable, but agreed upon canon. As a scientist interested in popularizing the field of molecular biology, he provides a conceptual bridge between the two cultures with a dual purpose: to elucidate complex genetic theory to non-scientists and at the same time provide an alternative way of seeing to molecular biologists.

For Powers, the split between the humanities and science has ceased to exist; in *The Gold Bug Variations*, the author demonstrates the inseparability of both domains. Conceptual frames produced in science cannot be viewed apart from the culture in which they take shape, and vice versa. The novel proves that a critique of science is impossible without a critique of *culture*. The constant traffic between science and culture, and the crossing of boundaries inherent to this movement, is by definition

multi-directional. Criticism of the gene and genomics should not only entail a criticism of its narratives, but of its technical production, institutional incorporation, and the cultural matrix from which it arises. Or, as Donna Haraway argues, this type of "corporeal fetishism can operate at the level of ideas about what an organism is or at the level of what the boundaries between science and other kinds of cultural practice are" (Haraway 1997: 143). A reconceptualization of the new genetics is impossible without a recalibration of its metaphors, and the latter is contingent upon a re-evaluation of the relationship between science and culture. "Circularity" and "networks" thus not only function as new metaphors for genetics, but also offer conceptual models for the way in which knowledge of genetics is generated and disseminated.

Notes

1 For an interesting analysis of the iconic status of the double helix, see D. Nelkin and S. M. Lindee (1995) *The DNA Mystique*.
2 For an extensive elaboration on "the book of nature" metaphors, see H. Blumenberg (1989) *Die Lesbarkeit der Welt*.
3 See, for instance, M. Mattelart and M. Mattelart (1992) *Rethinking Media Theory*.
4 See, for instance, T. Fogle (1995) "Information metaphors and the Human Genome Project" and R. Doyle (1994) "Vital language."
5 For an extensive description of the various functions of metaphors in science, see, for instance, M. Black (1966) *Models and Metaphors*; J.J. Bono (1990) "Science, discourse and literature," and Mary B. Hesse and M. Black (1970) *Models and Analogies in Science*.
6 For an interesting analysis of musical theory in *The Gold Bug Variations*, see J.A. Labinger (1995) "Encoding an infinite message."

References

Black, M. (1966) *Models and Metaphors*, Ithaca: Cornell University Press.
Blumenberg, H. (1989) *Die Lesbarkeit der Welt*, Frankfurt am Main: Suhrkamp.
Bono, J. J. (1990) "Science, discourse and literature. The role/rule of metaphor in science," in S. Peterfreund (ed.) *Literature and Science. Theory and Practice*, Boston: Northeastern University Press, 59–89.
Chargaff, E. (1970) "Vorwort zu einer Grammatik der Biologie. Hundert Jahre Nukleinsäure-forshung," *Experientia* 26, 810–16.
Doyle, R. (1994) "Vital language," in Carl F. Cranor (ed.) *Are Genes Us? The Social Consequences of the New Genetics*, New Brunswick: Rutgers University Press, 52–68.
Fogle, T. (1995) "Information metaphors and the Human Genome Project," *Perspectives in Biology and Medicine* 38(4) Summer: 535–53.
Fox Keller, E. (1995) *Refiguring Life. Metaphors of Twentieth-Century Biology*, New York: Columbia University Press.
Gilbert, W. (1992) "A vision of the grail," in Daniel J. Kevles and Leroy Hood (eds) *The Code of Codes. Scientific and Social Issues in the Human Genome Project*, Cambridge: Harvard University Press, 83–97.
Haraway, D. J. (1997) *Modest_Witness @ Second Millenium. FemaleMan_Meets_Onomouse. Feminism and Technoscience*, New York: Routledge.
Hayles, N. K. (1993) "Constrained constructivism. Locating scientific inquiry in the theater of representation," in George Levine (ed.) *Realism and Representation*, Madison: University of Wisconsin Press, 27–43.
Hesse, Mary B. and Black, M. (1970) *Models and Analogies in Science*, Notre Dame: Notre Dame University Press.
Labinger, J. A. (1995) "Encoding an infinite message: Richard Powers' *The Gold Bug Variations*," *Configurations* 3: 79–94.
Mattelart, M. and Mattelart, M. (1992) *Rethinking Media Theory: Signposts and New Directions*, Minneapolis: University of Minneapolis Press.

Nelkin, D. and Lindee, S. M. (1995) *The DNA Mystique: The Gene as a Cultural Icon*, New York: Freeman.

Pollack, R. (1994) *Signs of Life. The Language and Meaning of DNA*, New York: Houghton.

Powers, R. (1991) *The Gold Bug Variations*, New York: Harper.

Schrödinger, E. (1967) *What is Life? The Physical Aspects of a Living Cell*, Cambridge: Cambridge University Press. Originally published 1944.

Snow, C. P. (1959) *The Two Cultures*, Cambridge: Cambridge University Press.

Bonnie P. Spanier

WHAT MADE ELLEN (AND ANNE) GAY?
Feminist critique of popular and scientific beliefs

Human sexuality is fluid and flexible.

(Jackie Black)[1]

You and I almost can't have a discussion, because you are interested in society. ... I, as a science journalist, am interested in science.

(Chandler Burr)[2]

The problem wasn't the idea that homosexuality is a biological, innate trait. That seems to be a well accepted concept nowadays.

(Gideonse 1997: 43)[3]

A S ALL SUCCESSFUL television hype should, the coming(s) out in April 1997 of the sitcom character Ellen Morgan and the comic actress who plays her, Ellen DeGeneres, managed to mesmerize American society for a time. An unintended benefit of the enormous media attention (which included *PrimeTime Live*'s Diane Sawyer interviewing Ellen DeGeneres and her family, as well as Oprah Winfrey interviewing both Ellen and her lover, the actress Anne Heche) is an opportunity for feminists to assess public understanding of – as well as attitudes towards – lesbian experience and homosexuality. When Oprah (who appeared as Ellen Morgan's therapist in the *Ellen* "coming-out" episode) dedicated a special show to the origins of homosexuality and brought on proponents of biological origins of homosexuality to do battle with social constructionists (including social and natural scientists, historians and feminists) over the meanings and origins of "sexuality," she foregrounded the influence of "science" on the public's thinking about homosexuality. What does the media hype around *Ellen* reveal about popular beliefs concerning what makes a woman choose another woman for her intimate companion? What impact has feminist analysis of sex, gender and sexuality made on this issue? Further, what does the media attention reveal about scientists' claims concerning what makes people gay – and how that information is understood?

What made Ellen gay? But what about Anne?

TIME magazine joined gay magazines like *The Advocate* in covering Ellen DeGeneres' and Anne Heche's emergence into gay "identity" – or, at least, public scrutiny of same-sex relationships. In the *TIME* interview, DeGeneres says that she ignored "being gay" until she was 18 when, after dating and liking guys, she "knew that I liked girls, too." She casts the "problem" in heterosexist terms; that is, by definition a person who is attracted to a woman has to (or ought to) be a man: "I thought, 'If I were a guy I'd go out with her.' And then I thought, 'Well, I don't want to be a guy, really' " (Handy 1997: 86).

On the same afternoon as the screening of the *Ellen* coming out episode, millions of viewers watched Oprah Winfrey interview Ellen DeGeneres and her girlfriend Anne Heche on the *Oprah Winfrey Show*. As Ellen talks about her childhood, photos of her as a girl are projected on the screen; one photo shows a young Ellen wearing a tie, a shirt and pants. Oprah and Ellen linger over this particular photo and laugh knowingly, as if this photo can explain everything, the girl dressed as a boy. Apparently, the power of that image is so great for Oprah that she highlights it again in a subsequent show on the origins of homosexuality. The photo is displayed as if it speaks for itself. Feminist analysis suggests otherwise, but neither that image nor the heterosexist corollary that a woman who loves or is attracted to another woman must in some sense really be a man – again, a corollary of heterosexism – is directly challenged in either show.

Politics as an analysis of power is equally absent or muted in the media display. Ellen DeGeneres herself eschews "politics" in the sense of a political position. She tells the *TIME* reporter that she does not want to represent any group. She has not been comfortable with the term "lesbian," making jokes (herself and as Ellen Morgan) when she repeats the word, lesbian, lesbian, lesbian. And yet, in Diane Sawyer's interview (*Prime Time Live*, 30 April 1997) following *the* episode, DeGeneres refers to the civil rights struggle of African-Americans as her inspiration.[4] The feminist insight that "the personal is political" remains unspoken. Are such transformative and threatening insights lost, then, to the non-feminist or anti-feminist viewers of *Oprah* and *PrimeTime Live*? Does celebrity status heighten the public's belief in explanations based solely on the individual, cast as choice or inborn lack of choice? As the analysis in the chapter will show, *Oprah*'s coverage does not allow discussion of the politics of biological claims about this particular category of difference.

What *is* challenged in the interviews is the idea that all individuals who engage in homosexual relationships are born homosexual, and the challenge comes from Anne Heche's story. When the camera turns to Heche, we see an attractive young woman whose feminine looks contrast with the boyish gender-neutrality of Ellen, DeGeneres or Morgan. Anne tells her story, that she looked across a crowded room, saw Ellen, and was drawn to her. Heche states, "I was not gay before I met her [Ellen]. I never thought about it." Oprah Winfrey expresses what the buzz from the audience suggests: "That confuses me." Oprah lets a woman in the audience ask Anne what she means, since "we're led to believe that people who are gay tend to know from birth, and you kind of disputed that." Heche replies: "I didn't all of a sudden feel, I'm gay ... I just all of a sudden felt, Oh, I love" (Oprah 1997a). Indeed, Anne Heche's story challenges a commonly-held belief that homosexual identity originates from birth and remains unchanged through life – and that in turn produces so much confusion that Oprah pursues the issue.

Over the years, such experiential challenges to biological determinist theories of (homo)sexuality have come from women who became lesbians because their feminism questioned the constraints of compulsory heterosexuality and because they chose to value and put women first over men in their personal lives.[5] Where, in the public and scientific debates about the origins of homosexuality, are feminist insights such as Adrienne Rich's (1980) about the relationship between sexism and heterosexism, about personal "choices" being political?

Oprah tries to understand where homosexuality originates

The strong (both positive and negative) and animated response to the DeGeneres/Heche interview prompted Oprah to follow only five days later with another show, on "how someone becomes gay." This show presented a range of conflicting views and evidence (as can be seen by this chapter's opening two quotes from the show and the third from an *Advocate* article on "the sexual blur" exemplified by Heche's story). The show touched on some of the different positions taken by scientists, historians, therapists, lesbians, feminists (including a woman who became a lesbian at the age of 38, and a lesbian activist who is now involved with a man) and gay men. Those positions generally fall into either biological determinist (including the caveat that environment can influence what biology has laid down) or constructionist (including a rejection of a fixed sexual orientation) explanations for sexual behavior in relation to same- or different-sex couplings.[6] Despite appearing to be open about why some people become gay – that is, how to take *both* Ellen and Anne into account – the show undercuts any effort to explicate and understand constructionist, including feminist, views of homosexual and heterosexual behavior.

Oprah shifts the intended balance of the show away from constructionist arguments towards determinist ones in several ways, both by trivializing guests' comments on the potential for close women friends to move from friendship love to sexual intimacy and by ignoring constructionist arguments raised by some guests against determinist claims made by other guests. Thus, more time is spent listening to the male guests with biological determinist claims than is spent on either the women who are themselves lesbians of "mixed" experience sexually or on the historians and social scientists like Jonathan Katz and John De Cecco who have written extensively on the drawbacks of biological studies and arguments for determinism.

Oprah's reactions (and lack of response, as well) to some of her guests' comments highlight the power of heterosexist beliefs in our culture – and the aversion it has to addressing political content. From scientist and non-scientist alike, feminist insights are missing about the profound threat posed to our society by same-sex intimate relationships ("sexism" was heard just once in the *Oprah* discussion). This lack illustrates how deeply-held conventional beliefs about the meaning of maleness and femaleness as natural sexual coupling combine powerfully with current theories about the biological origins and fixed identity of homosexuality.

After showing clips from the previous show's interview with Ellen DeGeneres and Anne Heche, Oprah starts the show with an audience member saying how she had explained to her 18-year-old daughter that gays are born "that way," that everyone around the young woman was heterosexual, so she should not "worry" about being gay. And here we have the "problem" that Anne Heche's statement created: how can the mother reassure her daughter (and herself) that she is not and never will be gay when Heche says she had never thought of being gay until she saw Ellen and fell in

love with her? Clearly, the notion of fixed and predetermined sexual orientation is comforting to those who are heterosexual, for reasons different from the comfort taken by those gay rights activists who claim that biological determinism of gayness will give gays equal rights.

Another woman in the audience gives a non-corporeal, spiritual explanation: we are attracted to one particular soul, and the sex of the body does not matter. A third woman, married for twenty-one years, says that she has had a "soulmate" for twenty-five years, a best girlfriend with whom she never engaged sexually.

The scientific explanation is given by a (male) science journalist and the author of *A Separate Creation*, Chandler Burr. In a firm tone that leaves no room for doubt, Burr assures us that sexual orientation is not a choice, that, rather than behavior, sexuality is what you *are*, not what you do. No basis is given for this claim. Oprah then introduces molecular geneticist, Dean Hamer, the author of *The Science of Desire*. Hamer summarizes his studies by saying that (identical) twin brothers who were both gay shared the same bit of DNA at a particular spot on the X chromosome, while this was not the case for twins who were discordant for sexual orientation (one is gay, the other straight). He adds that for females there is no correlation between the bits of DNA in concordant (both lesbian) twins.

Next, Oprah introduces John De Cecco, who states that there are major problems with Hamer's study. He suggests two problems but is not given the time to explain either one. First, since females have two X chromosomes we should see greater concordance with female twins rather than so much less than with males. Second, he comments, Hamer leaves the term "gay" undefined. Without the necessary time to explain why these are serious challenges to Hamer's work, these points are made to seem irrelevant. Later in the program, De Cecco responds to Burr's insistence that since scientists study traits, it is necessary to separate the categories male and female even though there is actually a continuum of the sexes. De Cecco implies that there is a political agenda in the scientific approach described by Burr, but Oprah simply ignores De Cecco, talking over him, and says, with a mischievous half-smile, "hermaphrodites, that's a whole other show." Thus an attempt to address the politics and values embedded in current scientific work on homosexuality is cut short.

Another male scientist states that the evidence for only men being born with a fixed sexual orientation is that most gay men feel they were born that way. Cue for a flashback to Oprah's gay guests over the years – all male, all saying they knew that they were gay when they were very young, as young as 1 year old. Without an opportunity to suggest that it doesn't make evolutionary or genetic sense to have different biological mechanisms for behavior as significant as sexuality, the idea gains credence as an explanation for inconsistent scientific research. Cut to the break.

Thus, in the opening quarter of the show, women in the audience ask questions prompted by Ellen's and Anne's stories, and men are the experts who answer them. An effort to complicate both the question and the answer by exposing and deconstructing politics embedded in the science of biological determinism of homosexuality is suppressed. Science is not questioned; nor is patriarchy.

After the break, lesbians are featured. First, Oprah replays Anne Heche's statement that she never had an attraction for a woman until she met Ellen DeGeneres. Jackie Black, a therapist, describes how, after being married twice and never thinking about being a lesbian, at age 38 she felt an intense attraction, "like falling in love," for a woman. Judy Wieder, editor-in-chief of *The Advocate*, explains that origins can be different for women than for men by drawing on spiritual as well as biological

influences. She cites as evidence the fact that many women claim they could go either way sexually. Oprah comments, "Maybe there is a gene, but it's a continuum of a gene," demonstrating a lack of understanding about the way we think genes work.[7] That Oprah is wedded to genetic and inborn explanations of sexuality is reinforced when she shows the picture of Ellen DeGeneres as a little girl wearing a tie. She exclaims: "She's a little girl going out with a tie!" Here, male-female sex designation is confused with same- and different-sex sexual interest or behavior. Analyzing that misleading conflation could lead to an appreciation of the arbitrary (socially constructed) and heterosexist definition of the sexes as "opposite" in some sense, but no one challenges the conflation.

Jackie Black insistently asks why are we "categorizing and compartmentalizing," instead of accepting the fluidity of human sexuality. The answer is given by one of the male scientists who continues to frame the explanation in biologically constrained terms when he says that interviews with men suggest there is a "biological window" on sexual orientation that closes early. What is absent from the discussion is the possible influence of a patriarchal system of values in which men are deemed more worthy, more valued, more interesting, more important than women of the same class or heritage.[8]

At this point in the show, Anne Heche's comment is interjected about how her father, who died from AIDS, had been gay but had kept it secret. Another guest, Judy Wieder, points to "the possible gene factor" in this scenario. But she also suggests that the idea that people won't stay exactly where you want them to stay is for many people a very frightening concept. Here is the start of a political analysis, but, again, there is no response, no questioning which would expand the debate. Cut to the break.

JoAnn Loulan is clearly the most disturbing guest for Oprah, who strangely over-pronounces the word "lesbian" when she introduces her, drawing out the "l." Loulan has been a lesbian activist for twenty years and is the author of a book, *Lesbian Sex*. She is now involved with a man. With humor, she refers to it as "deviant behavior" and says she believes that sexual orientation is complex. Loulan proposes that most heterosexual women get their loving from their women friends (echoing Adrienne Rich's concept of a woman-identified woman), and it is a pity that they don't act (sexually) on their feelings. Oprah's response is clear – and laden with judgment: no, it isn't a pity. "I have a best friend, Gail, and I never wanted a sexual experience [with her]." The audience claps noticeably loudly. "I feel a love for her," Oprah adds. She then repeats, in a weird little-girl voice, "But I can honestly tell you I have *no* desire to go to bed with her … not even a teeny weeny desire."[9]

Loulan identifies how disturbing this idea can be, and tries to discuss heterosexism and its relation to sexism. She says: "Because of sexism we are freaked out about a guy acting like a girl, and some girl might act like a boy." Oprah appears to ignore this last comment and asks Loulan, "What does your current boyfriend say about all this?" When in doubt, ask what the men think. Oprah is perhaps one of the richest and most powerful women in the US, yet she seems unable to engage publicly with our society's fear of the blurred lines of women's friendships and intimacy. Oprah then tries to categorize Loulan by asking her if she is "bisexual." Loulan resists the simplicity of a third category, a hybrid of homo and hetero, when she says, "It would be easier, but …" Another effort fails, this time by Wieder, to think about the societal context when we consider how we identify ourselves, and once again the male experts take over.

The quote by Chandler Burr which opens this chapter – "You and I almost can't have a discussion, because you are interested in society … I, as a science journalist, am interested in science" – is, perhaps, the most telling comment of the show. Burr's exasperated response to Loulan's effort to problematize the terms at issue epitomizes a chasm between "science" and "society" that confounds the possibility of agreement on the meaning of current research claims about biology and sexual orientation. Another "expert" scientific researcher, Michael Bailey, introduces his research on homosexuality in twins; he refers to the possible contribution of "environment" in shaping sexual orientation, but, as it turns out, what he is in fact referring to is the prenatal environment in the womb. This raises the question: how can scientists (like those on *Oprah*) engage in debates with feminists if the former believe they are doing science apart from any societal belief systems? Despite the pro-gay stance of the scientists on the show, belief in male-female difference and in reductionist biological explanations of behavior must have implications with regard to their openness to other forms of evidence and argument which challenge biological determinist claims.

In the end, the plea from a woman in the audience to help her understand her daughter's sudden announcement that she is gay, and just as sudden change to wearing men's clothes, prompts much sympathy and support from lesbian and straight women alike; but Oprah's show has not helped her gain a better understanding of her daughter's new identity and behavior. (If lesbian feminist comedian Kate Clinton had been there, perhaps she would have suggested that the young woman was actually dressing like a lesbian.) Oprah's show does nothing to bridge the artificial gap between society and science, since it fails to question the validity of the scientific claims espoused – either by applying traditional scientific standards that reveal inadequacies of methodology or by feminist critiques that show social influences on science – while it also obscures how feminist analysis illuminates cultural influences on sexual orientation and expression. This should not be surprising, since biological determinist claims about homosexuality have generally ignored feminist insights into sex and sexuality differences and are based on traditional notions of maleness and femaleness, despite sometimes claiming to have a progressive agenda. Not only is the general research into sexuality lacking in feminist insights, it is frequently short on adequate scientific methods and an openness to other possible explanations for the data. A closer look at the science that the public (and Oprah) seem to accept unquestioningly is thus necessary.

Feminism and a critique of biological determinist claims

Feminist analysis requires, at the very least, attention to women's lived experiences, power inequities and a consideration of the historical context. History, for example, provides us with a strong basis for skepticism about new scientific claims that biology determines behavior, by showing that claims of "biology" determining female and male homosexual behavior and/or identity are part of a long heritage of Western (white, male-dominated) scientific assertions that human biology determines human behavior, characteristics and, consequently, one's "natural" status in society. The long history of scientific claims, often by reputable scientists, about differences of concern to society (mainly predicated on class, race and gender) include nineteenth-century assertions that blacks and whites were separate races and so could be treated differently under the law; that women's brains were smaller than men's and this accounted for women's inferior rationality, for which reason citizenship rights could be denied;

that women's reproductive physiology (but not men's) would be impaired by higher education and so, for the sake of future generations, young women should not be allowed to go to college; and that non-English-speaking immigrants to the US were inherently retarded because they could not pass intelligence tests given in English (Gould 1981; Sayers 1982). Thus history illuminates connections between scientific claims about the biological basis for various "differences," usually cast in dichotomous categories such as male/female, white/black, heterosexual/homosexual.

Healthy scientific and political skepticism has arisen from a consistent history of political claims that are based on then current biological theories, claims that are subsequently either disproven or abandoned on the basis of inconsistent logic, exposure of outright fraud, lack of confirming evidence, or political shifts (see Fausto-Sterling 1989; Lewontin *et al.* 1984). History also shows that Western culture has changed from viewing homosexuality as a behavior by individuals to believing that homosexual identity is embodied in the physical being of the individual (De Cecco and Parker 1995). Biological studies of sexual preference preserve sexist and heterosexist assumptions from the nineteenth century (and earlier) that sexuality is about reproduction, and that femaleness and maleness exist in human nature as primary, dichotomous and opposed (or complementary) states of being that form the basis for gender differences (Terry 1990; Schiebinger 1989).

Contrary to most of the scientific claims about sex and race differences, current research suggesting that brain differences and gay genes account for inherent homosexuality comes from pro-gay scientists (the majority of whom are male, for example Simon LeVay, Richard Pillard, J. Michael Bailey and Dean Hamer) who argue, much as sexologists at the end of the nineteenth century did, that homosexuality is inborn and, therefore, homosexuals cannot be blamed for it.

While many gay rights advocates have welcomed the recent scientific claims, particularly in the face of vocal anti-gay religious conservatives who assert that homosexuality is an immoral choice that must and can be eliminated by a commitment to what is moral (heterosexuality), legal scholars such as Janet Halley argue that immutability has not been a sufficient condition for obtaining civil rights in our legal tradition. The history of the struggle for citizenship and rights for Americans of African heritage, where skin color and heritage are used to trace lineage, illustrates the latter argument well.[10]

The women's, lesbian-feminist, and gay liberation movements from the 1960s to the present day, as well as gay activism in response to the AIDS epidemic, have brought lesbian and gay rights issues to the public eye at the same time that society has increasingly accepted previously male-associated behaviors (smoking, promiscuity) and clothing (pants rather than skirts or dresses) for women. However, it is still not regarded as "normal" for men to wear skirts and dresses (they are considered cross-dressing transvestites), boys are still called "sissy" or "faggot" for playing with dolls or acting in female-associated ways, and the greatest put-down among supposedly heterosexual males is to call a male a girl or woman. Feminist theorizing might account for this by pointing to the (white Western) tradition of devaluing females relative to males, despite women's gains in latitude in some sex-associated behaviors such as smoking and wearing pants. In addressing the power imbalance between the sexes, as well as differential social mores, feminist theorizing does not have to resort to biological explanations for differences between gay men and gay women.[11] Without feminist insight into societally-created differences in the impact of the stigma of homosexuality on females compared to males as well as the impact of feminism

itself on women's and men's lives today, we have puzzled comments such as the one here by J. Michael Bailey, a researcher concerned with the study of twins:

> In talking to women who call themselves straight, it strikes me that many of them will admit to being attracted to women even if they have no desire to act on it. You can hardly ever get [straight] men to admit to that.
>
> (J. Michael Bailey, quoted in Wheeler 1993: A7)

Race or sex – biological determinist explanations share common conceptual errors

Critiques of biological determinist claims point to common inadequacies in scientific studies of differences – such as racial-ethnic, gender, class or sexual orientation/preference – deemed important by a society, whether we view the claims negatively (as supporting a racist agenda, for example) or positively (such as benefiting gay rights, politically or morally). What is unusual about the current work on homosexuality is the pro-gay stance of researchers like Bailey and Pillard (twin studies) and Simon LeVay (brain study), compared to most biological determinist scientific claims, making the question of the effect of scientists' political bias on their science more complex than simply having the right values.

In-depth scrutiny of the assumptions, methods, data and conclusions of scientific studies is a key ingredient of a feminist analysis of the scientific validity and meaning of biological determinist claims, in part because such critiques constitute legitimate debates in the arena of scientists, and because they assist all of us in understanding what we may come to know through science and what the limitations of that knowledge are. Adherents will continue to agree, for example, with Herrnstein and Murray's (1994) political assertions that a stratified society is "natural" and hence unavoidable, and we will no doubt see new variations of the same theme, but the detailed critiques of the science as well as the politics of *The Bell Curve* rigorously challenge the scientific credibility of the authors and their data (Jacoby and Glauberman 1995).

Many of the key theoretical assumptions questionable in racist claims such as those found in *The Bell Curve* also appear in biological determinist studies of the origins of homosexuality. Conceptual fallacies common to many biological determinism claims about difference include:

- Arbitrary categories of difference (race-ethnicity as in whites/Asians/blacks; sexual orientation as in homosexual/heterosexual/bisexual).[12]
- Groups, arbitrarily defined as different from each other, overlap to such a degree that assessed differences are *greater between individuals* within each group *than between groups* (so that the measurement for any individual cannot predict in which category the individual belongs).
- Complex, multifaceted, highly variable, culturally defined behavior is reduced simplistically to a single entity (e.g. intelligence, homosexuality), usually making "it" measurable with a linear yardstick (IQ or "g," preference for one or another gender in sexual engagement on a continuum between exclusively heterosexual to exclusively homosexual).[13]
- The effects of experience and behavior on bodily structure and function are ignored or minimized, so that a correlation is incorrectly assumed to imply causation.

- A physical mechanism determines behavior (genes determine IQ levels, brains shaped by sex hormones determine male-appropriate or female-appropriate behavior or desire, defined with heterosexual norms).[14]

Genetic diversity, changes in behavior of groups and individuals over time, cultural differences in norms and behaviors – all these and more are ignored or understated in biological determinist arguments (see Hubbard 1990, especially "Genes as Causes"; Lewontin *et al.* 1984).[15]

Simon LeVay and the resurgence of biology and homosexuality studies

Drawing much media attention, Simon LeVay was the first gay scientist to come out in *Science* magazine as a consequence of his 1991 article, "A difference in hypothalamic structure between heterosexual and homosexual men."[16] As is often the case in science, LeVay based his study (he did only one) on other researchers' findings that certain clusters of nerve cells (called INAH and identified with numbers) in the anterior hypothalamus of the brain were larger in men than in women. LeVay proposed that the observed difference in size of one of these clusters, INAH 3, distinguished heterosexual men from homosexual men (and women). He hypothesized that the brain difference was not due to *male-female sex* but to *sexual orientation* (defined as individuals sexually oriented towards women – heterosexual men and homosexual women – versus individuals oriented towards men – homosexual men and heterosexual women). Much of his argument rests on analogies drawn between sexual/reproductive activity, hormone effects and brain structures in humans compared to rats and monkeys. The leap from non-human "sex" behaviors to human actions and relations is a conceptual error that must be examined for legitimacy.

In addition to the other conceptual errors listed above, key flaws in experimental design, data and conclusions are common in biological determinist claims, and I intend to use LeVay's work here as an example. The failure to distinguish between *correlation* and *causation* is particularly important in conclusions that cannot be justified by the data. In brain research, for example, correlations are sometimes found between size difference and some behavior or characteristic trait, but studies with different species of animals show that the brain responds to behavioral changes and experience with physical changes. Even LeVay points out that a correlation does not necessarily mean that that brain part causes the behavior in question – an objection that he later ignores. Furthermore, other factors embedded within one category, such as all the homosexual men in the study having died of AIDS, may make correlations misleading; the results may be due to the reasons for dying, rather than to homosexual identity.

LeVay is also guilty of using an *inadequate sample size*. He compared sixteen presumed heterosexual males (their sexual orientation was actually unknown), nineteen homosexual males (LeVay included one self-identified bisexual), and six presumed heterosexual women (sexual orientation was actually unknown). Reference in the study to the six women should not have been made at all, since the number is so small. But, then, since the actual sexual orientation was not known for anyone except the eighteen men who self-identified as homosexual and the one man who self-identified as bisexual, it could be said that none of the other subjects should have been included in the study.

This information would indicate that the control group of heterosexual males did

not necessarily consist of heterosexuals; since their sexual orientation was not known, the study was *not properly controlled*. The broader problem that the categories are not mutually exclusive (and are not defined) is more serious. What constitutes "heterosexual" or "homosexual" or even "bisexual" as categories for individuals?

LeVay's sample was not representative of the population (the error of a *non-random selection of sample*). All of the self-identified homosexual/bisexual men had died from AIDS, while only some in the other groups had died of AIDS, as noted above. LeVay's effort to eliminate the possibility that AIDS could have affected INAH 3 is insufficient. Byne and Parsons (1993) point out that the origins of AIDS (intravenous drug use versus sexual activity), the course of the disease, relative health, and secondary effects of AIDS on testosterone levels are often different for heterosexual and homosexual males in the US, so that LeVay's comparison of "heterosexual" and "homosexual" individuals is also a comparison of different disease modes and states of health which could affect biology.

By *selective use of data*, LeVay does not discuss the discrepancy between his results and that of the work on which he bases his study; he did *not* find a size difference for INAH 2, as the other researchers had. Also, arguments that link sexual behavior to certain parts of the human brain leave out studies on non-humans that contradict the involvement of certain regions of the anterior hypothalamus with male sexual activity.

In his book *The Sexual Brain*, LeVay expands his claims about a biological difference between homosexuals and heterosexuals and explicitly links his arguments to claims of inherent male–female differences. In doing so, he does not even acknowledge the rigorous critiques in the published literature (LeVay 1993: 101–103).[17] Either LeVay did not read the critiques or he rejected them and did not consider them important enough to include in his book. Either way, he was not rigorous in his analysis of the literature on sex differences. Interestingly, LeVay did not continue in the field of scientific studies, moving instead to establish a center for gay youth.

Following close on the heels of LeVay's 1991 article came J. Michael Bailey's and Richard C. Pillard's study of twins and other siblings, claiming to prove that heredity plays a major role in causing homosexuality. This drew wide media attention, some of it relatively balanced with criticism by gay activists and scientists. J. Michael Bailey was one of Oprah's experts on the causes of (male) homosexuality, and twin studies are the current focus of the research by others in this area. In the following section, I will examine the scientific validity of Bailey's and Pillard's basic claim, scrutinizing the data, research design and their conclusions.[18]

Twin and sibling studies of homosexuality: a closer look at the scientific research

> This is the largest twin study done on homosexuality, says Mr. Bailey, and the results are exactly what you would expect if you assume there is a strong genetic effect for homosexuality.
>
> (Wheeler 1991: A11)

In December 1991, Bailey and Pillard published an article, titled "A genetic study of male sexual orientation," in the journal *Archives of General Psychiatry*. Using moderate language typical for scientific journal articles, they claimed that their study "was generally consistent with substantial genetic influence" (1094).

> [T]he present study provides some support for the view that sexual orientation is influenced by constitutional factors. This contrasts with previous attempts to test psychodynamic and psychosocial theories, which have largely yielded negative findings, and emphasizes the necessity of considering causal factors arising within the individual, not just his psychosocial environment.
>
> (Bailey and Pillard 1991: 1095)

The cautious sounding conclusion in the first sentence is belied by the ease with which other explanations of homosexuality are discarded. The article's introduction, in which the authors seek to justify their research framework, states that "data testing the psychodynamic hypothesis that during childhood, male homosexuals tend to be distant from their fathers, show small effect size and are causally ambiguous" (meaning that greater distance between father and son is not correlated with homosexuality). The authors then refer to anthropological studies that "suggest that sexual orientation is not conditioned by sexual experiences in adolescence" (Bailey and Pillard 1991: 1089). In one short paragraph, non-biological causes are dismissed with a minimum of supporting evidence and no reference to contradictory data, suggesting that they do not have to justify their position to their audience.

That these scientists cannot imagine "sexual orientation" – sexual attraction, behavior and affection leading to sexual and emotional intimacy – as a highly variable, multidimensional complex of feeling, actions, opportunities, cultural constructs, and so forth, is evident in Bailey's comment in an interview in which he rejects environmental determinism for biological determinism: "No one has ever found a postnatal social environmental influence for homosexual orientation – and they have looked plenty" (Holden 1992: 33). How many lesbians, in particular lesbian-feminists, are chuckling over that comment? What would constitute a sufficiently scientific study of the effect of feminism on sexual behavior and preference?

The rest of the introduction summarizes the currently popular neurohormonal theory of behavioral genetics, that "male sex" hormones make the brain masculine with regard to "male-typical" behavior (including attraction to females) that links sex hormones to differential brain structures which then cause differential sex/gender behavior.[19]

Bailey and Pillard placed ads in gay newspapers asking for gay male volunteers who were co-twins or had adoptive brothers. 161 men (termed "probands"[20]) were interviewed and their identical (monozygotic) twin, fraternal (dizygotic) twin, non-twin biological, and adoptive brothers were assessed for sexual orientation. The major question of the study was: what percentage of the different types of *brothers* of the homosexual twins were also homosexual? Some of the responses about sexual orientation were neither homosexual nor heterosexual, but bisexual. The researchers grouped bisexuals with homosexuals (without justifying the reasons for this).

The results are described in the article as: 52 per cent of the identical co-twins were homosexual or bisexual, compared with 22 per cent of the fraternal twins and 11 per cent of the adoptive brothers. These data are displayed in a table. The chi-square test for the significance of the different percentages indicates that the 52 per cent proportion for identical twin brothers was significantly different (P less than 0.001, or a one one-thousandth chance that the difference came from randomness) from both the 22 per cent of the fraternal brothers and the 11 per cent of the adoptive brothers – *but* that the difference between the fraternal brothers and adoptive

brothers (22 per cent and 11 percent respectively) was only marginally significant (P less than 0.10).[21]

Missing from the table, but found in a paragraph a page later, is the data that 9.2 per cent (did they drop tenths from others?) of *non-twin biological* brothers were also gay. The researchers point out that this number is significantly smaller (P less than 0.05) than the 22 per cent figure for fraternal twins. It is also significantly smaller than the "rate of homosexuality" of non-twin biological brothers in another study also authored by Pillard, so there is a discrepancy between the two studies on this point.

How should we interpret these numbers? Those familiar with simple Mendelian genetic relationships, based on half of the mother's genes and half of the father's genes coming together to form the full complement of gene pairs (on paired chromosomes) in a fertilized egg,[22] will spot data inconsistent with a simple genetic explanation for homosexuality. Identical twins come from a single fertilized egg (a zygote) splitting into two separate eggs (hence, "monozygotic"), so they have in theory the same genetic make-up. Fraternal twins ("dizygotic") come from two different eggs fertilized by two different sperm, so they have a genetic make-up comparable to non-twin biological siblings. In contrast, a child adopted into a family would in theory be as genetically related to its siblings as to anyone else in the population.[23] Therefore, according to their theory of major genetic influence, concordance should be about the same for dizygotic twins and non-twin biological siblings – and significantly higher for those two groups compared to adoptive brothers.

To sum up, only one piece of their data (the high 52 per cent concordance for identical twins compared to 22 per cent for fraternal twins) suggests a possible genetic influence (although other explanations are possible), while all the other data *contradicts* a major genetic influence. In fact, the 52 per cent concordance for identical twins also means that 48 per cent of the co-twins were *discordant* for sexual orientation, even though they shared genes and early environment. How do Bailey and Pillard address this inconsistency of the data on fraternal twins and non-twin biological and adoptive brothers (including the contradictory finding from a previous study), as well as the data that shows only marginally significant difference between the "rates" for fraternal twins and adoptive brothers? They do not comment on the latter, but they do discuss the former. Rather than noting that most of the data presented (other than the significantly higher proportion of identical twin brothers also being gay) does *not* support a genetic explanation for homosexuality, they speculate on why this study found only 9 per cent compared to 22 per cent found in the previous smaller study (where the probands were non-twins).

> Perhaps the rate of homosexuality in nontwin brothers differs according to whether the proband is a twin. This could occur *if the causes of homosexuality in twins and singletons were different*, i.e., if a special twin environment contributes to the development of sexual orientation. On the other hand, the low rate could merely be *due to sampling fluctuations.*
> (Bailey and Pillard 1991: 1094. Emphasis added)

This double-talk, entirely framed within genetic explanations for homosexuality, obscures the inadequacy of the data to support Bailey's and Pillard's claims. Note that to account for their data, the researchers suggest that the causes of homosexuality might be *different* in twins compared to singletons; add that to the proposed *different*

causes of homosexuality in men compared to women, and they have a growing list of different biological mechanisms that cause homosexuality. Such a view is inconsistent with what we understand about biology and genetics.

Bailey's comment (quoted above) that "the results are *exactly* what you would expect if you assume there is a strong genetic effect for homosexuality" (emphasis added, Wheeler 1991: A11) is clearly a misrepresentation; that is, it is simply wrong. Yet by considering only genetic explanations for their data, Bailey clearly rejects other explanations, such as *non-genetic* influences, when he refers to a "special twin environment." Such an environment or special relationship would also be present and perhaps even amplified in the interaction of identical twins.[24]

To suggest that "sampling fluctuations" might also explain the anomalous data is to say, according to conventional scientific standards, that the study is not adequate to give clear results, either because the sample size is too small, non-random, or due to some other major shortcoming. Instead of acknowledging this flaw in their research, the researchers sound very reasonable when they add that further research is needed to replicate the finding.[25]

When I examined some of the numbers with greater scrutiny (and there is much more data presented on heritability and gender nonconformity), I found even more problems. Remember that the most contradictory data (with regard to a genetic explanation), the 9 per cent of the non-twin brothers, did not appear in the table with the other data. In the same table, however, another set of data with slightly different numbers compares the "rate" of identical, fraternal and adoptive brothers, this time using information about the sexual orientation of the brother from the questionnaire completed by the brother himself and not just from the assertion of the twin proband. The figures for identical twins (50 per cent) and fraternal twins (24 per cent) do not change much and the difference between them is still statistically significant (P less than .005). But the number for the adoptive brothers has gone *up* from 11 per cent to *19 per cent*, a figure that is not at all different statistically from the 22–24 per cent figures for the fraternal twin brothers. If we try to apply a genetic explanation, we encounter the problem of having the same concordance for fraternal twin brothers as for adoptive brothers who are not genetically related! These data, then, show *no* evidence of a genetic influence on concordance at all among fraternal twins.

The authors explain that this "was primarily due to the decreased likelihood that a proband with a heterosexual adoptive brother would consent to have him contacted" to verify his identification as a heterosexual (Bailey and Pillard 1991: 1092). It seems that when the relatives of the homosexual twin were also homosexual, there was much greater cooperation both by the proband and the relative in consenting to complete the questionnaire (which was characterized as part of a general behavior genetics study of personality, attitudes and behavior and had only five questions about sexual orientation embedded in over a hundred questions). There seems to be a lesson in that observation which the researchers ignore. Despite not being told that the study was about homosexuality, the homosexual brothers were significantly more apt to consent to doing the questionnaire than were the heterosexual brothers. As I have suggested (see Note 25), the interest in twins and genetics is well known. If the heterosexual brothers were more apt to shy away from a genetic study that hinted at an interest in their homosexual brother's sexuality, isn't it possible that the converse may be true, that a gay identical twin would be more hesitant to respond to the ad if he had a heterosexual twin brother than if he had a gay twin? If so, this skews the

sample that responded to the ad to increase the number of probands who have iden-
tical twin brothers who are also gay (which is what their 52 per cent indicates). And
perhaps this effect holds, but to a lesser degree, for fraternal twins. That is, if the
second twin is not gay, awareness of biological determinist arguments might make
non-gay twins uncomfortable about questions about their sexuality, so they (as the
data suggests) and their gay twin brothers (as I am suggesting here) would be less apt
to respond to this study. All this is speculation, but it is at least as reasonable as the
premises of the study, and points to serious shortcomings in the sampling procedure
that may skew any results from this non-random protocol.

Thus the data actually show *no effect of genetic relatedness* on the proportions of
fraternal twin (22–24 per cent), non-twin biological brothers (9 per cent), and adop-
tive brothers (11–19 per cent) who are also gay,[26] a finding that is inconsistent with –
indeed, contradicts – a genetic explanation. Once we question the genetic explana-
tion as the only possible one, then the issue of non-random sampling error becomes
important as an alternative explanation for the high (52 per cent) concordance among
identical twins. Further, at least two features would skew the number in the same
direction, upward: the possibility that identical twins have more of a sense of them-
selves as "twins" and a stronger identification with their twin brothers who are also
gay than fraternal twins or other types of brothers, and the possibility suggested by
the researchers' own data that both the proband and his twin brother tend to want to
participate in the study if they were both gay.

Scientific research is filled with value judgments at every step in the process.
Anomalous results are frequent, and scientists make daily decisions about their
meaning. They are supposed to ask, was there something wrong with the set-up this
time so that the anomalous piece of data should be discarded? Or is this an inter-
esting anomaly pointing to a factor that has not been taken into account? Or is this a
seriously troublesome piece of data that raises questions about the entire conceptual
framework or paradigm within which the study is constructed? Within this normal
process of scientific knowledge production, it is easy to see where personal and
cultural biases can influence which science is considered valid and publishable.

It is also a reflection of the state of the field of behavioral genetics that Bailey and
Pillard chose to include their anomalous data – and that the peer reviewers and the
editorial board found their interpretation acceptable and permitted the paper's publi-
cation – and the subsequent publication in 1993 of a similarly constructed study of
female homosexuals.[27]

A close reading of "Heritable factors influence sexual orientation in women"
(Bailey *et al.* 1993) reveals the same shortcomings as their previous study, which is
not surprising since the protocol was the same. If we take the data at face value
(which we shouldn't), it shows the same sort of inconsistency in relation to a genetic
explanation of homosexuality. They find a high (38–51 per cent) concordance for the
monozygotic twins, significantly higher than for the other sibling relationships. But
there is no statistically significant difference at all between the rates for dizygotic
twins, non-twin biological sisters, and adoptive sisters, a result that confounds any
claim about genetic influence.

What is particularly interesting is the authors' premise that "there is no strong
reason to expect that genetic findings for males will be similar to those for females"
(Bailey *et al.* 1993: 217). Their reasoning reveals the intertwining of dichotomous
gender ideology with biological explanations for homosexuality.

> The most influential biologic theories of sexual orientation posit that the development of attraction to females requires the masculinization of relevant (hypothalamic) brain structures, and that attraction to males results if relevant neural structures do not masculinize. Thus, different processes are hypothesized for male and female homosexuality.
>
> (Bailey *et al.* 1993: 217)[28]

The authors are defining sexual orientation based on the sex of the person to whom you are attracted, and if you are attracted to females, you are masculine by definition (and vice versa). The convolutions of this reasoning, drawing as it does on male hormonal influence to "masculinize" an inherently "feminized" brain, reveal cultural ideologies of gender and sexuality at the core of current biological determinist theories of homosexuality.[29]

In the same issue of *Archives of General Psychiatry* as Bailey's and Pillard's study of homosexual women, William Byne and Bruce Parsons published a long "news and views" review of biological theories of human sexual orientation. After a detailed review of the literature, they conclude that:

> there is no evidence at present to substantiate a biologic theory, just as there is no compelling evidence to support any singular psychosocial explanation. While all behavior must have an ultimate biologic substrate, the appeal of current biologic explanations for sexual orientation may derive more from dissatisfaction with the present status of psychosocial explanations than from a substantiating body of experimental data.
>
> (Byne and Parsons 1993: 228)

Byne's and Parsons' close critique of the literature includes some of the problems I have raised about LeVay's brain study (Spanier 1995a) and Bailey's and Pillard's twin study.[30] Particularly telling is the nearly 50 per cent of the identical twins raised together who are *not* the same sexual orientation, pointing to "our ignorance of the factors that are involved, and the manner in which they interact, in the emergence of sexual orientation" (Byne and Parsons 1993: 230). Most striking, too, is the persistence of inaccurate beliefs about sex differences (such as that the corpus callosum is larger in women than in men) and hormone level differences (such as that homosexual males have lower levels of testosterone) (Byne and Parsons 1993: 228).[31] Notably, scientists, such as Byne and Parsons, who have critiqued biological determinist research are absent from the media's expert testimony.

The discrepancies introduced by thinking about women as part of the human population could not be ignored entirely by these researchers, although nothing shakes their confidence in genetic explanations. As noted earlier, Bailey is reported to have said, "In talking to women who call themselves straight, it strikes me that many of them will admit to being attracted to women even if they have no desire to act on it. You can hardly ever get men to admit to that" (Wheeler 1993: A7).[32] This offhand comment – and Bailey's follow-up explanation that *different genes* may determine homosexuality in men and in women – reveal implicit assumptions of *inherent* difference between men and women without attending to obvious differences in gender *socialization* and cultural attitudes about gender and sexual orientation nonconformity. Instead of re-examining his framework for explaining homosexuality, Bailey

sticks to his paradigm of genetic determination of sexual orientation, by saying that while homosexuality may be different for women than for men (with women exhibiting a higher degree of choice than men), he can interpret the results of his data to say that the genes that determine homosexuality in women are different[33] from the genes that determine it in men.[34]

Bailey's study of lesbians showed that lesbians were more apt to have lesbian sisters than to have gay brothers, raising similar problems about claims for heritability, again explained without reference to the differences in constructed meaning of maleness and femaleness in our society, sexism as it is expressed in heterosexism, and the differences from birth in socialization of boys and girls. Any claims about different biological origins of homosexuality for women and for men ignore the long list of problems with sex differences in behavior and cognition. Most dismaying is the sexism built into that explanatory framework, but it is not surprising, since speculative stories using genes as fundamental causes can be told and modified endlessly. When we take into account the shortcomings of the research, there is no valid scientific evidence to support these speculations.

Indeed, there is so much evidence of the power of cultural norms and the social institutions that support them, that when differences can be demonstrated in any consistent way (which they most often cannot), you cannot argue that behavioral differences derive from biology, since our biology is shaped in the context of a society with gender differentials as a fundamental principle of organization (such that babies are treated differently from birth depending on their sex). Furthermore, purported differences between two groups are usually not clear-cut, since the overlap between the two groups is great. That is, differences between individuals in the same group are much greater than the average differences between the two groups. This is as true of genetic composition as it is true of IQ (Lewontin *et al.* 1984).

Then why is Chandler Burr convinced by these questionable studies and so certain that a gene causes homosexuality in men? In *A Separate Creation*, Burr's review of the scientific literature ignores feminist critique (as did LeVay), and he embraces the reductionist genetic explanation for the complex array of life experiences we call sexual orientation or preference. Burr's acceptance of inconsistencies and major scientific flaws and his willingness to overlook contradictory evidence from "society" (the term he said was a totally different issue from "science") illuminate the power of a belief system, here a combination of a belief in natural differences between categorized groups and a belief in the explanatory primacy of science.

Burr, Bailey, Hamer and other biological determinists on the question of the origins of homosexuality do not address the way that our society emphasizes differences between arbitrarily grouped individuals, rather than the variation between any two individuals.[35] Nor do they address the shortcomings of the research.

Byne's and Parsons' summary concurs: "The inadequacies of present psychosocial explanations do not justify turning to biology by default – especially when, at present, the biologic alternatives seem to have no greater explanatory value" (1993: 236). They point out that what has consistently been missing from discussions is "an active role of the individual in constructing his or her identity" (ibid.). They propose an interactive model, "a complex mosaic of biologic, psychological, and social/cultural factors" (1993: 237).[36] An analogy between sex and playing music is apt here. Both have biological bases in the sense that our bodies and our senses are involved, but what we as humans do throughout a lifetime will cover a wide range of activities learned in various combinations of culture, microculture, creativity, sensate

experience, education, companions, opportunity, and so forth. While there is great variety found across cultures and time, it is not infinite in scope.[37]

It is difficult in our society for anyone to escape the explanatory power of scientific models for human behavior, and feminists are no exception. For feminist scientists, a fascination with the intricacies of the brain and neuroendocrinology may be stronger than the evidence of the limits of biological determinism; for non-scientists, there is little in the main scientific literature to teach them about those limitations. People will say that blaming (or crediting) "biology" gets parents (especially mothers, who are blamed for much of what is wrong with children) and society off the hook, but that logic can also work the other way around, as when parents feel responsible for passing their "bad" genes on to their children. Our cultural concept of "biology" must undergo radical deconstruction before we can get beyond the ideological constraints of biological determinism.

Conclusion

This analysis of the media play around Ellen DeGeneres' (and Ellen Morgan's) break-through emergence from the gay closet strongly suggests that feminist insights about heterosexuality as a cornerstone of sexism and about the constructed nature of what "male" and "female" mean have had little impact on the public consciousness about male and female behaviors, including sexual behaviors. Many well-meaning and powerful allies (such as Oprah Winfrey) for women's, racial-ethnic minority, and gay rights are not yet engaging in the political education necessary to struggle effectively for equity in the face of difference. Nor have feminist insights had any impact on the beliefs and assumptions that most researchers bring to their investigations of sexual orientation/preference. Lessons from the history of racist and sexist and heterosexist scientific claims about biological difference – that they do not stand up to scientific scrutiny; that they are more about politics and power than about valid science – apparently carry little weight for the researchers.

And, finally, much of the public does not seem prepared to evaluate the political content of scientific research claims about difference, nor to investigate what is scientifically inaccurate or questionable about the research itself.[38] Unfortunately, Ellen DeGeneres' sitcom was not renewed for Fall 1998. I can only imagine (and chuckle at) what Ellen could do with scientists' certainty about why she is gay.

Notes

1 Jackie Black, a therapist who was heterosexual until the age of 38, when she had an intense attraction for a woman (*Oprah Winfrey Show* 5 May 1997).

2 Chandler Burr, science journalist and author of *A Separate Creation: The Search for the Biological Origins of Sexual Orientation*, in response to JoAnn Loulan's view that sexual behavior is very complex.

3 Statement by Gideonse, in article about challenges to sexual identity coming from lesbians who are falling in love with men, gay men in love with women, and "straights falling for gays" (1997: 28), the last referring to Anne Heche's statement, "I was not gay before I met her."

4 In true comic style, she also makes a joke about the analogy between being gay and being black, ending her *TIME* interview by saying:

> But let's get beyond this [her sexuality as the subject of national debate], and let me get back to what I do. Maybe I'll find something even bigger to do later on. Maybe I'll become black.

> (Handy 1997: 86)

5 In Adrienne Rich's classic 1980 essay, "Compulsory heterosexuality and lesbian existence," she articulated what the growing women's liberation movement understood, that compulsory heterosexuality – the channeling of women's sexual and support energies into relationships solely with men, into marriages despite legal violence and sexual abuse – was a cornerstone of patriarchy.

6 Perhaps the two positions are better described as pro-biological determinist and anti-biological determinist, to avoid dichotomous categorization. In this mode, determinists who allow for social (or environmental) influences but who believe in sexual orientation as fundamentally set up by our biology are still very much biological determinists, just as sociobiologists who allow for the interplay of environment on our biology still assert that our genes determine basic patterns of behavior, even though those patterns might be modifiable.

7 Or it may be read in a more sophisticated way, as determinist proponents in sociobiology use the concept of several or even many (pairs of) genes to account for gradations between two types. Certainly genes act in concert with other genes, but the simple idea of gradation does not hold much genetic water. This is highly contested territory, as proponents of genetics explaining all behaviors speculate on the way genes work as part of their explanations of how genes control behavior.

8 When Simon LeVay came out as a gay scientist, along with his claim that a structural difference in the brain could explain sexual orientation, a similar talk show presented a panel with LeVay and other gay men. Only one man on the panel brought an awareness of power inequities to the discussion of what makes men gay when he said that he realized he was attracted to both men and women, but that he wanted to be coupled with a true peer, and men were obviously more worthy in our society.

9 The degree of Oprah's discomfort with discussing the possibility that girlfriends might love each other in a sexual way is very high, but by joking about the topic she is far more subtle than Diane Sawyer interviewing Ellen DeGeneres after the coming out episode. Sawyer visibly shrinks away from Ellen DeGeneres, never leaning toward her with her body or her face. The expression on Sawyer's face throughout the interview is one of great pain, which I read as personal and professional discomfort, but others might read as sympathy for the comedian's plight.

10 The belief that acceptance will be gained by proving that homosexuals are born, not made, has validity currently for the issue of acceptance. Catholic bishops in the US recently (September 1997) issued a strong statement that homosexuality is not a moral issue because of evidence that it is inborn and that it cannot be changed; therefore, they exhort good Catholics to accept their gay sons and daughters as they are, because they cannot help being gay. Does that mean that Ellen DeGeneres should be allowed civil rights and be accepted by society, but not Anne Heche or those of us who choose to be lesbians for political reasons?

11 Compare the non-feminist, gay view: why would anyone *choose* to be gay in this society? with a lesbian-feminist view: why not be proud to love women or why not choose to invest our energies and support only to women in order to disrupt the heterosexist, patriarchal assumption that women should consider only men as sexual intimates.

12 A key, questionable assumption of the studies is that homosexuality and heterosexuality are mutually exclusive conditions such that certain biological characteristics (the size or shape of certain brain structures or the information in certain genes) of homosexuals are different from those of heterosexuals. Countering this assumption is historical evidence that the concept of *the* homosexual (an individual with a set identity, rather than an individual who engages in homosexual *behaviors* at different times or in different circumstances in his or her life) emerged in Western culture only in the eighteenth century and was institutionalized in nineteenth-century medicine; thus it is a cultural creation rather than a biological given. At different times in history and in different cultures, homosexual activity did not in any way preclude the possibility of heterosexual activity at the same moment in time or in the future.

13 "Sexual preference" is rejected for "sexual orientation," a biological condition that inheres in the body to steer sexual behavior toward one sex or away from the other. Evidence countering this assumption is cross-cultural and historical, showing a wide range and combinations of human sexual behaviors that are taken as "normal" in different cultures at

different times. Dramatic changes in sexual behavior have occurred with social and political changes such as the second wave of feminism.

14 Another key supposition to be questioned is that "true" homosexuality is associated with feminine behavior and appearance in men and the reverse in women, linking assumed attributes of maleness and femaleness with sexual orientation or preference. In the 1950s, Money and Ehrhardt studied girls who had been exposed *in utero* to high levels of androgens ("male" hormones). The researchers claimed that the "masculinization" of the female fetuses' brains produced the following results (remember, this was the 1950s): wearing pants rather than dresses, wanting careers more and babies less, higher IQs, and (subsequently) lesbian identity. The claim for higher IQs as a result of being masculinized was dropped when the higher socioeconomic class of the families, and thus higher measured IQs generally, was taken into account. The researchers did not factor in, however, the effects on the girls of genital surgery several times or the attention given them for their "problem" (which might include infertility) by their parents and doctors, influences that surely could have turned a girl away from traditionally feminine activities.

15 Sexual behavior is viewed as mechanically driven by a physical entity and involving genital manipulation and copulatory activity, rather than unconsciously acquired behavior learned from the socializing environments of family, culture, society.

16 I have published elsewhere a detailed analysis of his article that highlights where the author makes key judgments not on sound evidence, but on his belief that male homosexuality is inborn (see Spanier 1995a).

17 See also Byne's and Parsons' comments on studies of the corpus callosum of men and women and my article, "Biological determinism" (Spanier 1995a).

18 Janet Halley's outstanding essay on legal arguments for gay rights includes a concise critique of the work of both LeVay, and Bailey and Pillard, arguing that their research cannot prove biological determinism because their untested hypothesis *assumes* that homosexuality must be biologically determined to a great degree. Without spotting that kind of circular reasoning, it is difficult to tease out hidden assumptions in the scientific logic of a study.

Halley's focus on legal arguments brings her to propose that "a common middle ground" between essentialists and constructivists will best serve pro-gay legal arguments: "sexual orientation, no matter what causes it, acquires social and political meanings through the material and symbolic activities of living people" and "pro-gay legal arguments from biological causation should be abandoned" (1994: 506), not just because the science does not hold up under scrutiny, no matter what is commonly believed, but because immutability is not a sufficient characteristic for legal rights.

19 The scientific mislabeling of sex hormones contributes to a distorted paradigm of bipolar difference determined by differential biology (genes, brain, etc.). See Spanier (1991b; 1995b, Chapter 5).

20 Proband is the term used in genetic studies for the initial member of the family contacted for study.

21 A P of less than 0.1 means that there is a one in ten chance that the difference comes from random variation. A smaller P of 0.05, or one in twenty, is taken as the borderline for statistically significant difference between two numbers.

22 Simple (Mendelian) genetics does not account for all genetic inheritance. Extranuclear genes are found in cellular organelles such as mitochondria and chloroplasts and independently replicating plasmids.

23 There are, however, many flawed assumptions in studies using adoption or twins. Children are often adopted into families related to the mother, so adoption does not necessarily mean a random genetic relationship. This obscured fact creates a flaw in the assumption of some genetic studies that adopted children are not related genetically to their adoptive family. This applies as well in twin studies where identical twins separated at birth often are placed with families that are distantly related to the same mother. Furthermore, they are often placed into families of similar cultural and socioeconomic background, so the assumption that their genes are the same but their environments were totally different is a questionable one. See Lewontin *et al.* (1984).

The assumption that the cultural environment is the same for all siblings is also questionable, given changes within families over time, although the most similar "environment" might be that of identical twins raised together in the same family. In addition, we can

question the assumption that identical twins raised together share only the same genotype; they also share the same family environment and the same impact of their physical characteristics on the people around them, prompting similar responses.

24 Furthermore, statistical results from a larger sample usually supersede a smaller one, but Bailey and Pillard dismiss the significance of the "better" data in their own article.

25 The sample in the study is clearly not a random sample for several reasons. I would argue, as other critics have, that awareness of interest (and strong belief) in gayness being genetic would pique the interest disproportionately of a gay twin whose twin is also gay – and further pique his interest if he were politically aware that gay liberation groups have seen the immutability argument as a saving grace for gay rights.

26 Recall that adoptive brothers are not genetically related to their brothers, while fraternal and non-twin biological brothers are genetically related to the same degree.

27 In a response, Theodore Lidz from the Department of Psychiatry at Yale University criticized the authors (*and* the journal) for drawing heavily on twin and adoption studies claiming to prove the heritability of schizophrenia (Lidz 1993). He provides details of major problems with those claims as well as broader claims for other behavioral traits and cites adoption studies that show no "clear-cut evidence of a notably genetic factor" in schizophrenia. His language is modest when he points to the flawed argument raised by the 9 per cent rate for non-twin brothers: "However, if we look past the findings, an alternative explanation can be just as valid [as the reasons the authors gave to explain away the discrepancy], namely that the genetic influence is being overvalued" (1993: 240). He concludes: "In brief, there may be a genetic component to homosexuality; it is the current fashion to find a major genetic component in all behavioral conditions. I simply wish to emphasize there is still need for more, and clearly better, studies" (ibid.). The recommendation for more studies is troublesome to me; this critique does not question sufficiently the framework of explanation, despite the significant flaws exposed in comparable claims about schizophrenia.

28 Note that female brain development is described as a process of the absence of male hormonal influence. This is another fundamental distortion of male and female development, whether or not you believe the theories of sexualized brains. See, for example, Fausto-Sterling (1989).

29 See above and below, Bailey's comment about heterosexual women.

30 Bynes and Parsons point to questionable assumptions common to most of the scientific research: homosexuals are intermediate between heterosexual men and heterosexual women, equating male homosexuality with effeminacy and less-than-normal virility; homosexuality is a unitary construct, the same across cultures; homosexuality comes from a pathological defect in either biology or socialization. The twin studies also suffer from other problems: the environment relevant to the trait of homosexuality may not be equivalent for identical and fraternal twins as well as other siblings studied; populations located through homosexual-oriented publications may not be typical and representative; twins raised together share genetics and environment; non-zero heritability does not mean that hypothetical genes work directly to produce homosexuality. Byne's critique in *Scientific American* (1994) is also very useful.

31 The corpus callosum claim "has remained viable in the literature for more than a decade despite more than 20 replication attempts, all of which have failed" (Byne and Parsons 1993: 228). William Byne co-authored one of those studies with Ruth Bleier, correcting for the inadequacies of the original De Lacoste-Utamsing and Holloway paper with a larger and representative sample, controlling for factors such as handedness and age that were known to affect the corpus callosum. Citing Meyer-Bahlberg's review of the literature on testosterone and male sexuality, three studies suggested lower hormone levels in male homosexuals, twenty found no differences, and two found higher levels in male homosexuals. Such results strongly suggest that there is no phenomenon of interest in that theory.

32 Bisexuals are categorized differently in different studies. While both Bailey/Pillard and LeVay put bisexuals into the homosexual category in their studies, more recent work, particularly by Dean Hamer, eliminates bisexuals to study only "true" homosexuals.

33 This does not make sense from a conventional genetic framework, but it suffers from the same flaw as conventional sociobiology: that men and women evolve as if they were separate species rather than the same species. Why would one set of genes for same-sex attraction evolve in women and a different set in men?

34 The variation in behavior found across the spectrum of humans is now becoming divided into more and more discrete types to be explained by more and more discrete genes. LeVay's theory puts heterosexual women and gay men into the same category because they both are attracted to men, while lesbians and heterosexual men share the attribute of desiring women. Bailey's and Pillard's theory separates gay men from gay women on the basis of twin-sibling studies. If genes determine behavior, why aren't we setting up categories of what people are actually doing together? Perhaps because oral sex, anal sex, sexual intercourse (does that include a woman wearing a dildo? What if she isn't a lesbian and she is doing this with a man?), and other forms of sexual activity are not gender-specific or sexual orientation-specific. (Does that mean that anyone who likes anal sex has a set of genes for that preference? Look for that study in the future.)

35 And this is killing us, as much from ignoring the effects of individual biological variation on proper medical treatment, as from discrimination against individuals based on their gender, racial/ethnic heritage, sexual orientation/preference, age, etc.

36

> We propose an interactional model in which genes or hormones do not specify sexual orientation per se, but instead bias particular personality traits [such as novelty seeking, harm avoidance, or reward dependence that would influence nonconformity] and thereby influence the manner in which an individual and his or her environment interact as sexual orientation and other personality characteristics unfold developmentally. Such a mechanism would allow for multiple developmental pathways leading to homosexuality and would account for the high concordance rate for homosexuality among identical twins reared together, as well as for the failures of various psychosocial theories that have focused exclusively either on personality traits of individuals or on various environmental factors, but not on the interaction of the two.
>
> (Byne and Parsons 1993: 236–7)

 In my opinion, even this stance goes further toward biology than I believe any data supports. For example, a characteristic, "conformity," that might be influenced by (hypothetical) personality traits does not predict anything about behavior, since the context of social norms varies from the macroculture to the microculture.

37 I have extended Leonore Tiefer's (1995: 6) analogy from *Sex Is Not a Natural Act and Other Essays*.

38 Feminist science education that promotes critical feminist analysis without falling into the abyss of cynicism about science's politics holds a promise as a key tool toward a future society that would see little value in the scientific pursuit of biological origins of difference between arbitrarily grouped populations. I am fortunate to be involved with a curriculum transformation project to that end. The Association of American Colleges and Universities has a three-year grant from the National Science Foundation to work with ten schools on "Women and Scientific Literacy: Building Two-Way Streets."

References

Bailey, J. M. and Pillard, R. C. (1991) "A genetic study of male sexual orientation," *Archives of General Psychiatry* 28 December: 1089–96.

——(1993) "Reply to Lidz's letter," *Archives of General Psychiatry* 50, March: 240–1.

Bailey, J. M., Pillard, R. C., Neale, M. C. and Agyei, Y. (1993) "Heritable factors influence sexual orientation in women," *Archives of General Psychiatry* 50, March: 217–23.

Birke, L. (1995) "Frenetic determinism," *Women's Review of Books* 12(4), January: 24–5.

Burr, C. (1996) *A Separate Creation: The Search for the Biological Origins of Sexual Orientation*, New York: Hyperion.

Byne, W. (1994) "The biological evidence challenged," *Scientific American* 270, May: 50–5.

Byne, W. and Parsons, B. (1993) "Human sexual orientation: the biologic theories reappraised," *Archives of General Psychiatry* 50, March: 228–39.

De Cecco, J. P. and Parker, D. A. (eds) (1995) *Sex, Cells, and Same-Sex Desire: The Biology of Sexual Preference*, New York: Haworth Press.

Fausto-Sterling, A. (1989) "Life in the XY corral," *Women's Studies International Forum* 12(3): 319–33.

Futuyma, D. J. and Risch, S. J. (1983/1984) "Sexual orientation, sociobiology, and evolution," *Journal of Homosexuality* 9(2/3), Winter–Spring: 157–68.

Gideonse, T. (1997) "The sexual blur," *The Advocate* 24 June: 28.

Gould, S. J. (1981) *The Mismeasure of Man*, New York: W.W. Norton.

Halley, J. E. (1994) "Sexual orientation and the politics of biology: a critique of the argument from immutability," *Stanford Law Review* 46, February: 503–68.

Hamer, D. (1994) *The Science of Desire: The Search for the Gay Gene and the Biology of Behavior*, New York: Simon and Schuster.

Handy, B. (1997) "Roll over, Ward Cleaver," *TIME* 14 April: 78–86.

Herrnstein, R. and Murray, C. (1994) *The Bell Curve: Intelligence and Class Structure in American Life*, New York: Free Press.

Holden, C. (1992) "Twin study links genes to homosexuality," *Science* 254, 3 January: 33.

Hubbard, R. (1990) *The Politics of Women's Biology*, New Brunswick: Rutgers University Press.

Jacoby, R. and Glauberman, N. (eds) (1995) *The Bell Curve Debate: History, Documents, Opinions*, New York: Random House.

LeVay, S. (1991) "A difference in hypothalamic structure between heterosexual and homosexual men," *Science* 253, 30 August: 1034–7.

——(1993) *The Sexual Brain*, Cambridge: MIT Press.

LeVay, S. and Hamer, D. H. (1994) "Evidence for a biological influence in male homosexuality," *Scientific American* 270, May: 44–9.

Lewontin, R. C., Rose, S. and Kamin, L. J. (1984) *Not in Our Genes: Biology, Ideology, and Human Nature*, New York: Pantheon.

Lidz, T. (1993) Letter, *Archives of General Psychiatry* 50, March: 240–1.

Oprah (TV show) (1997a) Interview of Ellen DeGeneres and Anne Heche, 30 April.

Oprah (TV show) (1997b) "How Someone Becomes Gay," 5 May.

PrimeTime Live (1997) Diane Sawyer's interview with Ellen DeGeneres, 30 April.

Rich, A. (1980) "Compulsory heterosexuality and lesbian existence," *Signs: Journal of Women in Culture and Society* 5(4): 631–60.

Sayers, J. (1982) *Biological Politics: Feminist and Anti-Feminist Perspectives*, London, New York: Tavistock.

Schiebinger, L. (1989) *The Mind Has No Sex? Women in the Origins of Modern Science*, Cambridge, MA.: Harvard University Press.

Spanier, B. (1991a) "Gender and ideology in science: a study of molecular biology," *NWSA Journal* 3(2), Spring: 167–98.

——(1991b) "'Lessons' from 'nature': gender ideology and sexual ambiguity in biology," in J. Epstein and K. Straub (eds) *Body Guards: The Cultural Politics of Gender Ambiguity*, New York: Routledge: 329–50.

——(1995a) "Biological determinism and homosexuality," *NWSA Journal* 7(1), Spring: 54–71.

——(1995b) *Im/partial Science: Gender Ideology in Molecular Biology*, Bloomington, Indiana: Indiana University Press.

Suzuki, D. T., Griffiths, A., Miller, J., and Lewontin, R. C. (1989) *An Introduction to Genetic Analysis*, New York: W.H. Freeman.

Terry, J. (1990) "Lesbians under the medical gaze: scientists search for remarkable differences," *Journal of Sex Research* 27: 317–40.

Tiefer, L. (1995) *Sex is Not a Natural Act and Other Essays*, Boulder: Westview.

Tobach, E. and Rosoff, B. (eds) (1994) *Challenging Racism and Sexism: Alternatives to Genetic Explanations*, New York: The Feminist Press.

Wheeler, D. L. (1991) "A genetic component of homosexuality is strongly indicated," *Chronicle of Higher Education* 18 December: A11.

——(1993) "Study of lesbians rekindles debate over biological basis for homosexuality," *Chronicle of Higher Education* 17 March: A6, A7, A12, A13.

Clinical practices

Kathy Davis

PYGMALIONS IN PLASTIC SURGERY
Medical stories, masculine stories[1]

WHILE THE TECHNIQUES of plastic surgery, most notably nose reconstructions, have been around since 3000 BC, modern cosmetic surgery has its origins at the turn of the twentieth century (Rogers 1971). The first operations for "pug noses" were performed in the late 1890s, and by the early 1920s operations for eye-bags and face-lifts were popular. In recent decades, cosmetic surgery has undergone an enormous expansion, becoming the fastest growing medical specialty in the US. Although in recent years more men are finding their way to the plastic surgeon's office, women continue to make up the vast majority of recipients (from 70 to 90 per cent). The accepted explanation for the disproportionate number of women who undergo cosmetic surgery is that women have historically been more concerned with their appearance than men. Whether this is because they are by nature more narcissistic – as Freud would claim – or are under more pressure to comply with cultural norms of feminine beauty, women's desire for cosmetic surgery tends to be linked with femininity (Davis 1995).

Although the typical cosmetic surgery recipient is a woman, the surgeon is almost always a man. Unlike pediatrics or psychiatry, surgery has always been a male-dominated profession. In recent years, medical specialties like gynecology and family medicine have begun to open their ranks to women. However, surgery – including plastic surgery – is "hard-core" medicine and continues to remain very much an "old boys club." Women represent just under 9 per cent of all registered plastic surgeons in the US.[2] If the "typical" medical encounter involves a professional man and a female patient, then plastic surgery is one of the most "gendered" of all medical specialties (Hearn 1982; Davis 1988). It expresses and reproduces the gender symbolism which has men doing the operating while women are the recipients of the surgery, the objects to be operated on.

The gender gap in medical specialties cannot be accounted for strictly by reference to the incompatibility of long internships, irregular hours, and the demands of child-rearing. The culture of a medical specialty can also be masculine, making it more appealing to men than to women. In his analysis of masculinity in various professions, David Morgan (1981; see, also, 1992) notes that there is a tendency to ignore gender when it comes to understanding the powerful – i.e. affluent, white, professional men. While gender is frequently invoked in research on women's activities, men's activities

tend to be described in gender-neutral terms. He illustrates this by drawing self-critically upon his own earlier research in which he collected biographies of Anglican bishops. While he originally linked the massive maleness of the episcopacy and the clergy to factors like economic and social status, he later wonders whether many of the typical traits which he discovered in these biographies were not simply instances of masculinity "in episcopal robes" (Morgan 1981: 88). He argues that we need to reflect on how professional values are conflated with and reinforce notions about masculinity and femininity.

In this chapter, I propose to explore the gendered underpinnings of the profession of cosmetic surgery. It is my contention that if women's decisions to undergo cosmetic surgery can be linked to the practices and discourses of femininity, then men's decisions to perform cosmetic surgery should also bear a connection to the practices and discourses of masculinity. As illustration, I shall examine a popular autobiography by a male plastic surgeon, entitled *Doctor Pygmalion* (Maltz 1954). By analyzing the textual practices which the author employs to construct his life as the idealized story of the plastic surgeon, the professional ideology of plastic surgery as well as the construction of masculinity in its professionalized form can be explored.

Autobiographies as cultural texts

Autobiographies are a popular genre in contemporary Western culture. They allow readers to escape from their humdrum existence by reading about the lives of the rich and famous, giving ordinary people a glimpse of their desires and struggles, and enabling them to give meaning to their own lives. They offer idealized models of the "good life" – models which furnish direction, sanction deviation, and provide standards against which people can measure and judge their own life course (Gergen and Gergen 1993: 194).

In recent years, social scientists have begun to draw upon popular autobiographies as a resource for understanding social life. Autobiographies provide insight into the ideologies of a particular culture (Plummer 1983, 1995; Denzin 1988; Stanley 1992; Gergen and Gergen 1993; Stanley and Morgan 1993). When individuals write their autobiographies, they are not simply providing factual accounts of their lives. Rather, they assemble various events, characters and behaviors in such a way that a certain kind of "self" is produced. In most autobiographies, the chief emphasis is on success (in some cases, success in overcoming some adversity like illness or poverty). The narrator positions her/himself as an expert – the wiser and more powerful person who sets out to "edify" the reader in what it means to be an extraordinary person or to have lived a noteworthy life. Autobiographies are embedded in the historical, cultural and social context in which they are produced, thereby providing valuable insight into the ideals, aspirations, but also contradictions and ambivalences, of that culture.

Within feminist scholarship, autobiographies have been taken up as a significant way to recover the experiences of the powerless – most notably, women. Attention has focused on the different ways women and men tell their life stories (Brodzki and Schenck 1988; The Personal Narratives Group 1989; Gergen and Gergen 1993). Autobiographies have also been treated as an object for investigating (and deconstructing) gender as textual practice (Stanley 1992). They allow us to understand how the ideologies of masculinity and femininity are implicated in the construction of ideal selves.

Doctor Pygmalion is not a typical autobiography. While most popular autobiographies are about famous individuals (well-known historical personages, politicians, literary figures or artists, scientists, inventors, film stars or musicians), Maxwell Maltz, although clearly successful, is not famous. At first glance, his autobiography seems to be a straightforward "rags-to-riches" story about a poor American youth who embarks upon a career. It is a tale of a mundane hero in single-minded pursuit of one goal: to become a plastic surgeon. However, *Doctor Pygmalion* is a career story with a twist.

The book is situated in the period when plastic surgery had just begun to make its entrance as a legitimate branch of medicine. Between 1900 and 1925, plastic surgery became popular in the US and Europe. It was advertised in daily newspapers and weeklies along with products like "bust creams," abdominal supporters, or chin straps designed to facilitate rejuvenation and attractiveness. "Cosmetic surgery parlors" lured thousands of women for face-lifts, eyelid corrections and nose jobs. Many of these early operations were performed by charlatans or physicians without training in plastic surgery. However, the line was a thin one as many trained surgeons borrowed the techniques and procedures devised by the "quacks," taking credit for them in scholarly articles (Rogers 1971). The first scientific articles and textbooks chronicling the development of cosmetic surgery appeared in the early 1920s in Europe and the US. *Doctor Pygmalion* opens in 1925, when Maltz decides to become a plastic surgeon, and continues through the Second World War, when he has reached the pinnacle of his career.

Unlike most popular autobiographies, it contains all of the ingredients of a medical textbook on plastic surgery. Each chapter contains a combination of personal stories taken from the author's life and technical, highly detailed descriptions of surgical procedures, replete with blow-by-blow accounts of operations and even details on the kinds of surgical instruments which are employed for the various techniques. The book is full of case studies and, indeed, most of the characters have been or are about to become the author's patients. At regular intervals, the story of his career is interrupted with historical sketches of how plastic surgery developed, illustrated with drawings of surgical instruments and procedures which were used in the early days of plastic surgery. Numerous references and anecdotes are provided about the "founding fathers" of plastic surgery. Before-and-after photographs of a variety of procedures are available (surgery for cleft palate, receding chin or webbed fingers; nose and ear corrections; face-lifts) with a note that, for reasons of privacy, they do not include actual patients of Maxwell Maltz. In fact, the only "personal" photograph in the book is a frontispiece portrait of Maltz, taken at the end of his career.[3]

The hybrid format of the book enables Maltz to interweave his personal story with the story of his profession. His ambitions, values and accomplishments become intertwined with the developments, discourses and practices of plastic surgery. His career trajectory is reflected in the emergence and development of plastic surgery as a legitimate medical specialty. Personal accounts of his youth or relationships with family and friends are mobilized to illustrate his socialization into the world of plastic surgery, thereby reproducing its discourses of professionality. When the author presents himself as an adventurous pioneer, an idealistic man of science or a compassionate physician, he also constructs his specialty as an exciting, revolutionary and worthy field of medicine. In presenting his life as an exemplary plastic surgeon, Maltz simultaneously constructs an idealized image of his profession – an image which represents the ideological underpinnings of plastic surgery.

Before turning to the construction of masculinity in *Doctor Pygmalion*, as well as the interconnections between masculinity and the discourses and practices of plastic surgery, let us take a brief look at the author's autobiography.

The story

Maxwell Maltz ("Maxie") was born in 1899 on the "wild and woolly" Lower East Side in New York, the only son of "formidably respectable," lower middle-class Jewish parents. After his father's early death, Maltz's mother sells her pearl choker so that her son can become a medical specialist. The decision to become a plastic surgeon is taken when Maltz, still an intern, delivers a baby with a hare-lip to a horrified young couple living in the tenements. Determined to combat what he sees as traditional views – deformities as "evidence of the displeasure of God for some grievous sin long since committed" (Maltz 1954: 11) – Maltz embarks upon his career in the "very noble and compassionate form of the practice of medicine," plastic surgery (12).[4] As plastic surgery was still very much in its early stages during the early 1920s, there was plenty of room for an idealistic and ambitious young man like Maltz. He decided to pack his bags and go to Berlin for his internship.[5]

In 1923, he enters the clinic in Berlin as an intern and studies under two professors. The first was a "frosty" aristocrat, Professor von Eicken who was known for having performed an operation on Hitler's throat. The second was Jacques Joseph who has been called the "father of the nose correction" and whose techniques are still referred to in handbooks of cosmetic surgery. Sander Gilman devotes an entire chapter of his book *The Jew's Body* (1991) to this man (dubbed "Nosef" in *fin-de-siècle* Berlin society) who was famous for reducing "Jewish noses" to gentile proportions. Gilman describes him as an "acculturated Jew" who changed his name from Jakob to Jacques and belonged to ultra-conservative fraternities where dueling was a sign of manliness. He himself bore several scars on his face as a sign that he had become integrated into German society. His scars ultimately didn't help him. Depressed by the Nazi's threats and persecution of the Jews, he committed suicide in 1934 at the age of 69 by shooting himself in the mouth. Maltz makes no references to tensions which must have been present in the clinic, nor does he indicate that his own Jewishness causes any difficulties in his interactions with his teachers. On the contrary, he invariably refers to them in admiring terms as "redoubtable men" (19) whom he wishes to emulate (by adopting their techniques or growing a mustache). Evidently, the context in which he works fades in importance against his burning ambition to become a plastic surgeon.

During his internship, Maltz meets the love of his life, the beautiful and rich American pianist, Sylvia. He travels around Europe with her as she gives concerts, earning his way by demonstrating the art of the nose job. Maltz and Sylvia plan to marry and he returns to New York to set up his practice and buy an apartment. Just as he has made all the arrangements, he receives a note from Sylvia that she has found another man who "needed her more." Momentarily heart-broken, but undeterred, Maltz recruits his first patient and, from then on his career as a plastic surgeon takes off.

By 1927 he already has a booming practice among the wealthy inhabitants of New York, despite the Great Depression, and by 1934, he has moved his practice to a penthouse and is treating actresses, celebrities and socialites. He has hired a butler and gives parties to which the Gershwins are invited. Although he briefly contem-

plates marriage, he remains a bachelor, unable to find a woman who can compare with the beautiful Sylvia. While Maltz clearly enjoys his success, he also writes that he suffers occasionally from pangs of conscience at the many wealthy women who demanded to have their already-beautiful noses corrected or their still-youthful faces lifted. Anxious that he has strayed from his initial idealism ("the noble and compassionate practice of medicine") by treating such trivial complaints, he assuages his moral qualms about his professional practice by offering his services to the poor for free, often recruiting them from his old neighborhood on the Lower East Side.

In the early 1940s, Maltz – like most plastic surgeons – was caught up in the war effort and spent his time lecturing on the latest techniques in reconstructive and plastic surgery in military hospitals throughout the US.[6] After the war, he embarks upon his "most ambitious medical undertaking so far" which involves traveling to Central and South America as an ambassador of "inter-American medical good will" (221) where he operates on "indigent people" and teaches his colleagues how to perform plastic surgery. Having reached the pinnacle of his career (Maltz was 55 years old when he published his autobiography), he ends the book on a personal note. Upon returning from one of his trips, he discovers a young woman in his waiting room with an astonishing resemblance to his old flame, Sylvia. Lo and behold, this woman turns out to be none other than Sylvia's daughter who has come to pay her respects now that she lives in New York. Upon closer inspection, the resemblance to her beautiful mother is marred by her sagging lower lip, a "deformity" which she has unfortunately inherited from her father. Maltz characteristically takes the initiative and offers to operate on Sylvia's daughter for free. As he magnanimously puts it when he calls the mother, "I have a purely selfish reason. ... I want to pretend she's my daughter – yours and mine. And how can I possibly do that if every time I look at her I see her real father looking back at me?" (223). The operation takes place and is successful. The young woman seems to be pleased with her new face and Maltz feels that if "only in a small measure" she "really was mine" and that he had "won out" over his old rival, after all (223). On that note, the book ends.

Identity constructions

In writing his autobiography, Maxwell Maltz is not simply providing an account of the facts of his life. Indeed, the reader frequently wonders just how true to life his autobiography actually is. The events of his life are constructed in such a way that he can underline the wonders of his profession and defend it against would-be critics. Maltz is also ongoingly engaged in the business of self-presentation. *Doctor Pygmalion* contains various intertwining stories which, in turn, provide different versions of the kind of person Maxwell Maltz is. For example, it is a success story about a poor Jewish boy, who like many American immigrants, pulls himself up by the bootstraps. There is the story of the adventurous physician who ventures forth into unknown territory by taking up a new medical specialty. It is the story of a socially engaged physician and his struggles to avoid being corrupted by money and success and remain true to the ideals of his profession. And, last but not least, *Doctor Pygmalion* is the story of a man in search of the perfect woman. While these stories provide different constructions of self, they are unified under one primary identity: the identity of a plastic surgeon. Maltz goes to great lengths to show himself as a representative of this profession.

I shall now take a closer look at the various "selves" which are constructed in

Doctor Pygmalion: the pioneer, the scientist, the idealist, the creator, and the aesthete, and show how each works toward creating a specific professional identity – the ideal plastic surgeon.

Pioneer

Maltz presents himself as a pioneer who must contend with the misunderstanding and prejudices of the medical mainstream and the general public in order to win acceptance for a new field. He complains about "traditional" views about physical deformities as punishment from God, to be accepted with impunity, rather than a problem which can be easily treated by "modern surgical methods" (11). Another misconception is that plastic surgeons are disreputable charlatans out to make a quick buck rather than "real" doctors. When he informs his mother that he wants to become a plastic surgeon, she is incensed, referring to his beloved vocation as being a "beauty doctor, a movie-picture kind of doctor, not a real doctor, like the man who pulled out tonsils and cured scarlet fever" (12). His mother is not the only person who is skeptical of plastic surgery. Maltz must continually undermine these prejudices and reinstate the image of his field as a legitimate and commendable branch of medicine. He does this by showing that his patients do not fit the stereotypical notions of plastic surgery as frivolous "vanity work," something for "fur-clad ladies." For example, when the director of the clinic where he works denies him a bed for his patient with the argument: "If she wants to have you make her face prettier, why doesn't she stop buying lipsticks and save her money until she can afford it?," Maltz points out that his patient is a young girl with a disfiguring burn: "she hasn't got into the lipstick habit yet. She's eight" (52). Or, he invites his colleagues who disapprove of his "new-fangled ideas" (66) to operations in which he dazzles them with his technical skill, forcing them to admit that his specialty is a worthwhile addition to medicine.

Somewhat paradoxically, Maltz underlines his status as a pioneer in plastic surgery by referring to his forebear Tagliacozzi, an Italian nobleman who is regarded as the "father of plastic surgery."[7] Tagliacozzi started doing nose reconstructions as early as 1597 on individuals who had lost their noses as a result of disease (leprosy, syphilis) or punishment or, in one case, an accident while dueling. Although his methods inspired plastic surgeons up into the twentieth century, he was considered a heretic in his time and, in fact, was ultimately killed at the hands of the Inquisition. The implication is that Maltz, like Tagliacozzi, is more enlightened than his more pedestrian colleagues – a foresighted but misunderstood pioneer in pursuit of a worthy goal.

Scientist

Maltz presents himself as a scientist engaged in discovering new techniques or refining old ones. He is no mere practitioner. Throughout the book he provides detailed accounts of his operations in which he displays his virtuosity and inventiveness in repairing cleft palates, restoring deformed hands or reconstructing noses. He always seems to be operating on his own – a solitary hero-surgeon, alone in his clinic in the sky (his clinic is situated in a penthouse on 5th Avenue). If there is a nurse in attendance, we do not hear about her.

Maltz is supremely self-confident. Even when he uses an unfamiliar technique, he never doubts his abilities or that his plan of action is justified. As scientist, he realizes that risks are part of the game and he continually underlines the necessity of experi-

menting with new procedures. Plastic surgery is not a specialty for the timid or the conventional, but requires qualities of daring and the willingness to embark on unknown paths. Already as an intern in Berlin, he admits to having had the "temerity to attempt to improve on the surgical instruments devised by the father of modern rhinoplasty, the Great Jacques Joseph himself"' (17). Later, he provides a gripping account of one of his early operations with a skin-graft. He knows that if the operation is unsuccessful, he will stand convicted as someone who had taken a chance and failed through lack of knowledge of what he was attempting to do and that "it would be hard to be more thoroughly blacklisted as a doctor" (67). However, with his faith in his new technique, he takes the risk:

> I was running with sweat and I should have been feeling tired, but I wasn't; I felt I had done very well; I felt that von Eicken would have been proud of me, and even Jacques Joseph; yes, I'd go beyond that – I felt that Harold Gillies [the originator of the skin graft procedure he was performing], had he been there, would have nodded in approval and told me that my modification of the Gillies tube was a clever piece of surgery.
>
> (Maltz 1954: 64)

While his colleagues are in favor of the conservative approach (his superior warns that "the quickest way isn't necessarily the best"), Maltz situates himself as an enterprising man of science who is willing to take risks and to follow his intuitions even in the face of an uncertain outcome.[8]

Idealist

Maltz is not just a man of science; he is a man with a conscience as well. He presents himself as an idealistic physician who is first and foremost concerned with alleviating distress and helping people to live better lives. We are informed at the outset of the book that plastic surgery is a "very noble and compassionate form of the practice of medicine" (11) and this sentiment is repeated at regular intervals, particularly when Maltz is in danger of losing his faith in his profession. Interestingly, his idealism is most endangered by his female patients. Throughout the book, he makes disparaging remarks about these women as the "newly rich who are only interested in finding new ways to spend their money" or "paper-millions ladies" who have discovered that they can lose ten years with the simple, quick and painless removal of the crow's feet around the eyes or a "face-lift" (80).

Although Maltz enjoys the material advantages of his profession and is clearly proud to have transcended his lowly origins, he makes it clear that success has its price. It forces him into an ongoing struggle to sustain his idealistic vision about his profession. Whenever he feels particularly sickened by the onslaught of wealthy, society women seeking his services for trivial reasons, he begins to wonder whether he has lived up to his vision. Recalling his experience as a young intern delivering a baby with a hare-lip in a tenement building, he wonders whether the idealistic young man he was then would consider that he had done well:

> God knows, in money, very well indeed. But was money what he had been thinking of, that windy, black morning as he stared at the pitiful little twisted face? The intern – and the boy out of whom he had grown – had

been on familiar terms with the brawling, wrangling, rushing, day-in-and-day-out life of the city; down in the hot, dusty street, not aloft on the cool garden terraces, in the splendid room with the polite voices of fashionable patients.

(Maltz 1954: 145)

Maltz seeks redemption in patients with physical deformities ("a misshapen face, scarred, burned, or harelipped") who are too poor to pay for his services. He actively looks for them, overcomes their suspicions (often no small task) and convinces them to let him help them, free of charge. The neighborhood newspaper vendor with webbed hands, the kindly candy shop owner from his old neighborhood with an unsightly scar, or the little girl with the "ski-jump" nose are presented as examples. These are the recipients of Maltz's altruism. By helping poor, working-class, and usually male patients, his commitment to his original ideals is reinstated. In this way, he establishes himself as an idealist who is not simply motivated by fame and financial success.[9]

Creator

Maltz describes his work as nothing less than "creating miracles": "I could whisk new noses out of the air ... just about everything lay within the compass of my magical powers" (209). There seems to be no deformity which he cannot fix and his operations are invariably successful, fulfilling "every man's [*sic*] divine right to look human" (145). Maltz's "magical powers" are by no means limited to changing his patient's bodies, however. He not only eliminates scars and repairs damage with skin grafts, but removes the "deeper scars" as well – "the scars of the mind" (220).

Interestingly, much of this autobiography of a plastic surgeon is devoted to tales about people whom Maltz helps in ways which do not involve surgery. For example, when a beautiful woman wants an operation on her face, he resists her request, relying on a mysterious "sixth sense" which tells him that this is not her "real" problem. Rather than sending her away empty-handed, he intervenes in such a way that – as he puts it – he can bring the unhappy woman "back to life" (124).

The objects of Maltz's divine interventions do not always want to be helped, often because of their – as he assures us – thoroughly unfounded fears that the operation will be painful. In such cases, he brushes off their objections, promising them that he can solve their problems. In most cases, he does convince his patients to go along with him, but some remain adamant that they do not want his services. (Interestingly, these candidates are always poor in contrast to the rich "ladies" who he has to fend off in order to maintain his ideals.) Maltz tends to transform such cases into a moral tale: for example, the plain "spinster" with the "bird-like face" who rejects the possibility of becoming more beautiful as trivial compared to the delight she has in making children laugh (even when it is her face they are laughing at!).

Despite – or perhaps because of – his own god-like abilities to intervene in people's lives, Maltz presents himself as sensitive to the problems experienced by others. For example, he describes catching his butler Rudolph surreptitiously trying on his master's white coat, trying to emulate him. Maltz invites him to an operation, taking great pleasure in his servant's fainting at the sight of blood. This moral lesson establishes Maltz's sovereign power, while chastising his servant for getting "too big for his britches."[10]

Maltz's most sublime creation is presented in the final chapter when he (re)creates his lost love, Sylvia, by operating on her daughter and remaking her in the image of her mother. Reminiscent of Zeus bypassing the Mother Goddess Metis and giving birth to Athena from his head, Maltz incorporates the creativity of artist-surgeon with metaphorical fatherhood and the divine powers of a deity.[11] Plastic surgery enables him to gain a daughter and regain the woman he has lost: "There, looking at herself in the mirror, was another Sylvia; and though to be sure in only very small measure, in part she really was mine" (223). Sylvia belongs to Maltz in a way which was not possible before. By operating on her daughter, she becomes his – his creation.

Aesthete

Maltz presents himself as a lover of beauty, particularly in women. However, his relationship to beautiful women is ambivalent. Throughout the autobiography, he expresses a mixture of contempt and admiration for a particular class of women – the beautiful, wealthy "fur clad" ladies who come to him for help. As a short, chubby, inexperienced youth from the Lower East Side, Maltz desired such women from a distance, realizing that they were firmly outside his reach. Writing about his first love, Sylvia, whom he meets in Berlin during his internship, he contrasts her ("she was everything I wasn't. She, with her lovely face, her beautiful clear skin, her expensive clothes, her well-to-do family in New York, her careful schooling, her high-priced piano lessons ...") with his own situation, living in a "garret-coffin on the other, the very, very wrong side of Berlin" (21). Ultimately, Sylvia jilts him and Maltz displaces his love for her on to the myriad women who he meets in his practice. Although he sometimes socializes with these patients, the encounters are also marked by contempt and rarely move beyond a platonic friendship.

Although he does occasionally encounter a woman who is interested in marrying him, he appears to have little interest in them. For example, when his mother attempts to match-make him with a nice Jewish girl from the neighborhood ("a fine, safe and sane girl ... who would watch the pennies and feed me well" and help him set up a "homely ... practice such as Dr. Smargel's," (48)), he rejects her proposal on the grounds that it wouldn't work with a "queer fish" like himself. The "Judy Rinkers" of the world are not for someone who wants to become that "strange kind of doctor known as a plastic surgeon" (48). When he is middle-aged and successful, Maltz falls briefly in love with a patient after giving her a "face-lift." However, as soon as he receives a message from his old love, Sylvia, he abandons his would-be fiancée without further ado. Sylvia, of course, has no intention to returning to Maltz, so that he is left, once again, alone with his fantasies of the ideal woman.

Drawing upon the Pygmalion myth of the sculptor who falls in love with his own creation and begs Venus to transform her into a woman, Maltz seems resigned to his fate, philosophically referring to the incident as the gods giving "a malicious twist to my elbow ... so that Pygmalion would spoil his Galatea and fall out of love with her" (194). Briefly saddened, he throws himself into his work. Ultimately, it is here that he finds a resolution of sorts for his problems with women. When he transforms Sylvia's daughter into the image of her mother, he has made her into his "statue" – not the "real thing," perhaps, but, nevertheless, a woman who is lovely enough for him to love.

Maltz idealizes women as beautiful objects and yet has difficulties with real

women. He describes his patients as objects of art, to be admired from a distance. And, indeed, he seems to prefer the beauty of his creation to the "real thing." As soon as his Galatea becomes a woman, Maltz runs away or seeks solace in his work. Maltz's constant search for the ideal woman goes hand in hand with his craft; he can create a perfect woman while shunning relationships with women of flesh and blood.

In conclusion, Maxwell Maltz constructs himself as an enlightened pioneer, endowed with impressive technical skills and the mentality of a scientist who is unafraid to take risks for the greater good. Although he is successful, he remains an idealist. He is determined to help the physically deformed and damaged, whether or not they actually want to be helped. He is a creator with the skills to not only remake his patients' bodies, but also their lives. Endowed with an almost god-like omniscience which enables him to see through his patients' motives to the "real" problem beneath, Maltz is the ultimate creator: god in a white coat. And, finally, he is a lover of beautiful women who resolutely refuses to settle for anything short of perfection.

Masculine stories

Autobiographies are structured differently, depending on whether the author is a man or a woman (Gergen and Gergen 1993). Men's autobiographies typically concern a high status or successful man in single-minded pursuit of his career. The protagonist generally has to do battle with opposing forces whereby he bravely tackles obstacles standing in the way of his goal. Men's autobiographies are about the "spirit defeating the flesh," whereby the protagonist displays bravado and self-assurance rather than giving way to self-doubt or feelings of vulnerability. Women's autobiographies, in contrast, weave together themes of achievement along with themes of love lives, children and friendship. The female protagonist is likely to express her emotions and women's stories are full of self-deprecation and uncertainty (Gergen and Gergen 1993: 196).

Doctor Pygmalion is a masculine story. It is a masculine story because the protagonist puts his career first. He has one goal and that is to become a successful plastic surgeon. His personal life is invariably subsumed under his career. Anecdotes about family or friends stand in relation to his career. His relationships with men are marked by competition and rivalry if they are powerful (his teachers, colleagues) and benevolent paternalism if they are not (his patients, his servant). If the hero is sometimes lonely or complains about not having a partner, this is, at best, a minor impediment to his well-being. Unlike a woman, he does not need relationships with other people in order to have a life which has made sense.

Doctor Pygmalion is a masculine story because it is structured as a typical heroic epic. The male protagonist has a quest, while the female is, at best, the object of that quest. As such, it resonates with American pioneer stories in which men seek adventure out West, where danger and excitement awaits them. Women, of course, are the ones who stay behind, minding the hearth. When Maltz rejects the safety of a neighborhood practice and the girl next door, he is simply enacting the story of the lonely cowboy riding out into the great unknown, more at ease with the uncertainties of the future than the certainties of his past.

Doctor Pygmalion is a masculine story because it celebrates mind over matter, rationality over irrationality, and abstract values over concrete needs of specific individuals. Unlike women's autobiographies which are oriented toward their own bodies

and emotions (and the emotions of others), this protagonist is disembodied. If he feels discomfort about the situation in which he must do his work (Berlin) or the fact that he is unable to maintain a relationship with a woman, he simply blusters his way out of it. His morality is all-encompassing and abstract ("noble and compassionate"), but is singularly oblivious to the concrete particulars of his patients' lives, let alone to their own desires and needs. It is his ideals rather than the wishes of his patients which are at stake.

And, finally, *Doctor Pygmalion* is a masculine story because it expresses the contradictory and ambivalent relationship between masculinity and femininity. It draws upon – and, indeed, is named after – the myth of Pygmalion – a myth which constructs men as subjects and women as objects. This myth has a long and venerable history, has been recycled several times, but in each rendition remains a parable of the dilemmas of masculinity. The original Pygmalion was a king of Cyprus who fell hopelessly in love with a statue of the beautiful Aphrodite. In his *Metamorphosen*, the Roman poet Ovid transformed the king into a sculptor with an aversion for women who decides to create a statue of a woman more beautiful than any mortal woman could ever be. As fate would have it, this Pygmalion falls hopelessly – and obsessively[12] – in love with his own creation and prays to the gods to give him a woman like his ivory statue. Venus takes pity on him, Galatea awakes, and they live happily ever after.

Freud took up the Pygmalion myth in his analysis of a popular novella of his time: W. Jensen's *Gradiva*.[13] This is the story of a young archeologist who falls in love with a relief of a young Roman girl – or, more specifically, with her characteristic gait – and becomes so obsessed that he travels to Pompeii in search of her. Freud (1909) treats this as a case of obsessional delusion, referring to the fatal combination of repressed male sexual energy and the equally masculine fear of intimacy with a real woman (most notably, the archeologist's childhood sweetheart). The most familiar rendition of the myth, at least for modern readers, is Shaw's play *Pygmalion*, written in 1916 (and adapted in 1956 as the popular musical *My Fair Lady*). This Pygmalion is a confirmed bachelor and woman-hater, Henry Higgins. The artist has become a professor of linguistics and his Galatea is the ignorant flower girl, Eliza, with a deplorable accent and working-class manners. Higgins decides to transform her into a lady with impeccable English.

What these renditions of the Pygmalion myth have in common is their portrayal of the "typical" male conflict between the desire for and fear of women. Feminist scholars have repeatedly linked masculinity – at least, in its white, Western, heterosexual forms – to men being socialized to suppress their identification with their mothers and to orient themselves to the unknown world of men outside the home (Chodorow 1978, 1989; Holloway 1984; Flax 1990; Segal 1990). This separation is fragile, leaving men vulnerable and inclined to project their weaknesses or feelings of irrationality or dependence on to women. The crux of masculinity, then, is an ambivalence between longing for the unreachable woman (the mother) and a fear of femininity in one's self. Pygmalions enact this prototypical masculine story in their intellectual or artistic idealization of woman and their aversion toward or contempt of actual women. They can escape their own feelings and embodiment, by projecting them on to women. They become the disembodied and powerful creators, while women are the passive objects, inert clay waiting to be shaped according to the artist's intentions. Pygmalions can play out their fantasies of being God. As Bordo (1987) has argued, man has – even since the ancients – attempted to overcome the

material exigencies of everyday life by associating the male with the Mind, the soul and divinity ("those qualities which the human shares with God" (Bordo 1987: 94)), and disassociating himself with all that is material, embodied, and female.

But the Pygmalion myth expresses the contradictions of masculinity as well. While Ovid's hero escapes with some help from Venus, latter-day Pygmalions have had to go it alone, remaining locked in their masculine obsessions and ambivalent relationships with femininity. Shaw's Pygmalion, Professor Higgins, merely shrugs his shoulders when his Eliza leaves him to marry another man. Jensen's protagonist prefers his hopeless love of an image of an ancient beauty, Gradiva, to his childhood sweetheart. And Maxwell Maltz – he continues to operate.

Masculinity and medicine

Doctor Pygmalion is not simply the particularized story of one man's life. It is the story of a profession. Maltz consistently presents himself as the mouthpiece of this profession, as the person whose task it is to set out the wonders of the "noble and compassionate" practice of plastic surgery. His "personal story" is, therefore, not so personal at all. It expresses and is shaped by the discourses which are part of his profession – the profession of plastic surgery.

Since Foucault, we can appreciate the significance of discourses for understanding the origins and nature of institutional and clinical practices. Medical knowledge is not simply constituted by the human subject but shaped by the discursive formations of the historical, cultural and social context in which it is produced. Just as Foucault could describe the emergence of the prison (1979) or the clinic (1973; 1975) through the accounts of prison directors or physicians, Maltz's autobiography provides evidence of the kinds of discourses which shape the practices of the emerging profession of plastic surgery.

The medical system is gendered, at the level of interaction between practitioners and patients, in the organization of its institution and practices, and in the conflation of its discourses with symbolic notions of masculinity and femininity. Historically, medicine emerged in the wake of a male-initiated take-over of women's control over healing and other matters related to reproduction like sexuality, birth, spirituality and death (Ehrenreich and English 1979; Hearn 1987).

Although the profession of medicine has since opened its doors to women, it still remains an indisputably male preserve. Gender segregation and exclusion of women from the higher echelons of medicine goes hand in hand with powerful medical discourses which construct women as archetypal patients: diseased, neurotic, and in need of repair (Ehrenreich and English 1979; Martin 1987; Jacobus et al. 1990). In contrast, men are viewed as eminently suited to the job of physician, while male patients are rendered invisible.[14] Medical professionality draws upon a gendered dichotomy between rationality and emotionality, whereby the patient is tied to the lifeworld through her emotions and her body while the practitioner may escape his emotions and body by maintaining a veneer of objectivity and "gentlemanly reasonableness" (Hearn 1987; Davis 1988). Rationality, objectivity and instrumentality are the hallmarks of medical science and masculinity. The image of science as a quest for discovery and control over the unruly forces of nature runs through modern science from Plato to the present day (Keller 1985). The male scientist is presented as the rational, disembodied mind while the object of his ministrations displays all features which are associated with femininity: irrationality, nature, and the body.

Plastic surgery is a quintessentially masculine profession or, to paraphrase David Morgan (1981), an example of masculinity in medical robes. Plastic surgery produces and reproduces masculinity as an integral feature of the historical, cultural and institutional practices and discourses of medicine. It reflects the gendered imbalances of medicine in its high incidence of male practitioners as well as its overrepresentation of women among its patients. It draws upon discourses of gender in its deployment of images of the physician as god-like creator rather than healer, in its tendency to privilege adventure over the mundane and everyday, and its idealization of feminine beauty (or woman with a W), while rendering ordinary women ugly, deficient, and in need of improvement (Young 1990).

In conclusion, *Doctor Pygmalion* enables us to understand why the profession of plastic surgery might be particularly attractive to male surgeons, while proving impenetrable territory for women as surgeons. It not only offers ample possibilities for the expression of masculinity – as lonely cowboys, as scientific heroes, or as god-like creators. It also provides a particularly compelling expression of and resolution to masculine fears of femininity, enabling the practitioner to idealize femininity while avoiding real flesh-and-blood women.

Notes

1 An earlier version of this paper was published in (1998) *Health: An Interdisciplinary Journal for the Social Study of Health, Illness and Medicine* 2(1): 23–40. I would like to thank Willem de Haan, Lena Inowlocki, Nora Räthzel, José van Dijck and Dubravka Zarkov for their helpful and insightful comments.
2 In 1995, 23.5 per cent of the specialists in family medicine and 30 per cent of the gynecologists were women, while female surgeons remained few and far between: 8.8 per cent of the general surgeons, 8.7 per cent of the plastic surgeons, 2.5 per cent of the urological surgeons, and only 0.02 per cent of the thoracic surgeons (American Medical Association, Physician Characteristics and Distribution 1996–1997).
3 This might be compared to other autobiographies which show the author at different stages in his or her life, family members and colleagues, places of residence or employment.
4 Throughout the remainder of this chapter, all references to Maltz's book will be given as a page number in brackets.
5 While several well-known plastic surgeons were operating in the US by the time Maltz became interested, the training programs did not allow students the experience of actually cutting up corpses – a practice which was permitted at the time in Germany.
6 Following the Second World War, the Veterans Administration organized a spate of "quickie courses" for physicians, designed to teach them the techniques of plastic surgery within two to three days (McDowell 1985). It seems likely that Maltz's trips to VA hospitals fall under that heading. While he presents this activity as a sign that he has arrived as expert in his field, McDowell refers to it as a "sordid chapter" in the history of plastic surgery, where established surgeons profited from their less successful colleagues and, at the same time, enabled poorly trained practitioners to engage in plastic surgery.
7 Although plastic surgery is one of the oldest medical interventions, it maintains an image of a nascent specialty. Contemporary plastic surgeons tend to discuss their field as still having to fight prejudice in order to be accepted as a full-fledged medical specialty.
8 This feature can be found in many biographies of famous scientists whose life is presented as an adventure story where the protagonist rejects the role of "dull lab worker" in favor of the solitary genius who stubbornly and sometimes arrogantly crosses his friends and colleagues in order to chart new horizons (Van Dijck 1997).
9 Contemporary plastic surgeons are also compelled to upgrade the image of their profession. Particularly in view of the enormous cosmetic surgery "craze" in recent years, surgeons are often suspected (and probably correctly) of operating with an eye to profit. Moreover, they run the risk of being viewed as spending their time indulging their primarily female clientele's trivial desire for beauty rather than helping patients who are suffering

from "real" problems. Like Maltz, these surgeons often justify their work with references to their altruistic motives and their work with "deserving" patients – usually men with industrial injuries or children suffering from burns or congenital birth defects.

10 Interestingly, most of Maltz's relationships with other men – his teacher and colleagues, his servants, Sylvia's husband – are fraught with competition. The only exceptions are his male, usually working-class patients.

11 Wilshire (1989) provides an interesting discussion of the use of God (and Goddess) mythology in the discourses of modern science. The image of Zeus disassociating himself from the lowliness of the body and its matter, including his own infancy and mother, and giving birth out of his head represents the male disembodied mind while women remain tied to their material bodies and unruly emotions and are, therefore, unsuited for scientific endeavors.

12 Ovid describes how the sculptor can't stop touching, caressing and kissing his ivory statue. He begins to dress her and adorn her with jewels, presenting her with small presents (canary birds, fruit). Ultimately, he places her on a divan in a reclining position, with cushions under her head (Ovid 1993: 243–97).

13 I would like to thank Janet Sayers for drawing my attention to this case study.

14 While contemporary plastic surgeons are prone to making statements about the increase in surgery among men, implying that equality has arrived in matters of appearance, they are notably reticent to elaborate on the particulars of men's difficulties with their appearance.

References

American Medical Association (1996/1997) *Physician Characteristics and Distribution*, 1996–1997 Edition, Chicago: American Medical Association.

Bordo, S. (1987) *The Flight to Objectivity: Essays on Cartesianism and Culture*, Albany: SUNY Press.

Brodzki, B. and Schenck, C. (eds) (1988) *Life/Lines. Theorizing Women's Autobiography*, Ithaca and London: Cornell University Press.

Chodorow, N. (1978) *The Reproduction of Mothering*, New Haven: The University of California Press.

——(1989) *Feminism and Psychoanalytic Theory*, New Haven: Yale University Press.

Davis, K. (1988) *Power Under the Microscope*, Dordrecht: Forum.

——(1995) *Remaking the Female Body*, New York and London: Routledge.

Denzin, N. (1989) *Interpretive Biography*, Newbury Park: Sage.

Ehrenreich, B. and English, D. (1979) *For Her Own Good*, London: Pluto Press.

Flax, J. (1990) *Thinking Fragments. Psychoanalysis, Feminism, and Postmodernism in the Contemporary West*, Berkeley: University of California Press.

Foucault, M. (1973) *Madness and Civilization: A History of Insanity in the Age of Reason*, New York: Vintage/Random House.

——(1975) *The Birth of the Clinic: An Archaeology of Medical Perception*, New York: Vintage/Random House.

——(1979) *Discipline and Punish: The Birth of the Prison*, New York: Vintage/Random House.

Freud, S. (1909) "Der Wahn und die Träume in W. Jensen's 'Gradiva,'" *Gesammelte Werke 7*, London: Imago Publishing Co., Ltd.

Gergen, M. M. and Gergen, K. J. (1993) "Narratives of the gendered body in popular autobiography," in R. Josselson and A. Lieblich (eds) *The Narrative Study of Lives*, Newbury Park: Sage.

Gilman, Sander (1991) *The Jew's Body*, New York and London: Routledge.

Hearn, J. (1987) *The Gender of Oppression. Men, Masculinity, and the Critique of Marxism*, Brighton: Wheatsheaf Books.

Holloway, W. (1984) "Gender difference and the production of subjectivity," in J. Henriques, W. Hollway, C. Urwin, C. Venn, and V. Walkerdine (eds) *Changing the Subject*, London: Methuen.

Jacobus, M., Keller, E. F. and Shuttleworth, S. (eds) *Body/Politics. Women and the Discourses of Science*, New York and London: Routledge.

MacDowell, F. (1985) "History of Rhinoplasty," in M. Gonzalez-Ulloa (ed.) *The Creation of Aesthetic Plastic Surgery*, New York: Springer-Verlag.

Maltz, M. (1954) *Doctor Pygmalion. The Autobiography of a Plastic Surgeon*, London: Museum Press Ltd.

Martin, E. (1987) *The Woman in the Body. A Cultural Analysis of Reproduction*, Boston: Beacon Press.

Morgan, D. (1981) "Men, masculinity and the process of sociological enquiry," in H. Roberts (ed.) *Doing Feminist Research*, London: Routledge and Kegan Paul.

——(1992) *Discovering Men*, London and New York: Routledge.

Ovid (1993) *Metamorphosen X*, Amsterdam: Athenaeum-Polak and Van Gennep.

The Personal Narratives Group (ed.) (1989) *Interpreting Women's Lives. Feminist Theory and Personal Narratives*, Bloomington and Indianapolis: Indiana University Press.

Plummer, K. (1983) *Documents of Life*, London, Allen and Unwin.

Rogers, B. (1971) "A chronologic history of cosmetic surgery," *Bulletin New York Academy of Medicine* 47(3): 265–302.

——(1995) *Sexual Stories: Power, Change and Social Worlds*, London: Routledge.

Segal, L. (1990) *Slow Motion: Changing Men, Changing Masculinities*, London: Virago.

Stanley, L. (1992) *The Auto/biographical I*, Manchester and New York: Manchester University Press.

Stanley, L. and Morgan, D. (1993) Special Issue, "Auto/biography in sociology", *Sociology* 27(1).

Shaw, G. B. (1916) *Pygmalion*, London: Penguin Books.

van Dijck, J. (1997) *Imagenation: Popular Images of Genetics*, London: Macmillan.

Wilshire, D. (1989) "Uses of myth, image, and the female body," in A. Jaggar and S. Bordo (eds) *Gender/Body/Knowledge*, New Brunswick: Rutgers University Press.

Lisa Cartwright

COMMUNITY AND THE PUBLIC BODY
IN BREAST CANCER MEDIA ACTIVISM[1]

It would be impossible to understand health cultures in the United States without acknowledging the crucial role of media in their formation. Television, print media, cinema, on-line discussion groups, and medical educational computer programs are important, if underconsidered, means through which health issues are taught, communicated and lived. This chapter will consider a few examples of breast cancer media produced by women who identify as activists, alternative media producers, and members of the community of women affected by breast cancer. First, however, I want to address some of the problems that have made it difficult to think through questions of identity and community around health culture without also considering the role of media (film, print media, photography, video and digital technologies) in the incorporation of illness and survival as aspects of identity and community. In the discussion that follows, I try to demonstrate the importance of focusing on "local" or "minor" media productions – work by independent or alternative media producers, personal video, and art photography – rather than mainstream media. As I will show, the concepts community and media function in highly specific ways within health cultures, demanding analytic strategies which take into account the specificity of media users and audiences.

Health and community

Arenas of political action devoted to health care, illness and disability historically have formed on the basis of collective responses to experiences to do with illness and the health care system. Advocacy and activist groups, self-help and support groups, and more loosely based networks of individuals, are organized on the basis of shared experiences which might include having a particular illness and/or treatment, protesting at a lack of access to medical treatment, advocating for research, managing pain, needing emotional support, negotiating loss of bodily functions, identifying as a survivor, confronting iatrogenic illness, facing ongoing disability, or doing support work or care-giving. Whereas broad social networks have formed around breast cancer generally, for example, the National Breast Cancer Coalition (NBCC), groups have also organized on the basis of these more delimited issues as well as on the basis of identity or region (for example, the Chicago Lesbian Community Cancer Project,

or the Atlanta-based National Black Women's Health Project). What are the implications of using the terms identity and community to refer to groups that coalesce around illness and/or disability? There are important discontinuities between health status as a category of identity or community and the more familiar identity categories of ethnicity, race, nationality, gender, class and sexuality. Akhil Gupta and James Ferguson present a version of current thinking on community formation that helps us to better understand this issue. They state that:

> something like a transnational public sphere has rendered any strictly bounded sense of community or locality obsolete. At the same time, it has enabled the creation of forms of solidarity and identity that do not rest on an appropriation of space where contiguity and face-to-face contact are paramount.
>
> (Ferguson and Gupta 1992: 9)

In the fragmented world of postmodernity, Gupta and Ferguson argue, space has been reorganized in a way that forces us to rethink the politics of community, solidarity and cultural difference. They make this point with regard to an issue wherein space – its occupation and its ownership – is essential in a particular way: they are concerned with the establishment of groups such as displaced and stateless peoples, ethnic groups, exiles, refugees, and migrants. But what are the implications of this idea of the obsolescence of bounded community and locality when we consider collective identity as it forms, provisionally, on the basis of illness, disability, and the fight for access to treatment? Do reterritorialized space and transcultural formations become metaphors, or is there a parallel reconfiguration and dispersal of collective identity in the postmodern experience of breast cancer? For example, would it be accurate to describe survivors of breast cancer as a transcultural or transnational community because breast cancer strikes women of all classes, ethnicities and nationalities?

"Community" formation on the basis of health and illness is always highly provisional and unstable, in part because group formation takes place on the basis of a condition or experience that is always strongly determined by more conventional identity categories. Illness is not necessarily attached to, but must always be lived through, other categories of identity and community – categories that come into play at every level of the construction of publics and cultures around disease. In short, illness may take on the trappings of an identity category; it may be the basis for the formation of a (highly conditional) community; and it may be the grounds for the formation of a public sphere. But the experiences and cultures of illnesses none the less are always lived through identity positions and arenas of public and professional discourse that exceed the frameworks and cultures of disease. This is further complicated by the fact that "illness communities" are comprised of people whose respective identities as ill or disabled shift throughout the course of a disease. Within breast cancer communities, one might occupy the position of caregiver, patient, and survivor at different points in time, or even simultaneously.

While distinctions among these positions are fairly well acknowledged within groups formed around health issues, differentials of class, cultural identity, ethnicity and sexuality are quite often bracketed in order to underscore the unifying factor of disease. The on-line breast-cancer listserv, for example, is comprised of women with breast cancer, survivors, and their caregivers (doctors, health professionals, hospice

workers, friends and family). The individuals who participate in this forum forge conditional bonds on the basis of their day-to-day experiences. But this kind of tran-scultural alliance sometimes problematically fulfills the conditions of Habermas' concept of a liberal public sphere, rather than becoming an increasingly more interac-tive, less rigidly class-, race- and nation-based model of a public. In broad-based groups like the breast-cancer listserv or the NBCC, participants from disparate back-grounds bracket cultural differences on the basis of a common experience with breast cancer. This approach is to be lauded for its emphasis on the pervasive scope of the disease, but it provides limited means for addressing the class and cultural specificity of the experience, diagnosis and treatment of breast cancer among women of different ages, economic groups, regions and designated races. Following the model of white middle-class women's organizations in the 1970s and earlier, broad-based support groups tacitly uphold the liberal fantasy of a quasi-universal discourse among women.

What I am arguing against here is the idea that disease is the great leveler, or that coalition politics can or should smooth over differences as they impact experiences of disease and disability. Much of mainstream breast cancer media so far has elided these differences. For this reason, I have chosen to focus on media texts that emphasize the specificity of different women's experiences with breast cancer. The work that I have singled out for attention falls into the categories of alternative or activist media. Rather than looking at material such as public service advertisements, prime-time feature stories, and Lifetime television specials, I will consider instead activist and art photography and film. Before turning to this work, however, I want to look more closely at some presuppositions that often accompany the analysis of non-mainstream media.

Health care and alternative media

The analysis of activist media often relies on a binary model that sets off local, oppo-sitional, community-based groups against the globalizing force of mainstream medicine and media institutions. Much recent health-care activism, however, crosses the boundaries between these two spheres. Groups like ACT UP (AIDS Coalition to Unleash Power) and the NBCC include among their members media and medical professionals with entrenched institutional practices as well as patients and lay advo-cates. In many areas of political organizing, alliances, however uneasy, have been forged across genders, classes, professions and cultures. What is new here is not what counts as community or coalition, but the fact that the crisis of illness, and not an aspect of shared identity in the conventional sense, is the basis for alliance. Since the 1980s we have seen an unprecedented degree of influence over medical policy brought to bear by medical counter-cultures composed of patients, activists and non-professional caregivers. The very idea of a counter-culture as an extra-institutional force becomes complicated when we consider this traffic between the medical profes-sions and activist groups and the role of laypersons in policy-making.

Some of the more significant media activity shaping US health culture is taking place through advocacy, activist and community health groups using visual media as a prime form of public intervention. It is essential to consider how agents within these arenas gain a public voice; how they acquire access to decision-making at the level of the institution or the state; and what the relationship is between media productions that originate from a position of activism or community politics (AIDS videos, breast

cancer awareness pamphlets) and those that originate within "minor" public spheres whose position at the margins of public culture does not necessarily stem from oppression, or from a stance of opposition. Progressive work in medicine is not necessarily coming only from practices identified as counter-cultural or as oppositional, as I will demonstrate below in the case of the work of photographer Matuschka. When we look at the interaction among various media forms (political cinema, mainstream photojournalism) and various public constituencies, it becomes difficult to theorize "media activism" as a unitary sphere situated outside institutional medicine, or outside a mass public culture.

Viewed in this light, the binaries of a public and a counter-public, mainstream politics and activist politics, become less than productive analytic models. These formulations parallel the media studies binaries of broadcasting and narrowcasting, mainstream media and alternative media. The terms counter-public or counter-cultures suggest oppositionality, when in fact many alternative publics are forged around the increasingly fragmented special interests that constitute the global market. Similarly, the term narrowcast implies marginality of those cultures who are targeted (ethnic groups, special interest groups, exilic cultures, language groups, and so on), when in fact these groups often are comprised of financially and politically powerful, if numerically small, sectors of the viewing public.[2]

Within media studies, the concept of the local more often appears in writings about alternative media production, decentralized community-based programming, and activist media. The term carries connotations of appropriation and resistance to mainstream media politics and institutionally sanctioned uses of technology. If much of the literature on media assumes a singular monolithic form, failing to account for the specific conditions of discrete media forms and uses, writings about alternative media often construct the flip side of that image – what Coco Fusco (1988) has dubbed "fantasies of oppositionality," totalizing accounts of resistant media strategies that do not take into account the partial and specific constituencies, locations and effects of particular media interventions.

In the case of the breast cancer media texts considered in this chapter, gender, class and cultural identity become key factors in the formation of distinct public cultures around breast cancer. Moreover, I shall argue that within these cultures there is no unitary concept of breast cancer. The disease is represented and lived through such issues as class, beauty, fashion and aging. Emotions like anger, pain and fear are tied to the correlated effects of disease and aging, hair loss through chemotherapy, and the physical, visible transformation of that iconic and fetishized body part, the breast. Audre Lorde emphasized this cultural aspect of breast cancer in *The Cancer Journals* when she criticized "other one-breasted women" for "hiding behind the mask of prosthesis or the dangerous fantasy of reconstruction" promulgated by groups like Reach to Recovery (R2R), the American Cancer Society's signature program for women with breast cancer (1980: 16). R2R, developed by breast cancer patient Therese Lasser in 1952 (when the Halsted radical mastectomy was the conventional treatment), was based on the then radically new idea that lay women who had experienced breast cancer could provide a unique form of emotional support for other women in recovery. In officially adopting this program in 1969, the ACS placed certain topics off limits for discussion, such as family relationships, doctors, and the scar itself, emphasizing instead the goal of convincing women with mastectomies that they do not have a handicap but a condition from which they can recover – given the right attitude, clothes and prosthesis. Lorde cautioned that this

sort of "cosmetic sham" would undermine the sense of community and solidarity necessary for women with breast cancer to organize effectively (1980: 16).[3]

The circumstances that Lorde described in 1980 – the depoliticizing cosmetic cover-up of not just the (missing or altered) breast but the cultural and personal diffi-culties surrounding the disease and its aftermath – have taken on new proportions. In 1988, the ACS launched "Look Good, Feel Better," (LGFB) an initiative conducted jointly with a charitable foundation set up by cosmetic manufacturers in which women receiving breast cancer treatment are invited to their hospitals for LGFB programs, essentially group make-over workshops in which they get tips on such things as devising stylish head coverings and applying make-up. Anthropologist Janelle Taylor, in a critique of the marketing of beauty products to women under the guise of charity, describes an LGFB ad that appeared in the magazine *Mirabella* concerning "appearance-related side effects of breast cancer." The ad argues that "When you give yourself an original Oscar de la Renta design, you're not the only one who gets something beautiful. ... You're helping in the fight against breast cancer. ... So give. And get" (quoted in Taylor 1994: 30). Often marketed in the conjuncture of breast cancer and fashion are particular items which take on status as fetish and icon (the scarf as a means of concealment and adornment, standing in for lost hair; the shoe as a fetish object *par excellence*). A similar message is conveyed in an ad for Larry Stuart shoes, part of an editorial spread promoting the fall 1994 three-day charitable event of the Fashion Footwear Association of New York (or FFANY, an acronym that suggests displaced attention from breast to butt?). The event, sponsored by 800 companies, was a shoe sale held at the Plaza Hotel in New York. The ad presents a photograph of mud-covered hiking boots with the caption "These are for war." Below is a second image – a pair of classy black suede T-strap pumps with a matching evening bag. These shoes, the ad tells us, "are for the war on breast cancer."

If these are part of the uniform for the war on breast cancer, we might ask, then where is the battleground? Apparently "the foot that comes down against breast cancer," to borrow a line from the Larry Stuart ad, is shod in the signifiers of conser-vative femininity. My issue with this ad is not that it suggests that activists might wear heels, or that corporate America is not a viable battleground for cancer activism (it most certainly is). Rather, the ad is part of a broader trend in which liberal and right-wing campaigns appropriate the strategies and language of more progressive campaigns and movements, changing their constituencies and goals in the process. It has been widely acknowledged that AIDS activism of the 1980s and early 1990s was a model for the development of a broad-based campaign against breast cancer in the 1990s. But whereas in the 1980s AIDS activism was hardly a mainstream campaign, by 1996 breast cancer had emerged, in the words of journalist Lisa Belkin (1996), as the year's hot charity.

Lorde (1980) has argued that "the socially sanctioned prosthesis is merely another way of keeping women with breast cancer silent and separate from each other." The ad and programs of the 1990s described above, all of which promote beauty aids as prosthetic means of recovery, suggest instead that the media cultures of fashion and beauty technologies do provide a resource for community building. However, this process appears to be occurring predominantly among those women concerned about breast cancer who are invested in conventional notions of gender, body and beauty. The problem we face is not that women are depoliticized, silent or separate, but that the media-savvy breast cancer activism that has emerged in the late 1990s

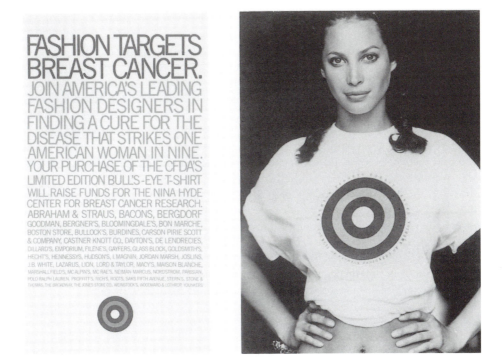

FIGURE 8.1 Advertisement for a T-shirt to raise funds for breast cancer research, appearing in women's magazines in the mid-1990s.

constructs the breast cancer community around a set of signifiers that includes white, straight, middle and upper class, urban, educated, professional, and conservative. In addition to marginalizing women who are poor or working class and/or less educated (and who are less likely to have access to information and treatment), this concept of community also fails to acknowledge the lifestyles and concerns of women who do not share the politics, fashion preferences or sexual orientation of the collective profile tacitly generated by this media campaign.

In the texts I consider below, alternative media producers take up breast cancer via beauty and fashion in reflexive and innovative ways to provide a new, non-normative means of constructing the post-operative body. The formation of communities and public cultures on the basis of breast cancer politics entails a reconfiguration of the post-operative female body in public space. Breast cancer culture becomes a crucial site for the revaluation of what counts as a beautiful body, and what meaning age, race and cultural identity have, in a culture where disease and health technologies are reconstructing what a healthy body is, and what particular body parts mean.

Activist photography

Alisa Solomon's important article chronicling breast cancer activism, "The politics of breast cancer," appeared in the *Village Voice* in May 1991.[4] Significantly, the article begins with an ironic anecdote about a post-op breast surgery patient named Miriam who is visited by a R2R volunteer – a woman with big hair, long nails, and a body-hugging Lana Turner-style sweater. To Miriam's consternation, the volunteer's main agenda is the prosthetic recovery of Miriam's breast – that is, her body's public

return to normative standards of female bodily form. Up until the early 1990s, the typical media image of a woman with breast cancer was the smiling, middle-aged white woman, identified as a survivor – a woman whose clothed body and perfectly symmetrical bustline belied the impact of breast cancer. A 1995 episode of the TV medical-drama series *Chicago Hope* typifies this public fantasy of survival as physical restoration. This particular episode features a teenage girl. She is African American and beautiful – and, tragically, she has breast cancer. This perfect young body loses a breast to mastectomy. However, by the end of the episode a skillful plastic surgeon returns the girl's body to its near-perfect state. We are given a view of the young woman's reconstructed body as her mother exclaims to the doctor: "How do you do what you do?" Here the body of the woman with breast cancer is finally made public. However, the body this episode makes available for public display is a black woman's body, a move that replicates the medical tradition of using the bodies of black women for teaching demonstrations and textbook examples. The privacy of white women's experience with breast cancer is thus maintained. Moreover, this episode culminates by displaying the body of the woman with breast cancer at a moment when all signs of disease and its treatments are erased. Elided is not only the scar of the un-reconstructed breast, but the fact that the great majority of women with breast cancer are far from young. Like many print advertisements promoting mammograms, the *Chicago Hope* episode makes invisible the factors of age and associated issues of beauty that are relevant to the majority of women with breast cancer, while including black bodies only to replicate a centuries-old problem in Western medical representation.

The repression of the image of scar tissue, hair loss and aging is not limited to the popular media. Two years after the publication of Solomon's article, her title, "The politics of breast cancer," was appropriated by a flurry of feature articles published in the scientific, liberal feminist, and mainstream presses. In 1993, *Science* (Marshal *et al.* 1993) and *Ms* (Rennie *et al.* 1993) both published special sections under this title. Interestingly, neither series featured the female body in any significant way. *Ms* used a typeface graphic design on its cover and illustrated the personal vignettes that were scattered throughout the essays with small, flattering portraits of smiling "survivors" with symmetrical bustlines. *Science* opted for what the editors described as "a statistical portrait of breast cancer" (a display of graphs and charts) along with the "great men of science" approach (the only portraits in the piece were head-shots of scientists credited with research breakthroughs).

Surprisingly, it was the *New York Times Magazine*'s variation on Solomon's title theme that provided a radical twist on the mainstream tendency to disembody breast cancer. To illustrate "The anguished politics of breast cancer" by Susan Ferraro, the cover story for 15 August 1993, the *New York Times Magazine* editors chose for the cover a photograph of a stylishly thin woman wearing a fashionable white sheath dress and a head scarf, her dress cut low on the diagonal to reveal the woman's mastectomy scar. The prominently placed publication of this image, a self-portrait by the artist Matuschka titled "Beauty Out of Damage," marked a watershed in media representations of breast cancer. Matuschka, an ex-fashion model and photographer, not only exposes her scar for public viewing, but artfully frames and lights it for optimal display. As she puts, "If I'm going to bother putting anything on my chest, why not install a camera?" (Matuschka 1992: 33). The scar occupies the space closest to the center of the page, a locus toward which the eye is drawn by angles cut by Matuschka's arm and the shadows created by her prominent bone structure and the

gown's neckline. Matuschka's head is in profile, turned away from the camera, as if to dramatize the large caption that fills a portion of the page to pronounce: "You Can't Look Away Anymore."

The publication of "Beauty Out of Damage" was a watershed in the public representation of breast cancer because it rendered public an image previously familiar only to medical students, doctors, and women and their care-givers, families, and close friends. The image stunned the *New York Times* readers because it exposed physical evidence of breast cancer surgery that previously had been subject to repression in the mainstream press, with its images of smiling survivors and charts. It generated a vast outpouring of commentary by readers both in support of and opposed to the paper's editorial decision to use this image on its magazine cover. While some readers saw in the photograph the message that women who have undergone mastectomy are not victims to be pitied and feared, and the altered or missing

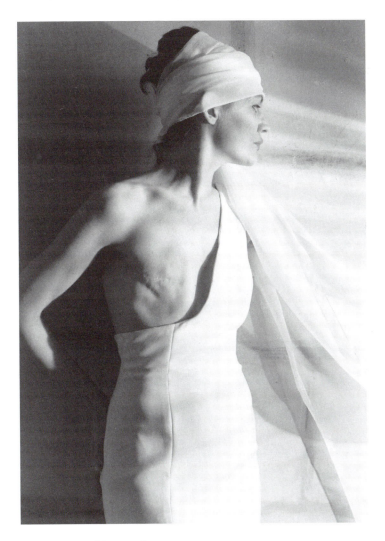

FIGURE 8.2 "Beauty Out of Damage"

Source: © Matuschka (1993).

breast as something not to be prosthetically and journalistically covered over and restored, others saw the image as an inappropriate display of private parts and private matters. The issues that concern me most, though, are the photograph's representation of age, beauty and agency, and its apparent evocation of the natural and the technological as they pertain to these issues.

Solomon, in her account of Miriam and the R2R volunteer, suggests that the volunteer projects an outmoded politics of the body on to the post-operative Miriam. She relates that Miriam is offended by the volunteer's assumption that prosthetic simulation or restoration is the first step to recovery. Solomon seems to advocate, along with Lorde, a public body that bears its scar as a natural and perhaps even healthy condition. This body is represented in a photograph used to illustrate her 1991 *Village Voice* article, photographer Hella Hammid's 1977 portrait of Deena Metzger, titled "The Warrior."

Metzger was 41 years old when she was diagnosed with breast cancer in 1977. In an interview, she recalls that after her mastectomy "When I went to a health club – even a women's health club – I noticed that I was the only one in the place with a mastectomy. I began to understand that women who had mastectomies were not showing their bodies." A poet and novelist who had been fired from her tenured professorship for teaching a poem she had written about censorship (she eventually won an appeal in the Supreme Court), Metzger was not one to comply with the times and hide her body. Instead, she adorned her scar with a tattoo so as to better display it. "If I were sitting in a sauna or I would be swimming or something, because my

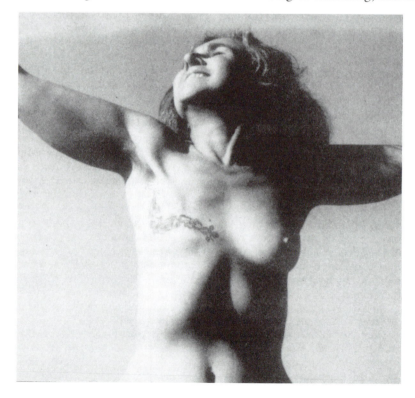

Figure 8.3 "The Warrior"

Source: Hella Hammid (1977).

chest was tattooed, it was implicit that someone could look at my body," she explains. "In this intimate setting, women would turn to me and say, 'Thank you,' and they felt relief. They saw having a mastectomy was not the end of the world."[5]

Wishing to document the scar and tattoo, Metzger contacted Hammid, whose previous work included child photography shown in "The Family of Man" exhibition curated by Edward Steichen for the Museum of Modern Art in the 1950s. "The Warrior" features the nude torso of Metzger, her white skin, naturally curly hair, and exuberant expression framed against a backdrop of clouds. Her arms reach out in a gesture of openness to nature and the cosmos – a gesture that also exposes fully her single breast and her scar and tattoo, itself an image evoking nature (a tree branch). Like the image of Matuschka, this photograph puts a positive and politicized spin on the scar and the one-breasted female body, evoking Lorde's fantasy of an army of one-breasted women descending on Congress (1980: 16). But the two images differ in an important way: Metzger's curly hair, unclothed torso, and setting evoke an aesthetic of natural beauty and health. She is shot against the sky, as if euphorically reaching to recovery without the aid of technology. As journalist Delaynie Rudner has remarked, the image "draws you in with a touch of innocent hippie celebration" (1995: 15). Rudner describes Hammid's photograph of Metzger as the perfect "first" in the non-medical imaging of a mastectomy scar. Whether or not this is true, the image certainly presented a stunning alternative to the ongoing medical tradition of repre-senting mastectomies, wherein women's faces are blacked out or their heads cut off to maintain anonymity. "The Warrior" sends a clear invitation to look and to acknow-ledge that a mastectomee can be healthy and happy without being physically "restored."

Matuschka's self-portrait is a far cry from this upbeat late 1970s depiction of pleasure in the post-operative body in its "natural" state. Matuschka occupies a stark environment suggesting both clinic and urban art studio – sites where bodies and body images are technologically transformed. Like Metzger, she looks away from the camera; however, her expression is serious if not severe. She is clothed in a form-hugging sheath dress that suggests both a hospital gown and formal evening wear, a garment that evokes the body's discipline and restriction within the terms of high fashion. Her head scarf, covering her short dark hair, is reminiscent of the turbans preferred by some women to conceal the fact of their hair loss as a result of chemotherapy treatments. Matuschka's public image of breast cancer clearly advo-cates pushing the envelope of cultural expectations about the body within the fashion industry: She "looks forward to the day *Vogue* magazine would consider devoting an entire issue to the dozens of beautiful one-breasted women who live all over the world" (Matuschka 1992: 33). While Metzger's scar is displayed in a manner that seems to promote its joyous revelation, Matuschka's is artfully lit and framed to emphasis the role of concealment and display in its disclosure. And whereas "The Warrior" puts forth the post-operative woman as a naturally beautiful figure, "Beauty Out of Damage" suggests a concept of beauty whose aesthetic involves an apprecia-tion of the fashioning of the body. The photograph seems to suggest that far from destroying beauty, mastectomy can be appropriated for a politicized display of high-tech beauty. In a new twist on technoaesthetics, mastectomy joins the repertoire of body-altering surgical techniques that have gained currency in 1990s mainstream fashion, techniques that include breast prosthetics, implants and reconstruction; lipo-suction; face lifts; tummy tucks; eyelid reconstruction; and body piercing. While some of these techniques are associated with the impetus to render the body closer to cultural norms, others appeal to cultural constructions of the exotic or the unique.

While the association of one-breastedness with disease makes it unlikely that this condition will ever be incorporated into mainstream beauty culture, Matuschka's photograph goes a long way toward placing the fact – and the look – of this bodily state into public consciousness. I am not arguing that Matuschka's self-portrait critiques the technological alteration of the body offered in processes like breast reconstruction or the use of prostheses. Rather, my point is that this portrait fore-grounds the scar as a physical and aesthetic transformation of the body that is as significant to the experience of breast cancer as these other techniques and their more conventional (and familiar) results. In this image, Matuschka has opted to reclaim the scar as an object of aesthetic and political significance and, more profoundly, as an object of fascination, if not beauty.

Despite its appearance in such a well-respected public site as *The New York Times Magazine*, Matuschka and her photograph, "Beauty Out of Damage," were not embraced by the breast cancer community as universal signifiers of the current state of breast cancer politics. The magazine cover image was nominated for a Pulitzer prize in 1994, but this moment did not necessarily mark a shift in the public politics of breast cancer. The photograph, like previous and subsequent work produced by Matuschka, was not received with universal enthusiasm. That some readers were dismayed by the editorial decision to use the image is clear from some of the many letters to the editor that followed the story's publication. Indeed, author Susan Ferraro forewarned readers of the controversial nature of Matuschka's work: "Her poster-size self-portraits have shocked even some of her mainstream sisters," she writes. This is not surprising, since Matuschka's work circulated primarily in activist and art venues such as demonstrations and exhibitions including the Women's Health Show, a multi-site show mounted in gallery spaces around New York City in the winter of 1994.

Despite this public perception of Matuschka as too controversial or too radical a figure, her identity as an activist and member of a health-care counter-culture is far from secure. Originally a photographer's model, Matuschka's transition into breast cancer activism was, in her own words, by chance. Although a member of the Women's Health Action Mobilization (WHAM!), an activist group close to ACT UP in its tactics and structure, Matuschka's relationship to health activism seems to have been largely through the group's embrace of her work. As she explained in an inter-view,

> WHAM! discovered me. I didn't even know what WHAM! was. I was at a talk-out on breast cancer in Washington, D.C., in front of the legislature and various other politicians back in 1991. I was on chemotherapy. I was wearing a blonde wig, and I had already made a bunch of posters ... Evidently, when I got up and spoke I moved a lot of the audience. There were two or three WHAM! members there, and they had just started a breast cancer department. They said that they would like to use one of my images, and asked me to come to one of their meetings. So I went to their meetings. That's how it began.
>
> (Matuschka, quoted in Cartwright 1994)

Conventions like the Washington talk-out provided Matuschka with a venue to market her photographs, in the form of postcards and posters. It was at the Breast Cancer Coalition Convention in California in May 1993 that Susan Ferraro encoun-tered Matuschka by chance, displaying her posters on her own body, sandwich-board

style (she had been barred from selling them). Andrew Moss, the editor of the *New York Times Magazine*, explained that Matuschka was called when the magazine decided to run Ferraro's story, which included material on Matuschka, at the eleventh hour, and they had only a few days to locate a cover image. According to Matuschka, the magazine specified that they wanted an image with a face but no breast. Moss' account suggests that the photo struck the editorial team "like a hammer," leaving them unanimously committed to using it for the cover (quoted in Rudner 1995: 24–6).

Matuschka's ambiguous status as, on the one hand, conventional model and art photographer and, on the other, activist by default, allowed her to emerge as a public icon of breast cancer activism in a mainstream media venue like the *New York Times*. Similarly, her ambiguous status as both youthful/beautiful and "damaged" (to quote the term she chose for her photograph's title) allowed her image to play a particular role for a particular set of readers. For the photograph in question was undoubtedly targeted to a very specific readership, those who buy the *New York Times* – those women whom Ferraro identifies as the "mainstream sisters" who might be offended by Matuschka's more daring work (see Figure 8.2). Presumably these women might be willing to participate in "activism" in the form of liberal political pressure groups and advocacy organizations – FFANY, for example. The *Times* tacitly marketed Matuschka the activist as an evocative but acceptable symbol of white, urban, middle-class, professional women's breast cancer activism. Ferraro's article documents and constructs an activist countersphere whose ties to nineteenth-century liberal counter-spheres of women-only voluntary associations are strikingly apparent, if not stated outright. Breast cancer, in this formulation, is a disease with its own class aesthetic, culture and constituency.

In sum, this image that apparently functioned as a mass public icon was in fact identified with a relatively elite sector of women. The public image of breast cancer put forth in the photo tacitly incorporates whiteness, youth, thinness, and urban chic as core elements of the collective body for which the activist feminist body collectively speaks. Yet very rarely do we see public representations of older women (in their fifties and sixties, say), who constitute the greater majority of breast cancer cases in the US and who certainly comprise a good percentage of the *New York Times Magazine* readership. Photographs like the self-portrait of artist Hannah Wilke and her mother, from a series produced between 1978 and 1981, are much less likely to circulate in public venues. This image documents Wilke's mother's breast cancer. Wilke, like Matuschka, built her career on self-portraits, many of which featured her nude and youthful, slender body. In the early 1990s, Wilke ended her career with "Intra-Venous," a series of nude self-portraits of her own aging and cancer-ridden body. Not surprisingly, this series, which documents her treatment for lymphoma (the disease from which she died in 1993), received far less attention than her earlier work.

These points about the factor of age in representations of breast cancer lead me dangerously close to making an argument in favor of some sort of media realism: "breast cancer campaigns should depict older women," and so forth. This is hardly my goal. Rather, I am in favor of representations that take up the complexities of age and beauty as they pertain to specific groups of women for whom breast cancer is most immediately a concern (women in their fifties and sixties) as well as those women categorically left out of discussions about breast cancer media (for example, black women). It is worth recounting here a well-known tenet of feminist film

FIGURE 8.4 "SOS – Starification/Scarification: Self-Portrait of the Artist with her Mother
 Selma Butter" (1978–81) by Hannah Wilke
Source: © the estate of Hannah Wilke. Courtesy Ronald Feldman Fine Articles of Agreement, New York. Photo
 credit: D. James Dee.

theory: audience members do not always or necessarily recognize themselves in
images of "their own kind" – that is, older women may not necessarily identify any
more with images of other older women than they would with images of, say,
younger women. (If this were not the case, Matuschka's image would not have
received the broad-based response that it did.) Perhaps the inordinate number of
representations of youthful, slender bodies in mainstream breast cancer media
campaigns is not an error on the part of media producers, but an effective use of the
mechanisms of identification and fantasy that invite viewers to look at and identify
with particular bodily ideals and particular cultural norms, regardless of their own age
and appearance.

To elaborate on this possibility, I will turn to a second media text, Ngozi
Onwurah's *The Body Beautiful* (1991), an experimental documentary film about the
relationship between a young woman – a teenage biracial fashion model – and her
mother, a white woman in her fifties who is disabled by rheumatoid arthritis and who
bears the memories and the scars of breast cancer surgery. This loosely autobiograph-
ical film foregrounds the cultural aspects of breast cancer that are repressed not only
in the erasure of the post-operative body, but in the elision of cultural difference
among women impacted by the disease.

The body beautiful

In the United States, Ngozi Onwurah has been represented as a black British film-
maker, a documentary film-maker whose work circulates in the women's film festival
circuit. These designated categories of race, nationality and genre inform the recep-

tion of her three best-known films currently in circulation in the US (*Coffee-Colored Children*, 1988; *The Body Beautiful*, 1991; and *Welcome to the Terror Dome*, 1994). But what is less than clear from the promotion of her work in the US is that Onwurah is not only British but also Nigerian. Whereas in the States she is mainly identified as a black film-maker, in the UK she is recognized (and identifies herself) as mixed race. Her films are also difficult to categorize within the limited terms of American film criticism: they combine techniques of conventional and experimental documentary and narrative, resisting categorization within any of the categories of "Black British cinema" familiar to American independent film audiences.

By introducing Onwurah in this manner, I mean to highlight the fact that race is as provisional and circumstantial a category as illness or disability. As *The Body Beautiful* aptly demonstrates, cultural identity and disability can also be interconstitutive categories. While Onwurah shares a history, a national identity, and representational politics with many black British film-makers, her work is also structured through a discontinuity that also shapes cultural identity and representational strategies in highly particular ways – that is, in ways that, for Onwurah, have to do not only with having been raised in Nigeria and exiled to England at age nine, but with her subsequent experience as an exoticized beauty, a professional model whose commodity is her light-skinned body and her ambiguously African-Anglo features. Both *The Body Beautiful* and Onwurah's earlier film *Coffee-Colored Children* demonstrate that race is an historical category that can be structured through experiences such as exile, loss of a father, a mother's disability, and a general loss of the unity and stability of such basic categories as family and body. Onwurah's identity is deeply informed by her status as the daughter of a white, disabled and scarred mother – a woman with whose body she strongly identifies, and a woman whose erotic and identificatory investment in the beauty, youth and color of her daughter's body is also profoundly deep. *The Body Beautiful* is primarily about Madge (Ngozi's mother) and Ngozi Onwurah's relationship to public perceptions of aging, disfigurement and disability. But, unlike the print media breast cancer coverage discussed earlier, questions of identity (nationality, race, class, sexuality and gender) and related issues (health, beauty, aging) are the fundamental terms through which this film engages with public views about breast cancer.

In the central scene of the 30-minute film, Ngozi convinces her mother to accompany her to a sauna (coincidentally also the site of Metzger's enlightenment about the public repression of the scar). Inside the sauna, women lounge bare to the waist. Madge keeps her towel wrapped up high, covering her mastectomy scar. But she dozes off and the towel slips, exposing her scar. While Madge sleeps, Ngozi witnesses the stares of the women in the sauna as they look and turn away from her mother's scar. Madge wakes up, almost instantly feeling for her towel and pulling it up over her chest, looking around in shame to see if anyone has noticed.

This scene performs a function not unlike that of Matuschka's photograph: the taboo mastectomy scar is placed on display, shocking a public audience, while the performer of this scene averts her gaze from the eyes of the viewer. But there are crucial differences between these texts. Whereas Matuschka's youthful and fashionably thin body is framed by a high-fashion dress, Madge's plump, aging torso is haphazardly draped with a towel. Moreover, while Matuschka clearly poses for her photograph, we gaze on Madge while she sleeps, ostensibly unaware of her position as spectacle. And while Matuschka as photographer actively proffers her body as both icon and model of what breast cancer can mean (albeit for women of a particular age,

culture and class), Madge (who, significantly, plays herself in the film) performs at the direction of her daughter, who is behind the camera (and is played by an actor). If Matuschka's image is a performance of defiant pride and an assertion of the agency of the woman with breast cancer, Madge's is a staging of public embarrassment for the benefit of Ngozi's (and the viewer's) enlightenment. Ngozi (we) learns compassion and awareness of the meaning of Madge's difference through Madge's humiliation.

This distinction is due in part to Matuschka's status as media icon which buffers her availability as an identificatory figure for women viewers. Her function as a highly symbolic image precludes the shock of recognition available in the representation of Madge. In the scene in which Madge's body is exposed to the gaze of other women, the camera provides us with subjective shots taken from the point of view of the various women in the sauna, intercut with shots of these women from Ngozi's line of sight. The organization of shots invites the viewer to see Madge through the eyes of her daughter. We see Madge being seen by those women who clearly are made uncomfortable at the sight of Madge's body. It might be argued that Madge's body represents not only the unimaginable, unimage-able fear that any woman might one day be disfigured by breast cancer, but that age itself inevitably will generate bodily changes (sagging, weight gain, loss of muscle tone) – aspects of female bodily transformation held in general public contempt and denial. In a sense, the missing breast is just one signifier of Madge's bodily aging. But the scene also represents Ngozi's shift from a strong identification with the body of the mother to her ability to see that body with a distanced, public eye. By shifting the emphasis from the scarred body as iconic (as in the case of Matuschka's photograph) to that body as a locus in the shifting politics of looking, *The Body Beautiful* is able to direct its viewers to work self-consciously through complex responses like recognition, identification, and denial of bodily signs of disease and aging.

The theme of the negotiation of the public eye and the iconic status of the marked body carries over from Onwurah's earlier film, *Coffee-Colored Children*, an experimental documentary devoted to recounting Ngozi's and her brother Simon's experience growing up mixed-race in Britain. In *Coffee-Colored Children*, we see the siblings as children being taunted with racial slurs, attempting to wash off their skin color, and eventually coming to terms with the complex public meanings of their bodies. *The Body Beautiful*, then, functions, like the earlier film, as a means of coming to terms with the body of the mother as a white body, but as a body that is also marked by a complex of other cultural identities and conditions. This is not to say that physical disability and racial identity are like, but that disability is a process implicated in the construction of cultural identity along with race, class and gender; and that historically there has been continual slippage between the classification and ranking of bodies according to racial typologies and according to categories of health, disability and illness.

I want to consider this point more fully through one of the more controversial scenes in *The Body Beautiful*: a fantasy/memory scene featuring Madge. Leaving the sauna, Madge and Ngozi stop for a cup of tea. Madge spies a young black man playing pool and exchanging sexist banter with his friends, a conversation in which a woman's breasts are referred to as "fried eggs." As Madge looks on, the man catches Ngozi's disapproving narrowing of the eyes, and he returns her look with interest. This exchange of looks prompts Madge to recall a memory of her Nigerian husband. Madge states in voice-over, "I saw the look in his eyes and remembered it from somewhere in the past. A single caress from him would smooth out the deformities,

give me the right to be desired for my body and not in spite of it." The shots that follow demonstrate the strength of the identificatory bond that exists between mother and daughter on the basis of one another's bodies. As Madge and the young man make love, the soundtrack gives us Madge's subjective memories of the young Ngozi and her brother arguing. Intercut with this scene are shots of Ngozi the model, her lips and breasts being made up for a photo shoot, and Madge looking on and directing the love scene from an ambiguously situated off-screen space. Just as the mother lives through her daughter's public body, as if it were a prosthetic extension of the sexuality and youth she feels she has lost, so Ngozi imagines herself in control of the enlivening of her mother's sexual desires. Above all, Ngozi wants to return to her mother the sexual life she feels she has lost with the loss of her breast and (subsequently) her youth. However, rather than visually restoring her mother's body to some prior state of completion for the purpose of the fantasy, Ngozi demands that the scar itself must be rendered a site of sexual pleasure for both her mother and the young man. The shots of love-making between Madge and the young man are intercut with shots of Ngozi being made up and shot by a fashion photographer who commands, "pump it up, give me some passion." Like the photographer who directs her performance from off-screen space, the character Ngozi also directs her mother's in the love-making scene from extradiegetic space. As the young man moves down Madge's torso with caresses and kisses, he hesitates at the scar. "Touch it," Ngozi commands from her directorial position in off-screen space, "touch it, you bastard."

Without question, *The Body Beautiful* is about constructing a public image of breast cancer that goes beyond generalized notions of illness, disability and cultural identity. As Onwurah explains,

> It wasn't simply just a mother-daughter thing. [The film] had all of the obvious stuff about the body and beauty, but it had quite a lot about race in it, too, almost by accident – things that I hadn't really thought about. For example, her fantasy sequence would need to be with a black man, and I wanted to try to get out of that. This sequence involved black-white, young-old, disabled-nondisabled. Just for this fantasy sequence, the film was going to take on all of these missions. At one point I was going to try to have a white guy in there, but mom was really insistent that her fantasies weren't just abstract fantasies. They were fantasies to do with her, and she wanted this black guy.
>
> (Cartwright 1994b)

The Body Beautiful demonstrates that public discourse on disability is always about issues such as desire and pleasure, race and age. But how does this film function within public cultures of health, specifically? Who is the audience for this film? In the US, *The Body Beautiful* circulates through independent film venues. It has been shown at women's and experimental film festivals, academic conferences, and in university film and women's studies classrooms. In the States, it is not a "movement" film in the sense that it isn't often screened among groups formed on the basis of health issues. However, the film has a very different set of venues in the UK. Onwurah explains that:

In England, we have something called the WI [Women's Institute]. It's the kind of organization that Miss Marple would have belonged to in the rural areas. They have the largest women's health support network in the U.K. Their groups have actually used *The Body Beautiful*. And they're the most right-wing, the most conservative, that you can get. But I think that here [in the US] you actually have more restrictions or self-censorship on things to do with nudity, sex, or violence. I'm just beginning to realize this.

(Cartwright 1994b)

Onwurah continues:

The Body Beautiful wasn't meant to be an educational film. It isn't a film for women who have just learned that they have breast cancer. You have to be a little bit down the journey to see the film. But still, it's used widely. Quite often my mom goes out with it, and it's a completely different experience then. It's still mainly a filmmakers' film, a women's festival film. It's just too blunt. If someone diagnosed me with breast cancer and I saw the film the next day I think I'd go out and kill myself the day after, it's so confrontational.

(Cartwright 1994b)

The contradictions here are striking: in the UK the film is used in the most conservative sector of women's advocacy groups, yet it is too confrontational for even its own producer to tolerate if she were to watch it as a woman with breast cancer. Here we see the same contradictions evident in the appropriation of activist Matuschka's demonstration posters for the *New York Times Magazine* story. This suggests that perhaps in Britain, as in the US, we are seeing a blurring of boundaries between institutional health cultures and counter-cultures, and between mainstream and alternative media venues and audiences. Onwurah herself emphasizes the importance of recognizing local conditions of use and context:

In Britain there is a burgeoning disabilities movement, and I definitely saw [the film] in the context of that. It had a place within the issues surrounding the rights and disabilities movements. I've gotten involved because my mother's always been disabled and my grandmother was deaf since the age of two, so we used to sign with her.

(Cartwright 1994b)

At the beginning of this chapter, I posed the questions: what are the implications of this idea of the obsolescence of bounded community and locality when we consider collective identity as it forms, provisionally, on the basis of illness, disability and the fight for access to treatment? Do reterritorialized space and transcultural formations become metaphors, or is there a parallel reconfiguration and dispersal of collective identity in the postmodern experience of breast cancer? *The Body Beautiful* speaks to these questions in so far as it addresses viewers across the bounded communities of health educators, the British and American independent film communities, and disabilities movements, while also addressing issues of identity and its relationship to race, age, illness and disability.

But while the film addresses with great complexity the specific cultural issues

framing experiences of breast cancer, it none the less fails to generate a sense of community among its diverse audiences. Most immediately, the film's display of an intergenerational and interracial sexual fantasy and a physically close mixed-race mother–daughter relationship place its message beyond the interests of many mainstream viewers. Onwurah's own admission that she would not want to see the film if she herself were facing breast cancer has been echoed by numerous women who have been in audiences where I showed and spoke about it. These points leave me facing a troubling contradiction: How are these issues to be raised and worked through, if not by women to whom they are of the most concern? Would it be better to bracket differentials of class, cultural identity, ethnicity and sexuality in order to underscore the shared experiences of disease? Are the effective media texts those that provide easy answers (e.g., prosthetic recovery) and false closure (a return to some ideal of a normal life)? I would argue that work like Matuschka's and Onwurah's, as "difficult" as it may be, performs the crucial task of widening the pool of collective images, expanding the possibilities of what can be seen beyond outmoded norms and altering historical concepts of the body beautiful to incorporate the effects of breast cancer's limited treatment options.

Notes

1 This essay was previously published by Routledge in (1998) *Cultural Studies* 12(2): 117–38.
2 See, for example, Hamid Naficy's study of the Iranian exilic community in southern California that both produces and views Persian-language programming – narrowcast cable shows that more often than not embrace family values and political views that would be regarded as conservative within Euro-American cultural standards (Naficy 1993).
3 For a brief discussion of R2R and similar groups, see Batt (1994: 221–37).
4 This article, titled "The politics of breast cancer," was republished in (1992) *Camera Obscura* 28: 157–77, and in Treichler, P.A., Cartwright, L. and Penley, C. (eds) (1998) *The Visible Woman: Imaging Technologies, Science, and Gender*, New York: New York University Press.
5 Quoted in Rudner (1995: 14–15). I am indebted to Rudner's essay for the information regarding the Hammid/Metzger photograph. He notes that the photograph was originally the inspiration for a book of poetry by Metzger titled *Tree*. When the publisher refused to use the image for the book's cover, Metzger used it to accompany a poem she wrote for a poster that became a cult item in feminist circles in the US. In 1992, in the third of its four printings, *Tree* was finally published with "The Woman Warrior" on its cover (by Wingbow Press). Hammid died the same year of breast cancer (Rudner 1995: 15–16).

References

Batt, S. (1994) *Patient No More: The Politics of Breast Cancer*, Charlottetown, Canada: Gynergy Books.
Belkin, L. (1996) "How breast cancer became this year's hot charity," *New York Times Magazine* 22 December: 40–6, 52, 55–6.
The Body Beautiful (1991) Dir. Ngozi Onwurah. Distributed in the US by Women Make Movies, New York City.
Cartwright, L. (1994a) Interview with Matuschka. Unpublished.
——(1994b) Interview with Ngozi Onwurah. Unpublished.
——(1998) "Community and the public body in breast cancer," *Cultural Studies* 12(2): 117–38.
Coffee-Colored Children (1988) Dir. Ngozi Onwurah. Distributed in the US by Women Make Movies, New York City.
Ferguson, J. and Gupta, A. (1992) "Beyond 'culture': space, identity, and the politics of difference," *Cultural Anthropology* 7(1): 6–23.

Fusco, C. (1988) "Fantasies of oppositionality: reflections on recent conferences in New York and Boston," *Screen* 29(4): 80–93.

Lorde, A. (1980) *The Cancer Journals*, San Francisco: Spinsters Ink.

Marshal, E. (1993) "The Politics of Breast Cancer," *Science* 259, 22 January. Special section on breast cancer.

Matuschka (1992) "The body positive: got to get this off my chest," *On the Issues* 25, Winter: 30–7.

Naficy, H. (1993) *The Making of Exile Cultures*, Minneapolis and London: University of Minnesota Press.

Rennie, S. (1993) "The politics of breast cancer," *MS.* 3(6), May/June: 37–69. Special section on breast cancer.

Rudner, D. (1995) "The censored scar," *Gauntlet* 9: 13–27.

Solomon, A. (1992) "The politics of breast cancer," *Camera Obscura* 28: 157–77. Also published in P. A. Treichler, L. Cartwright, and C. Penley (eds) (1998) *The Visible Woman: Imaging Technologies, Science, and Gender*, New York: New York University Press.

Taylor, J. S. (1994) "Consuming cancer charity," *Z Magazine* 7(2): 30–3.

Maria Nengeh Mensah

SCREENING BODIES, ASSIGNING MEANING

ER and the technology of HIV testing

> An effective response to an epidemic (as to any widespread cultural crisis) depends on the existence of identities for whom that epidemic is meaningful and stories that take up those identities and give them life. Though plentiful, the identities AIDS scripts for women have rarely worked to expand women's own awareness of the epidemic or to further social change.
>
> (Treichler 1994: 130)

> Too often the various actors in HIV/AIDS discourse have been terribly isolated from one another.
>
> (Goldstein and Manlowe 1997: 10)

THE AMERICAN TELEVISION series *ER*, a well-known acronym that stands for "emergency room," can be seen in more than 66 countries around the world. Since its premiere in the fall of 1994, the intense hyper-real hospital drama has been must-see viewing for three million Canadians every week.[1] Recently, *ER* devoted one of its major plot narratives to the implications of living with HIV/AIDS. According to Neal Baer, co-producer and medical consultant for the show:

> So many people have HIV today that we decided to make a story with one of our characters. Because, for one, it hadn't been done where a health care provider has HIV, and two, it hadn't been done where a health care provider or anyone doesn't die. We wanted to show someone who is very healthy, fully functioning, and a member of the medical team who is living her life with HIV.[2]

Introduced mid-way through the first season, *ER*'s HIV-positive character Jeanie Boulet, played by Canadian actress Gloria Ruben, was created as a love interest for Dr Peter Benton, the show's ambitious African-American surgeon. Since then, Jeanie has emerged as one of the show's most distinctive and complex characters. Her HIV-positive diagnosis and its consequences on her work and her identity have taken a central place in the show's third season and beyond. For activists involved in community AIDS work with women and those who are living with the disease, this new

female HIV-positive character is a welcome figure. She is healthy; she is getting on with her life, personal and professional; she's developing intimate relationships; all aspects of living with HIV that are rarely seen on television. Other televised characters with HIV status usually just wither away and die, and everybody around them pities them. Two prime examples are Cindy Chandler on the Emmy Award winning soap opera *All My Children* (ABC 1989) and Rose in the made-for-TV movie *A Mother's Prayer* (Lee Rose Productions 1994).

A running theme throughout the unraveling of Jeanie Boulet's "secret" identity is the ramification of being seen and thus known as seropositive. Jeanie's personal development is highlighted by a series of confessions whereby she is increasingly identified as a seropositive woman. These confessional moments undoubtedly produce various narrative effects: emotional appeal, dramatic edge, human interest, identification, and so on. But more importantly, they reinforce the technology of HIV testing as an ensemble of organizing and visualizing rituals that serve to see HIV in women's bodies and in the Body Politic. This chapter will examine the technology of HIV testing and the ways in which it permeates popular representations of HIV-positive women on television. Specifically, I address the conditions of emergence of Jeanie Boulet's seropositivity by comparing and contrasting the biomedical strategies for seeing HIV in women with the weekly story-line about a woman with HIV in the series *ER*. My analysis suggests that the specific biomedical relations of power and knowledge embedded in the technology of HIV testing determine the representational stakes in making HIV-positive women visible on television. In other words, that epidemiologic HIV-exposure categories organize ways of screening and seeing seropositive women.

Seeing HIV in women

In her study of the concepts of pollution and societal taboo, Mary Douglas theorizes that corporeal pollution, or dirt, signals the immanent danger that threatens individual and social systems.[3] Douglas shows how dirt, by definition meaning "out of place" (1966: 2), is always rejected from classification schemes because it is perceived as neither one nor the other of pre-established categories.

> There is no such thing as absolute dirt: it exists in the eye of the beholder. If we shun dirt, it is not because craven by fear, still less dread or holy terror. Nor do our ideas about disease account for the range of our behavior in cleaning or avoiding dirt. Dirt offends against order. Eliminating it is not a negative movement, but a positive effort to organize the environment.
>
> (Douglas 1966: 2)

Thus only the exaggeration of the difference between existing categories creates a semblance of order (Douglas 1966: 4). The prevailing interpretation of HIV-infection lends itself to a similar analysis. The unclean virus uses the human body as a site of self-multiplication, progressively integrating the human genetic code and thereby provoking an indeterminate state of health. The HIV-infected subject is in-between; a *mélange* of two different sets of elements, namely the world of viruses and the world of humans. She is configured in terms of a loss of purity, integrity or authenticity. She embodies pollution and emanates danger to others. The insertion of this ambiguous body into the existing order seeks to eliminate all potential confusion

of categories such as virus and human, or disease and health. Hence, following Douglas, the danger is controlled by ritual which precisely separates the seropositive body from her old status, segregates her for a time, and then publicly declares her entry into a new status (1966: 96). The new status of "HIV seropositivity" eliminates the possibility of an unseen HIV infection, allowing *us* to divide, classify and conquer the HIV pandemic.

Along this same line of thought, Catherine Waldby (1996) claims that the reinforcement of the divisions between the world of micro-organisms and the world of humans is characteristic of the biomedical imagination.

> This imagination refers to its speculative and explanatory universe, the kind of propositional world that biomedicine makes for itself. In the case of AIDS this imagination is preoccupied with the establishing of distinctions between the normal and the pathological.
>
> (Waldby 1996: 9)

In the process of re-establishing order, seropositive bodies are readily identified as viral agents, as "a human locus for the viral" (Waldby 1996: 38), even though they figuratively and literally embody an indeterminate position between the worlds of viruses and humans. HIV-infected bodies are considered a threat to public health precisely because they exert disease. In particular, HIV in women is seen as crossing specific pre-existing borders. Seropositive women's bodies are imagined as unique conduits between homosexual and heterosexual HIV transmission, as well as a source of the threat of AIDS to the unborn. Like dirt they are abject matter and disorder.

Epidemo logic

The biomedical strategy to solve the indeterminacy of HIV infection – as both viral and human – uses naturalizing notions of sexual identity under the epidemiological heading of "exposure categories," the most probable mode of HIV acquisition. Exposure categories rely on epidemiological classification procedures and the notion of "risk group." The word epidemic has its roots in Greek: *epi* which means "among" and *demos* meaning "people." I return to these roots here in order to signify the biomedical logic of identifying disease quantitatively and qualitatively by seeking to visualize it among various pre-defined populations. The biomedical dependence upon such an *epidemo logic* may very well explain women's disappearance from AIDS epidemiology. As Cindy Patton points out, "[t]he significance of women as subject of the disease was first mystified, then sensationalized, then marginalized by fragmenting women by behavioral categories which obscured the rapid increase of infections" (1994; 11). The predominantly gay male slant to HIV discourse is evident in existing HIV exposure categories listed by the Centre Québécois de coordination sur le sida, Quebec's provincial AIDS surveillance bureau, the first of these literally entitled "Homosexual/bisexual man." In order of importance, exposure categories are as follows:[4]

- Homosexual/bisexual man
- Injection drug user
- Recipient of coagulation factors
- Heterosexual contact

- Person originating from an endemic country
- Partner of an infected person or of a person at high risk
- Transfusion recipient
- Mother-to-child transmission
- Unidentified risk factor, possible heterosexual contact
- Unidentified risk factor

Women with AIDS are most frequently identified as "partner of," a category so vague that it only seems to reinforce long-standing views that women's identities are determined by the significant other to whom they are attached. With the notable exceptions of women "originating from an endemic country," those who "inject drugs" or who have "received contaminated blood, blood products, organs or semen," women are assigned to exposure categories which confuse identity with behavior. Categories which also provide, according to Paula Treichler, "a new occasion for recycling old narratives out of women's historical role in epidemics and disease" (1994: 131), as natural receptacles and as vectors of transmission. Mutually exclusive sexual identities for women with AIDS can be summarized as follows:

- Mother of an HIV-infected child
- Sexual partner of a bisexual man
- Sexual partner of a person originating from an endemic country
- Sexual partner of a transfusion recipient
- Sexual partner of an injection drug user
- Sexual partner of person known to be HIV-seropositive or living with AIDS
- Unidentified

Evidently, this sexual imperative favors certain identifications while disavowing others. For instance, although explicitly gendered these "exposure identities" do not officially recognize the existence of lesbians living with HIV/AIDS. As Waldby points out in her *AIDS and the Body Politic* (1996), the production of exposure categories as *true* sexual identity relies on the binary opposition between activity and passivity to explain and control HIV transmission (101–9). While the behaviors considered at highest risk for acquiring and transmitting HIV are refigured as "risk groups," highest risk exposure categories are coded "feminine," as if women naturally lend themselves to receptive sexual capacity. Sexual receptivity is attributed to men's bodies as well, namely gay men's bodies. Inversely, as Waldby suggests in her own analysis of Australian HIV exposure categories, the masculine heterosexual body (figured as sexually active in generic categories such as "Heterosexual Contact") escapes this association.

> [W]ithin AIDS epidemiology the heterosexual male body is not assigned a causal status. Rather it is reserved the membership of the 'general population' because AIDS epidemiology is a knowledge which generally replicates or constitutes the point of view of that body. The heterosexual male body fails to appear as an object in AIDS epidemiology precisely because it occupies the position of subject of that discourse's enunciation.
>
> (Waldby 1996: 109)

He is a phallic body that penetrates yet is never penetrated. Ultimately then, "hetero-sexual men remain the masters of contagious circulation" (Waldby 1996: 109) while women, because of their "capacity to act as a transmission point between high and low risk males, and high risk male and foetus" (Waldby 1996: 103), are always already implicated in that circulation.

The majority of women living with HIV, however, have not received an AIDS diagnosis and are therefore not accounted for in AIDS surveillance data (Goldstein and Manlowe 1997). When an infected person is asymptomatic the "presence" of HIV can only be detected by using sophisticated screening technologies. It is through these *seeing* procedures that biomedicine's strategy to control the HIV pandemic becomes most apparent.

The technology of HIV testing

I use the term "technology" here in a broad sense: as a form of social knowledge, a set of practices, representations, and discourses. The technology of HIV testing basi-cally strives to visualize HIV infection. It includes the actual HIV test, as well as individual counseling and public health protocols. It is also the very first time a woman can be seen as seropositive. In fact, the technology of HIV testing sets in motion the very constitution of the HIV-seropositive subject, as both effect and object of biomedical power and knowledge. It attempts to trace the progression of the virus through (a) clinical procedures that see individual infection in the body and (b) epidemiological procedures, which see infection in the Body Politic.

Clinical procedures

In order to establish HIV-seropositivity three positive test results must be obtained. Two reactive Enzyme Immuno Assays (EIA) and one positive confirmation test – this second independent assay is usually the Western Blot test – define a single HIV-seropositivity diagnosis (CMA 12). Multiple clinical procedures minimize the production of false-positives and increase diagnostic reliability. These combined tests also serve to spatialize illness in a manner that becomes susceptible to clinical observa-tion. As Michel Foucault (1963) has described, medicine first established itself as a discipline through its incessant mapping of pathology on the spatial surfaces of the body, external or internal. This spatialization of disease and the emergence of a clinical gaze are equally critical for HIV/AIDS. HIV-antibody testing procedures assume that screening and confirmation tests can detect infection in the space of a blood sample which can then be extended to the blood stream, and so on. The spatial demarcation of disease in the body makes it possible for laboratory technicians and medical doctors to see HIV infec-tion and pronounce various diagnostic interpretations.

The HIV test seems to be a simple indicator of the virus' presence or absence. However, the underlying binary logic of positive/negative results is no more than a simplification of a very ambiguous domain. On one hand, the test actually detects the presence of HIV-antibodies developed by the immune system response to HIV infec-tion and not the virus itself. More complex genetic tests currently exist which can directly detect HIV but these are quite costly and further clinical investigation is required to assess their efficacy. On the other hand, serological status can only be attributed in those binary terms if other variables are held constant. Exposure cate-gory is one constant upon which seropositivity is measured.

Indeed, the interpretation of HIV test results often depends on the manner in which the tested subject is classified during pre-test counseling procedures – whether she is considered at higher or lower risk and which position she occupies within the hierarchy of exposure categories.

> There is an important difference between scientific and popular understandings of the test: the laboratory scientist simply establishes whether, in a situation which meets the required laboratory standards ... [the] assay performed reacts or does not react, or produces a partial reaction that is inconclusive. It is in the counseling process that the categories "positive" or "negative" are assigned to the test, supposedly after the counselor has determined whether the person has any traits ... [that] could potentially cause test reactivity in the absence of HIV.
>
> (Patton 1990: 33)

Components of pre-test counseling recommended by the Canadian Medical Association (CMA 8–11) include assessing the person's risk of HIV infection and whether the timing of testing is appropriate, in part through a comprehensive sexual history.[5] The interpretation of indeterminate results is further problematized by the possibility of false-negative and false-positive test results.

> Early estimates of the test placed the false positive rate at as much as 10 to 30 percent. However, false positivity rates in actual use are a statistical function contingent on the probable seroprevalence within a particular group. Thus, statistically speaking, in groups of heterosexual non-injecting drug users, the false positive rate would be higher because the likelihood of infection would be quite low. On the other hand, in a group of sexually active gay men in a large urban area, again statistically speaking, the rates of false positivity would be relatively low. Counseling protocols are based on these statistical functions, so that positive results among people reporting risk behaviors go unquestioned, even though a number of gay men and injection drug users are among the false positives.
>
> (Patton 1990: 35)

False-negatives are ruled out by determining whether or not the tested subject is in the window period, according to estimated risks of exposure. Similarly, the probability of false-positives is determined by the known seroprevalence in the population to which she is thought to belong. Across clinical procedures, then, exposure category is a constant against which seropositivity is measured.

Epidemiological procedures

HIV-antibody testing also visualizes the presence and location of viral agents from a central panoptic viewpoint that differs from the above clinical gaze. Epidemiological procedures rely on the concept of "general population" which is directly involved in the constitution of a national Body Politic. Epidemiological surveillance data is organized according to geo-political boundaries so that each nation can be said to posses its own seropositive body. Once HIV status is established by clinical procedures, a second constellation of medical and administrative practices takes over to

classify and organize tested subjects. A coercive technology of confession, to paraphrase Cindy Patton (1990), epidemiological procedures are supported by counseling rituals which seek the truth about the tested subject's sexual practices and identity. This particular regime of visibility produces both and at once: the constitution of the HIV-positive woman as an individual describable object (an "AIDS case") and the elaboration of a comparative system (between "risk groups" and the "general population"). In fact, components of post-test counseling can be broken down into a series of events which position and mark the tested subject as being HIV-seropositive and as belonging to an exposure category. Again, the Canadian Medical Association's HIV testing and counseling recommendations (1995: 12–16) clearly set the stage for such positioning. Post-test counseling of a seropositive subject includes:

- extracting a confession confirming exposure identity, through a detailed sexual history and revision of sexual practices;
- entrance into medical surveillance process, including referrals to specialists and symptoms management, the nature of which depends on exposure category;
- encouragement to participate in research protocols and some clinical trials, which also depend on sexual confession;
- obligation to (re)confess her status to others at risk of exposure;
- promise of self-scrutiny and self-regulation.

These panoptic post-test procedures operate in conjunction with the *epidemo logic* to mark HIV-positive women's entry into a field of knowledge. This knowledge is constituted mainly through a network of personal testimonials, written documentation and diagnoses. Here, then, disciplinary power operates by inducing a conscious and permanent state of visibility in the seropositive subject.

Screening HIV on television

So how do popular media reinforce this particular regime of visibility? The televised portrayal of HIV-positive women cannot change the underlying assumptions that make the category "woman" a figure of both sexual purity and danger. Rather than enumerating the effects of such constructions on *real* women, it is more useful, according to Cindy Patton (1994), to describe how particular ideas about sexuality and gender have emerged and informed representations of positive women in HIV media discourse. Patton claims that popular media have taken advantage of the increasing rates of AIDS among women to reinforce preconceived notions about women's (hetero)sexuality. In a chapter devoted to "women at risk," she summarizes her thesis: "To put it bluntly, women are either vaginas or uteruses, and curiously, never both at the same time" (Patton 1994: 107). This sexual dichotomy of woman-uterus and woman-vagina, she argues, corresponds to a particular conception of women's sexuality: a naturalizing conception aligned on a continuum ranging from asexualization to hypersexualization. Within this interpretive economy, popular media present HIV-positive women as responsible for HIV transmission in men and children, because women *are* always already infected mothers (asexual) or whores (hypersexual). She goes on to argue that this tendency to heterosexualize AIDS also provides a conceptual displacement because, according to this logic, *heterosexual AIDS* means the feminization of the pandemic – the underlying assumption being that women *are* heterosexual.

I agree with Patton's assumption that popular media tend to normalize the epidemic by drawing on HIV-positive women. However, media representation does not and cannot operate in a vacuum. Biomedicine plays a central role in HIV media discourse and the cultural narratives and identities that it represents. The biomedical strategy to solve the ambiguity or invisibility of HIV infection permeates popular representations of HIV-seropositivity. Assumptions about gender and women's bodies anchored in the biomedical imagination determine the representational stakes of making women living with HIV visible in the media by implicitly drawing on the association of femininity with contagion and disorder, and the fluidity of the female body's boundaries. The TV drama *ER* offers some clues for a better understanding of the interconnectedness of popular and scientific representation of gendered seropositivity.

First, the show's internal chronology sets up an ideal format for presenting a step-by-step figuration of HIV testing protocols. *ER* is set in a hospital. Its focus is explicitly on biomedical practices and events which supposedly reflect real-time hospital emergency response. The serial's narrative structure plays heavily on the professional and personal trajectories of its characters within this particular setting. *ER*'s internal chronology is illustrated in the way the technology of HIV testing is configured for Jeanie. While much of *ER*'s format largely depends upon accurate depiction of clinical procedures, not much air-time is devoted to dramatizing clinical procedures involved in determining whether Jeanie has been exposed to HIV. In the second season's final episode, after finding out the previous week that her estranged husband Al has AIDS, Jeanie asks to have blood drawn and for it to be sent to the lab to have it tested for HIV. Viewers are not witnesses to the multiple clinical procedures involved. The following episodes concentrate on post-test rituals, which I shall address later in this chapter.

Second, the implicit rationale behind Jeanie's HIV-seropositive status illustrates the predominance of exposure categories as defining attributes. She, like most American female cases of AIDS, is black and has acquired HIV from a long-term lover (Goldstein and Manlowe 1997). As many avid *ER* viewers predicted, the third season begins with Jeanie learning that she has tested positive and her ex-lover, Dr Peter Benton, has tested negative. "I figured it had to happen this way," writes an *ER* fan on the Internet. He continues:

> Jeanie and Benton have to have some kind of conflict related to this issue; it wouldn't be right if their results matched, with the resulting uncharacteristic bonding (whether positive or negative). Jeanie's got some tough things to work out with herself and her co-workers in the weeks ahead, and what I sort of liked about this story is that it's happening to one of the show's most flawed characters. Note how easy it was for Jeanie to lie to Kerry [her colleague], and to persuade Peter to do the same; not that either act was unjustifiable, but Jeanie is spinning in circles.
>
> (Hollifield 1997)

Why should Jeanie be considered a TV character custom-made to be HIV-positive? Because it validates her posture as a lone martyr isolated in Peter's orbit? As a "flawed" character then, seropositivity suits Jeanie well. She did have sex with Peter while still technically married to Al, and based on these previously established character traits, the diagnosis of HIV infection becomes intelligible.

Finally, the emphasis on disclosure and confession of Jeanie's serostatus serves to reinforce the technology of HIV testing as the primary mechanism for seeing HIV in women. The focus is on Jeanie's emotional and ethical dilemma to disclose her HIV-positive status to her ex-lover, to fellow seropositive patients, to colleagues, to other staff members, to potential love interests, etc. Jeanie's personal character development through disclosure highlights two major identifications. On one hand, Jeanie is positioned as a health care provider. On the other, she is identified as a potentially sexually active woman. Both these seropositive identities increasingly become meaningful as she admits, confesses, and later affirms, her HIV status. Furthermore, in these episodes, hospital staff and patients take on the role of the Body Politic, a concerned constituency whose safety may be put at risk by the mere possibility of an HIV-infected health care provider working among them.

Disclosure, seropositive identity and confessional moments

At first, the only person Jeanie informs about her HIV test results is Peter, who is also at risk since, to quote Jeanie "You and I were careful, but not that careful." Later, Jeanie visits the hospital's outpatient AIDS clinic to check in, but while waiting, a fellow patient urges her to seek another clinic farther away from her workplace and suggests that she not tell any co-workers about her serostatus. Taking this advice to heart, Jeanie lies to her closest (if not only) female colleague Kerry, telling her that her test came back negative. Wanting her serostatus to remain secret, Jeanie then tries to pay cash for her "HIV cocktail" medications to avoid having the hospital find out about her condition.

Next, we are made aware that the consistent use of universal precautions in the workplace should be sufficient to protect patients from her infected blood. Universal precautions should always be applied in any health care setting and against all blood-borne pathogens, including HIV. These measures include thorough washing of the hands before and after all patient contact, wearing gloves during all procedures, and minimizing hand-to-hand transfer of sharp objects or instruments. Universal precautions are enacted, at least partially, in virtually all *ER* episodes. Jeanie's seropositivity serves here as a reminder to the viewer, as well, of the actual safety of health care facilities both on and off screen. Nevertheless, Jeanie is positioned as an ambiguous risk. In the same episode, she pauses before using a sharp instrument on a young patient but doesn't hesitate to pitch in to help a man in the ER with an open chest wound.

The following episode shows Jeanie experiencing side-effects from her antiretroviral therapy, but this situation does not last very long and she is rapidly re-presented as a healthy and fully functioning worker. For the next few weeks, Jeanie deals with euthanasia and ever-lasting love when she treats various husband and wife couples during otherwise uneventful shifts at the hospital. Her HIV status remains unspoken throughout these episodes yet it looms like a menacing ghost. Finally, the season-long secret of being HIV-positive slowly unravels after Jeanie lies to another colleague, Mark, when interrogated about her relationship with Al who is admitted to the hospital for an AIDS-related complication. She tells him that she tested negative. Still suspicious, Mark checks her file and discovers that she is HIV-positive. Mark reports the fact to his superior, whose response is to request a meeting with the hospital's legal department to verify existing policies on health care providers with HIV.

During the episode preceding the Christmas holiday, a meeting to discuss hospital HIV policy takes place. The circling camera angles, typical of *ER*'s hyper-visual style, are removed from the usual operating room table and instead show us the entire *ER* staff engaged in a lengthy debate opposing universal precautions and individual patients' right to know they are being treated by an HIV-positive doctor. Everyone is talking about the potential risks. In one poignant scene, Jeanie walks in on a group of hospital staff members discussing the subject. Attempting to quell rumors, Mark starts soliciting opinions from everyone on how the theoretical "Employee X" should be treated. As opinions fly on both sides of the argument, Jeanie interrupts them. "Would you please quit calling me Employee X?," she says, "I am HIV-positive." Her presence and input inspire some progress in the debate. Jeanie volunteers to exclude herself from treating deeply penetrating, poorly visualized cavities (a Center for Disease Control guideline), and Kerry offers to personally observe any emerging symptoms such as dementia. This seems to have the policy matters resolved but when Jeanie leaves the meeting and walks through the emergency room, she notices people's reactions to her: staring with strained smiles. At the end of the episode, Jeanie and Maggie (the soon-to-be-self-identified-lesbian on the show) are among the few people left in the emergency room. "That was a gutsy thing you did today," Maggie tells her. She comments that the lobby room Christmas tree is missing some-thing on top, and as Jeanie places an ornament belonging to her and Al on the tree-top, Maggie comments, "You should put it on your family tree." "I just did," replies Jeanie.

Here, then, Jeanie's identity as a seropositive health care provider is consolidated as her story reaches a culmination of sorts. The hospital policy on her condition is established and knowledge of her seropositivity is finally common knowledge among the other employees. The confessional scene is indeed very effective (not to mention "gutsy," to quote Maggie), and throughout the episode, the camera seems to have a special eye for Jeanie's emotions both before and after her secret is uncovered. Jeanie's acknowledgement that the staff has become her "family" highlights her desire for belonging and serves as a heartening end to a holiday episode.

The remainder of the third season of the series focuses attention on Jeanie as a sexual seropositive subject. In her search for a personal HIV doctor, now that her condition at the hospital is common knowledge, Jeanie is introduced to Greg, well-regarded for his work with HIV-patients. Greg is interestingly suited to Jeanie's unique position. He is an HIV specialist and considered "one of the most eligible heterosexuals in Chicago," according to Kerry. After an aborted involvement with a one-time-only character a few episodes earlier, Jeanie seems motivated to be involved with this man, and when he spontaneously kisses her on their first date, she instantly discloses her serostatus.

The evolution of Jeanie's sexual character progressively takes on a life of its own. Dealing with patients affected by AIDS in her practice at the hospital, Jeanie learns the limits imposed on seropositive existence. With these in mind, she must decide whether or not to develop a sexual relationship with Greg. At first, she tells him: "You don't want to date a woman who's HIV-positive, you don't owe me anything." Then, after their second kiss, she murmurs, "I'm afraid of liking you too much. Aren't you afraid?" Later, when it looks like Jeanie is letting go of her fears of being sexual again, Greg tells her "I think we should start sleeping together." She expresses that maybe they're going too fast but nevertheless admits that she wants to be prepared should the "spontaneous moment" arrive. Worried about the potential risk

of sexual transmission, she tells Kerry that she does not want to expose Greg to HIV unless "she's sure that he's the love of her life." Sex without love is an impossible position for this HIV-positive character, even if loveless sexual intercourse was her primary role prior to being seropositive.

Soon enough, Greg is shown not to be "the love of Jeanie's life" as her ex-husband Al slowly returns as her main love interest. "I don't want to be angry anymore, I don't want to be that kind of person," she tells him. Heading towards the season finale, Jeanie and Al are growing closer, spending more time together, exchanging gifts, and getting to know each other again. There is a chemistry between them, exploited by many poetic scenes showing them sitting quietly and laughing together, which leads us to think that Jeanie will dare to find love, and indeed sex, in the upcoming fourth season. In the end, her seropositive identity as "partner of" is firmly re-established and exposure category reinforced as the only *true* identity available to her.

Screening bodies, assigning meaning

In conclusion, I would argue that *ER* draws on the technology of HIV testing as the primary mechanism for constituting HIV-positive identity on screen through a series of confessional moments. The disciplinary effects of seeing HIV in women have already enabled biomedicine to solve the problem of the indeterminacy of HIV infection, as both viral and human. In the realm of popular media, the task at hand appears to be not how to see HIV in women but rather how to see women with HIV. Little or no emphasis is put on the clinical procedures for seeing HIV in women's bodies while the *epidemo logic* mobilizes Jeanie's story and character development. Between the desire to see HIV in women and see women with HIV the two become confused, combined and reinforce one another as a normative device that inscribes the very bodies it seizes. Repeated inscription and confession of exposure identity as true identity evokes a perception of Jeanie as polluted while compelling her to be seen and thus known as such.

From a different standpoint than previously mediated HIV-positive roles for women, *ER* indeed formulates opposition to contested images. The series offers a character and a story-line where gendered HIV-seropositive identities are taken up and animated, to paraphrase Paula Treichler. Jeanie Boulet is not guilty for her diagnosis. She is to be identified with, not shunned, abused or judged. She is a woman living with HIV not dying from AIDS. Yet, this "new" identity is quickly reconfigured within the confines of "partnerhood," the most prevalent exposure category applicable to women's seropositivity. The specific narrative structure through which Jeanie is constructed as both effect and object of biomedical power and knowledge illustrates how this media representation of seropositive identity never operates in a vacuum. In more ways than one, scientific understandings of HIV and the biomedical regime of visibility which sustains it inform how we see and thus know Jeanie *is* seropositive. The issues raised by screening HIV infected bodies are located, then, not so much at the level of "positive" or "negative" representation (or interpretation), but at the level of organization, disruption, and reinforcement of the processes of meaning production which take place as scientific and popular realms make sense of the AIDS epidemic.

Notes

1 In March 1996, CTV aired a special report about *ER*'s HIV-positive role on *W5*, a Canadian news and public affairs program. Audience statistics were described by the program's co-host, Lloyd Robertson, "Canada's most trusted anchorman."

2 Quoted from the above *W5* program.

3 For Mary Douglas: "The body is a model which can stand for any bounded system (...) We cannot interpret rituals concerning excreta, breast milk, saliva and the rest unless we are prepared to see in the body a symbol of society, and to see the powers and dangers credited to social structure reproduced in small on the human body" (1966: 115). Corporeality, then, allows her to think through broader questions pertaining to the Body Politic.

4 This list is translated from the official French language technical notes attached to Quebec AIDS surveillance statistics. The original text reads exposure categories as: "Homme homosexual/bisexuel," "Contact hétérosexuel," "Transfusé," "Transmission mère-enfant," "Aucun facteur de risque identifié, contact hétérosexuel possible," "Aucun facteur de risque identifié, VIH+, sida" and "Risque élevé, facteur non précisé" (CQCS 1997: 27).

5 The interval following infection and before the appearance of HIV antibodies is known as the serological "window period." If the tested subject is in the window period her test results will be inaccurate. Virtually all infected subjects (i.e. 95–99 per cent) will develop HIV antibodies within three to six months after the most recent risk event leading to HIV infection (CMA 8). Risk events are classified in and around previously stated HIV exposure categories.

References

CMA (Canadian Medical Association) (1995) *Counseling Guidelines for HIV Testing*, Ottawa.

CQCS (Centre Québécois de coordination sur le sida) (1997) *Surveillance des cas de sida, Cas cumulatifs 1979–1997. Update no. 97–01.* Ministère de la santé et des services sociaux, Government of Quebec.

Douglas, M. (1966) *Purity and Danger. An Analysis of Concepts of Pollution and Taboo*, London: Routledge & Kegan Paul.

Foucault, M. (1963) *Naissance de la clinique. Une archéologie du regard médical*, Paris: Presses Universitaires de France.

——(1975) *Surveiller et punir. Naissance de la prison*, NRF: Éditions Gallimard.

Goldstein, N. and Manlowe, J. L. (eds) (1997) *The Gender Politics of HIV/AIDS in Women: Perspectives on the Pandemic in the United States*, New York: New York University Press.

Hollifield, S. (1997) *ER Review Home Page*, http://www.digiserve.com/er/erdex.html (20 March).

Patton, C. (1990) *Inventing AIDS*, New York: Routledge.

——(1994) *Last Served? Gendering the HIV Pandemic*, London: Lord & Taylor.

Treichler, P.A. (1994) "AIDS, identity, and the politics of gender," *Technology on the Brink*, Seattle: Dia Center for the Arts, 129–43.

Waldby, C. (1996) *AIDS and the Body Politic. Biomedicine and Sexual Difference*, New York: Routledge.

Lisa Finn

COMPLICATIONS
An analysis of medical abortions in the US

Introduction

The advent of medical abortion methods, using either methotrexate or mifepristone (RU 486) combined with misoprostol, represents the first new abortion option for women in twenty years. Medical abortion, a procedure during which abortion is induced by a medication rather than through surgery, has the potential to change the terms in which abortion debates are fought. In comparison to surgical procedures, such as suction curettage, medical abortions can be performed earlier (at four to seven weeks' gestation as opposed to seven weeks and later), will allow women to avoid surgery and anesthetics, will eliminate the risk of cervical laceration or perforation, and can be managed in the privacy of a physician's office and a woman's home, thus making direct intervention by anti-abortionists less likely. Though both mifepristone and methotrexate share these assets, methotrexate is more difficult for anti-abortionists to track; while mifepristone is primarily employed to induce abortion, methotrexate is indispensable for other applications, including the treatment of psoriasis, rheumatoid arthritis, systemic lupus erythematosus, Crohn's disease, a variety of cancerous tumors, and ectopic pregnancies (Schaff *et al.* 1996: 198). In the US, this advantage represents a significant political and practical consideration in relation to current anti-abortion tactics in that, though its use may be regulated, methotrexate will not be taken off the market.

In 1948, methotrexate was approved by the US Food and Drug Administration (FDA) for cancer treatments; this means any physician can prescribe it. However, prescribing methotrexate and misoprostol to induce abortions constitutes an "off-label" use, which means that the procedure is not covered by malpractice insurance and is generally not paid for by health insurance. FDA spokesperson, Lawrence Bachorik has said that, "the off-label use of approved drugs is considered to be the practice of medicine" (Radlauer 1996: 39). The problem is that prescribing a drug for "off-label" use may increase practitioners' vulnerability to malpractice suits, and considering the controversy surrounding abortion in the States, many physicians are unwilling to take the risk.

In order to be approved for and covered under medical abortions, a pharmaceutical company would have to fund a much larger study and bring it before the FDA.

Unfortunately, because of the controversy surrounding abortion debates in the US, it remains unlikely that any pharmaceutical company will fund methotrexate research for early abortion. This unlikelihood is further ensured by the fact that the patent for methotrexate has expired; any company willing to provide the US$6 million necessary to run a large study for FDA approval would not make enough profit from a drug that is available generically to justify, in their view, such costs (Schaff *et al.* 1996: 203). In fact, until 1996 only one company, Delta Pharmaceutical Group Ltd, had attempted to raise the money for FDA studies of early medical abortions. Delta is a privately funded research and development company in New York City that is dedicated to women's reproductive health issues. Though they received FDA approval to commence a study of low-dose methotrexate and misoprostol for early pregnancy termination in 1,500 women, the company has been able to raise only US$3 million of the necessary US$6 million thus far (Rodgers 1995: 22). More recently, in September 1996, Planned Parenthood Federation of America (PPFA) announced that it had received FDA clearance for a nationwide study of methotrexate and misoprostol for early abortion. If the trials meet the FDA's requirements, early abortions using methotrexate could be considered an "on-label" use (Planned Parenthood 1996).

As is evident with the political pressures surrounding mifepristone, most pharmaceutical companies seem unwilling to risk boycotts and demonstrations from anti-abortion groups. Although it has been available in France since 1982 and is currently used for early abortion in France, the United Kingdom, Sweden and China, there has been only one US clinical trial of mifepristone, funded by the Population Council, the New York-based non-profit organization that obtained US patent rights (Winikoff 1995: 142). This trial involves 2,100 women in eighteen cities and has encountered setbacks because of violence by anti-abortion protesters. Research had to be halted at one trial site in Brookline, Massachusetts after a worker at the clinic was shot and killed in 1994. The trials later resumed without further incident, but the woman's death clearly demonstrates the continuing peril that clinics and individuals must face in researching abortion methods (Jouzaitis 1995a: News 1).

A recent survey conducted by the Kaiser Family Foundation, a non-profit organization in Menlo Park, California, helps to more specifically locate the debates about mifepristone and methotrexate for early abortions in the US ("Fewer U.S. Doctors" 1995: A3). The national survey found that two-thirds of practicing obstetrician-gynecologists do not perform abortions. The availability of abortions is down from the 42 per cent of physicians who offered pregnancy termination in a 1983 survey by the Alan Guttmacher Institute. The Kaiser Family Foundation found that doctors under 40 were more likely than their older colleagues to mention reasons like community pressure or institutional barriers such as practicing in groups or at hospitals that do not perform abortions. Half of all obstetrician-gynecologists who perform abortions are 50 years of age or older, with those over 65 more than twice as likely to do so as their colleagues under 40. While there was little difference between the likelihood of female and male doctors performing abortions, there were strong regional differences. About 42 to 45 per cent of obstetrician-gynecologists in the Northeast and West reported doing abortions, compared with 25 per cent in the South and 16 per cent in the Midwest. Overall, the Kaiser Family Foundation survey emphasizes that the availability of surgical abortion in the US has significantly decreased.[1]

Considering the decreasing availability of surgical abortions, the advent of medical abortions has the potential to dramatically change the ways in which abortion has

been figured in the States. The Kaiser Family Foundation survey found that one-third of physicians who said they do not perform surgical abortions stated that they would be likely to prescribe mifepristone if it were approved by the FDA. Part of these physicians' willingness to perform medical abortions may be due to the advantages of medical versus surgical abortion. Specifically, one of the reasons many obstetrician-gynecologists do not perform surgical abortions is fear of harassment or violence from anti-abortion protesters. As discussed above, medical abortions, especially those using methotrexate, make it far more difficult for anti-abortionists to track and target. As Dr Richard Hausknecht, a private obstetrician and gynecologist, states in the conclusion to his study of methotrexate for early abortions, "Given the increasing violence and threats directed toward providers of abortion services, the methotrexate-misoprostol protocol offers a safe and effective regimen with drugs that are currently available" (Hausknecht 1995: 540).

Methotrexate and misoprostol – what are they?

Methotrexate is a folic acid antagonist that terminates pregnancy by blocking the action of folic acid, targeting rapidly multiplying cells, including cancerous and embryonic or fetal cells. The half-life of low doses (50mg per square meter of body surface area) of methotrexate is 8–15 hours and methotrexate is undetectable 72 hours after an intramuscular injection. The drug undergoes minimal metabolism in the liver and is excreted through the urine. Widespread studies of experience in ectopic pregnancies (for which the same dose is used) and for choriocarcinoma (multiple higher doses) provide evidence of no long-term adverse effects on either the patient or on subsequent pregnancies (Potts 1995: 655). According to Dr Mitchell Creinin, a researcher at the University of Pittsburgh and the University of California at San Francisco, the peak serum level of a low dose of methotrexate ($50mg/m^2$) is significantly lower than the accepted toxic level. For comparison, Creinin states that some chemotherapy regimens use a similar dose of methotrexate for five days in a row and it is usually after successive days of treatment that side effects begin to occur (Creinin and Vittinghoff 1994: 1190). High doses of methotrexate for cancer treatments have been found to cause an increased incidence of other cancers later in life, but this risk has not been found with chronic use for psoriasis (Potts 1995: 655). Adverse effects from low doses of methotrexate include heavy bleeding (characterized as heavier than that associated with a normal menstrual period), cramping, and mild irritation of the lips and gums that lasts less than 48 hours without treatment (Schaff et al. 1996: 201).

Although it has not yet been approved by the FDA for this indication, methotrexate was used as an abortifacient as early as 1952 (Thiersch, cited in Creinin 1993: 519). Currently, methotrexate is considered an acceptable treatment for early unruptured ectopic pregnancies and is effective in approximately 95 per cent of these cases (Schaff et al. 1996: 198). Three separate studies illustrate that methotrexate, rather than tubal ligation, is an excellent method of treating unruptured ectopic pregnancies because it does not seem to affect future fertility or pregnancies.[2] Moreover, a study conducted by Creinin highlights the fact that a medical abortion may be the only option other than hysterectomy for women who, because of scars, cysts or tumors in their uterus, cannot undergo a surgical abortion.[3] Finally, while one disadvantage of mifepristone is that current regulations require strict medical monitoring, during which patients must spend at least four hours in a clinic (Jouzaitis

1995a: News 1), with methotrexate there is no need to keep clients in an office or clinic for extended periods of time.

Most of the physically uncomfortable effects from medical abortions are due not to either mifepristone or methotrexate but rather to misoprostol, a prostaglandin used to prevent stomach ulcers caused by anti-inflammatories.[4] Misoprostol causes uterine contractions and is used in conjunction with methotrexate and mifepristone to expel embryonic tissue once a pregnancy has been terminated. An intravaginal dose of 800 mcg of misoprostol is inserted approximately seven days after the administration of either mifepristone or methotrexate; the dose of misoprostol used for early abortion is no greater than the FDA's recommended daily dose when misoprostol is administered for ulcer prevention (Creinin *et al.* 1996: 321). Misoprostol is excreted in urine and has a half-life of 20 to 40 minutes (*The Medical Letter* 1996: 39). The adverse effects reported with the use of misoprostol include nausea, fever, and diarrhea (Potts 1995: 655).

Research studies of methotrexate-induced abortions

On 31 August 1995, *The New England Journal of Medicine* published a study by Dr Richard Hausknecht, a private obstetrician and gynecologist who is also associated with Mount Sinai Hospital in New York, which detailed the use of methotrexate and misoprostol to induce early medical abortions (Hausknecht 1995: 537–40). Pregnant women at 63 days' or less gestation were given a single intramuscular dose of methotrexate ($50mg/m^2$) followed five to seven days later by 800 mcg misoprostol administered intravaginally. If the first dose of misoprostol proved ineffective, a second dose was administered a week later. The report showed that 171 of the 178 women (96 per cent) had successful abortions after the first or second dose of misoprostol; the remaining 4 per cent were given surgical abortions. Hausknecht also found that for the patients who did require suction curettage because the misoprostol failed to completely expel the embryo, the procedure was easier and less painful than most surgical abortions. Because misoprostol softens the cervix, "either cervical dilation was not necessary or only a single dilator was needed before the insertion of a flexible 6-mm suction cannula" (Hausknecht 1995: 538); the cramping and pain associated with cervical dilation during a surgical abortion is lessened or eliminated when misoprostol has been used. Overall, when women were asked to rate the amount of pain they experienced during the study, more than 75 per cent reported little or moderate pain (Hausknecht 1995: 539). Since his study was published, Hausknecht has been extremely vocal in cautioning other physicians to wait for the results of larger studies before widely using methotrexate for abortions. He points out that before physicians begin using the drug combination, they should go through training and counseling procedures in order to familiarize themselves with possible adverse effects.

Though his work elicited some volatile responses, Hausknecht is not the first to publish a study of methotrexate and misoprostol for medical abortions.[5] Creinin was the first to extensively experiment with these drugs for early, elective abortion. As I will detail below, since 1992, Creinin has conducted more than a dozen studies of methotrexate-induced abortion, several of which have been published in medical journals. However, Hausknecht's study initially attracted more attention to this work by virtue of what some see as his disregard for the "proper channels" of research protocols. The controversy ensuing the publication of Hausknecht's study was a

result of his ability as a successful, private physician to work around formal research regulations. Hausknecht advertised his study in a newspaper and began his research without offering his protocol for approval from any Mount Sinai Hospital or FDA committee, usually a prerequisite for human experimentation to ensure that participants are not abused. Instead, Hausknecht ran the study through his private practice on Park Avenue in New York City and only applied for approval after pressure from both the FDA and Mount Sinai Hospital (Baum 1995: E1). Once approval was granted by both bodies, Hausknecht ran a second study which was published in *The New England Journal of Medicine*.

Though the initial lack of institutional supervision may call his methods into question, Hausknecht's defense of his decision illustrates the difficulties of studying abortion procedures in the US. An article in the *Los Angeles Times* presents Hausknecht as a "medical maverick" who felt that he had to "forge ahead to find a safe, easy, legal, inexpensive and private technique" for abortion. Hausknecht argues that, as a longtime proponent of abortion rights, he needed to spread the word about the efficacy and safety of methotrexate and misoprostol for early abortions. He contends that he recognized the poisonous political climate surrounding abortion that would at the very least delay the adoption of an alternative procedure. Moreover, few US research centers are willing to advocate or publicly associate themselves with breakthroughs in abortion technology. According to Hausknecht, as long as only the readers of medical journals were familiar with methotrexate's efficacy as an abortifacient, a majority of women would not be aware of the possibility that medical abortions could be performed using a drug that is both readily available and inexpensive (Radlauer 1996 :39). Within this context, Hausknecht used his position as a successful, private obstetrician-gynecologist not only to develop a methotrexate protocol[6] for other physicians to follow but also to draw wider media attention to his efforts. Indeed, with the help of other researchers, Hausknecht succeeded on both counts; several news articles addressed his controversial study and in April 1996, Hausknecht and Dr Eric Schaff, a researcher at the University of Rochester School of Medicine in New York, announced a methotrexate treatment protocol at the annual meeting of the National Abortion Federation in San Francisco (Radlauer 1996: 38).

Other physicians, including Creinin, consider Hausknecht's disregard for formal regulations dangerous. Creinin states, "I feel people have to put together something formal, go to their institutional review boards, make sure what they are doing is medically sound. You don't just use people as guinea pigs" (Baum 1995: E1). Hausknecht counters that since low doses of methotrexate have been found safe for other medical procedures, he is not endangering his clients. He claims, "Sure I'm a nut, a maverick and somewhat of a revolutionary. I've been part of radical political movements all my life. I've put my life on the line physically, recreationally and politically. … But I'm a very conservative doc. I don't gamble with the health of my patients" (Baum 1995: E1). Though his attempts to draw attention to methotrexate as an alternative to surgical abortions may be laudable, Hausknecht charges US$500 for a procedure that requires US$10 worth of readily available drugs. Hausknecht asserts that this price covers the three office visits and two ultrasound tests necessary for his study. He also states, "It's my time and effort, and I'm not being funded. I'm charging $500 for an abortion. For 1075 Park Avenue that's cheap" (Baum 1995: E1). While Hausknecht's claim might be valid in that he was researching through his private practice and pricing medical abortions comparably to surgical abortions on

Park Avenue, other researchers have conducted less problematic and more affordable studies of methotrexate.

Dr Eric Schaff runs similar studies of methotrexate and misoprostol at the University of Rochester School of Medicine in New York. He charges his patients US$300 for the procedure, which includes office visits, ultrasounds, and a surgical abortion if the misoprostol fails to expel the embryo (Schaff 1995). Schaff explains that since no public funding is available for abortion research and private funding is difficult to raise because of the political controversy surrounding the issue, this is one of few studies for which patients themselves are paying. In fact, he is required to pursue his research outside his place of employment because the Family Medical Center, a University of Rochester-affiliated hospital, wants to avoid any ensuing protests. Instead, Schaff studies methotrexate across the street at Highland Hospital, where surgical abortions are performed.

In his article, Schaff (1996) details the University of Rochester Research Subjects Review Board's approval of his study and outlines both the eligibility requirements and consent forms for women who participated in this research.[7] Of the 282 participants, 274 (97 per cent) had a successful medical abortion. Eight (3 per cent) of the participants required surgical intervention: four for continued pregnancies and four for excessive bleeding. After analyzing participants' satisfaction questionnaires, Schaff found that adverse effects were common, brief and comparable to complications from surgical abortions; more than 80 per cent of the women found bleeding and adverse effects acceptable and would prefer a medical abortion to a surgical procedure in the future. In addition, 88 per cent of the women in the study agreed that the procedure went well. Schaff also found that women who were less than six weeks from their last menstrual period reported significantly fewer adverse effects and had reduced failure rates from medical abortions.[8] Schaff writes that these results indicate that one important goal with medical abortions will be to emphasize the benefits of early pregnancy determination.

Schaff associates high acceptability rates with participants having realistic expectations; he emphasizes that caution and clear explanations of medical abortions are necessary in order to make the process more understandable for clients who may be unfamiliar with the procedure. Schaff asserts that the participants in the study must be aware beforehand of the delays that sometimes occur with medical versus surgical abortions. On the one hand, surgical abortions are usually not performed until after the seventh or eighth week of pregnancy because the embryo or fetus may be too small to extract before that time, so the risk of failure is higher. However, once the procedure begins, it usually requires only one office visit, with a follow-up exam later, and can take as little as ten to fifteen minutes. On the other hand, though they can begin as soon as a woman finds out that she is pregnant, even before the sixth week, medical abortions may require more office visits and more time to complete because once the methotrexate has been injected, participants must wait approximately seven days before the misoprostol insertion. If the first dose is not successful, participants may have to return for more misoprostol.

Though Hausknecht found that 88 per cent of the women in his study had a successful abortion within twenty-four hours of the misoprostol insertion, some women in Schaff's study waited as long as a month for the combination to work. Schaff explains, "These delays, causing anxiety, and the possibility of heavy bleeding at home, as well as the psychological problem of having to view the abortion are disadvantages of medical abortions. ... A medical abortion may not be the choice of

everyone" ("New Study Confirms" 1995). Hausknecht responds to claims that seeing the embryo will be psychologically detrimental to women by asserting, "the notion that what comes out of a woman's body at 56 days ... is a baby, is simply outrageous. It's not recognizable. The sac is about the size of a suit button that's the entire sac and the embryonic plate inside of it is not recognizable as a fetus, even" (CNN 1995). Indeed, many of the women in Schaff's study compared the passing of the embryonic tissue to heavy clotting during menstrual bleeding.

None of the methotrexate or mifepristone studies have found that seeing the expulsion of the embryo causes any more psychological distress than does a surgical abortion. On the contrary, many women choose a medical over a surgical procedure to avoid the emotional strain of surgery. Dr Ellen Wiebe, an obstetrician and gyne-cologist conducting methotrexate studies in Vancouver, British Columbia, found that nearly 45 per cent of the women in her study rated "fear of surgery and anesthetics" as a "very important" reason for deciding to have a medical rather than surgical procedure (1997: 70). Wiebe asserts that in the written and verbal comments "it was obvious that for some women this fear was overwhelming and that they were very highly motivated to avoid surgery" (ibid.). Wiebe also found that despite the uncer-tainty of when or whether they would abort, the bleeding, and the pain of the procedure, the majority of women who chose to have medical abortions would choose this method again. Finally, 80 per cent of the women who had had both surgical and medical abortions said they would choose a medical abortion if faced with the same decision (Wiebe 1997: 69). In this context, it seems that for many women avoidance of surgery often warrants more concern than does anxiety about the more lengthy process of a medical abortion.

Studies made by Creinin, who has conducted the most extensive research of methotrexate-induced abortions, and his colleagues can serve as examples of well-run trials.[9] In each of their reports, Creinin and his colleagues detail the study protocol, its approval by institutional human research review committees, and the lengthy consent forms signed by participants. In addition, though the source of funding is not mentioned in the article, participants in a large, multicenter trial in Pittsburgh, San Francisco, and Wichita were not responsible for any costs during the study (Creinin and Burke 1996: 19). Interestingly, the percentage of women citing cost as the main reason for participating differed depending on whether or not medical assis-tance pays for elective abortion. In San Francisco, where elective abortions can be covered by medical assistance, only seven (7.4 per cent) women stated that they chose a medical abortion because it was free. In contrast, in Pittsburgh and Wichita, where medical assistance will not fund an elective abortion, twenty (18.3 per cent) women and seventeen (21 per cent) women, respectively, gave that response (Creinin and Burke 1996: 19). Further, the number of women in the study was lowest in Wichita because this study site had the most difficulty recruiting participants. In Wichita, even though they were offered a medical abortion free of charge, women still overwhelmingly chose to have a surgical procedure because it requires fewer office visits and has a higher success rate. Creinin and his co-author, Anne Burke, emphasize that this finding points to the fact that rates of acceptability for medical abortion will vary across the country (Creinin and Burke 1996: 22).

Creinin and his colleagues report results similar to those of Wiebe; in the multi-center trial, the most commonly cited reason for choosing a medical abortion was to avoid some aspect of surgery. Of the 170 women who selected this answer on post-study questionnaires, 109 (64 per cent) provided a specific reason, including pain,

"scraping," noise of the suction (34.7 per cent), and the emotional stress associated with a surgical abortion (19.4 per cent) (Creinin and Burke 1996: 20). Overall, 238 out of 285 women (83.5 per cent) stated that they would choose a medical over a surgical abortion (Creinin and Burke 1996: 21).[10] Of the sixteen women who stated that the medical abortion "took too long," eleven would still choose a medical abortion if faced with the same decision in the future (ibid.: 21). Finally, though most researchers cite the multiple appointments required for a medical abortion as a disadvantage, Creinin and Park assert that the visits allow repeated interactions between health care workers and participants, facilitating a relationship that often is not possible during surgical abortions when the client frequently does not meet the physician until the time of surgery (Creinin and Park 1995: 43). Even considering some of the drawbacks of medical versus surgical abortions, including longer delays before the abortion is complete, Creinin's and his colleagues' findings seem to support those of previously mentioned researchers; a majority of women would still choose a medical over a surgical abortion. Keeping this in mind, I will now address some critics' responses to methotrexate-induced abortions.

Critics' responses to methotrexate studies for early abortion

Randall Terry, the founder of Operation Rescue, a militant anti-abortion organization, responded to Hausknecht's study in a manner that is indicative of not only the ways in which medicine, science and politics intersect but also of some resulting threats to abortion providers: "Let 'Doctor' Hausknecht remember the fate of the Nazi 'doctors.' Let Richard Hausknecht and every chemical assassin who follows him be forewarned: when abortion is made illegal again, you will be hunted down and tried for genocide" (American Political Network 1995a). Though Terry claims that his faxed response is not a threat, he continues, "If a doctor prescribes this, we're going to find out who he is, we're going to find out where he practices and where he lives, we're going to picket at his office and at his home, and we're going to use our First Amendment rights to make his life a living nightmare" (ibid.). For the reasons discussed above, though it will be more difficult to target physicians who prescribe methotrexate for medical abortions, the use of mifepristone is open to the attacks outlined by Terry. And while the site of abortion debates may shift from clinics to individual physicians' offices, it seems unlikely that these struggles will cease with the advent of medical abortions.

Several other reactions to methotrexate and mifepristone studies demonstrate the sophistication with which opponents of abortion have been able to argue in order to gain more widespread support; anti-abortionists align themselves with movements or groups that have historically been considered "progressive". For example, Wanda Franz, president of the National Right-to-Life Committee, denounces medical abortion studies in terms of concern for women's health: "Pro-Lifers are appalled at the push by pro-abortion advocates to use women as guinea pigs." She says that her group "strongly opposes the use of these dangerous drugs because they kill unborn children and because the long-term side effects for women are unknown" ("New Study Confirms" 1995). Laura Echevarria, a spokesperson for the same organization, explains that her concern about methotrexate is "not only for the unborn child but also for the health of the woman and the drugs' effects on her reproductive system ... and the psychological effects of seeing her unborn child aborted before her very eyes" (Rutter 1995: 705).

To contest Franz's and Echevarria's arguments point by point, in her research, Wiebe is careful to address potential congenital anomalies if a woman decides to continue her pregnancy after methotrexate or misoprostol exposure. Though some studies do report that methotrexate and misoprostol may cause congenital anomalies, Wiebe emphasizes that in Europe, women who choose medical abortion have a surgical procedure if the medical abortion fails, so the risk of congenital anomalies in infants born after methotrexate exposure is low (Wiebe 1996: 166). While this low risk is not to be disregarded, it seems clear that most of the women who decide to have an abortion, whether medical or surgical, have considered this risk before making their choice. This point is bolstered when considering the implementation of waiting periods or counseling regulations prior to abortions throughout much of the US. To address Echevarria's second point, though seeing the results of a medical abortion may be disturbing for some women, this possibility is not limited to medical procedures; many women who have surgical abortions see the results of the procedure in a sink, jar or plastic tube. Moreover, as discussed above, many women cite noise of the suction and "scraping" as the reason they chose to have a medical over a surgical abortion. Though Echevarria and Franz contend that all forms of abortion should be made illegal, it seems that having the option between surgical and medical abortions better serves the interests of women who decide to have an abortion.

Franz's and Echevarria's arguments echo those by feminists about the historical abuses of women as test subjects in medical trials. By aligning themselves with feminist concerns, Franz and Echevarria complicate the ways in which methotrexate and mifepristone can be advocated by pro-choice organizations. However, as Dr Robert Benjamin and Betty Benjamin point out in their letter to the *Star Tribune* about anti-abortionists' "feigned concern" for the psychological and emotional impact on women, "If antiabortion groups were truly concerned about women's emotional state, they would not continue to engage in a nationwide campaign of harassment against women who seek to legally and safely terminate a pregnancy" (Benjamin and Benjamin 1995: Metro 21A). While it would be difficult if not impossible to determine whether or not their concern is "feigned," responses by such anti-abortionists as Franz, Terry and Echevarria indicate that, though publicly stated concern for the well-being of women who are pregnant may be a way to gain support for their arguments, the importance they place on the embryo or fetus outweighs any anxiety about the effects of harassment on women. For many anti-abortion advocates, since the fetus is a "helpless" and "innocent" entity, it requires protection over and above women who are pregnant. The potential harm produced by picketing and violence can be justified for anti-abortionists in terms of saving the "unborn child."

One of the most vocal critics of medical abortions, Dr Bernard Nathanson, perhaps best-known for his involvement in the film *The Silent Scream* (1984), remains staunchly opposed to what he considers the "murder of unborn children." Even more disturbing than Nathanson's unsurprising claims about life beginning at conception in the "sanctuary" of the womb, however, is the misinformation he uses to attack medical abortions. During his presentation in Rochester, New York on 21 October 1995, Nathanson referred to methotrexate as an "abortion cocktail for two."[11] By using this metaphor, Nathanson not only called on pervasive, negative associations with drinking alcohol or "cocktails" during pregnancy but also attempted to emphasize that his concern is for "two": both the woman who is pregnant and the embryo. Throughout his lecture, Nathanson cast himself as an expert in both medicine and bioethics by virtue of his history as an abortion provider and the

recent acquisition of a degree in bioethics. Since Nathanson's arguments echo those of other critics mentioned above, I will dispute his main points one by one.

Nathanson began his presentation by describing a "dominant concept in bioethics," the risk-to-benefit ratio, which basically means that the benefits of any given medical procedure should outweigh the risks in order to be justifiable or ethical. According to Nathanson, when methotrexate is used in cancer treatments the benefits outweigh the risks because, though methotrexate is a "toxic, dangerous drug," the possible avoidance of death from cancer outweighs the risks of adverse effects from methotrexate.[12] In contrast, since pregnancy is not a "disease" but rather a "natural state" for women, Nathanson claims that it becomes impossible to justify the use of methotrexate on "perfectly healthy women" because "pregnancy is not a state which is inimical or adverse to how a woman feels." Nathanson further emphasizes that "infertility is abnormal, not pregnancy. Pregnancy is not a disease by any normative definition." In order to accept Nathanson's analysis of the risk-to-benefit ratio for methotrexate and medical abortions, one has to agree with the premise of his argument, namely that pregnancy is not under any circumstances detrimental to women's health. Unfortunately, for a large number of women, giving birth, raising a child, or any combination of other outcomes from pregnancy may be extremely harmful. Nathanson's universalizing description depends on his problematic view of pregnancy as a "natural state" for women.

Nathanson also attacks Hausknecht's study of methotrexate by claiming that Hausknecht failed to obtain informed consent from his patients, did not take precautions to avoid risks to participants, and did not mention any reports to the Mount Sinai Hospital review board, which would have indicated that Hausknecht's study was being supervised. Nathanson goes on to describe how the women in Hausknecht's study were "thrown to the wolves" when they "vanished from medical supervision" and then he wonders aloud how such poor, "federally funded" research could have been allowed. As I noted earlier, Hausknecht did not present his study for review by either a Mount Sinai Hospital or FDA committee until he was pressured to do so. However, he did submit the research to which Nathanson is referring, the study published in *The New England Journal of Medicine*, for review by both Mount Sinai Hospital and FDA committees. Also, an article in the *Los Angeles Times* points out that the first article Hausknecht submitted to the journal was "promptly rejected because he had done his original research without supervision. So he treated another 178 women and detailed the results in another paper that the journal accepted – but only after Hausknecht provided the editor in chief with copies of each woman's consent form" (Baum 1995: E1). Moreover, as I discussed previously, Hausknecht received no federal funding for his research, which is why women paid to participate in the study. Finally, while Hausknecht's willingness to begin research without the expected supervision may remain problematic, studies of methotrexate for unruptured ectopic pregnancies support Hausknecht's assertion that low doses of methotrexate produce none of the long-term adverse effects associated with higher, more prolonged usage in cancer treatments. And even by the time of Nathanson's lecture, Creinin had published some of his better-run and more thoroughly supervised research. In effect, Nathanson erroneously condemns all medical abortions based on the partially flawed research of one man: Hausknecht. And though the published version of his lecture claims that the 1994 research conducted by Creinin and Vittinghoff is "a similar and equally odious experiment," Nathanson's assertion holds little merit when one considers Creinin's and Vittinghoff's research protocol (Nathanson 1996: 25).

Like Franz and Echevarria, Nathanson strategically aligns himself with historically feminist arguments, but he does so in such general terms that it becomes difficult to discern his position. Specifically, Nathanson criticized the notion of "privacy" in medical abortions; compared the use of women in methotrexate studies to that of laboratory rats or guinea pigs in animal experimentation; made analogies between medical abortion research, the Holocaust, and the Tuskegee syphilis experiment; and finished his lecture with a list of various cultures and religions that "condemn abortion." Nathanson's references to religions and cultures other than his own could be seen as inclusive or open-minded; many feminists also criticize the notion of "privacy" as a way to relegate women's experiences to individuals rather than collectives, especially in relation to medical experimentation and procedures; and abuses of humans as scientific test subjects are widely condemned. But which feminists does Nathanson align himself with and exactly how does this occur? The terms he constructs appear to revolve around concern for women, yet Nathanson does not address either the detrimental effects of unwanted pregnancies on women or the fact that medical abortions are less invasive and typically entail fewer risks for damage from surgical complications, such as cervical laceration or uterine perforation.

Nathanson's comments are especially confusing when considering some remarks in the published version of his lecture: "The unprofessional and unethical means by which the procedure was tested, the unknown long-term medical effects on women of the drugs involved, and the *extreme dangers to the human gene pool* posed by partially completed medical abortions all suggest a strong societal interest in banning the 'abortion cocktail' " (my emphasis, Nathanson 1996: 25). Here, Nathanson's argument dovetails with those of eugenicists, who have historically been discredited for the forced sterilization and other abuses of people deemed "unfit" to propagate, or in extreme circumstances, even to live. While it would be impossible to determine from this single statement what Nathanson means by "extreme dangers to the human gene pool," his vague assertions thwart any clear understanding of his position.

Once Nathanson's statements about "ethically shabby" research and methotrexate's adverse effects on women are examined and refuted, his analysis depends on whether or not one believes that life begins at conception, the fetus is an "unborn child" whose entitlement to human rights should usurp those of women who are pregnant, and abortion is unacceptable because it is the "murder of a baby." Since I have already refuted most of his other points, Nathanson's discussion finally rests on a morality debate about abortion that may never be fully resolved. By constructing his concern for the fetus as concern for women's well-being, Nathanson weaves a complicated argument that potentially fosters increased medical risks for women who are pregnant, but which may gain support unless it is closely examined and taken apart, at which point debates about the morality of abortion will still continue.

How the advent of medical abortions will alter abortion debates in the US

Since more than 90 per cent of abortions in the US are already performed in the first trimester, early medical abortions are clearly feasible even though they occur earlier in pregnancy than do surgical procedures. As Wiebe asserts in her study, because women now often diagnose their pregnancies very early at home with pregnancy test kits, many have made their decision to abort before a surgical abortion is possible. Many women mentioned the earlier timing of the medical abortion as an important

factor in their choice; in their written comments, "many mentioned that it felt better emotionally to abort the pregnancy as early as possible" (Wiebe 1997: 70). In this context, the earlier timing of medical abortions becomes an asset in that it not only relieves some of the emotional strain of having to wait until seven weeks' gestation for a surgical abortion but also may be effective in reducing the adverse effects and failure rates associated with later abortions. However, because they are not available to women who are more than eight weeks pregnant, medical abortions will not completely replace the need for surgical abortions. Moreover, surgical procedures must be available for women having medical abortions in case of complications, such as heavy bleeding or an incomplete abortion, that would require surgical intervention. Thus, struggles to make surgical abortions accessible, affordable and available will not cease with the advent of medical abortions.

In terms of abortion availability in the US, one advantage that methotrexate and mifepristone share is their similarity to a spontaneous miscarriage. As one physician conducting research on mifepristone states, "Here in the Midwest we're talking about traveling great distances – maybe 10 hours – for an abortion, and then going back to a totally Catholic or Dutch Reformed community where you can't ever mention it" (Jouzaitis 1995a: News 1). The physician goes on to describe how some of her patients who have had abortions, seeking follow-up care in their hometowns, have been berated publicly in medical office waiting rooms by health care workers who oppose the procedure. She points out that patients who have had medical abortions could seek care in their hometowns and "no one would know" that they had had a medical abortion "because it's so much like a spontaneous miscarriage" that even other health care workers would have a difficult time telling the difference (Jouzaitis 1995a: News 1).

Since any physician familiar with the protocol can administer a medical abortion, many advocates of this procedure laud potential accessibility and relative safety from anti-abortion harassment as a way to make abortion a more "private" decision between a woman and her physician. Though at this point they may be more time-consuming than are surgical procedures, medical abortions have the potential to alter the circumstances in which abortions are performed. Responses to Hausknecht's study include statements such as Joan Beck's, "What politics hasn't been able to give pro-choice supporters, science has. Abortion will increasingly become a private matter between a woman and her physician" (1995: B9). The National Abortion Rights Action League's (NARAL) Kate Michelman argues in similar terms: "When you start putting government and politicians in between doctors and their patients, that is where even anti-choice members of Congress will draw the line" (American Political Network 1995a). Michelman also asserts, "Anti-choice groups are sure to attempt to block the use of this procedure, but sound medicine – and not anti-choice politics – must determine whether this method is eventually approved" (Rutter 1995: 705). While I would like to remain optimistic about the ways in which the availability of medical abortions has the potential to make abortions more accessible, I doubt that Congress members "draw the line" at intruding on patients' "private" relationships with their physicians. Legislation banning private funds from and regulating access to abortion indicate that anti-abortion Congress members are more than willing to interfere in patients' "privacy." Moreover, the notion that the relationship between a physician and client is private seems problematic in that it is overdetermined by economic, social and historical factors, as is evidenced by the previously cited berating by physicians of patients who had had abortions. Michelman's statements

about the "private" nature of physician/client relationships, as well as her and Beck's claims that "science" and "sound medicine" will succeed in offering women alternatives that have been previously thwarted by "politics," all seem to be working under the assumption that "medical knowledge" is somehow separate from "politics." However, the continuing controversy surrounding any research on or access to medical and surgical abortions clearly demonstrates that no such separation of medicine, science and politics exists.

In her review of medical abortion studies, Beverly Winikoff describes women's responses to medical versus surgical abortions (Winikoff 1995: 144). She explains that medical abortions were by far the preferred method for both women who had and had not experienced a prior surgical abortion:

> Women treated with the medical regimen gave it higher ratings after the abortion, saying they valued the naturalness of the method and the privacy during the treatment. On the other hand, they disliked the pain and the duration of treatment and reported more bleeding than did the women who had a surgical abortion. They viewed the possibility of a self-administered abortion method more positively after the experience of medical abortion.
>
> (Winikoff 1995: 144)

In her conclusion, Winikoff asserts that, although medical abortions seem to produce higher levels of satisfaction than do surgical abortions, they also paradoxically result in slightly higher levels of dissatisfaction. Winikoff attributes this disparity to the possibility of "unrealistic expectations about a new method or providers' lack of experience in identifying and counseling women likely to be unhappy with the characteristics of the method. Medical abortion may also have been over-sold in the media or by medical personnel with little experience of medical abortion" (Winikoff 1995: 148). Winikoff's findings reflect those of other medical abortion researchers, including Schaff and Hausknecht, who emphasize the importance of counseling and explanation in order to familiarize women with the procedure (Jouzaitis 1995b: Womanews 1).[13]

Results from studies of medical abortions, whether with mifepristone or methotrexate, seem to support Winikoff's findings. Physicians who used mifepristone reported that it was easier to administer than they had expected, but many doctors are still unfamiliar with the procedure (Jouzaitis 1995b: Womanews 1). The failure rate for mifepristone is about 4 in 100 for women who are seven weeks pregnant or less. For women in their eighth and ninth week of pregnancy, the failure rate is significantly higher, about 20 in 100 (Jouzaitis 1995b: Womanews 1). Also, approximately 4 in 230 women experience excessive bleeding with mifepristone, which is one of the reasons that monitoring a medical abortion is necessary (ibid.). However, as discussed above, most of the adverse effects, such as heavy bleeding and cramping, decrease if the woman is seven weeks pregnant or less.

Women's reports of their experience with medical abortions appear to indicate that, while the process might entail some pain and adverse effects, medical procedures may seem less invasive than surgical abortions. In fact, when women participating in Schaff's study were asked how they would respond to another woman considering a medical abortion, they repeatedly commented on the "privacy," "naturalness" and "non-invasive[ness]" of the procedure. And again, most of the women's reactions against pain or the sight of heavy bleeding and/or clots were accompanied by their

emphasis on the necessity of explaining the process to other women going through the procedure. In addition, many of the adverse effects of medical abortions, such as bleeding and cramping, also occur with surgical abortions. Finally, as noted above, medical abortion virtually eliminates the slight chance of surgical complications such as uterine perforation and cervical laceration. Given this, the comments of women in the studies seem to indicate that the benefits of "privacy," "naturalness" and "non-invasive[ness]" outweigh any possible delays with or adverse effects from medical abortions.

The controversy surrounding abortion will not disappear even if methotrexate and mifepristone are approved by the FDA for use in medical abortions. Joan Beck writes:

> Abortion has played a long, bitter role in U.S. politics for decades. More than 31 million unborn infants have been destroyed since abortion became legal in 1973. Its availability has helped to loosen sexual mores and undermined social proscriptions against extramarital sex. It has influenced elections, troubled politicians, divided churches. It won't be the same in the future.
>
> (Beck 1995: B9)

Though Beck's claims about the effects of legal abortion on sexual mores are questionable, at least as the sole reason for extramarital sex, her assertion about abortion's influence on elections has been clearly demonstrated. And, as I have argued, whether or not one agrees that abortion should remain legal, the lack of public funding for and accessibility of surgical abortions, as well as the decrease in the number of physicians willing to perform them, is likely to hinder the adoption of medical abortions as an alternative to surgical procedures. As both Schaff and Hausknecht explain, federal funding is not even available for studies on the efficacy and safety of methotrexate for medical abortions, so research has been mostly funded by women who can pay the US$300–500 fee. Without major systemic changes in the funding of abortion availability and research, medical methods may remain as inaccessible as surgical techniques for women who cannot afford medical care. Unfortunately, in contrast to Beck's statement that "it won't be the same in the future," without vigorous and active support of medical abortion research, the decreasing availability of surgical abortions may reflect the fate of medical abortions.

Notes

1 Another study that describes the decrease in residents who are trained in abortion procedures is MacKay and MacKay (1995).
2 Creinin and Darney (1993); Creinin and Washington (1993); Stovall and Ling (1993). After the publication of Hausknecht's study, Dr Stovall actually attempted to distance himself from any associations with abortion research by releasing a statement, "I have very strong personal views about abortion and don't want anyone being misled that the treatment I developed … was ever developed or intended as a method of 'abortion' for a normal pregnancy or for birth control" (cited by the American Political Network (1995b)).
3 Creinin (1996b). Another article details how a methotrexate-induced abortion prevented a woman from having to undergo a hysterectomy when her pregnancy implanted in a thin uterine scar, making the pregnancy potentially life-threatening (see Ravhon et al. (1997)).
4 Hausknecht (1995); Potts (1995); Creinin, (1996a). In Creinin's study, the rates of adverse effects from misoprostol are nausea (35 per cent), vomiting (15 per cent) and diarrhea (5 per cent).
5 For an excellent review of medical abortion research, see Grimes (1997).

6 In medical terms, a protocol is essentially a detailed set of instructions.
7 All citations in this paragraph come from Schaff *et al.* (1996).
8 Schaff *et al.* (1996: 202). Failure of a medical abortion is characterized as failure of the misoprostol to expel the embryo. These findings are reproduced by Creinin *et al.* (1996). In this study, Creinin found that the efficacy of the methotrexate regimen was best at 49 days gestation (91 per cent) as compared to 50–56 days gestation (82 per cent). Creinin and his colleagues have published at least a dozen articles in medical journals. Some of those not previously mentioned include: Creinen (1994); Creinin and Grimes (1994); Creinin and Park (1995); and Creinin *et al.* (1995).
10 In another study by Creinin and Park, 89 per cent of the participants said that they would choose a medical over a surgical procedure, including 18 out of 20 (90 per cent) of the women with a delayed abortion and 5 out of 9 (56 per cent) of the women who required a surgical procedure to complete the abortion (Creinin and Park (1995: 43)).
11 Parts of this lecture were later published in Nathanson (1996).
12 All quotations from Nathanson's presentation are taken from my notes unless otherwise cited.
13 Jouzaitis also writes that at least one professional accrediting group, the National Abortion Federation, is ready to begin organizing training sessions in medical abortions if large studies result in FDA approval.

References

American Political Network (1995a) "Methotrexate II: study prompts new security at journal," *Abortion Report* 31 August.
——(1995b) "Methotrexate abortions: doctor says his method is misused," *Abortion Report* 19 October.
Anonymous (1995) "New combination drug therapy provides alternative to surgical methods of early pregnancy termination," *PR Newswire* 30 August: A3.
——(1995) "New study confirms medical abortion safe," *U.P.I.* 14 September, Domestic News, BC Cycle.
——(1995) "Fewer U.S. doctors doing abortions; survey cites moral, ethical, religious beliefs, along with community pressure," *Austin American-Statesman* 23 September: A3.
Baum, G. (1995) "Medical maverick: gynecologist Richard Hausknecht flouted protocol with successful use of abortion drugs," *Los Angeles Times* 4 October: E1.
Beck, J. (1995) "Drug to put privacy label on abortion," *The Denver Post* 8 September: B9.
Benjamin, R. B. and Benjamin, B. M. (1995) "Let's not return to days of dangerous, illegal, back-alley abortions," letter in *Star Tribune* 4 November: Metro 21A.
CNN (1995) "Doctor urges colleagues to be patient in new finding," transcript no. 1098–4, 31 August.
Creinin, M. (1993) "Methotrexate for abortion at 42 days gestation, " *Contraception* 48(6) December: 519–25.
——(1994) "Methotrexate and misoprostol for abortion at 57–63 days gestation," *Contraception* 50(6) December: 511–15.
——(1996a) "Oral methotrexate and vaginal misoprostol for early abortion," *Contraception* 54(1) July: 15–18.
——(1996b) "Medically induced abortion in a woman with a large myomatous uterus," *American Journal of Obstetrics and Gynecology* 175(5) November: 1379–80.
Creinin, M. and Burke, A. E. (1996) "Methotrexate and misoprostol for early abortion: a multicenter trial. Acceptability," *Contraception* 54(1) July: 19–22.
Creinin, M. and Darney, P. D. (1993) "Methotrexate and misoprostol for early abortion," *Contraception* 48(4) October: 339–48.
Creinin, M. and Grimes, D. (1994) "Medical options for early pregnancy," *Contemporary Ob/Gyn* 39(4) April: 85–90.
Creinin, M. and Park, M. (1995) "Acceptability of medical abortion with methotrexate and misoprostol," *Contraception* 52(1) July: 41–4.
Creinin, M. and Vittinghoff, E. (1994) "Methotrexate and misoprostol vs. misoprostol alone for early abortion," *Journal of the American Medical Association* 272(15) 19 October: 1190–5.

Creinin, M. and Washington, A. E. (1993) "Cost of ectopic pregnancy management: surgery versus methotrexate," *Fertility and Sterility* 60(6) December: 963–9.

Creinin, M., Vittinghoff, E., Galbraith, S., and Klaisle, C. (1995) "A randomized trial comparing misoprostol three and seven days after methotrexate for early abortion," *American Journal of Obstetrics and Gynecology* 173(5) November: 1578–84.

Creinin, M., Vittinghoff, E., Keder, L., Darney, P.D., and Tiller, G. (1996) "Methotrexate and misoprostol for early abortion: a multicenter trial. I. safety and efficacy," *Contraception* 53(6) June: 321–7.

Feldkamp, M. and Carey, J. C. (1993) "Clinical teratology counseling and consultation case report: low dose methotrexate exposure in the early weeks of pregnancy," *Teratology* 47, January: 533–9.

Grimes, D. A. (1997) "Medical abortion in early pregnancy: a review of the evidence," *Obstetrics and Gynecology* 89(5) May: 790–6.

Hausknecht, R. U. (1995) "Methotrexate and misoprostol to terminate early pregnancy," *The New England Journal of Medicine* 333(9) 31 August: 537–40.

Jouzaitis, C. (1995) "Abortion pill clinic tests drawing to a close in U.S.; government approval of RU-486 may come in about 6 months," *Chicago Tribune* 30 August: News 1.

——(1995) "Abortion pill may be just what the doctor ordered," *Chicago Tribune* 22 October: Womanews 1.

MacKay, H.T. and MacKay, A. P. (1995) "Abortion training in obstetrics and gynecology residency programs in the United States, 1991–1992," *Family Planning Perspectives* 27(3) May/June: 112–15.

"The medical letter on drugs and therapeutics 38,973" (1996) 26 April: 39–40.

Nathanson, B. (1995) "The abortion cocktail," lecture given in Rochester, New York, 21 October.

——(1996) "The abortion cocktail," *First Things* 59, January: 23–6.

Planned Parenthood Federation of America (1996) HTTP: //www.igc.apc.org/ppfa/news (11 September).

Potts, M. (1995) "Non-surgical abortion: who's for methotrexate?" *Lancet* 346,8976 (9 September): 655.

Radlauer, S. (1996) "A whole new choice," *New York* 1 April: 36–41.

Ravhon, A., Ben-Chetrit, A., Rabinowitz, R., Neuman, M., and Beller, U. (1997) "Successful methotrexate treatment of a viable pregnancy within a thin uterine scar," *British Journal of Obstetrics and Gynaecology* 104(5) May: 628–9.

Rodgers, K. (1995) "Abortion combo: study raises new dilemma for r.ph.s," *Drug Topics* 139(19) 9 October: 22.

Rutter, T. L. (1995) "Drug combination adds fuel to U.S. abortion debate: methotrexate and misoprostol," *British Medical Journal* 311,7007 (16 September): 705.

Schaff, E. A. (1995) interviewed by author in Rochester, New York, 20 October.

Schaff, E. A., Eisinger, S. H., Franks, P., and Kim, S. S. (1995) "Combined methotrexate and misoprostol for early induced abortion," *Archives of Family Medicine* 4, September: 774–9.

——(1996) "Methotrexate and misoprostol for early abortion," *Family Medicine* 28(3) March: 198–203.

Stovall, T. G. and Ling, F. W. (1993) "Single-dose methotrexate: an expanded clinical trial," *American Journal of Obstetrics and Gynecology* 168(1) June: 1759–65.

Tiersch, J. B. (1952) "Therapeutic abortions with a folic acid antagonist, 4-aminopteroyglutamic acid administered by the oral route," *American Journal of Obstetrics and Gynecology* 63: 1298–304.

Wiebe, E. R. (1996) "Abortion induced with methotrexate and misoprostol," *Canadian Medical Association Journal* 154(2) 15 January: 165–70.

——(1997) "Choosing between surgical abortions and medical abortions induced with methotrexate and misoprostol," *Contraception* 55(2) February: 67–71.

Winikoff, B. (1995) "Acceptability of medical abortion in early pregnancy," *Family Planning Perspectives* 27(4) July/August: 142–8, 185.

Angela Wall

MOTHERS, MONSTERS AND FAMILY VALUES
Assisted reproduction and the aging natural body[1]

> For monsters live beyond the boundaries of community and they test the limits of social acceptability.
>
> (Donna Haraway 1992)

THE 1990S COULD be characterized in the history of reproductive technology as a decade in which the institution of motherhood was publicly declared in crisis. Since the birth of the first test-tube baby in 1978, pregnancy's categorization as a "natural" act has been contested medically and scientifically. However, by the 1990s, the successful delivery of infants to a number of post-menopausal women captured the interest of the mass media and placed the concept of a traditional or natural pregnancy under greater public scrutiny. While the "serious" news media worked on couching the anxiety that emerged from this kind of assisted reproduction in the form of ethical concerns, popular entertainment genres downplayed them by enveloping the issue in comedy. Thus, I want to begin this chapter by offering a snapshot example from popular culture that captures many of the dominant cultural sensibilities about pregnancy and the aging female body in the 1990s.

In the film *Father of the Bride 2* (directed by Charles Shyer, 1995), Diane Keaton plays Nina Banks, a menopausal mother of two who is about to become a grand-mother. The news that she and her husband, George, played by Steve Martin, are to become grandparents prompts a small mid-life crisis for George. He insists that they are not old enough to become grandparents and he turns to his body for verification – he dyes his hair, changes his look and makes love with his wife spontaneously on the kitchen floor. For we all know that grandfathers don't look and act like this. George's youthfulness is verified when Nina's emotional symptoms of fatigue are diagnosed not as menopause but as pregnancy. George responds to the news by crying out that "people our age don't have kids." The *National Inquirer* will have a field day, he shrieks, with headlines such as "Grandmother has baby." He reminds Nina with increasing alarm that they'll be close to 70 when the child graduates from college. In this way the film raises many of the anxieties and concerns frequently associated with pregnancies in older women: anxieties and concerns that are grounded in the unnaturalness of such pregnancies.

However, by paralleling the pregnancy of a 50-year-old mother with that of her

twenty-something daughter, the film posits age in terms of experience. Questions concerning Nina's suitability for resuming infant care are quickly suppressed and instead we see an older woman who is able to cope with her pregnancy just like other – even significantly younger – women with whom she comes into contact. The Banks' are economically stable, and this enables them to build a new, ultra-modern, highly expensive, suite for the baby. The film offers a clear message that the Banks, unlike their financially insecure daughter and son-in-law, are able to "properly" prepare for the arrival of the child. The prospect of parenthood rejuvenates the couple, especially George. Returning from the hospital after hearing the pregnancy test results, George's thoughts are narrated: "Nina was positively glowing" he thinks to himself – a frame of mind which contrasts with his own state of heightened agitation.

Father of the Bride 2 offers an undisguised male point of view. Most of the film's action is accompanied by George's voice-over. Thus the film quite literally sets about restoring George's ego, which has been threatened by cultural horror-stories about aging. Yet the restoration of his ego comes at a cost: George returns to his youth via his kids, his virility, and via Nina's reproductive body. Nina is captured in one of the final frames of the film outside her house. Having waved good-bye to her eldest daughter, Nina walks up the front path, arm around her adolescent son, smiling over her shoulder directly at the camera and George. She is framed as the perfect mother – at least this is how George sees it and this is how we, the audience, are encouraged to view it. Pregnancy for older women who are married, economically secure, have already raised a family and who are still capable of becoming pregnant via "natural" methods is viable – especially when the pregnancy quite literally rejuvenates the husband. By the end of the film, George Banks' problems with aging are thwarted and his mid-life crisis is over. Thus, while the film might confirm an older woman's decision to have a child and positively reflect on that decision, it does so within pre-determined and traditionally defined parameters. Nina's desires are never directly addressed. Her thoughts are always filtered through her husband's consciousness despite the use of her body as a vehicle for restoring the declining self-image and sense of self-importance of the film's central authorizing figure – her husband. The film briefly and comically touches upon the "unconventionality" of grandparents as parents, but the financial stability and the "natural" way in which Nina becomes pregnant seem to head off any real concerns. In this case, pregnancy in an older women recuperates the female body – as well as the male body – into their natural biological roles. However, when medical technology is called in to aid in making pregnant an aging female body, such factors as financial stability, experience and maturity provide ammunition for character assassination and ridicule rather than a means to validate the decision of the women concerned.

Unlike "serious journalism" which stakes its credibility in its public recognition as a truth producing genre – one that conveys issues of "actuality" and "facticity" – the Hollywood film genre lays no claims to such a grounding.[2] Yet as Peter Dahlgren points out in *Journalism and Popular Culture*, serious journalism is united with popular culture by the key link of "storytelling" in that both rely on narrative as a way of knowing the world (1993: 14). Journalism utilizes a form of storytelling characterized by "referential information and logic," popular culture by "narratological configurations which provide coherence via enplotment." He continues,

> [j]ournalism officially aims to inform about events in the world – analytic
> mode – and does this most often in the story mode. One of the key features

of stories is that they create their own 'worlds'. ... Narratives have ingredients which culturally competent audiences can readily recognize and classify, which prestructure and delimit the likely range of meanings – and also help foster cultural integration.

(Dahlgren 1993: 15)

By looking at the seemingly incompatible genres of news journalism and Hollywood film in terms of their shared cultural narratives and the available range of meanings, it is possible to tease out the construction of what counts as "normal" or "natural" in various popular accounts of assisted reproduction and the aging reproductive body. In the process, a cultural cohesion is produced and reproduced; however, what emerges simultaneously is a taxonomy in crisis – a system of classification which both medical and health practitioners rely on to maintain their position as purveyors of reproductive norms. In brief, the conjunction of these genres, practices of assisted reproduction, and the aging female body produce a complex story about the management of motherhood in the age of assisted reproduction – a story whose subjects do not fall into the exclusive modes of classification upon which the production of medical knowledge about pregnancy, aging and the female body is based.

Taking their lead from the medical profession, many news media accounts of reproduction in older women reproduce the debate in simple binary terms. A typical story centers around a male infertility doctor who serves as the central figure in the decision-making process of whether or not assisted reproduction is possible for women who are outside of what constitutes the medically determined age for "safe child bearing." For many feminists, these stories reiterate a familiar doctor–patient narrative: developing reproductive technologies simply relegitimate circumstances in which mostly male doctors are, once again, given power over women's reproductive bodies. Yet, a closer look at stories about assisted reproduction reveal more than these simple binaries allow. They reveal anxieties concerning the unnaturalness of the aging pregnant body and, simultaneously, they begin to question the decisions made by the "designated, trained expert." Indeed, these anxieties are unsuppressable in spite of the authorizing presence of medical science. The impact, then, of assisted reproduction is more complex than a binary reading would suggest, and current methods for making sense of reproduction reveal the limitations of our cultural thinking about pregnancy and the aging body. In short, the increasing ways in which women's lives variously intersect with medical technologies demand that we imagine more creative paradigms through which to examine these stories. These limitations are demonstrated in an interview for a recent *New York Times* article on decreasing birthrates in Europe and the US. Nicholas Eberstadt, a demographer at the American Enterprise Institute in Washington, suggests that if trends in depopulation continue "in a generation or two there may be countries where most people's only blood relatives will be their parents." He elaborates, "'Would this be a lonelier, sadder world?' Yes, I think it would. But that might simply be the limits of my own imagination" (Specter 1998: A1).

Cartoons, cover stories and a crisis

In 1997, almost every US news magazine cover lampooned, chastised or expressed shock over women who both failed and exceeded the traditional expectations of motherhood. A glance over these covers reveals motherhood as an institution of extremes.

The covers declare that as a practice in the last decade of the twentieth century, reproduction severely tests the limits of social acceptability. In its most traditional and recognizable form in the US, motherhood has, in the minds of ideologues, always gone hand in hand with secure marital status (heterosexuality), youth, health and sobriety: in doing so, it has confirmed the contemporary good health of the state of the US if not the world.[3] Yet assisted reproduction in its latest media manifestation emerges as a potential threat to this popular iconography with the unnatural figure cut by the post-menopausal mother.

In the plethora of cartoons that surfaced after the 1997 announcement of another post-menopausal birth, the cover of *The New Yorker* magazine depicted a very pregnant, very "aged" woman (Falconer 1997). Complete with sensible shoes, white collar and "granny-knotted" bun this older woman stares at her enormous protruding belly in the mirror with a look of bewilderment, one hand tenderly wrapped around her stomach, the other clutching a walking stick for support. The image she evokes is doubly absurd: as a pregnant "old woman" her look is "unnatural" to our cultural sensibilities and she literally embodies that unnaturalness not just once but twice, through her reflection. Even after a second look, the image makes no sense to our cultural ways of seeing motherhood. After all, why would a pensioner want to be pregnant? The absurdity is heightened further by the subtle inclusion of a "stim-mobile," the latest psychologist-approved aid in infant stimulation: age and youth are conflated in ways that cannot be reconciled in contemporary US culture.

This "absurd" and "unnatural-looking" embodiment of aging and pregnancy is developed further in a cartoon carried by *The London Times* accompanying a story on the issue of post-menopausal pregnancy (PVH 1997: A1). This cartoon features the window display of one of Britain's foremost maternity stores, "Mothercare." Here, the store advertises walkers, walking sticks, slippers, mittens, shawls and spectacles. In these instances, humor works as a reminder of what, culturally, we collectively understand as "normal" or "natural-looking" – by juxtaposing the "weird" with the "normal" the cartoon serves up a lighthearted version of whatever threat the reality of post-menopausal mothers poses socially. It masks our shared cultural anxieties about developments in medical technology.

Cartoons depict the issue with humor and a clear-cut sense of absurdity, while media narratives are less self-assured. They document the "public outcry" against the "unnaturalness" of assisted reproduction in a rhetoric of confusion that presents medical practitioners as divided in how to classify post-menopausal pregnancies using existing categories – can they really be described as "natural" births? Newspaper accounts mediate the testimonies of medical researchers, doctors and the post-menopausal women who are the controversial subjects of this procedure. They serve as the popular access route to scientific debate. These mass-mediated accounts offer public explanations and responses to medical science in an attempt to make sense of non-conventional approaches to pregnancy and motherhood. Frequently, in its response, medical science is unable to offer an authoritative or reassuring answer. Instead, medical authority is portrayed in a state of debate and the story told suggests that, for many doctors, cases of *in vitro* fertilization in post-menopausal women are an example of medical science going too far, interfering in the biological aging process of the body and such practices, they suggest, "border on the Frankenstein syndrome." For other doctors, the opportunity that *in vitro* fertilization makes possible for post-menopausal women enables medical science to align the biological function of the body with the changing needs of women.

Is this a monster story, then, or a medical marvel? In their attempt to make sense of these issues, media accounts turn to a lexicon of ontological support that the very practice of assisted reproduction is in the process of undermining. In that this story shows us that the medical establishment is divided among themselves, we are also treated to a story about the confusion of medical certainty. Media coverage of assisted reproduction inevitably contributes to this breakdown of scientific authority by falling back on structures of support that reveal, in the process, the economy of values that give rise to such rationales. Given that this issue is so contentious – is it monstrous or not? – it should give us pause to consider this moment of confusion as a site of slippage wherein the diverse needs of women are at odds with a system of social, medical and cultural practices. We need to be alert as we read these moments for how they differently reconfigure spaces for women (some older black women, for example, have often been positioned as post-menopausal mothers: first to the children of white women, and more recently to the children of their unmarried daughters). In short, we need to consider how these instances reproduce age-old positions for women of many ages and ethnicities.

An examination of the various current cultural configurations of assisted reproduction and the aging body involves looking at some of the first cases where technology was used to enable pregnancy in a post-menopausal woman; it also involves looking at media stories that represent these cases. Such stories are fertile with popular anxieties about the possibility of older women as mothers. Along with these anxieties emerge ethical conflicts regarding the well-being of children born to aging parents and questions concerning the regulation, availability and access to these technologies.

Media coverage, especially print media, has struggled over how to articulate the complexity of the positions that contribute to our understanding of assisted reproduction. Several accounts try to make sense of the issue through a legal lens. "No legislation as yet" limits assisted reproduction in the US (Koorijian 1997). As such, discussions of how to legally manage assisted reproduction and its availability to a diverse body of women can be considered only in terms of European legislation. In June 1994, the French government approved legislation limiting the age at which women could attempt artificial insemination – legislation that restricted assisted reproduction to heterosexual and infertile couples. The Italian parliament called for a ban on artificial insemination for post-menopausal women and demanded guidelines similar to those established in France after artificial insemination enabled a lesbian couple to give birth. And in Germany, *in vitro* fertilization with donated eggs is prohibited without exception.[4] The conjunction of the media's fascination over assisted reproduction for older women with legislative guideline discussions offers interesting insights into what is at stake in recent cultural constructions of post-menopausal assisted reproduction both in and outside of the US.

Such strident legislative measures speak to the possibility that these new technologies hold: indeed, family units will be able to emerge that don't resemble the traditional ideal! A crisis in the scientifically grounded understanding of the aging process and the biological stages of the life cycle inevitably calls into question the lifestyles and values such knowledge validates – lifestyles and values that are often assumed to be "normal" or "natural" and thereby "appropriate" and "acceptable." With increased medical accessibility to assisted reproduction, heterosexual sex can no longer be used to validate heterosexuality based on its biological claim to "natural" or "normal" means of impregnation. Thus complications in the representation and definition of what constitutes a "normal" or "natural" pregnancy and family structure

emerge as more and more – in cases of non-fertility – technology is brought in to give nature a "helping hand." These instances of medical developments in assisted reproductive technology offer important places wherein the production of social and moral values take place. These sites also open up a space from where different or alternate value systems might emerge. This is a reproductive moment on many different levels – scientifically, medically as well as legally and socially. At stake is not simply the reproduction of children but the simultaneous reproduction of a cultural value system. The moment is rife with possibilities, yet as closer examination reveals, it is unclear what possibilities are available and what possibilities will be foreclosed upon.

Although the first child born to a post-menopausal parent was in South Africa in 1987 – a grandmother was implanted with the fertilized egg of her infertile daughter – one of the most popular stories of post-menopausal assisted reproduction occurred in 1993. The *New York Times*, among other newspapers, covered the story of a 59-year-old British woman who had recently given birth to twins on 25 December 1993 after being artificially impregnated with eggs donated by a younger woman and the older woman's husband. The British woman is described as a "well-to-do business executive married to a 45 year old economist" (Schmidt 1993: A1). New reproductive possibilities are made available, then, to a particular class identity, one that describes affluent, educated, white women with financial access to exclusive technologies.[5] The *New York Times* story focuses on the ethics of such medical practices and the subsequent article offers a variety of medical responses to the pregnancy, most of which are negative. Dr John Marks, the former chair of the British Medical Association Council, comments that such cases "bordered on the Frankenstein syndrome" (Schmidt 1993: A6). In addition, he questions the ability of a 69-year-old to cope with 10-year-old twins. This sheds a particular hue on how we might make sense of this debate, especially given that the companion story for this article concerns a 53-year-old American woman who acted as a surrogate for her infertile daughter and gave birth to her own grandchild. Ethical issues according to the *New York Times* story were "muted by [the grandmother's] altruism."

These two scenarios offer very distinct ways of looking at assisted reproduction. Post-menopausal women who want to defy nature to become pregnant in order to satisfy their own desire for a child are monsters: their cases border on the "Frankenstein syndrome." Alternatively, the second scenario suggests that a mother who becomes pregnant so that her infertile daughter may experience motherhood is exempt from direct ethical judgment – her altruism defies cultural chastisement. While the first case elicits a response that very clearly implies an ethical stance, the uncertainty that surrounds how to respond to the second case hints at a confusion that lies at the heart of this issue. In both cases the condition of motherhood is being perversely extended. Yet the alternate methods by which these women become pregnant necessarily de-naturalize how we might understand motherhood. The case of the American mother who carries her daughter's child exemplifies this. The decision of the 59-year-old Briton to give birth to her own child challenges not only the medical and biological construction of her body, but it also presents an older woman who has defied the culturally sanctioned and clearly marked roles that are outlined for women of her age. She is a successful executive, she has a much younger husband, and after having given the most productive years of her life to building a career, she now has a child. The American mother-grandmother conforms in this instance to the traditional roles assigned to the maternal and grand-maternal positions. She is the

ultimate maternal figure: a mother to her daughter as well as to her grandchildren. She quite literally embodies maternalism – her body is the "natural" choice for her daughter's surrogate pregnancy. However, in both cases, the body violates well-established cultural sensibilities about aging and the female body. In the case of the British woman, though, she offers herself as a testimony to the notion that women are not dependent on "the biological clock" should they wish to combine children and a successful career. In this way, current technology enables the emergence of an un-natural mother figure who threatens to challenge particular myths about mother-hood. But which myths? And is this a medical marvel or a monster story?

In her discussion of the history of the monster figure, Rosi Braidotti (1996) writes that in Babylonian times, prediction or divination based on the examination of the murdered body of "monsters" was practiced in the form of "teratoscopy." The Greek etymology of the word teras/teratos, she writes, refers both to "a prodigy and to a demon … something which evokes both horror and fascination, aberration and adoration" (Braidotti 1996: 136). This simultaneity of opposite effects, she concludes, is the "trademark of the monstrous body" (ibid.). Braidotti continues that the structural ambiguity of monsters as a "figure of simultaneous and contradictory signification is not confined to antiquity" (ibid.). The Reformation, she writes, "had a vested interest in the idea that monsters had signifying powers which were used for anti-clerical propaganda" and at the time of the religious wars the authority of monsters became the means to solving disputes over whom God favored (Braidotti 1996: 137). For Ambroise Paré, writing in 1573, the rarity represented by monsters was testimony to the ingenuity and the great variety of nature suggesting that monsters existed *inside* rather than outside of the natural order. Such a view, Braidotti notes, continued well into the eighteenth century. Finally, she comments that monsters are linked to the female body in scientific discourse through the question of biological reproduction. Discourses about monsters are fundamentally "epistemophilic," they express and explore a deep-seated curiosity about the origins of the deformed or anomalous body. Historically, she writes, the question that was asked about monsters was: ' "How could such a thing happen? Who has done this?" ' (Braidotti 1996: 139).

Braidotti's genealogy suggests that monsters evolve out of paradoxical situations and exist in the in-between zones. In terms of assisted reproduction, her work offers insights into the current figure emerging in discourses about the conjunction of science, medicine, technology, culture and the female body. As nature's control over the body is being eclipsed, as the body is seen less as a natural object and more as a human-technological hybrid, and as popular discourses about new reproductive technologies struggle to describe the ambiguous nature of the female body, the arrival of monsters on the medical horizon seems fitting and timely. Thus, from a historical perspective, the monstrous body is both an organic body and a textual one.

What emerges out of a cursory glance at the discursive construction of assisted reproduction and the aging body is a confused, tangled knot of issues made up of cultural anxieties, ethical conflicts, and the challenges posed to established ways of understanding by developing research in medical science. At this point in my discussion, I want to begin to work more closely at untangling some of the knots in order to better understand how this confusion might be useful to feminist investigations of how motherhood gets managed by technology.

In the case of assisted reproduction in post-menopausal women, technological intervention has pointed out the artificiality embodied by the naturalization of the

post-menopausal state: according to the established frame of reference (medical science) older women shouldn't be able to have children, but new technology (brought to us by medical science) can now make their bodies capable of pregnancy. Rather than validating cultural beliefs about the characteristics of the aging biological body – expectations that are primarily drawn from the realms of medical science itself – medical science is instead calling into question the very concepts that have helped to formulate cultural categories such as age, gender, menopause, and post-menopause. As a result, these women's bodies cannot be understood simply in terms of natural or biological functions, age and gender. Un-natural possibilities are now made possible and these new possibilities destabilize conventionally sanctioned "natural" practices.

This destabilization of the term "nature" as a result of the permeation of reproductive technologies with the practice of medicine on the female body has proved consequential to the work of many feminist theorists. Nelly Oudshoorn writes that

> the very act of classifying phenomena as natural is not without consequences. Natural phenomena are accorded the ambivalent status of objects of scientific inquiry: only those phenomena identified as natural will be included in the research agenda of natural scientists.
>
> (Oudshoorn 1996: 123)

As an example, Oudshoorn cites the view held in the late nineteenth and early twentieth centuries that sex and reproduction were "more fundamental to Woman's than Man's nature" (Moscucci 1990, cited in Oudshoorn 1996: 126). The result of such a belief was the emergence of a new specialty of biomedical sciences: gynecology. A shift in understanding of the term "nature" necessarily undermines the viability of the female body as an object of scientific study based on its status as a natural phenomenon. The increasing interest of feminist cultural studies in science and technology, particularly in reproductive technologies, has brought about the increased scrutiny of the structures that in turn construct what gets to count as natural and thus qualify as scientific objects of study. Further, technologies that contribute to the process of reproduction, a process historically grounded in its natural fit with the female body, inevitably expose the constructedness of such a cultural myth. Often at times, this is seen as a great advance for women – to be freed finally from the tyranny of the natural.

But the use of the term "natural" in recent articles addressing assisted reproduction in post-menopausal women illustrates the figuration of "nature" as a discourse under duress. Haraway describes our relationship to nature as one that enables us to "order our discourse" (1992: 296). Nature is the means by which we reinhabit "common places – locations that are widely shared, inescapably local" (Haraway 1992: 296). Nature, she continues, "is figure, construction, artefact, movement, displacement. [It] cannot pre-exist its construction" (ibid.). As such, "nature" or the "natural" is often used with the assumption that regardless of context, it possesses a universal meaning. In the case of the aging reproductive body, repeatedly "shared" and "commonplace" biological states such as "menopause," "pregnancy" and "aging" are called into question by the very authorities – scientific and medical discourses – which have helped established these shared meanings, and we begin to see nature as a "movement," a "displacement." Thus, fissures are created by such movements which leads the term "natural" in discussions of assisted reproduction to question medical concepts that rely on beliefs of universality. In the process, the role

of the popular media in repositioning "nature's" discursive location within a more postmodern condition gradually comes into focus.

Assisted reproduction, suggests Sarah Franklin, in her essay "Postmodern procreation," serves as both a "foundation and an anti-foundational moment as it is full of the unbounded promise of enablement" (1995: 334). What Franklin refers to here is the dual nature of the possibilities offered by new reproductive technologies. They are foundational in that they continue to remind us of what gets to count as "natural," and anti-foundational in their capacity to call into question such configurations. In other words, assisted reproduction, and the scientific and technological practices on which it relies, unravels the mysteries of nature by securing through medical practices what previously has been available only through "natural" procedures.

Postmodern pregnancies

In recent media stories about assisted reproduction in post-menopausal women, the confused and often contradictory coverage of medical responses to this procedure reveals an unstable relationship between the body *and* scientific practices and pronouncements. This relationship points to the slipperiness of what constitutes the "natural" and the now perverted redeployment of the reproductive body. In her 1994 article in the *Chicago Tribune*, "Pregnancy risks and age," Susan Fitzgerald's writing demonstrates the problems of trying to describe the female reproductive body as both a site of medical practice as well as a natural biological entity. As a result, her article struggles to constitute "normal" or "natural" practices for the female reproductive body in light of how these terms clearly circulate in a broader economy of reproduction. The piece opens with a brief history of the dichotomous relationship between women's reproductive issues and medical science. As an example, Fitzgerald describes how many doctors have eagerly worked on the pill to help "give women the freedom to decide if and when they [want] to get pregnant" (1994: Evening 7) while most now caution women of the increased risk of breast cancer that can result from delaying childbirth into their 30s and 40s. Fitzgerald's example illustrates the contradictory signal women are given by medical science with regard to their choices about when and if to have children. Such mixed messages aren't the exception; rather, they form the staple of many of the statements offered by medical professionals in their responses to such scenarios as the ones currently under examination. As such I want to closely examine the statements of Mark Sauer, a California fertility doctor, who was featured as a prominent spokesperson on the issue of post-menopausal pregnancy.

Sauer's narrative of how nature, culture, medicine and science interact in the case of a post-menopausal pregnancy demonstrates the extent to which assisted reproduction articulates a position for nature which lies at odds with its definition as relied upon by medical science (Fitzgerald 1994: Evening 7). I want to use this cultural moment when medical technology can be seen to be at odds with its own foundations to analyze how a commonly termed "natural" act, such as pregnancy, is medically mediated and managed.

Dr Mark Sauer is frequently described as a renowned fertility expert and is the former director of the infertility program at USC. In his response to post-menopausal pregnancy he states that "Nature didn't assume we would evolve the way we did and have so many people in their 40s who want to have children" (Fitzgerald 1994: Evening 7). He continues, "from a strictly reproductive point of view, you really

should be trying to have your babies when you're younger. Unfortunately, as a society we have not accommodated women's biological needs" (ibid.). Sauer's words demonstrate the uncertainty of how to construct meaning at a time when medical and cultural categories are increasingly threatened. His statements are confusing precisely because the language he draws from is in the process of being reconfigured by new reproductive practices – of which he is a pioneer – and will no longer substantiate the meaning he wants to convey. This quotation places at odds the concepts of nature, biology, women's reproductive needs and society's accommodation of those needs – that is those needs as they are commonly understood as ideological constructions of the mainstream by an assumed community.

Using a familiar trope, Sauer pits nature against culture. Yet assisted reproduction necessarily involves culture's intervention into what was once perceived as a natural process. Nature is clearly constructed as possessing a dual role here: Sauer tries to give nature a pre-existing condition – one in which presumably women's needs played no part – while simultaneously acknowledging the different position it occupies in relation to a medical-cultural-scientific locale. The nature that Sauer constructs requires the making of assumptions: He states that "'nature' didn't assume we'd evolve the way we did and have so many people in their 40s who want to have children" (Fitzgerald 1994: Evening 7). He calls upon nature's assumptions to differentiate between what is perceived to be biologically suitable and what is culturally practiced. However, in suggesting that nature makes assumptions, Sauer ultimately positions nature in a role that implicitly involves agency. In his discursive construction of the role of nature in women's decisions to reproduce, Sauer suggests that nature – rather than science – has made assumptions about the female body. Under these circumstances, nature's agency and scientific agency are conflated and shift between the biological, the medical and the perceived needs of women.

While Sauer returns the female to the "natural" body, he simultaneously describes it as being increasingly at odds with its surroundings: it is a body that in practice is comprehensible only via its relationships to a common set of givens about science, medicine, nature, culture, economics and gender. Evident, then, in the confusion that emerges out of Sauer's words is a public framework at odds with itself. For example, if women can "choose" at what age – and if – to have children and if medical technology is able to broaden and accommodate the choices and decisions women make, then the biological needs of women would seem to rest in part with women's decision making and in part with their position *vis-à-vis* medical practices, legislation, employee benefits, adequate health care, and easy access to childcare. The concept, then, of the "natural woman" that emerges is a shifting figure whose identity is discursively unidentifiable – dare I say monstrous?

When medical science and social needs permeate an understanding of how we evolve, nature's position in medical practice as the sole proprietor over the body is a fallible one. As Sauer moves between positions that acknowledge social and cultural influences – what he describes as "women's needs" – and those that are assumed to lie outside of such influences – i.e. with nature – he has to qualify his frame of reference. At the end of his comment he is speaking from a "*strictly* reproductive point of view." In order to offer his opinion about assisted reproduction, he has to qualify biological reproduction with a referent "strictly" to indicate to the public audience that the term "reproduction" has meanings and associations that extend its biological reference. As a practice, then, reproduction cannot be confined within the boundaries Sauer attempts to place around it. Furthermore, in speaking from a "strictly

reproductive" point of view, Sauer attempts to detach his comments from a larger social and cultural context in which medical practices operate – a context he later acknowledges is implicit to the practice of medicine and the role of medical practitioner. What is primarily at odds then in many of these accounts are the structural references used to try to manage medical advances in reproductive technology. Repeatedly, the term "natural" is called upon and repeatedly it is a referent whose meaning constantly shifts in this semiotic system. Nature is not always a constant and reconfigures at culturally specific moments.

The use of nature as a universal signifier in discussions of assisted reproduction is replete in news coverage. Sheryl Stolberg, medical writer for the *Los Angeles Times* asks, "Is it proper for doctors to defy nature by assisting post-menopausal women in giving birth – knowing they will not be able to nurse their babies, may not have enough energy to raise them and may not even live long enough to see them graduate from high school?" (Stolberg 1994: A6). Nature is used by Stolberg, as a stable signifier, one that involves implicit ethical stakes. Furthermore, the discussion of post-menopausal assisted reproduction by the World Medical Association, as it took place in 1994, still drew on the term "natural" in its ethical guideline proposals for doctors. The proposal states that doctors should not artificially assist women to get pregnant after "natural menopause" (Gardner 1994: 15). In both of these examples, the term "natural" is used to shore up a familiar given with culturally recognizable definitions. However, in the context of assisted reproduction, the authority of the natural body is no longer a given.

Yet, celebrations over reproductive technologies as the great liberator of the female body are premature. Media representations of the different cases concerning reproductive technologies continue to reinscribe women into prescribed roles that all too often fall along extremely conservative lines which tend to accentuate biological similarities. This produces problems for feminists searching for the promises of such technologies when an essentially maternal identity is reproduced once again for the female body. The potential challenge to conventional ways of reproducing and parenting that assisted reproduction can enable is in fact emerging – ironically – via a class of women who are firmly situated in a position of racial, sexual and economic dominance. Yet the irony serves as a double-edged sword. The affluent women whose assisted pregnancies are the focus of these newspaper accounts seem to have it all – the beneficiaries of the women's liberation movement, they are now the beneficiaries of post-feminist reproductive technologies. In this way, these stories reflect so much that is troubling about new reproductive technologies: such technologies are available only to a few women, they are expensive, and they are infrequently performed. Furthermore, such technologies do little to challenge existing lifestyles and do nothing to promote alternative ones. The significance of race and class privilege is important here and produces a line of feminist critique that would seem to suggest we have nothing to do with such technologies based on their exclusivity. However, such an approach masks the possibilities made available by these technologies. A too easy dismissal misses important possibilities such as the extent to which, among medical practitioners, discussions over these processes of reproduction are fraught with confusion and contradiction.

Media coverage of post-menopausal pregnancies reflect this crisis in legitimation. Reports often include the comments and thoughts of prominent fertility specialists, feminists, medical ethicists, as well as women who have become "mother's in their fifties." These accounts offer us the cultural formation of reproductive technology as

it is laid out for popular consumption. And what is increasingly of interest in such accounts – what was so neatly headed off in *Father of the Bride 2* as misdiagnosed menopause – is the recognition that science is fallible and women's reproductive choices do not follow biology or medical text book protocols. Doctors are in disagreement over whether or not women over 50 should be impregnated. The director of the Center for Parent Education in Newton, Massachusetts, states that couples coming to parenting in their later years are "asking for a lot of trouble." Furthermore, he adds that he "doesn't think this is the best deal for their children" (Chira 1994: 1.1). However, Mark Seigler, the director of the Center for Medical Ethics at the University of Chicago suggests that "to say that simply because these women are post-menopausal and above the age of 50 they can't provide adequate child care to a baby is patently ridiculous" (ibid.). Indeed, as yet other doctors have pointed out, in many families the responsibility of childcare has long been with grandmothers anyway.

Ethical concerns that arise in responses to post-menopausal women as pregnant and as mothers are unequivocal for some. They argue from a position that demands consideration of the child's welfare and their concerns run something like this: "what about the lifestyle available to children of mothers who are in their seventies? Is it fair to these kids that their parents won't be able to perform traditional childrearing rights and practices? Can a parent with arthritic knees get down on all fours and play with their child? Won't such kids really experience a different childhood as the kids of pensioners rather than children of middle-aged parents?" But different from what? I want to argue that I don't think it's that easy: what about cultural communities wherein maternal figures are responsible for the caretaking of three generations of offspring; what about women – many academic women, for example – for whom deferred motherhood is a direct response to economic circumstances; what about family units wherein a mother is physically or emotionally unable to care for a child leaving an older relative to raise him or her? Is it plausible to assert that youth in and of itself is a prerequisite for good parenting skills? As these questions demonstrate, practices of assisted reproduction can no longer be simplified into polemical moral differences grounded in ideas of what counts as good parenting. The different positions and stances that are currently available with regard to this issue illustrate the extent to which questions of pregnancy, motherhood and reproduction are simultaneously bound up in a cultural construction of what counts culturally as viable practices of motherhood, viable methods of pregnancy, viable and sanctioned processes of reproduction and caretaking. More and more, cases of assisted reproduction bear out the permeability of such categories and reveal them as the gatekeepers of morality and "family values." In saying this, in no way do I want to deny the importance of raising "ethical questions" concerning the well-being of the children of post-menopausal mothers; however, what I do want to emphasize is the extent to which such concerns, like others adopted in this debate, relate to a constellation of positions which are themselves grounded in their own equally permeable set of cultural or "natural" values – depending on your position.

In an effort to think through this complexity, Thomas Murray describes our varying moral positions as "a world marked by a multiplicity of interests and duties." "We are," he suggests, "certainly entitled to give good moral weight to our own interests" (Murray 1990: 215). However, he examines the limitations of simplifying ethical issues. In the case of a woman who must decide whether or not to work in a potentially toxic environment, for example, he insists that the ethical dimensions of

her dilemma be portrayed not simply as beginning and ending with the well-being of the fetus. For in doing so, he argues, we "rip a complex decision out of its moral, as well as its social and political, context." Yet, he suggests, this is commonly done when a woman's desires or "rights" are counterposed to the fetus' or child's right to protection from harm. Such a framework is useful in thinking through the ethical issues that inevitably arise in cases of assisted reproduction.

The diverse responses to assisted reproduction particularly in older women suggest that there are many current social conventions or practices of childcare and child rearing that would be broken down if assisted reproduction were made readily available. Frequently, accounts identify as a "problem" the age of the mother in relation to the child focusing particular attention on the ability of a mother in her seventies to cope with the needs of a teenager. Of course, this ignores the prospect that as women choose to parent at older ages, childcare will have to become the responsibility of someone other than the mother herself. Thus parenting would have to be redefined in terms of responsibilities that fall to someone other than the mother as primary caretaker. This offers a double-edged sword as better childcare facilities for all mothers are a much needed commodity. An argument that such support be awarded to older women might be viewed as implicitly challenging the competence of women over 50 to satisfactorily care for young children. When issues of class, race, and economic status are raised, many young mothers, especially teenage mothers, rely on a parent or grandparent to take care of a younger child. Conversely, affluent families have always been able to consider and utilize the option of assisted childcare in the form of daycare or home help.

Alternatively, the control that assisted reproduction places in the hands of doctors and legislators is clearly a concern for many feminists who view the increased medicalization of the female body and the increase in the number of ways in which women are able to reproduce as another means by which to limit women's freedom. Such concerns continue to inform and hound feminist debates about how to strategize a feminist response to the plethora of procedures that developments in reproductive technology have made available to women. Yet as many of the above articles demonstrate, the anxiety currently surrounding assisted reproduction seems bound to the way in which hegemonic discourse still seems to want to recuperate a universalist "nature." This realization informs Sarah Franklin's (1995) recognition of the impact of such technologies on the foundations of scientific authority. Assisted reproduction reveals that the needs of women cannot be easily addressed nor can what constitutes the accommodation of women's needs be agreed upon by medical practitioners, legislators, and women's advocacy groups.

Yet the promise of something new mixed with the threat of everything staying the same continues to loom large in the possibilities of assisted reproduction. Assisted reproduction for post-menopausal women consistently addresses the needs and conditions of white heterosexual women. As pointed out earlier, many older women of color, many older women of lower economic means, women of other nationalities have long acted as "mothers" well after menopause. Embracing as liberatory a technology that serves to reinscribe affluent white heterosexual women into a role in which many women have only ever figured is hardly cause for celebration. Any consideration of the potential of new assisted means of reproduction must take this into account. However, assuming that the reproductive needs of one woman are good for all women equally recuperates women into a system of legislative and linguistic conventions that reinforces the status of the reproductive body as biologically determined

rather than culturally configured. The liberatory issues that emerge out of the possibilities offered by these new technologies are as confused as the language that science relies upon to explain the relationship of medicine to the process of reproduction. In a crisis of legitimation it is not clear where the liberatory possibilities are: they exist for some women but not for others which makes the appeal to any authority to legitimate these practices extremely difficult.

Recognizing these accounts in terms of the framework in which they are cast, that is as monster stories, provides us with a context through which to think these positions. Monsters, Donna Haraway reminds us, "have always defined the limits of community in Western imaginations" (1990: 180). They exist, she suggests, on the boundaries of community. They test the limits of social acceptability. Post-menopausal women who become pregnant via assisted reproduction are culturally positioned as monsters but their positioning as such tells the tale of a cultural response to the coupling of the needs of a specific group of women, cultural expectations and scientific and medical exploration. As feminists, we need to learn from this tale and be reminded that the practices of assisted reproduction have drawn our attention to the diversified and expanded roles and needs of women in the late twentieth century. The possibilities offered by new reproductive technologies are simultaneously perverse and attractive: we don't quite know how to legitimize our response. Yet it is my assertion that within the uncertainties that accompany a belief system in crisis lie the promises of monsters.

Notes

1 This chapter took its shape from and was heavily informed by conversations I had with Kavita Philip. In addition, Anne Balsamo generously shared with me her intellectual insight. I am indebted to both of them for their support. Parts of this essay have previously been published as "Monstrous mothers: media representations of post-menopausal pregnancy" in a special issue on "Constructing nature" in *Afterimage: The Journal of Media Arts and Cultural Criticism* 25(2): 14–16.
2 I am grateful to Kim Sawchuk for this insight and for drawing my attention to the work of Peter Dahlgren. Given the currency within the news media of the content of such films as *Father of the Bride 2*, the film medium is most definitely a genre that circulates within the realm of "actuality and facticity."
3 As the old saying goes: "You can tell the good state of a country by how it takes care of its children and its old people."
4 This information was culled from several sources: Waxman (1994); Gardner (1994); and Stolberg (1994).
5 In her book, *Manufacturing Babies and Public Consent: Debating New Reproductive Technologies* (1995), José van Dijck talks at length about the public debates and the cultural production of responses to new reproductive technologies. In particular, she pays close attention to the coverage by the British press of the birth to the 59-year-old British woman.

References

Braidotti, R. (1996) "Signs of wonder and traces of doubt: on teratology and embodied differences," in N. Lykke and R. Braidotti (eds) *Between Monsters, Goddesses and Cyborgs: Feminist Confrontations with Science, Medicine and Cyberspace*, London: Zed Books, 135–51.
Chira, S. (1994) "Of a certain age, and in the family way," *New York Times* 2 January: 1.1.
Dahlgren, P. (1993) "Introduction," in P. Dahlgren and C. Sparks (eds) *Journalism and Popular Culture*, London: Sage.
Falconer, I. (1997) Cartoon, *New Yorker* 12 May: cover.

Father of the Bride 2 (1995) dir. Charles Shyer.

Fitzgerald, S. (1994) "Pregnancy risks and age," *Chicago Tribune* 4 October: Evening 7.

Franklin, S. (1995) "Postmodern procreation: a cultural account of assisted reproduction," in F. Ginsberg and R. Rapp (eds) *Conceiving the New World Order: The Global Politics of Reproduction*, Berkeley: University of California Press, 323–45.

Gardner, M. (1994) " 'Retirement pregnancies:' are limits needed?" *Christian Science Monitor* 14 July: 15.

Haraway, D. (1990) "A cyborg manifesto: science, technology and socialist-feminism in the late twentieth century," in D. Haraway, *Simians, Cyborgs, and Women: The Reinvention of Nature*, New York: Routledge, 149–81.

——(1992) "The promises of monsters: a regenerative politics for inappropriate/d others," in L. Grossberg, P. Treichler and C. Nelson (eds) *Cultural Studies*, New York: Routledge, 295–37.

Koorijian, R. (1997) "Government and media relations, American society for reproductive medicine," phone interview by author, 15 April.

Moscucci, O. (1990) *The Science of Women: Gynaecology and Gender in England 1800–1929*, Cambridge: Cambridge University Press.

Murray, T. (1990) "Moral obligations to the not-yet born," in R. T. Gull. (ed.) *Ethical Issues in New Reproductive Technologies*, Belmont, CA: Wadsworth Publishing, 210–23.

Oudshoorn, N. (1996) "A natural order of things? Reproductive sciences and the politics of mothering," in G. Robertson, M. Mash, L. Tucker, J. Bird, B. Curtis and T. Putnam (eds) *FutureNatural: Nature, Science, Culture*, New York: Routledge, 122–32.

PVH (1997) Cartoon, *The London Times* 25 April: A1.

Schmidt, W. (1993) "Birth to 59-year-old Briton raises ethical storm," *New York Times* 29 December: A1+.

Specter, M. (1998) "Population implosion worries a graying Europe," *New York Times* 10 July: A1+.

Stolberg, S. (1994) "Science helps Italian woman give birth at 62," *The Los Angeles Times* 19 July: A1+.

Tuohy, W. (1993) "Medical, ethical flap erupts over birth to Briton, 59," *The Los Angeles Times* 28 December: A4.

van Dijck, J. (1995) *Manufacturing Babies and Public Consent: Debating the New Reproductive Technologies*, New York: New York University Press.

Waxman, S. (1994) "Older French women face artificial insemination ban," *Chicago Tribune* 4 January: 1.1+.

Feminist science studies

Anne Balsamo

TEACHING IN THE BELLY OF THE BEAST

Feminism in the best of all places

WHILE IT IS true that scholars of all stripes who teach technoscience studies have come under considerable criticism recently, when Paul Gross and Norman Levitt took on the project of "debunking" the academic critique of the ideological work of the natural sciences, they *singled out* several prominent feminist scholars as unduly influential in provoking the "Left's" hostility to science (Gross and Levitt 1994). Donna Haraway's (1990) famous line notwithstanding ("I'd rather be a cyborg than a goddess"), feminists were lumped together as issuing an "ecofeminist harangue from the Goddess-worshipping camp" (Gross and Levitt 1994: 10). From the other side of the political divide, feminists who teach technoscience studies have been accused by other feminists of sabotaging feminist aims by contributing to women's disillusionment with science, and of discouraging female students from pursuing careers in scientific and technological fields (Koertge 1994: A80). Commentators from both sides of the political divide transcode the intellectual aim of feminist technoscience criticism – to critically examine the implications of scientific and technological practice for the lives of women and the construction of gender – into a broad-stroked condemnation of science. Where one side criticizes feminist technoscience scholars of fostering an aggressive, debilitating hostility toward science in young students, the other side accuses feminists of a wide-sweeping ecological utopianism that promotes the transcendental value of a feminized "nature." Needless to say, feminists who teach technoscience studies find themselves navigating a difficult intellectual landscape.

What is needed is a map that can guide feminist efforts to hack our way through this landmine-pocked terrain. We also need a set of reliable tools to help us to construct a pedagogical practice that remains attentive to the dual aims of feminist technoscience studies: to be both critical in the assessment of the practices and institutions of science and technology, as well as supportive of the women who choose to pursue careers in these fields. This chapter begins the project of outlining the broad coordinates of such a map. It also offers a speculative design for a useful, but at this stage still science fictional, teaching device. To this end, I begin with the future and work back to the present. The first section of this chapter outlines a science fictional project for the next generation of feminist teachers – the design of a multimediated feminist primer in science and technology. This "turn" to science fiction is inspired by Joanna Russ' book, *How to Suppress Women's Writing* (1983), in which she uses

the tropes of science fiction to describe the process whereby women's writing has been historically devalued and dismissed. In so doing, she demonstrates how to use science fiction as a narrative lens through which readers can gain a more nuanced perspective on the cultural terrain which we currently navigate (Russ 1983). In this spirit, I borrow a science fictional device described in Neal Stephenson's cyberpunk novel, *The Diamond Age* (1996) – an illustrated multimediated primer – and rework it as a technology that would support and enact feminist pedagogical ideals.

Given that multimedia is a relatively recent "emergent" communicative form, and that its pedagogical potential is still a matter of speculation, most feminist teachers will continue to rely on more familiar educational technologies: those of the classroom and of the women's studies curriculum. With this in mind, the second part of this chapter addresses the dynamic situation of scholars/teachers who find themselves teaching feminism in unlikely places by describing the organization of a course in "Science, Technology and Gender," I taught at the Georgia Institute of Technology. The map of this course offers one possible way through the tangled terrain we must navigate for ourselves and with our students – as daily life is increasingly shaped by the power of science and the agency of technology. Armed with such a map and a set of feminist tools, I think we would be well prepared to engage both our students and our critics in the debate about the ethics and value of technoscience studies, and about the technoscientific manipulation of everyday life. Finally, I argue that the ultimate pedagogical aim of feminist technoscience studies is not to turn women away from science by detailing the many ways women have been ill-treated in the histories of these institutions, but rather to illuminate for students (women and men) the process whereby science, technology and medicine accrue cultural authority so that they may be better equipped not only to recognize abuses of this authority in their lives, but also to intervene in the ongoing reproduction of the misuse of such authority in the future.

A feminist technology for teaching desirable literacies and skills to young women

At the center of Neal Stephenson's novel *The Diamond Age* (1996) is a science fictional device that curiously and delightfully embodies feminist virtues: an interactive, multimediated lesson book called "A Young Lady's Illustrated Primer." The functionality of the device is such that the primer is designed to "tune into" (in a mysterious way) the educational "needs" of one individual girl. Stephenson's novel tells the many tales of a primer that belongs to one particular young girl, Nell, who is the heroine of the novel. The "Illustrated Primer" is much more than a book. At various times throughout the novel it serves not only as a lesson book and guidebook, but also as a communication medium between Nell and an animated presence. This animated presence is, in the "real" world of the novel, an actress (or "ractor") who has been employed to perform the lessons in the book and to interact with and guide Nell (again via a mysterious process mediated by the primer) as she encounters different adventures. With the help of the primer and its animated presence, Nell learns the hard, but necessary lessons for living life in an uncertain age.

"A Young Lady's Illustrated Primer" is a piece of high-technology, based on advances in nanotechnology, described in the book by the computer scientist who designed it as follows:

The database is ... a catalogue of the collective unconscious. In the old days, writers of children's books had to map these universals onto concrete symbols familiar to their audience – like Beatrix Potter mapping the Trickster onto Peter Rabbit. This is a reasonably effective way to do it, especially if the society is homogeneous and static, so that all children share similar experiences. What my team and I have done here is to abstract that process and develop systems for mapping the universals onto the unique psychological terrain of one child – even as that terrain changes over time. ... The Illustrated Primer is an extremely general and powerful system capable of more extensive self-reconfiguration than most.

(Stephenson 1996: 107–8)

In contrast to the allegorical books written by, among others, Beatrix Potter for children who grew up in an age of continuity and homogeneity, the "Illustrated Primer" is imprinted by one particular young girl such that it configures itself for an individual user, once and forever, to offer her personalized guidance in making sense of a world which is constantly shifting around her and within her. Early on in the novel, Nell's primer relies on the narrative form of a fairy-tale fantasy where Nell is represented in the primer's stories as "Princess Nell" and assigned certain magical and allegorical companions who help her in her adventures. Because she is very young, and barely literate when the primer first comes into her life, the fantasy form is perfectly configured to Nell's cognitive landscape. Although the novel focuses on the stories told by/through Nell's primer, readers are led to believe that another girl's primer would use different textual and narrative devices to convey the lessons that that particular girl needed to learn. The fantasy on offer here is of an intensely intimate, personalized guidebook that is designed to provide all the education one girl needs in the exact form and increments that she requires in order to best learn the lesson at hand.

While it is not the place here to rehearse the many interesting suggestions offered throughout the novel about the lessons and pedagogical methods young girls require in order to be successful in making their place and finding their way in a crazy world, it is provocative to think about the old-fashioned idea of a primer refashioned in the form of a hypermediated digital learning environment. As a guiding thought experiment for this essay, I have tried to imagine what a feminist primer would look like that took as its focus the education of women in science and technology. While the specific technological design of such a primer remains to be invented (and is beyond my programming skills), its informational design begins with the questions: what literacies and skills would be built into such a primer, and what aims would it serve for the young women who would use it? The more realistic aim of such an exercise is to expand our thinking about the pedagogical usefulness of current multimedia technologies as tools for feminist teachers.

Designing a feminist primer in science and technology

Although it may seem like a retrogressive step, I would have the "Feminist TechnoScience Primer" begin by presenting a portrait of science and technology that focuses on its magical dimensions. This is the portrait that circulates most frequently in popular culture and everyday life where science is invested with a power that can only be described as magical and profound: the power to cure diseases and even to

save the world (see Figure 12.1). In a similar way, technology is portrayed as the means by which heartbreaking problems can be solved, life enhanced, and fantasies fulfilled (see Figure 12.2). This is a provocative image of power and potency – wherein "science" and "technology" are cast as abstract agents that can empower those who simply invoke the "name" of science as well as those who master technological interfaces. And yet, as we also know, the power that science and technology promise is not really magical in the sense of being mythical or insubstantial (see Figure 12.3). On the contrary, the power promised by science and technology is life-transforming power: the power to explain, to describe, to create, and to modify the material world (see Figure 12.4). In short, the power of science and technology is the power to make the world.

Thus the underlying rationale for beginning with such a lesson is not as retrograde as it may at first appear, even though it is provocative, especially in light of long-standing feminist critiques of science and technology: women need to be taught to

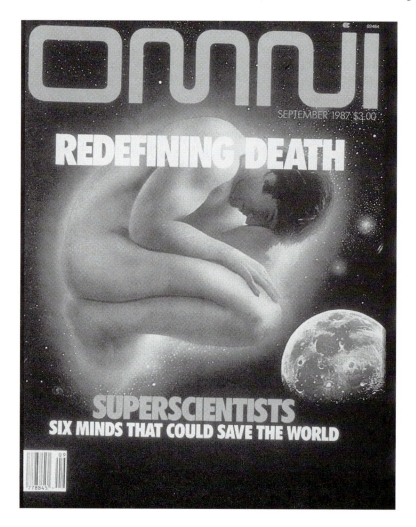

FIGURE 12.1 Cover of *Omni* magazine: "Redefining death"
Source: *Omni* (September 1987).

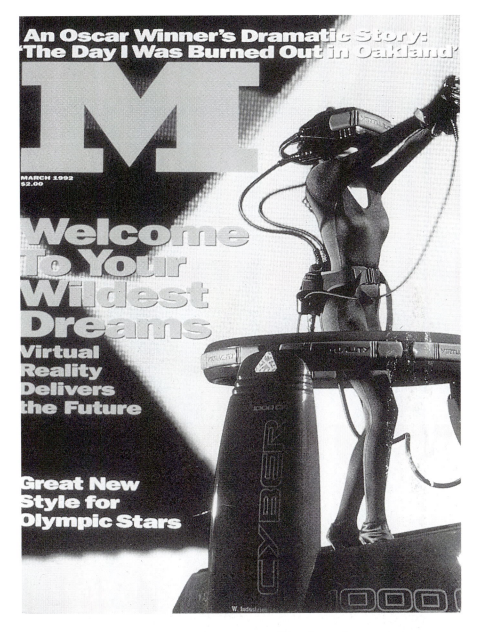

FIGURE 12.2 Cover of *M* magazine: "Welcome to your wildest dreams"

Source: *M* (March 1992).

want the power that science and technology offer. But of course, they need to be taught much more. They need to be taught the difference between the *magical promises* that circulate through advertisements and the *material effectivity* of the actual deployment of scientific knowledge and technological devices. To begin the process of dispelling the myths in favor of re-presenting the actual, I would design the primer to include hypertextually-linked pages which would construct bridges between the magical incantations represented in advertisements and the multi-dimensional realities of the technologies on offer. These pages would be annotated through the use of images,

FIGURE 12.3 Advertisement for Lotus.

Source: INC Technology (19 November 1996).

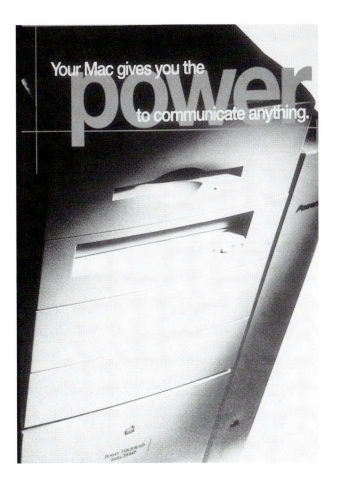

FIGURE 12.4 Advertisement for Apple Macintosh computers.

sounds, smells and textures. Moreover, young women need to be taught the *nature* of the power offered by science and technology – how it is constructed, how it is hoarded, how it is deployed, how it is misused, and above all, how it has been implicated in the perpetration of violence against particular groups of people, in the destruction of ecological systems, and in the creation of a socio-political context in which it is possible to imagine the reality of global mass destruction. Thus the first lesson offered by the Feminist TechnoScience Primer is one that recounts both the magic and the horrors manifested through the use of technology and the development of scientific knowledge.

After the horrors are introduced, but which can never be exhaustively documented, the next challenge for such a primer is to keep young women interested in science and technology, even though it is well-documented within feminist and other critical work that the power it enables has provoked countless tragedies. An old-fashioned technique may be useful here – to appeal to their sense of the heroic and to their firmly-socialized desire to "make a difference," and to have their lives stand for something. Here the primer would offer a different portrait of the power of science and technology – that of its employment and economic empowerment. In the US, since the 1970s, there has been an increase in the number of women educated and

employed in the fields of science and engineering (see Figure 12.5). For instance, in 1993 the number of women *enrolled* in science and engineering doctoral programs was 30 per cent (National Science Foundation/SRS 1994). Between 1983 and 1993, the percentage of women *granted* doctorates in science and engineering increased from 25 per cent (of the total number of doctorates granted) to 30 per cent. In 1993, women comprised 20 per cent of the total number of doctoral scientists and engineers employed in the US labor force, compared to 15 per cent in 1990 (National Science Foundation/SRS 1996). The point in including these statistics in the Feminist TechnoScience Primer is to suggest to young women that there are important career possibilities for them in scientific and technical fields, and that these career paths present interesting opportunities for them to invent and transform the way in which science and technology is practiced.

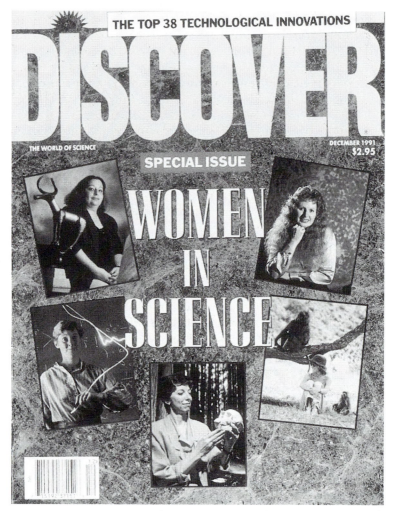

FIGURE 12.5 Cover of *Discover*. Special issue, "Women in Science." Uncredited women scientists who are pictured: Barbara Smuts (primates), Sallie Baliunas (astrophysicist), Adrienne Zihlman (evolution), Helen Quinn (interacting particles), Aslihan Yener (archeologist).

Source: *Discover* (December 1991)

At first glance, these statistics paint an optimistic picture – that there has been a real increase in the number of women employed in scientific and engineering fields over the past decade in the US and Canada. However, it remains difficult to assess the significance of this increase. As feminists continue to monitor the situation of women's employment in the sciences and engineering, other factors have become matters for concern: issues of rank and promotion, of salary equity, and of retention are equally if not more important indicators of the professional climate women encounter in these fields. Moreover, the increase in numbers of women students and doctorates is not manifest in all fields. For example, when considered together, the sciences (which includes the computer/mathematical sciences, life sciences, physical sciences, and the social sciences) employed 23.3 per cent women in 1993. Whereas the percentage of women employed in *all engineering fields* in 1993 was only 4.3 per cent. Although this might suggest that the sciences are more hospitable for women than are the engineering fields, the percentage of women employed in such fields varies greatly from field to field: physics remains the least populated with women (5.3 per cent), while the field of sociology/anthropology employed the greatest percentage, 37.1 per cent. Such a range – although not as wide – is also evident across the fields of engineering, where aerospace/aeronautical engineering reported employing less than 50 women in the field (out of 3,120 people) in 1993, while the percentage of women working in industrial/systems engineering was approximately 14 per cent. Unlike this essay, the Feminist TechnoScience Primer would always be able to reference the latest figures and automatically render the most meaningful comparisons through direct links with research centers and statistical databases that would be continually updated and monitored by feminist investigators. The question remains, how can these numbers be used to motivate young women to pursue careers in science and engineering when the picture they document is of an employment scene that remains heavily populated by men?

While it is clearly important for young women to have a sense of the professional terrain that they will move into, with such low numbers of women in these fields it would hardly seem to be a compelling horizon. The reason this scene doesn't seem very compelling is not because women somehow need to work in areas that are populated by other women due to some sort of gendered psychological insecurity. On the contrary, there are pragmatic and professional reasons to avoid fields that have been dominated by men for so long. There is ample evidence, for example, that suggests that having minority status in a profession hinders an individual's success in that profession due to such factors as a paucity of opportunities for professional socialization, interpersonal awkwardness on the part of those in the majority, or an increase in unwarranted "visibility" and "representational service" – this is the phenomenon whereby women and members of racial and ethnic minority groups are "pressed" into service as "minority representatives" to participate in discussions, meetings and committees that often have little to do with their actual professional labor (Caplan 1993).[1] As with the best of the new hypertextual encyclopedias, The Feminist TechnoScience Primer would be able to provide the relevant background information about the conditions that set up the disproportionate gender ratios of specific employment scenes. For example, to contextualize the meaning of the statistics on the employment percentage of women in engineering, it is important to know how many women are eligible to be employed as professional engineers in a given year. This requires additional information about the number of engineering degrees awarded each year at each rank to men and women, the number of women actively

seeking positions in professional fields, and the number of women who opt out of the profession of engineering for personal reasons – for example, to pursue a different degree or career track.

Through an as-yet-to-be-invented information-simulation process, I would like to have the primer offer a detailed digital simulation of typical employment scenes where women could interact and experience the contextual differences between scientific fields such as biology and physics, or between various engineering fields. The purpose would be for the primer to provide young women with a glimpse of the different professional stages upon which they will enact their careers. The aim of providing simulations of different employment scenes is to re-embody the statistics that have been stripped of context, of human faces, and of politics.

The Hall of Adventure, Knowledge and History

It is also true that these statistics offer a picture of an intriguing territory – that of a professional scene which is being increasingly populated by women who are often cast in the role of pioneer and adventurer. Another way that the Feminist TechnoScience Primer can re-embody such bloodless statistics is to present biographical information about these scientists and engineers. Here is an opportunity to appeal to women's sense of adventure attendant to the possibility of trailblazing new paths for themselves as well as for others. The informational backbone of this section of the primer would be a database which would include a description of the many contributions women have already made to the collective enterprise of science, as well as to our collective stock of inventions and innovations. This section, in turn, would build on several other lessons that discuss, for example, the specific historical, structural and institutional conditions that prohibited women from gaining scientific and technological education and the credentials necessary to be recognized and employed as a scientist or technologist. Especially important are the related lessons that describe the ways in which women's contributions are "written out" of the official histories of science, invention and medicine because of gendered proscriptions about who can make claims in the name of science, who can register and own patents, and about who are empowered to engage in technological practices. But the central focus of this section would remain on the women who did *persevere*, even in the face of daunting obstacles, and who went on to contribute important scientific insights, observations and inventions – insights and inventions that are not only significant to the cumulative knowledge base of different sciences, but also ones that people continue to rely on every day. For this purpose I would design within the Feminist TechnoScience Primer a digital "Hall of Fame" which would include, for example, profiles of women who contributed inventions in food preparation, medicine, and health maintenance.[2] Inspired by Autumn Stanley's book, *Mothers and Daughters of Invention: Notes for a Revised History of Technology* (1995), the "Hall of Fame" would include photographs, lists of publications, honors, collaborations, statements of ethics, and the personal passions that animated such scientists as Mary Engle Pennington (1872–1952), an innovator of household and commercial refrigeration, Dr Elizabeth McCoy (1903–78) who produced an incredibly productive strain of penicillin during the Second World War, and Jeanne Mance who invented the pre-paid health-care plan.[3]

It would be wonderful if these digital biographies could be animated by feminist designers who would create virtual profiles of the lives of these noteworthy women.

<figure>*FIGURE 12.6* Cover of *CLASS*

Source: *CLASS* (Feb. 1993)</figure>

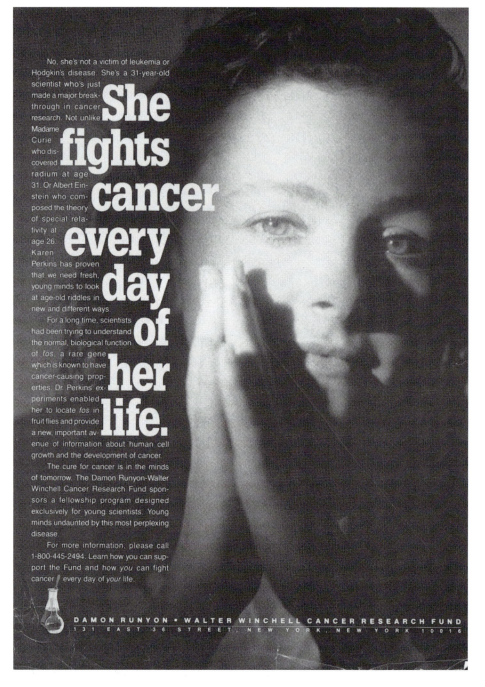

FIGURE 12.7 Advertisement for women in science.

Source: Damon Runyon/Walter Winchell Cancer Research Fund (*circa* 1991).

In addition, I imagine the design of several different "interactive games" that would offer young women the opportunity to participate in virtual dramas based on the adventures of these scientists and inventors. Although the ostensible objective of each adventure might be different – the search for an antidote, the design of a new viewing instrument, or the diagnosis of a diseased ecological system – a collection of critical methods and tactics will accumulate for game participants.[4] They will learn practices of discovery, building, reasoning, inventing, testing, and failing. Like a virtual version of the childhood game of playing "dress-up," these interactive games would be designed to provide young women with the narrative and intellectual material they need to imagine themselves as important participants in our collective technoscientific future.

Of course, there are many more lessons the Feminist TechnoScience Primer would need to address; lessons that draw from the significant body of work now going on in the name of feminist cultural studies of science and technology. As a work of science fiction, this primer remains the projection of a feminist imagination animated by a sense of urgency and of possibility. It is evident that the science and technology arena has changed significantly for women over the past decade. More women are entering and completing medical school. In the engineering fields, the average entering salary for women under the age of 30 in 1993 was US$1000 higher than for men under the age of 30 entering the same field. By the end of the 1990s, there are few, if any, scientific and technological fields that remain exclusively populated by male professionals. None the less, there is still much that needs to be accomplished, both within the US and worldwide. Moreover, because of the dynamic and tenuous nature of social change, these advances require continued feminist attention to ensure that transformative efforts are consistent and equitable. New feminist pedagogies that incorporate new tools and new knowledges will ensure that feminism remains relevant to the young women who will be the key architects of our collective feminist future. They live in different worlds, historically and virtually; the challenge for feminist teachers is to find ways to make connections to those worlds. Until the day when nanotechnologists design the processes and devices whereby a primer, such as the one described here, could deliver these lessons with inspiring realism, engaging simulations, and personal relevance, we have to accept the fact that feminist teachers will have to make do with tried-and-true technologies: college courses and classroom-based pedagogies, multi-modal teaching materials and humanistic curricula.

The belly of the beast: teaching a course in "Science, Technology and Gender"

The institutional context

In 1990, the English department at the Georgia Institute of Technology (Georgia Tech) was redesigned as an interdisciplinary School of Literature, Communication and Culture (LCC). The formation of the School of LCC provided the former English department faculty with the opportunity to design a new humanities-based undergraduate major. This was to be the first humanities major ever offered in the 110-year history of Georgia Tech. Seizing the opportunity to develop a major that reflected both the new interdisciplinary focus of the school and the increasing interest in humanistic studies of science and technology, the faculty proposed a major in "Science, Technology and Culture" (STAC) including courses that merged the

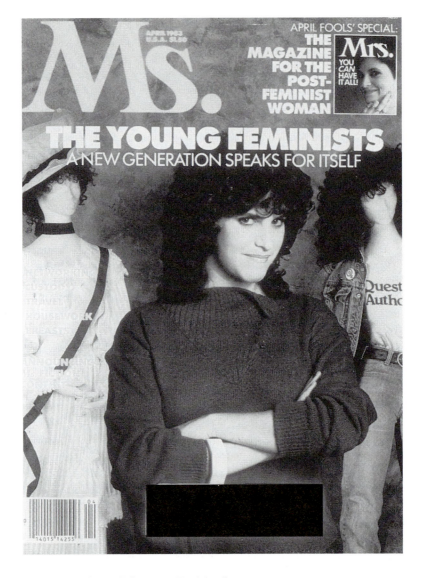

FIGURE 12.8 Cover of *MS*.: "The Young Feminists"
Source: *MS*. (April 1983).

interests and perspectives of recent literary theory and cultural studies with the topics and issues central to the emergent field of technoscience studies.

The course in "Science, Technology and Gender" is an upper-division offering in LCC's undergraduate major in "Science, Technology and Culture" and has been part of the humanities curriculum at Georgia Tech since the major was first proposed in 1990. Because of the nature of the student body at Georgia Tech, the majority of those who enroll in this course are white, male engineering students who take the course for a humanities credit. Although the course attracts an increasing number of STAC majors, it is still common to have a roll-sheet filled with the names of students who are in their final academic term and need one more humanities course to grad-uate. The course that I taught for the past seven years relies exclusively on feminist

studies of science and technology for its organizational rationale and selection of reading and discussion materials. Thus it often proves to be quite challenging for some engineering students who, although in the last quarter of their academic careers, have encountered few, if any, female faculty, and have never been given the opportunity to engage seriously in feminist scholarship.

Although space prohibits a lengthy discussion of the pedagogical methods required for dealing with such an obligated and at times often resistant student audience, a few comments will suffice to indicate the challenges posed by teaching feminist work in a potentially hostile environment. When I first began teaching the course, there were disturbing misunderstandings among other faculty about the nature of the course. One faculty member, responsible for student advising at the time, persistently referred to the course as "Anne's sex course" – an unfortunate misnomer that provoked all sorts of unrealistic expectations on the part of many students. Male students, in particular, who enrolled in the course because they had no other options available to satisfy their final humanities requirement, often felt compelled, and indeed fully empowered to contest every reading and every lecture. Discussion contributions from such students often took the form of sweeping generalizations, for example: "statistics prove that most people would rather be treated by a male physician than a female physician," or "men suffer too from the abuses of science." Ritual invocations of Rush Limbaugh as an authority on feminism, which would invariably be labeled "femi-nazism," made class discussions difficult to manage gracefully and respectfully. The few women (typically 5 out of 35 students in the early years) who enrolled in the course often "confessed" confusion about their interest in it. They were simultaneously intrigued intellectually by the topics of the course, as well as reticent to be identified as "feminists" if they expressed too much interest or agreement with the feminist analyses discussed in course readings. When I think about the many instances of students' reticence and frequent overt masculinist resistance to course topics, and remember the experiences with colleagues' hostility and skepticism about the nature of the course and its intellectual value, I often think of my faculty position as an assignment "teaching in the belly of the beast." Before I elaborate the reasons why a feminist scholar might choose to stay in such a challenging environment, I would like to describe in some detail the organization of the "Science, Technology and Gender" course in an effort to elaborate how feminist scholarship makes sense in this institutional location, and how it can contribute to the humanistic education of future leaders in science and technology.

The course

Although there are now several faculty who teach the course in "Science, Technology and Gender," and each one teaches it slightly differently, there is general agreement on the main objectives for the course. For example, most of the faculty agree that one of the key objectives is to offer students an introduction to the basic philosophical issues pertaining to the study of science, technology and gender, especially those issues concerning the epistemology of science and the ethics of scientific and medical practice. But there is no standard syllabus; individual faculty are encouraged to modify the course to reflect their particular research and scholarly interests. Thus, where I include a module that reviews recent studies of gendered technologies, my colleague, Rebecca Merrens, includes an extended investigation of the treatment of women in the history of science, focusing specifically on the history of the treatment

of women throughout the "birth" of the scientific enlightenment. Such divergence in topics has proven very fruitful – such that subsequent versions of my course show the influence and insight of my colleague's interests.

The current status of women in science and engineering

In the version I have taught most frequently, the course is divided into ten modules: each module includes a reading assignment, a group project report on a related topic, and some form of media presentation. As is typical for many STAC courses, graded class assignments also include a mid-term exam and a final paper. The first module of the course is devoted to a discussion of the current status of women in science and engineering. Thus, I always begin with a discussion of the "Chilly Climate" report, first published in 1992 by Roberta M. Hall and Bernice R. Sandler for the Project on the Status and Education of Women. This report, which will be familiar to many readers, was one of the first extended investigations of how the campus environment (at various US institutions of higher education) is experienced by female students. Of particular note, this study found that women who enroll in "traditionally masculine" fields – such as science, mathematics and engineering – often experience a very different educational "climate" than the one enjoyed by their male peers. The report details the structural and pedagogical aspects of what they label the "chilly climate" for women (Hall and Sandler 1991).[5]

The group project topic for this module is a "Report on Women at Georgia Tech." This module addresses several course goals: first, it encourages students to become familiar with the gendered differences in the nature of science and technical education, both currently and over the past two decades, and second, it requires them to construct an empirical description of the gender distribution of the Georgia Tech student body and faculty. In confronting "the numbers," students acquire a better sense of how under-represented women are, as students, faculty and administrators, in the engineering and science programs, and indeed throughout the Institute as a whole. Moreover, this often proves to be an eye-opening module for male students who have never heard a description of how women's experiences of what may be the very same educational setting differ so dramatically from their own. This provides the occasion to talk about related issues such as the history of women at Georgia Tech, the importance of Georgia Tech's "pipeline programs," the "glass-ceiling," and the professional demands of science and engineering careers.

A critical aspect of this module is a presentation and discussion about the "Montreal massacre." The "Montreal massacre" is the name given to the murder of fourteen women, most of whom were engineering students, at the University of Montreal in 1989. The details of the massacre are chilling: on 7 December 1989, a man entered the Polytechnic, made his way to a lab, separated the men from the women and began shooting the women as he verbally accused them of being "feminists." His suicide note included the names of other women, both well-known and local, whose names made the list simply because the killer believed them to be feminists. Students read descriptions of the event and excerpts of various feminist analyses that followed. They also watch Maureen Bradley's video documentary called *Framing the Montreal Massacre*, which investigates and powerfully analyzes the media treatment of the event as it unfolded on Canadian television in the aftermath of the murders. This material always provokes a powerful reaction in students – primarily because *they never knew* it had occurred. When I remind them of the other events

that were in the news at the same time, events which they can remember and that seem so present to them, they are struck with the understanding that this event drew little noteworthy attention in the US media. Other than a vague claim to have seen something on it on CNN, few students can remember hearing anything about this atrocity – both at the time, or in the intervening seven to nine years. Even if we make allowances for their average age at the time – 10–12 years old (although when I first included discussion of this event in the course in 1992 there was even less of a time-gap between the students' average age and their age when the murders happened) – there is no excuse for their lack of awareness about this event. As I have discovered several times over, their memory for other mass murders is quite strong.

Teaching this material offers students an injunction "to remember." This is perhaps the most important pedagogical aim. But it also invariably provokes other discussions about (1) how women who transgress traditional gender boundaries are transformed into targets for violent acts, (2) how feminism is considered to be de-stabilizing and threatening to patriarchal order – and thus something to be feared and resisted, and sometimes violently oppressed, and (3) how the media process the meaning of horrific events. In the case of the "Montreal massacre," media coverage effectively diminished its political significance (as an act of extreme misogyny) and whitewashed its emotional consequences – it was routinely portrayed as a "sad" tragedy, a "tragic loss," and a "crime against humanity," rather than (also) an instance of socially motivated violence against women. Instead of portraying it as an occasion for justified feminist outrage and anger, it was perversely soft-peddled as a

FIGURE 12.9 Cover of the book, *The Montreal Massacre*

Source: Louise Malette and Marie Chalouh (eds) (1991).

crime against all. What was lost was the opportunity to focus mass attention on the need for social and institutional transformation of the treatment of women who pursue professions and vocations in traditionally male fields.

Feminism and Science

The topic of module two is "Feminism and Science," and the media presentation is a video tape about the women astronomers associated with the Harvard College Observatory during the late nineteenth and early twentieth centuries. Module three presents material on "Feminist Epistemologies" and includes a video interview with Evelyn Fox Keller on the masculinist bias of the key questions at the heart of the scientific enterprise. Module four reviews Autumn Stanley's work on women in the history of technology and includes a slide presentation of images from the 1960s to the 1990s which documents a more recent history of the mythologies that persist about women and technology as these circulate through popular cultural images and advertisements (see Figure 12.10). I then ask students to discuss the story being told about the relationship between gender and science in three specific advertisements:

1 An ad for EMC (see Figure 12.11) which shows a woman in a lab coat holding a glass beaker with the caption, "You never know what science will uncover."
2 An ad for Lilyette underwear, which shows a woman wearing a bra and leaning against a counter while the caption offers her speculations on the nature of "gravity": "Well, it may be a good force for the universe. But it's an evil force for a pair of 34 D's."
3 An ad for Symantec "automatic" virus protection software application featuring the face of an older woman who looks somewhat befuddled, under the bold caption, "Typhoid Carol."

Using a standard pedagogical technique informed by work in cultural studies, the analysis of these advertisements illuminates how the media of everyday life serve as informal educational channels about the meaning of science and technology. The specific point of this exercise is to demonstrate how advertisements, in particular, play a significant role in the circulation of cultural mythologies about the relationship between gender, science and technology.

Mid-term assignment

The mid-term assignment is very straightforward in that it requires students to write a biographical report on a woman who has contributed to a particular scientific field, or who has invented or modified a significant technology. I provide students with a list of names of approximately 300 women connected with science – the list is based on one included in Marilyn Bailey Ogilvie's book, *Women in Science: Antiquity through the Nineteenth Century*, and on the index in Stanley's book (Ogilvie 1986; Stanley 1995). Based on recent feminist research, all the women whose names are included on this list have made some sort of contribution to the histories of various scientific fields and technological domains. And indeed, although many of them are discussed in Ogilvie's and Stanley's books, I instruct students not to rely on either of these texts as a primary reference. Instead, students are instructed to select a name and to try to locate information about their subject from other sources. (To date

FIGURE 12.10 Cartoon in *LIFE*

Source: *LIFE* (13 August 1971: 55).

there is only one name that has been deleted from the list because her life is so familiar and well documented: Marie Curie.) I suggest that students look in various encyclopedias and directories that purport to catalogue famous scientists and inventors; fortunately, the Georgia Tech library is well-stocked with these reference materials. The purpose of this assignment is twofold: to give students the opportunity to learn more about specific female scientists and inventors, and to gain primary research experience in locating basic information about important women. As is typically the case, although students usually begin by searching for information about a woman in a field they find interesting, they often complete the assignment based on more pragmatic reasons. This is to say that they often complete the assignment based on what information they can find about any woman on the list – rather than on a particular woman whom they find interesting. Part of the assignment asks them to document their research process: what resources did they review? Where did they expect to find information? Where were the "dead-ends"? The value of this exercise is as much a consequence of the frustration students experience when they confront the fact that there simply isn't much material available on many of the women listed. As they engage in the research project, I counsel them on techniques of finding information about "lost women" – women whose contributions were simply not deemed important enough to record and document. They come to appreciate the value of the research effort that supported Ogilvie's and Stanley's projects of "reclamation." Students present their biographical findings in class as well as their experiences doing research on these "lost women." Collectively we learn a little bit more about the women who contributed to our historical knowledge base in science and technology

*Y*ou'd be surprised
what science can uncover . . .

You're doing all the right things to achieve

a lean, healthy body . . .

 OR ARE YOU?

Your body and your biochemistry are as

unique as your fingerprint. Good health

and good looks depend on good nutrition.

Don't guess about yours.

 WE TAKE THE GUESSWORK OUT.

Backed by decades of research and based

on state-of-the-art laboratory analyses of

your blood using our

precision technology,

your individualized

biochemical profile

will uncover and define your specific nutritional needs. The initial testing package includes a one-

month supply of your custom-designed supplements, containing vitamins, minerals, antioxidants, fatty

acids and amino acids, based on your unique biochemical fingerprint.

 Make the most of what you were born with. Try the ION Program from EMCS.

*I*ndividualized *O*ptimal *N*utrition. For _EVERY_ body. Biochemical Fingerprinting starting at

$295.00. For more information, call 404-242-9744 or 1-800-466-EMCS.

ERGOGENIC AND METABOLIC CONSULTING SERVICES
ATLANTA, GEORGIA

FIGURE 12.11 Advertisement for Ergogenic and Metabolic Consulting Services, Atlanta, GA.
Source: *Vie: Health Fitness Beauty* (December 1994).

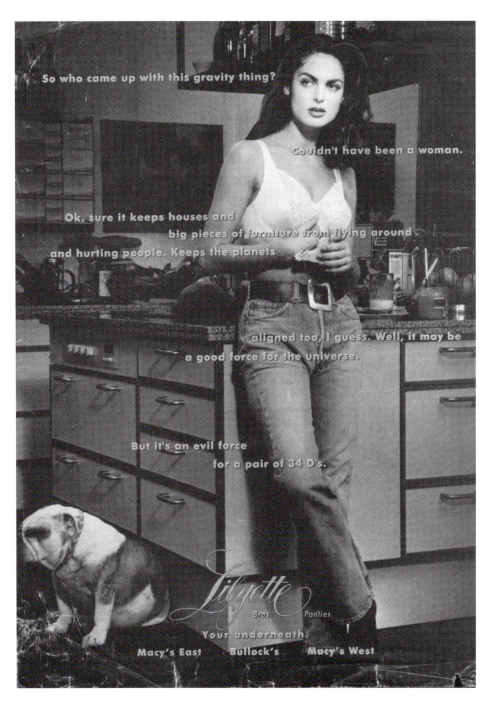

FIGURE 12.12 Advertisement for Lilyette underwear

Source: *Cosmopolitan* (1993)

FIGURE 12.13 "Typhoid Carol": advertisement for Symantec

Source: MacUser (July 1991: 27).

and on the importance of feminist historiography as a political as well as a scholarly practice.

Gendered technologies

Other module topics include ones on the gendered nature of everyday technologies, reproductive technologies and the reproduction of gender, and women and new media. I focus more attention on the relationship between gender and technology for two reasons. First, the history of women and science is frequently taught by my colleagues who teach other STAC courses in "Science, Technology and the Age of Enlightenment," or "Science, Technology and the Industrial Revolution." Second, I believe that the issues pertaining to the relationship between gender and technology will have a particularly profound impact on students in their everyday lives both in the near and far future. For example, the module on "Reproductive Technologies and the Reproduction of Gender" describes the different feminist assessments of the new reproductive technologies; the group project topic for this module addresses the "Economics of Reproduction" where students research the current costs of hospital-based child birth, various methods of birth control, and new techniques of assisted reproduction. Students also investigate the structure of the emerging "industry" of reproductive engineering to discover, for example, the differential screening proto-cols used for oocyte (egg) and sperm donation. I remind these students that they belong to the first generation who will enter their child-bearing years with a full-array of technologically mediated reproductive choices already tested, verified and marketed especially for them. As can be expected, this module is also the one that most explicitly provokes questions about the ethics of current medical practices and of new research projects such as those on cloning, the human genome project, and post-menopausal pregnancy.

New media studies

The module on women and new media focuses on the gendered aspects of the World Wide Web, multimedia and interactive electronic games. First we discuss the experi-ence of girls and women in connection with interactive media and cyberspace (see Figure 12.15). Next, we revisit the claims made for cyberspace – such as the ones made in an MCI television commercial which asserts that: "There is no race, there is no gender, there are no handicaps in cyberspace." The aim is to explore the question of whether or not this space is as free from the "constraints" of body-based identity as advocates claim, and the consequences of making such claims.

The media presentation for the module on women and new media focuses on a demonstration of an interactive project that my colleague Mary Hocks (Spelman College/Georgia State University) and I created for the 1995 NGO Forum staged in conjunction with the United Nations Fourth World Conference on Women (held in Beijing, China). The project, called "Women of the World Talk Back," is an example of what we identify as "feminist multimedia." Our design decisions were explicitly based on feminist work in aesthetics, narrative theory and video documentary. At the heart of the project are several video segments called "Video Dialogues" that feature prominent international spokespeople talking about the four major themes of the UN Conference: (1) what do women want?; (2) economic opportunities; (3) access to education; and (4) empowerment. Incorporating some of the material we gathered as

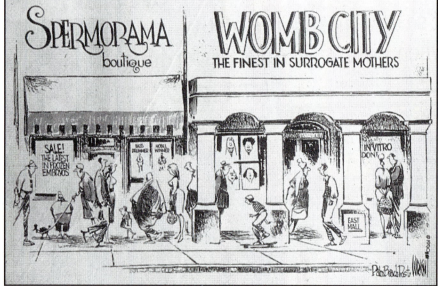

FIGURE 12.14 Cartoon, "Spermorama, Womb City"

Source: Wright, for the *Palm Beach Post* (reprinted in *Chicago Tribune*, 11 November 1990).

Forum participants, the project now also includes a short video documentary about the NGO Forum and a narrated "headline" review of the key political and logistical events leading up to the Forum during the early months of 1995. The purpose in demonstrating this high-tech multimedia project is to encourage students to imagine the political possibilities of new media – possibilities that are often obscured by the relentless corporate take-over of new media forms and spaces. I elaborate the collaborative process used to build the project as well as the response we received from the women who viewed it in Hairou, China when we presented it.

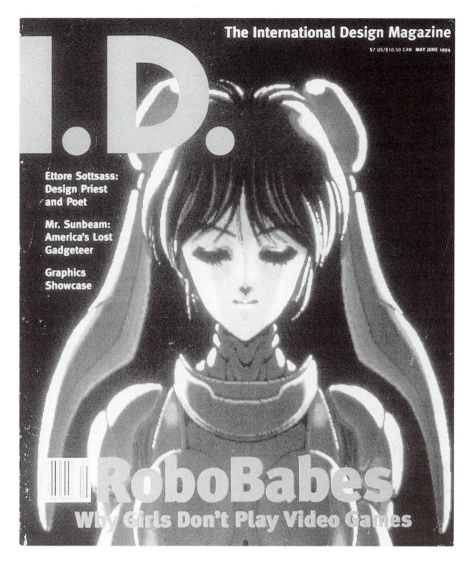

FIGURE 12.15 Cover, *I.D.* magazine. Cover feature, "RoboBabes: why girls don't play video games"

Source: *I.D.* (May/June 1994).

To get a sense of the horizon of feminist activism in different national and global locations, students read an annotated copy of the most recent version of the *Draft Platform for Action* that was debated at the 1995 United Nations Fourth World Conference on Women. Together with the objectives outlined for the 1995 NGO Forum, these documents provide an encapsulated account of not only the challenges and inequities that exist for women with respect to access to scientific and technological training (as one example), but also of the provisional steps that world governments must make to begin to redress these situations. Inevitably, this leads to a discussion about the role that Hilary Clinton played in the United States' participation in the 1995 UN Conference and our objectives in taking a delegation of Georgia Tech students to the NGO Forum. I distribute a copy of a position paper on

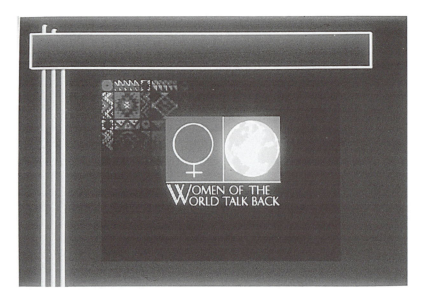

FIGURE 12.16 "Women of the World Talk Back" logo.

"The Education of Women in Science and Technology" that I wrote and circulated to members of the US delegation while we were in China. I also play audio excerpts of interviews with Donna Shalala and Veronica Biggens, both members of the US delegation, whom we were able to interview about their positions on the global disparities in the education of women in science and technology. The "Women of the World Talk Back" project, as well as the discussion about the 1995 NGO Forum and UN Conference, serves to remind students of the broader global context for the discussion of the relationship between women, science and technology. For example, based on our experiences at the Forum, I am able to outline the wide range of activist projects going on across the globe that seek to improve the situation of women *vis-à-vis* medical practices and technological education. In describing these projects, I stress the diverse nature of the feminist agenda: where the main issue in one country might be clean water and increased access to agricultural technologies, other countries' representatives to the NGO Forum focused their energies on identifying specific educational reforms that would encourage young girls to stay in school so that they may be trained in technical skills. I remind students that the *UN Draft Platform* also included a section on the representation of women in the media – an issue that was not seen as specific to any one region of the world, but, rather, was understood to be a critical area of intervention precisely because of the way in which the media function (globally) as a powerful educational and socialization agent. In this case, what is often thought of as a Western feminist concern, or even a US-based feminist concern – that of the politics of representation and of media socialization – was cast as a concern of women around the world.

The greatest insight that emerges in our discussions about the NGO Forum and the UN Conference concerns the wide range of issues that were "put on the agenda" by various feminist and grassroots activist groups from around the world. Here students confront the reality that there is no single global feminist agenda that would universally promote (for example) birth control over abstinence, abortion over adoption, or careers over family. The picture that emerged from the 1995 UN Conference

is that women's concerns address a heterogeneous mix of political issues, health and sanitation practices, educational reforms, and cultural interventions. As a matter of fact, the only agreed upon "agenda item" was the call to stop the widespread violence against women that happens in every country.

New formations, new possibilities: building feminist futures

The final section of the course focuses on a work of feminist science fiction. In offering narratives that detail alternative arrangements of reality, that may include alternative futures, alternative worlds or alternative pasts, feminist science fiction suggests possibilities for the future – both negative and positive. Books such as *The Female Man* by Joanna Russ, *Synners* by Pat Cadigan, *Slow River* by Nicola Griffith and *The Handmaid's Tale* by Margaret Atwood offer provocative scenarios that are built on the cultural and social formations currently in place. In thinking through the relationship between these science fictional possibilities and the current situation of women, students are encouraged to explore the mechanisms whereby the future is built on the institutions of the present. If there is any hope of changing these institutional arrangements, and thus the functionality of contemporary formations, women need to learn practical skills in negotiating institutional arrangements, in communicating effectively and creatively, and in building alliances across differences. The course ends by asking students – men and women – to outline a plan for personal development and social activism and to describe how they will work to develop such skills and where they will find places to put them in action.

The belly of the beast? Feminism in the best of all places

As mentioned in the previous section, the course "Science, Technology and Gender" has been offered every year since 1991 and is now also part of the required core of courses in a new undergraduate minor offered jointly by LCC and the School of History, Technology and Society in "Women, Science and Technology." Significant advances have been made to put "gender" on the educational agenda at Georgia Tech, both in the curriculum and in the daily operating procedures of the Institute. I am fortunate to have a significant number of feminist colleagues (most hired since 1992). This is not to say that Georgia Tech has retooled itself into a perfectly hospitable environment for women and minority students and faculty.[6] Significant improvements have been enacted due to the efforts of several faculty – male and female, feminist and non-feminist – but as a recent NSF supported Institutional Evaluation details, there is still much to be done to improve the educational and working environment for women at all levels. Although the graduation numbers of women with engineering degrees may be consistent with national averages, they are still too low. The percentage of women on the faculty, especially in the sciences and engineering, does not approach the percentage of women *receiving* doctoral degrees in these fields. None of the Institute's "named chairs" are held by women. Although this isn't the place to do so, the list of micro-inequities could continue.[7]

As can be expected, working in this chilly climate eventually takes a toll.[8] The main reason I stayed so long rests with the female students who are incredibly motivated, intelligent, creative and diligent. In 1996, the average composite SAT score of first year female students was 1,280; an average that has increased steadily from 1986 when it was 1,138. Moreover, women's SAT scores do not differ significantly from

men's. In 1996 men averaged 1,278; in 1986 their average was 1,184. In fact, all entering first year students at Georgia Tech greatly exceed the national average SAT composite score which in 1996 was 1,014. While the overall percentage of female students is still significantly less than that of male students, in 1996 women comprised 28.1 per cent of the entering class, a percentage that has gradually increased over the past decade; in 1992 the figure was approximately 26 per cent. A recent study of attrition and retention rates attests to the fact that female students persist and graduate at the same rate as their male counterparts. In 1996, women received 26.6 per cent of the bachelor degrees awarded by Georgia Tech; the highest concentration was in the sciences where women received 44.4 per cent of the BS degrees awarded. Although there are other schools across the US that graduate more female students in engineering at each of the three degree levels, Georgia Tech's graduation rates are very strong in comparison: in 1996, 22 per cent of its bachelors degrees, 19.7 per cent of its masters degrees, and 18.7 per cent of its doctoral degrees in engineering were granted to women. Thus by the mid-1990s Georgia Tech could claim that it graduated the highest total number of female engineering students of any engineering school in the US.

Because many of the Georgia Tech female students are first generation college students who have already confronted and overcome a whole host of obstacles in their pursuit of higher education, they often have learned very useful survival skills – sometimes in the classroom, but more often than not outside the class. They have learned to persist in the face of overt opposition, to keep focused on important, personal goals, and to survive in a chilly institutional climate. In short, these are women whom feminism cannot afford to lose. These are the women whom feminism must support in their aspirations to become scientists, engineers and technologists. These are also the women who demand that feminism refashion itself to stay relevant for their lives because they are the next generation who hold the key to our collective future well-being.

Having accused Georgia Tech of feeling like the "belly of the beast," I want to modulate this statement slightly to suggest that it is not the only place where the education of women, and in particular the practice of feminist scholarship, has and will continue to encounter difficulties. In that feminists live and work in a distributed global network marked by extreme inequities in resource consumption and standards of living, we are all living and working in the midst of many beastly situations. When I think about the possible places and ideal conditions for feminist work, I think this is exactly where feminism needs to be.

Notes

1 A classic study of the difference in organizational roles and experiences is Kanter (1977). For an annotated bibliography on women and organizational behavior see Balsamo (1985).

2 The Women in Science and Technology International already has a "Hall of Fame" website that includes profiles from their inductees from 1996, 1997 and 1998: www.witi.org- /Center/Museum/Hall/index.html. The Hall of Fame that I would include in the Feminist TechnoScience Primer would also include profiles of women throughout history, annotated with photographs, animations, drawings, lab notes, diaries, and other documents of women's lives.

3 These names are selected from Autumn Stanley's book *Mothers and Daughters of Invention: Notes for a Revised History of Technology* (1995). For recent biographies of female scientists, see Glater (1998); and Huskey and Huskey (1980).

4 A book that might serve as a biographical resource for such an interactive game is June Goodfield's (1991) account of the process of scientific discovery as exemplified by the work of Anna Britt. For her final MS project, Debra Levin produced a prototype of an interactive "learning" environment designed explicitly to encourage young girls' interest in science (Levin 1998).

5 Hall and Sandler's report (1991, originally published 1982) and the follow-up report (Hall and Sandler 1986) are both available from: Project on the Status of Women, Association of American Colleges, 1818 R. St., NW, Washington, DC, 20009. See also Flam (1991).

6 Indeed many of the sexist and racist attitudes and actions referred to by Evelynn Hammonds in her interview about her experiences in the dual degree (engineering) program at Georgia Tech in 1974 persist to this day, see: Sands (1993). However, there have been some institutional changes. The Office of Minority Education (OMED) was created in 1982 to enhance the recruiting efforts and educational support services for minority students – especially African-American students – and is in part responsible for Georgia Tech's success in graduating the greatest number of African-American engineers (including all degree levels) in the US.

7 In fact, in 1996 there were only 106 female faculty out of a total of 778 (approximately 13 per cent). Currently (1999) there are four female school/department chairs out of a total of 30. There is one female Dean who is the Dean and Director of the Libraries. In fact, the School of Literature, Communication and Culture is the only academic unit on campus to have a majority of female faculty – primarily due to the large number of adjunct instructors who teach composition courses (Office of Institutional Research and Planning 1996).

8 In 1999, I left Georgia Tech to take a position as a research scientist at Xerox PARC. One of the final projects I worked on at Georgia Tech was an evaluation of the "Institutional Climate for Women." This evaluation was done as part of an NSF-sponsored grant on "Gender Equity" called "In-GEAR: Integrating Gender Equity and Reform." The final climate report can be found at: http:/www.academic.gatech.edu/study/.

References

Balsamo, A. (1985) "An annotated bibliography on women and organizational behavior," *Women and Language* IX(1/2): 6–33.

Caplan, P. J. (1993) *Lifting a Ton of Feathers*, Toronto: University of Toronto Press.

Flam, F. (1991) "Still a 'chilly climate' for women?," *Science* 252 (21 June): 1604–5.

Glater, R. A. B. (1998) *Slam the Door Gently: The Making and Unmaking of a Female Scientist*, Santa Barbara, California: Fithian Press.

Goodfield, J. (1991) *An Imagined World: A Story of Scientific Discovery*, New York: Harper & Row.

Gross, P. and Levitt, N. (1994) *Higher Superstition: The Academic Left and its Quarrels with Science*, Baltimore, Maryland: Johns Hopkins University Press.

Hall, R. M. and Sandler, B. R. (1986) "The campus climate revisited: chilly for women faculty, administrators and graduate students," *Project on the Status and Education of Women (PSEW)*, Association of American Colleges.

——(1991; originally published 1982) "The classroom climate: a chilly one for women?," *Project on the Status and Education of Women (PSEW)*, Association of American Colleges.

Hass, V. B. and Perrucci, C. C. (eds) (1984) *Women in Scientific and Engineering Professions*, Ann Arbor: University of Michigan Press.

Haraway, D. (1990) "A cyborg manifesto: science, technology and socialist-feminism in the late twentieth century," in D. Haraway, *Simians, Cyborgs, and Women: The Reinvention of Nature*, New York: Routledge.

Harding, S. (ed.) (1993) *The "Racial" Economy of Science: Toward a Democratic Future*, Bloomington, Indiana: Indiana University Press.

Huskey, V. R. and Huskey, H. D. (1980) "Lady Lovelace and Charles Babbage," *Annals of the History of Computing* 2(4) October: 299–329.

Kanter, R. M. (1977) *Men and Women of the Corporation*, New York: Basic Books.

Koertge, N. (1994) "Point of view: are feminists alienating women from the sciences?" *The Chronicle of Higher Education* 14 September: A80.

Levin, D. (1998) "BEARS: The Biome Educational and Research Project," MS project in "Information Design and Technology," School of Literature, Communication and Culture, Georgia Institute of Technology, June.

Mallette, L. and Chalouh, M. (eds) (1991) *The Montreal Massacre*, trans. Marlene Wildeman, Charlottetown, Prince Edward Island: Gynergy Books.

National Science Foundation/SRS (1994) "Women, minorities and persons with disabilities in science and engineering." Available URL: www.nsf.gov/sbe/srs/wmpdse94/start.htm (1 October 1998).

——(1996) "Women, minorities and persons with disabilities in science and engineering." Available URL: www.nsf.gov/sbe/srs/women/start.htm (1 October 1998).

Office of Institutional Research and Planning (1996) *The Georgia Tech 1996 Fact Book*, Georgia Institute of Technology, Atlanta, GA.

Ogilvie, M. B. (1986) *Women in Science: Antiquity through the Nineteenth Century. A Biographical Dictionary and Annotated Bibliography*, Boston, Massachusetts: MIT Press.

Russ, J. (1983) *How to Suppress Women's Writing*, Austin: University of Texas Press.

Sands, A. (1993) "Never meant to survive: a black woman's journey. An interview with Evelynn Hammonds," in S. Harding (ed.) *The "Racial" Economy of Science: Toward a Democratic Future*, Bloomington, Indiana: Indiana University Press, 239–48.

Stanley, A. (1995) *Mothers and Daughters of Invention: Notes for a Revised History of Technology*, New Brunswick, New Jersey: Rutgers University Press.

Stephenson, N. (1996) *The Diamond Age or, A Young Lady's Illustrated Primer*, New York: Bantam Books.

Jennifer Daryl Slack and
M. Mehdi Semati

THE POLITICS OF THE "SOKAL
AFFAIR"[1]

IN SPRING 1996, as part of the backlash against significant changes in the cultural and political climate in the US, New York University physicist Alan Sokal perpetrated a "hoax" on the journal *Social Text*, when he submitted an article titled "Transgressing the boundaries: toward a transformative hermeneutics of quantum gravity" (Sokal 1996c). The *Social Text* collective included it as the final piece in their spring/summer 1996 special issue on "Science Wars" (*Social Text* 1996), which focused on the recent debates in the field of science studies and attacks on it by some members of the scientific community and the political right. Coinciding with the release of *Social Text*, *Lingua Franca*, in collusion with Sokal, published another article by Sokal exposing the *Social Text* article as purposefully fraudulent (Sokal 1996b; herein referred to as the Sokal exposé). Sokal explains that he had become convinced of the "apparent decline in the standards of rigor in certain precincts of the academic humanities" and sought to confirm his conviction (Sokal 1996b: 62). He confessed that his article was "a modest (though admittedly uncontrolled) experiment: Would a leading North American journal of cultural studies – whose editorial collective includes such luminaries as Fredric Jameson and Andrew Ross – publish an article liberally salted with nonsense if (a) it sounded good and (b) it flattered the editors' ideological preconceptions?" (Sokal 1996b: 62). The answer for Sokal, and for many others, has been a simple "yes." And the "experiment" has been taken largely as demonstrating that the humanities – or at least some sectors of it – have become corrupted.

Situating the Sokal affair

One might expect this episode to be of little interest outside the audience for the *Chronicle of Higher Education*, which did cover the matter relatively evenhandedly (McMillen 1996). But in this case the story found its way on to the front page of the *New York Times*, into editorials in most of the major US newspapers, and was covered by CNN's *Capital Gang Show* and the *Rush Limbaugh Show*. The issue, which in the tradition of TV journalism came to be called "the Sokal affair," was taken up in the media in proportions befitting a major political scandal.[2] Despite reasonably credible explanations and measured defenses offered by the co-editors of *Social Text* (Ross

1996b; Robbins and Ross 1996) and the executive director of Duke University Press, which publishes *Social Text* (Fish 1996), most of the media coverage was and continues to be derogatory, siding with Sokal in his indictment of the humanities.[3] We should ask ourselves, why? What is it about this issue that warrants such extensive media coverage? And what is the significance of the overwhelmingly derogatory coverage?

It is important to distinguish between different ways of approaching the Sokal affair. One approach might address Sokal's submission of the bogus article and *Social Text*'s decision to publish the article. Relevant questions would include at least the ethical dimension of Sokal's conduct and the professional aspects of *Social Text*'s decision. A second approach might address the widespread reactions to the incident as reflected in the press. While one might study these approaches as representing separate analytical questions, both are subsumed within a third, more comprehensive view which we take here: that the Sokal affair emerges within a particular historical context and is put to particular political use.

The Sokal affair is not simply a case of clashing or competing paradigms, reducible to the contestation of different concepts and theoretical formulations within and between the sciences and the humanities. Nor is it simply an argument over intellectual standards. Rather, we would argue that the Sokal affair can best be understood in the context of conflicts between the sciences and the humanities in conjunction with anti-liberalism, anti-intellectualism and conflicts among the left over what constitutes a legitimate politics. The articulation of this moment constitutes an attack on higher education in the liberal tradition as part of a conservative agenda that justifies cleansing from the academy intellectually and politically undesirable elements. However, the university is, we suggest, merely the point of attack against much larger social and political currents. The university, at least in the US, has been the site of the proliferation of the so-called "new social movements" – including feminism, multiculturalism, Afro-Americanism, environmentalism, etc. – hence it becomes a crucial site of contestation by the conservative movement.

As we illustrate further, cultural studies is the occasion of this attack. The occasion might well have been – and might yet be – feminism, with its far more public presence. Similarly, the occasion might have been – and might yet be – environmentalism, multiculturalism, Afro-Americanism, etc. All of the political currents we discuss in this chapter are equally maligned as part of a constellation condensed, for particular historical reasons, as cultural studies.

Our particular institutional location in the academy as practitioners of cultural studies motivates us, at least in part, to intervene on behalf of cultural studies. The stakes are considerable, involving the legitimation of intellectual projects, the distribution of institutional resources, and the policing of thought in the receding horizon of democracy in the US. The political significance of the matter compels our somewhat polemical response. Our description of the incident highlights these themes, draws connections among them and points to gravely serious political implications. We hope that in drawing this map, the stakes will become clearer for those of us in cultural studies and related fields – as well as for those outside those fields with commitments to democratic processes. The Sokal incident is both smaller and larger than it originally appears to be. On the one hand, it is a rather trivial matter, blown out of proportion by rather silly media hype. On the other hand, the Sokal affair holds more important messages about the growing totalitarian influences in American culture – both inside and outside the academy.

A scientist's quarrel with ...

Sokal quarrels with science studies – sort of. Actually he quarrels with much more. But to track down the target(s) of his attack puts one in the position of tracking insubstantial ghosts. Sokal points to them; you see them there clearly out of the corner of your eye. But as you turn to look at them directly or reach for them, they dissimulate; they are neither what Sokal says they are nor are they familiar. But there is method in this madness, or if not "method," which implies intent, at the very least there is substantial and pernicious impact. Sokal's method works, in part, by fixing an indeterminate target, to give the illusion that something which is in fact concrete and ridiculous (like the figure of a ghost) is under attack. In so doing, that which *is* concrete is violated and turned into caricature, given a new form which is ultimately insubstantial. The conjury is integral to both the philosophical and political signifi-cance of the Sokal affair; and one way to conceive of the map that we offer in this chapter is as a map of that conjury. However, because the identification of the target is problematic at a number of levels, including the most mundane, it is difficult to engage the arguments that define this affair without considering what it is that Sokal and those who follow his path (which, for the sake of convenience, we shall shorten to Sokal *et al.*) claim to be criticizing in the first place. What Sokal *et al.* take as their object of analysis is always already ambiguous. We take part of our task to be to bring coherence to what keeps moving just out of range in Sokal *et al.*, to give the ghosts shape.

In his exposé, Sokal begins by declaring his motivation to be the fact that he has been "troubled by an apparent decline in the standards of rigor in certain precincts of the academic humanities" (1996b: 62). In the next paragraph, the target, those "precincts of the academic humanities," is identified further in "a leading North American journal of cultural studies." Several paragraphs later he asks, "Is it now dogma in cultural studies that there exists no external world?" (ibid.). One might surmise, then, that the target is cultural studies as it is practiced in the academic humanities. However, by the second page, the target shifts as Sokal asserts that "*Social Text*'s acceptance of my article exemplifies the intellectual arrogance of Theory – postmodernist *literary* theory, that is – carried to its logical extreme" (1996b: 63). By the third page the target is "theorizing about the 'social construc-tion of reality'" (Sokal 1996b: 64). In Sokal's "Afterword," submitted to *Social Text* (though rejected) and widely circulated on the Internet, the target is "confused thinking" exemplified by feminist philosopher of science, Sandra Harding (Sokal, unpublished).

Cultural studies, postmodernist literary theory, social constructionism, and femi-nist science studies are treated by Sokal as a singular enemy, irrespective of their specificity as intellectual projects. Why? What unites these otherwise diverse modes of inquiry? An answer can be found in his further remarks where he claims that "[m]y concern [is] about the spread of subjectivist thinking" (Sokal 1996b: 63); later, it is about "epistemic relativism" (ibid.: 64). It is about "contemporary academic theo-rizing" that consists "of attempts to blur these obvious truths," that is, that "There *is* a real world; its properties are *not* merely social constructions; fact and evidence *do* matter" (ibid.: 63). As Sokal states, "my concern is explicitly political: to combat a currently fashionable postmodernist/poststructuralist/social-constructivist discourse – and more generally a penchant for subjectivism" (Sokal, unpublished). Presumably, this is the kind of thinking done by those who practice cultural studies, postmodernist

literary theory, social constructionism, deconstructionism, and feminist science studies. But more broadly, as Sokal claims, "The targets of my critique have by now become a self-perpetuating academic subculture that typically ignores (or disdains) reasoned criticism from the outside" (1996b: 64). One is tempted to surmise that any thought that questions (or any thinker who questions) the relationship between reality and our representations of it is the target here – especially those that have come to be identified as belonging to particular academic disciplines or subcultures.

One should recall that this debate is ostensibly about "science studies." Sokal's contribution to *Social Text* paraded as a scientist venturing onto the ground of the postmodern critique of science. The point of his experiment seemed to be that the gurus of science studies (Harding, Haraway, and Ross?) wouldn't know the difference between science and a poor imitation of it. But Sokal's exposé is more a diatribe against leftist academic humanists generally than it is against practitioners of science studies. He argues, for example, that scholars "have appropriated conclusions from the philosophy of science and put them to work in aid of a variety of social cum political causes for which those conclusions are ill adapted" (Sokal, unpublished).

We need to consider the context of Sokal's motivation not only for his attack against *Social Text* but for the extension of his attack beyond the journal to his amalgam of targets. At least part of his motivation can be attributed to the influence of the book by Paul Gross and Norman Levitt, *Higher Superstition: The Academic Left and its Quarrels with Science* (1994). Sokal is explicit that his motivation for perpetrating the hoax article was influenced by Gross and Levitt. As reported by Linda Seebach:

> Sokal was prompted into parody by a 1994 book, *Higher Superstition: The Academic Left and its Quarrels with Science*, by Paul Gross and Norman Levitt, which ruffled a lot of postmodernist feathers.
>
> "I'm an academic leftist and I have no quarrel with science," Sokal said, "so the first thing I did was go to the library and check their references, to see whether [Gross and Levitt] were being fair" and they were. In fact, he found even more examples of scientific illiteracy, some of them even worse.
>
> (Seebach 1996: 17A)

Gross and Levitt are invoked explicitly by Sokal *et al.* throughout this affair. But even more important, the issues they raise and the vicious and dismissive tone they use echo throughout. The enemies they take on turn out to be much less science studies than what they perceive to be sectors of society eminently dangerous to science and society more generally. Those sectors include feminists, multiculturalists, deconstructionists, supporters of affirmative action, the academic left, etc. – in other words, the same left-liberal amalgam identified by Sokal *et al.* As Ross discusses in the "Introduction" to the "Science Wars" issue of *Social Text*, *Higher Superstition* has set the "shrill tone" of the conservative backlash against the humanities generally (Ross 1996a: 7). In the wake of the book, the scholarly media have written about, and a variety of high-powered conferences have been held, to take up its issues. The Sokal affair is thus in a very real sense a continuation of the argument. Although *Higher Superstition* technically predates the affair, it is integral to its understanding.

Reactions in the Sokal affair

Sokal, with the imprimatur of scientist, purports to react to publication standards in the humanities when science studies is on the agenda. But it is striking how little is said about science studies or science specifically throughout the reaction to the hoax. Rather, the quarrel with science studies provides a salient symptom (and symbol) of a wide-spread dis-ease with the power of contemporary theory and the challenges it represents; it functions as a synecdoche for the configuration of targets of a conservative political agenda. This became clearer as we analyzed commentary further removed from the participants in the incident. The further removed the commentary, the less likely it mentioned science studies or science at all and the more likely it resembled unabashed political attack.

Norman Levitt, mathematician and co-author of *Higher Superstition*, reveals overtly that science studies provides the symptom and thereby a convenient way into the complex of concerns of which it is only one manifestation. Sharon Begley and Adam Rogers in their *Newsweek* coverage of the incident quote Levitt: "the left has lost itself in a lot of crummy theory and bad philosophy. Science studies is not the only realm where this occurs, but it's one in which people's predilection to make asses of themselves is easily exposed" (Begley and Rogers 1996: 36). The range of targets, what in Levitt's words has been contaminated by "crummy theory and bad philosophy," is simply staggering. Feminism, environmentalism, cultural constructivism and postmodernism all receive full chapter attacks. Within those broadsides, Gross and Levitt malign post-structuralism, deconstructionism, cultural studies, critical studies, literary studies, cultural history, psychoanalysis, social construction, Marxism, socialism, multiculturalism, and nihilism. But more than theory and philosophy, a range of academic (and non-academic) practices also become targets: college curricula, Afro-American studies, affirmative action, academic writing, the academic and progressive left, tenured radicals, and so on. So, for example, Roger Kimball (1996), in his 29 May *Wall Street Journal* column on the Sokal affair, manages to criticize deconstruction, post-structuralism, cultural studies, post-colonial studies, psychoanalysis, social construction, discourse (as a theoretical term), academic radicals, the academic left, and their language practices.

The Sokal affair provides evidence of the advancing dis-ease with significant changes in the contemporary university system and in contemporary thought generally, changes that seem to have the appearance to many of creeping up on mainstream academic life and challenging the structures of power that have kept certain ways of understanding the world (scientific ways, for example) preeminent. University of California, Davis, Professor of History, Ruth Rosen, sympathizing with Sokal in a *Los Angeles Times* piece, claims that: "The scandal actually began about a decade ago, when a growing cadre of Academic Emperors began empire-building within American universities" (Rosen 1996: A11). The empire includes those disciplines, philosophies, and theoretical positions mentioned above. One "reigns" in the empire courtesy of an emerging celebrity system. Pollitt maintains that this celebrity system developed in the 1980s and "meshes in funny glitzy ways with the world of art and entertainment, with careerism" as well as with "the need for graduate students" (Pollitt 1996: 9).

Gross and Levitt depict this new cadre of scholars and disciplines as the product of years of deep resentment against the life sciences for their (perhaps only folkloric, but perceived to be real) ill-treatment of the humanities (Gross and Levitt 1994: 12).

Rising up angry then, these new scholars and disciplines have forced their *counter-programs* on the university, their world views, their presence and voice.[4] The opening sentence of Gross' and Levitt's chapter on gender, called "Auspicating gender," proclaims, "American universities have adopted feminism" (1994: 107). In short, for Sokal *et al.*, the radicals have been too successful. The prominence and visibility of Derrida and Foucault, as well as of Haraway, Harding and Ross represent to them the attempt to "regain the high ground" that the humanities once occupied (Gross and Levitt 1994: 12).

Cultural studies, that new "hybrid" discipline, as Gross and Levitt refer to it, has more than once made headlines. The changing relations of power that have accompanied these developments can be gleaned from new institutional structures and arrangements in the university. As Larry Grossberg wrote about cultural studies in 1988,

> In the United States, cultural studies is a success; in fact, its recent rise has all the ingredients of a made-for-TV-movie. Its success can be measured economically – publishers seek manuscripts and journals that can be framed and nominated as cultural studies; it can be measured professionally (it now enters into job descriptions and the titles of academic centers); and it can be measured discursively – it appears to be the latest signifier of what was called "critical theory" in a variety of academic organizations.
>
> (Grossberg 1988: 8)

In the ensuing years, this has only become more true. Graduate students have gravitated to programs in cultural studies and coveted academic positions have been filled by professors of cultural studies; book stores, not just publishers, have sections for books on cultural studies. Furthermore scholars, disciplines (like literary studies) and journals (like *Social Text*) have enhanced their images, status, and their theoretical and political options by identifying with cultural studies.

The threat posed by the very presence of these new hybrid disciplines (such as science studies, cultural studies and women's studies) with their powerful critiques of current institutional relations of power and politics is often met with a response that takes the form of complaint about the "arrogance" of these intellectual movements – an arrogance that is depicted as dismissing rationality. Sokal contrasts his own commitment to rationality: "I'm a leftist (and a feminist) because of evidence and logic, not in spite of it" (1996b: 64).

The arrogance under attack is identified with particular individuals associated with these movements whose independence and status is taken as evidence of arrogance. Rosen refers to "the unearned prestige that the Academic Emperors have heaped upon themselves" (1996: A11). George Will asks, "So what, beyond ignorance, explains why *Social Text*'s editors swallowed it [the Sokal article]?" "Arrogance, for starters," he answers (1996: A31). Peter Berkowitz, Associate Professor of Government at Harvard, comments in *The New Republic* on the fact that the *Social Text* editors did not seek a scientist's opinion of the Sokal hoax article by asking, "From whence did this arrogance derive?" (Berkowitz 1996). Leading theorists are routinely depicted with disdain – as arrogant and ignorant. They are "superluminaries" (Seebach 1996: 17A) and "trendy academic theorists who have created a mystique around the (hardly new) idea that truth is subjective and that objective reality is fundamentally unknowable" (Rosen 1996: A11). Ross, Jameson and the editorial collective of *Social Text* are "luminaries" (Sokal 1996b: 62). Stanley Fish is

"the infamous Duke deconstructionist who is also executive director of the Duke University Press" (Kimball 1996: A18). A summary of Rush Limbaugh's program, broadcast 22 May, reports that "Rush has seen [Stanley] Fish on some of the TV 'Firing Line' type shows and he's truly in a different world than most, being the prototype of the effete, elitist academic who's 'above it all'" (Switzer 1996). The *Social Text* editors are "self-styled academic rebels, who pride themselves on putting playful mockery to good scholarly use" (Berkowitz 1996). Nowhere, however, is the flavor of disdain for these academics more clearly captured than in the recurring use of the fable of the emperor with no clothes. In a story carried on the *New York Times* wire service, Linda Seebach writes: "Many scientists believe that the emperors of cultural studies have no clothes. But Sokal captured the whole royal court parading around in naked ignorance and persuaded the palace chroniclers to publish the portrait as a centerfold" (1996: 17A). In contrast with these ignorant and haughty charlatans, Sokal's "satire" is considered "brilliant." He is seen as having managed to initiate the equivalent of a palace coup that "may finally have punctured the hyperinflated hot-air balloon of cultural studies" (Kimball 1996: A18). It is not only that these new academics have corrupted relations of power within the university; far worse, they are seen as having contaminated intellectual thought itself. They, and what they believe, have come to exemplify what is "wrong" about the humanities. In a particularly blistering attack against the humanities made available on Sokal's Internet home page, Gary Kamiya (1996) points to the trend to bash the new academics for what they believe, teach and promote: "For well over a decade, critics from all points on the political spectrum have been bashing the obscurantism, scholastic pedantry and phony radicalism rampant in the contemporary humanities." What is it the contemporary humanities stands for collectively? What contamination, what dis-ease has it spread?

Gross and Levitt are perhaps the clearest on this question. First, they identify this group as the "academic Left." But what defines that group is more specific: they state that they use "*academic left* to designate those people whose doctrinal idiosyncrasies sustain the misreadings of science, its methods, and its conceptual foundations that have generated what nowadays passes for a politically progressive critique of it" (Gross and Levitt 1994: 9). But the academic left, whose doctrinal idiosyncrasies sustain these objectionable readings, do not just do science studies:

> What defines it, as much as anything else, is a deep concern with cultural issues, and, in particular, a commitment to the idea that fundamental political change is urgently needed and can be achieved only through revolutionary processes rooted in a wholesale revision of cultural categories.
>
> (Gross and Levitt 1994: 3)

This is perhaps why cultural studies is a special target. Here the scientists and laypersons join together in their suspicion of what they understand to be cultural studies, for the term implies in their common-sensical view the study of culture (aka representation) which in turn implies opposition to truth.

The ground traversed has indeed been well traveled by philosophers and other scholars for centuries: what is the nature of reality, of truth, of culture, of the culture of nature? Even within the purview identified by Sokal *et al.* as the contaminating Others, a range of responses characterizes a debate, not an answer. The extreme positions in this debate have been described by *Social Text* co-editor Bruce Robbins

(1996), as "space cadet idealism" (there is no reality other than that which we create, i.e., solipsism) and "dumb-as-a-post positivism" (if you can't count it, it isn't real). But really, so few contemporary philosophers, scientists or cultural theorists occupy the space of those extreme poles that it is hardly worth considering them. The tendency in the Sokal affair has been to proceed as if everyone must choose between one of the extreme positions and that the contaminating Others have chosen "space cadet idealism." Ross' "Introduction" to the "Science Wars" criticizes positions such as those advanced by Gross and Levitt that collapse significant philosophical and theoretical differences and debates into "a caricature of the enemy as buffo nihilists who deny outright the existence of natural phenomena such as recessive genes, or subatomic particles, or even the law of gravity" (Ross 1996: 10). It is pointedly ironic that Sokal's simultaneous exposé invites "[a]nyone who believes that the laws of physics are mere social conventions ... to try transgressing those conventions from the windows of my apartment. (I live on the twenty-first floor)" (Sokal 1996b: 62). In the manner of television journalism, where everything gets reduced to its potential as a sound bite, the caricature prevails, not the serious intellectual and political question. According to Janny Scott of the *New York Times*, the relevant question is "whether there is a single objective truth or just many differing points of view" (1996: A1, 22). She continues with a version of Sokal's caricature: "Conservatives have argued that there is truth, or at least an approach to truth, and that scholars have a responsibility to pursue it. They have accused the academic left of debasing scholarship for political ends" (ibid.). For the academic left, nothing is real: "Is there a sound when a tree falls in the forest and no one hears it? Under the theory of social construction, there's not even a tree" (Seebach 1996: 17A). If nothing is real there is no truth: "Social construction," which for Kimball stands (for at least a moment in his text) as the doctrine which all these vilified approaches have in common, "denies the very possibility of verifiable, objective truth upon which the authority of science depends" (Kimball 1996: A18). If nothing is real and there is no truth, then everything is always only representation and therefore political:

> The *lumpen* Marxists and other theory-mongers begin with Nietzsche's assertion that there are no facts, only interpretations. ... And they arrive at an encompassing relativism, by which they justify seeing everything through the lens of politics.
>
> Everything, they assert, from science to sexuality, is a "social construction," and thus arbitrary.
>
> (Will 1996: A31)

Of course what the proponents of this extreme position in defense of a transparent reality (from conservative scientists to Rush Limbaugh) are blind to is the simple proposition that if we all had access to a transparent reality prior to its representation, we would all walk away with the same interpretations and there would be no debate (over the Sokal affair). Debate presupposes a split between reality and its representation.[5]

Apparently, the academic left's disregard for truth and its reduction of everything to politics is also an indication of its loss of intellectual and academic standards. As Berkowitz notes in *The New Republic*:

> What distinguishes postmodernism is the extreme and dogmatic belief that the principles of morality as well as reason itself are socially constructed –

that is, created by human beings for pleasure and profit – and nothing more.
… What is truly troubling about the "cultural" or "critical" study of science
as it tends to be carried out in universities today is what is troubling about
postmodernism in general. By teaching that the distinction between true
and false is one more repressive human fiction, postmodernism promotes
contempt for the truth and undermines the virtue of intellectual integrity.

(Berkowitz 1996)

As the logic of the argument unfolds, intellectual integrity is replaced by and covered
over by academic stardom (as discussed earlier) and jargon-laden obfuscation. Sokal's
article was accepted because, according to Kamiya (1996), with "deadly accuracy" it
parroted "the style and intellectual approach of the standard mediocre progressive
post-structuralist paper available cheap over every academic counter these days." The
style is one of "dense writing that passes for cutting-edge theoretical criticism"
(Rosen 1996: A11).

Especially vituperative language is reserved for the language of the contaminating
Others: "the jargon and cant that passes for deep think these days" ("A wake-up call
for academia" 1996: B6). In identifying "the imponderable syntax and jargon of
contemporary theoretical writing" (Rosen 1996: A11), terms as mundane as these
are held up to ridicule: sign, reading, constitute, ambiguity, hegemony, epistemology,
discourse, non-linearity, and liberatory![6] Many complain that these terms are mere
"gibberish" (Switzer 1996). It is as though the meaning of anything that anyone
writes in the humanities must be immediately transparent, unlike the jargon of
science, where jargon is well-understood to be both necessary and worth the consid-
erable effort to learn it. It is as though cultural phenomena are themselves
transparent; only science ponders what is complex. Peter Jones argues for this distinc-
tion in his siding with Sokal: "We need terms such as 'chromosome' and
'dactylo-epitrite.' They are shorthand for complex phenomena. Jargon, however, is
longhand for simple phenomena. Its purpose is to obscure and obscurity seems to be
the particular vice of the humanities and social sciences" (Jones 1996). We wonder
what acts of philosophical and cultural repression permit the belief that studying
culture is any simpler than studying science.

Cultural studies, or something like that

The predominance of "cultural studies," to the point of overshadowing feminism,
science studies, deconstruction, literary criticism, social constructionism, etc., as a
signifier in the Sokal affair and its vilification by the press is striking. But these critics
of cultural studies (along with the other intellectual projects scrutinized) don't seem
to know what it refers to (even as they assert that they know). Cultural studies has
assumed the role of a "floating signifier," a theme without a precise meaning to
which meanings and political projects can be attached (see Laclau 1990b: 92). In
other words, cultural studies has become a term that, like a political slogan paraded
out in front of the troops, ("down with cultural studies"), serves as a rallying cry for
the positions of the opposition. The resemblance (there is very little) between what is
held up as cultural studies and cultural studies as it is actually practiced is irrelevant
for those who carry the banner. The consequences of this kind of misuse are signifi-
cant for those who practice cultural studies and for those in the humanities more
broadly.

The power to name something (in this case, cultural studies) does not exhaust its meaning. But naming can work to articulate the term in ways that have real consequences. So in a sense, the invocation of cultural studies is part of a struggle to make claim to the term, to fix its meaning and attach it to differing political projects. But why has cultural studies been put in this position in the Sokal affair?

To begin, the question must be asked why cultural studies is identified at all. In a rather straightforward sense, the answer is obvious. In his exposé, Sokal characterizes *Social Text* as "a leading North American journal of cultural studies" (Sokal 1996b: 62). And it may well be that much of the media has simply mimicked that characterization. After all, one must ask oneself, how much does Rush Limbaugh really know about cultural studies? We can track the obvious a bit further and point out that, as Sokal himself has credited Gross and Levitt as his inspiration, it is likely that Sokal was led to identify cultural studies by them.[7] Gross and Levitt do not occupy a consistent and logical position on the relationship between cultural studies and postmodernism or science studies (or anything else for that matter). Cultural studies is, for example, discussed in a short section (Gross and Levitt 1992: 88–92) as a way to vilify Ross, then simply dropped. Sometimes, cultural studies functions as just one of the many – virtually equivalent – sites where the kind of thinking they despise is practiced; sometimes the name of that kind of thinking is postmodernism, social constructionism, feminism, etc. Other times, however, as might be supported by the logic of the following quotation, cultural studies functions with the special status of the institutional embodiment of the kind of thinking that Gross and Levitt despise: "The realm of cultural studies, only a few years old, and yet the virtual center of current left-wing theorizing, is to all intents the institutional embodiment of postmodernism" (Gross and Levitt 1992: 72). The sweeping, inclusive and confused nature of their attacks, combined with the vehemence of their pontifications, make it possible for readers to latch on to the particular complaint that strikes a chord in them. It is almost like a visit to a convenience store where you can satisfy your immediate needs rather cheaply with a product to match. There is something there for everyone, but nothing of substance. But many people, including Sokal, still more so the popular media, have identified the complaints as against cultural studies. Why?

Cultural studies *is* relatively easily identified because unlike almost any of the other targets of attack it has, as alluded to earlier, gained institutional status at many universities that renders its presence as an approach more salient. There are programs and departments of cultural studies, as well as conferences and journals. The influence of cultural studies *has been felt* across disciplines: in communication, anthropology, history, feminist studies, critical race theory, literary studies, science studies, etc. But Sokal *et al.* reduce any work that address the questions of culture and representation to cultural studies. In contrast, *Social Text*, for example, is an interdisciplinary journal in the small magazine tradition that specializes in politically oriented cultural criticism. In fact, some of the loudest criticism of cultural studies has been associated with the journal (see, for example, Jameson 1993). Similarly, the reduction of the identity of particular people to cultural studies, such as Ross to the status of a guru of cultural studies, is simply misplaced. Ross's identity – institutionally, politically or philosophically – cannot be reduced to cultural studies. Similarly the identity of cultural studies is not exhausted by the identity of Ross.

In effect, these critics (along with some left-wing academics) deploy the term cultural studies with shamefully little attention paid to the specificity of the history and practice of cultural studies. Any serious engagement with the literature in cultural

studies reveals the presence of parameters of what constitutes cultural studies. Further, these parameters have been the topic of ongoing and explicit discussion for a long time among those who consider themselves to be its practitioners.[8] In fact, part of the highly reflective political and theoretical project of cultural studies has been to keep that question at the forefront as the nature of its parameters evolve along with the theoretical and political questions its practitioners find necessary to address. When practitioners claim that cultural studies is therefore "open," they do not imply that "anything goes." Similarly, the way in which cultural studies *intersects* with other traditions has always been part of theorizing in cultural studies. This does not mean that cultural studies is reducible to those other traditions. Cultural studies has engaged in theoretical dialogue with a broad range of other disciplines, approaches and theories: including Marxism, structuralism, feminism, environmentalism and post-colonialism. So, for example, cultural studies took seriously what it might learn from postmodern theory. In 1989, Lawrence Grossberg wrote of the intersection of cultural studies and postmodernism:

> [c]ultural studies is not built upon a theory of the specificity of culture (usually defined in terms of signification, ideology, subjectivity, or community); rather, cultural studies examines how specific practices are placed – and their productivity determined – between the social structure of power and the lived realities of everyday life. It is for this reason that current work on postmodernity intersects with cultural studies; it is not a matter of taking up postmodernism as a political and theoretical position but of engaging its description of the nature of contemporary cultural and historical life.
>
> (Grossberg 1989: 416)

More than a decade ago, Grossberg (1986) set out to distinguish between cultural studies and postmodernism. His position became part of an ongoing dialogue, again not the last word on that relationship. There are those who would identify themselves as postmodern cultural theorists, those who would not. To reduce cultural studies to the institutional manifestation of postmodernism or science studies (or anything else) is simply wrong. It is to deny its own specificity. The error offers evidence of more than simply poor research but a total absence of understanding of how theory develops in cultural studies.

Political uses, political abuses

For our argument, it is less relevant to press the issue of the reduction of cultural studies and its vilification than it is to explore the meanings that are being attached to it as a floating signifier. What matters most is the fixing of its meaning as something especially pernicious. From Rush Limbaugh to a *Los Angeles Times* editorial and a *New York Times* article, the field of cultural studies is pointed to as the site of the problems being discussed. It is a field whose balloon needs to be popped (Switzer 1996), a field "sluggish in making progress [that] may need to bone up on Strunk & White's *Elements of Style*" ("Serious prank in scholarly world" 1996: B4), and a "baffling field" (Scott 1996: A1).

Every field – cultural studies and physics included – requires labor and patience to develop competence. The determination of significance and competence is not always straightforward even in fields with a long established history. The difficulty of making

determinations of significance and competence increases when a field is interdisciplinary. There is generally more literature to know, more ground to cover, and more disparate knowledge to integrate. The point that we want to make is that it is academically and intellectually irresponsible to do a "quick take" (of the kind that Sokal, Gross and Levitt do) from outside a field – especially interdisciplinary fields like cultural studies, literary studies or women's studies – and use that quick take to pass judgment on an entire field. We are *not* saying that scholars from outside one's discipline should not write about or critique another. We are saying that to do so requires more labor and patience than Sokal *et al.* demonstrate.

Setting aside the rather trivial irony that Sokal, Gross and Levitt practice exactly what they say science studies cannot legitimately practice (i.e., write about a discipline from outside that discipline or rely on received authority rather than sound argument), evidence abounds that they abuse what little they have read: often failing to read with knowledge of the context within which things are said, failing to acknowledge the integrity of the projects within which matters are explored, failing to extend latitude (or even to recognize) when innovative scholars are advancing difficult arguments and traversing new ground. Instead, they rely on secondary sources and, even worse, intellectual gossip (though that may be oxymoronic) and name dropping. Their treatment of Foucault illustrates this point.[9]

Foucault is mentioned eighteen times in *Higher Superstition*. For the most part he is used in passing, as in "Foucauldian skeptics" (Gross and Levitt 1994: 89), "Foucauldian historicism" (103), and "Foucauldian apothegms" (194). Nowhere is any specific argument of Foucault addressed or cited, and there is no evidence that Gross and Levitt have ever read Foucault. They appear to rely on secondary treatments of Foucault for their knowledge of his work. The lengthiest treatment, the one in which they purport to explain Foucault, is three paragraphs long. In it they dismiss Foucault, not on any force of reason or evidence, but on innuendo and gossip. The treatment warrants quoting at length – if only to illustrate that we are not taking their arguments out of context:

> Like Derrida, Foucault is a thinker whose appeal has been mainly to social theorists and literary intellectuals, rather than to philosophers, who are less swayed by the emotive aspects of his writing, and who tend to regard it as a kind of poetry, rather than as philosophy proper or sound history. For one thing, Foucault's epistemological relativism arises from a study of the presumably exact facts of social history, which his best work examines minutely.[8] Thus, despite himself, Foucault is ultimately tied to the postulate of a real world, definitely knowable in at least some of its aspects. Moreover, his reputation, too, has been attenuated of late, perhaps unfairly, by revelations of his deeply neurotic and self-despising personal life which, one cannot help feeling, dictated the tone of his speculations, as well as giving them their peculiar emotional force.
>
> (Gross and Levitt 1994: 77)

Their footnote number 8 in this quotation reads:

> Foucault's most influential work is probably to be found in his historical studies: *Madness and Civilization*, *The Birth of the Clinic*, *Discipline and Punish*, and *The History of Sexuality*. It goes without saying that despite

Foucault's celebrity, many professional historians are highly critical of his selective and impressionistic methodology. Many of his admirers now concede that his histories are probably best regarded as "novels" of a singular type, works which, for better or worse, say more about their author than about the truths of history.

(Gross and Levitt 1994: 265)

This general reference to Foucault's historical studies – presented here in its entirety – is the closest Gross and Levitt come to citing Foucault. But the studies are not discussed, merely listed. "Many professional historians" has no referent. There is no evidence of an attenuating reputation. In fact, if anything, we take their intervention to suggest the opposite. The use of anonymous authority gives this argument the structure of gossip – exacerbated by thinly veiled moralism.[10]

Our intention in offering this example is not to take up the research of Gross and Levitt, but to point to the kind of research that is then mimicked by Sokal, and caricatured still further by the media.[11] Sokal (unpublished) in his "Afterword," dismisses Foucault with a quotation identical to that used by Gross and Levitt in a footnote citing a book review by Alan Ryan on Foucault. In a National Public Radio (NPR) interview, Sokal further reduces all of French philosophy (including, presumably, Foucault) and dismisses it with one broad brushstroke: "French imports like deconstruction and post-structuralism ... they've lost contact with the real world" ("All things considered" 1996).[12] When these arguments wend their way through the popular media the caricature is complete. For example, Jones (1996) writes in *The Times* that all the "jargon-ridden world of 'cultural studies'" is the product of French philosophy:

Those mainly responsible are 20th-Century French linguistic philosophers. They argued that language could never reflect or describe external reality, only create it. Reality was therefore personal to the creator, i.e., the speaker (and especially, for some reason, the writer). It could not be shared by anyone else.

(Jones 1996)

The absurdity of these reductions of contemporary philosophy is revealed most especially in the recurring comment, here from *The Patriot Ledger* in a classic sound-bite version summarizing all of French philosophy's critique of science: "In other words, some dumb scientists actually believe the world exists" ("Journal doesn't get physicist's satire" 1996: 5). How are we to understand such abuses?

Overdetermination of the Sokal affair

In order to understand the reductive dynamic in the Sokal affair it is important to point to its location within a climate increasingly hostile toward higher liberal education. The hostility is constituted by the coming together of four currents. The first current is anti-liberalism. Within both the academy and the popular arena this has taken the form of attacks against tenured radicals, feminists, multiculturalism, affirmative action, and so on. The second current is anti-intellectualism situated both within the academy and within the popular. Within the popular, anti-intellectualism often takes the form of a mistrust of higher education. Within the university, anti-

intellectualism has taken the form of discomfort with feminism, postmodernism, deconstruction, and cultural studies. The third current manifests as conflict or debate among the left about what constitutes the "legitimate" left, that is, what constitutes legitimate grounds for political intervention. The fourth current is the long-standing "gap" between science and the humanities, more specifically, the often-perceived incompatibility of the scientific world view with humanistic views of the world, most recently with reference to feminism, post-structuralism, postmodernism, cultural studies, science studies, etc.

When these strands articulate, as they have in the overdetermined moment called the Sokal affair, a powerful alliance between conservatives and liberals is forged which reduces complex intellectual argument to political caricature that feeds more than anything a conservative attack on the liberal university. In other words, Sokal's attack may intend to be against "some sectors" of the (liberal) academy (which he poses as a left versus left issue), but his attack is sustained by and greatly enhances a more widespread attack by the conservative movement against the left.

The articulation of these strands and the concomitant reduction of complex intellectual and political argument is not unique to the Sokal affair. Another incident, known as "the Paul de Man scandal" takes place within the same historical formation where conservatives, the popular press, and some on the left both sustain and exploit academic and political debate in service of the reduction of complexity to simple caricatures. A brief juxtaposition of the de Man scandal illustrates the pattern. The Sokal affair follows the pattern, but renders it more salient.

Briefly, the de Man scandal was this: between 1940 and 1942, during Belgium's Nazi occupation, the young de Man (in his early twenties) contributed columns on art criticism to *Le Soir*, a newspaper controlled by the Nazis (as was all legally printed matter). The tone in some of these articles has been taken to indicate acceptance of German occupation, and one in particular is written with an anti-Semitic flavor (Colinet 1989: 432). De Man also translated the books of two authors considered to be Nazi collaborators. These kinds of activities apparently ceased by 1942 when, as de Man stated in 1955, "Nazi thought-control did no longer allow freedom of statement" (de Man 1989: 476).

When de Man's wartime journalism, as it has come to be known, became public knowledge in 1987, many US academics (including left academics) and media commentators used the material to discredit de Man's personal life, pronounce his intellectual *oeuvre* corrupt, and malign the philosophical project to which he was aligned. De Man, a well-established literary theorist and chairman of the Comparative Literature Department at Yale when he died in 1983, was accused of being both a Nazi collaborator and an anti-Semite, his philosophical project, by extension, was presumed to be fascist.[13]

The difficulties of sorting out the relationships among de Man's life, motivations and influences, the politics of Belgium and Europe, the war, Nazism, and de Man's wartime texts are considerable. The difficult philosophical and empirical task of doing that is being taken up, as exemplified by the collection, *Responses: On Paul de Man's Wartime Journalism* (Hamacher *et al.* 1989), of which Derrida's (1989) contribution stands out as a particularly important one.[14] The quality of analysis that characterizes the *Responses* contrasts sharply with the superficial, vacuous and sweeping condemnations that inform much of the media treatment of the de Man scandal. The wartime journalism has been used in a fast and loose fashion not only to attack de Man but more significantly to attack his intellectual trajectory and the project of deconstruction in the university.

Apart from the question of the "fairness" with which the de Man texts have been read, the violence is twofold. First, there is a complete reduction of text and author, such that the meaning and significance of the text is reduced to the biography of the author and vice-versa. Hence, the logic dictates, if de Man was a fascist, all of his philosophical contributions must be fascist; or if a specific text is anti-Semitic, de Man must be anti-Semitic. The position permits no contradiction – either textually or personally. Second, conservative and some left academics as well as the media extended the condemnation of de Man's personal and intellectual life to a total condemnation of deconstruction as a philosophical movement (for example, Wiener 1988). Because de Man was among the first scholars in the US to take Derrida's work seriously, discrediting his work is used to put "the character of deconstruction as a whole … on trial" (Weber 1989: 405). Thus the de Man scandal becomes a scandal of the liberal university – the place where "de Man's teaching and catch-phrases are parroted in departments of English and comparative literature across the country" (Kimball 1988: 36).

While the de Man scandal is not principally a debate among the left, it is given shape by debates among the left, specifically as to the political and academic value of deconstruction. For example, Jon Wiener, Professor of History and contributing editor of *The Nation*, in obvious sympathy with the critics of de Man asserts in his analysis of the de Man affair in *The Nation* that:

> Critics on the left have argued that the presuppositions of deconstruction – that literature is not part of a knowable social and political reality, that one must be resigned to the impossibility of truth – make it at worst nihilistic or implicitly authoritarian and at best an academic self indulgence.
>
> (Wiener 1998: 22)

Embedded in this left versus left construction, the complaint registers the suspicions of a scientific world view which fears that "certain segments of the humanities" essentially deny the existence of reality. The disdain with which de Man, deconstruction, and the liberal university are treated must also be understood as expressions of anti-intellectualism. According to Kimball (1988) de Man and deconstruction's commitment to "the thought that language is always so compromised by metaphor and ulterior motives that a text never means what it appears to mean," is characterized as "doctrinaire skepticism and infatuation," and practitioners of the movement are characterized as members of "a literary movement that has so arrogantly proclaimed itself a champion of freedom" (Kimball 1988: 36–7).

As with the de Man scandal, the Sokal affair condenses the currents of anti-liberalism, anti-intellectualism, scientific disdain for the humanities, and conflict among the left, but it renders them all more salient. Further, in so doing it more clearly contributes to the condemnation of the liberal university. Its significance can only be appreciated within this larger context.

Most significantly, the Sokal affair takes place within and as part of the attack on the liberal university, recently referred to as the "PC wars," joined now by the "Science wars," both of which are a part of a larger conservative movement. The nature of this conservative movement has been explored in analyses of the anti-politically correct movement by such scholars as Ellen Messer-Davidow (1995) and John Wilson (1995).[15] While a comprehensive treatment of the formation of this

movement is beyond the scope of this chapter, it is crucial to demonstrate the way the Sokal affair is, at least in significant part, a manifestation of that movement.

Messer-Davidow and Wilson focus on the development of the movement since the 1960s when anti-war and civil rights activities, academic feminism, and secular humanism generally were seen by conservatives as becoming entrenched in universities. Both writers demonstrate how the movement built an effective organizational infrastructure by the 1990s. The components of this infrastructure include the channeling of huge amounts of money from industry and private donors through think-tanks, foundations, politicians, scholars, students and journalists in support of positive press and pressure for a conservative agenda and negative press for a liberal one. Its components also include an attack on the academy for what is believed to be its liberal monopoly on higher education. The goal in this regard is to replace higher education with free-market competition among competing educational institutions – a situation that would surely favor the superior spending power of the conservative machine. There is clearly much more at stake here than arguments about the relationship between reality and representation.

The targets of the conservative movement as considered by Messer-Davidow and Wilson are almost identical to those of Sokal *et al.*: feminism, post-structuralism, Marxism, academic radicalism, critical legal theory, multiculturalism, affirmative action, speech codes, deconstruction, women's studies, cultural studies and liberal ideas about rationality, free speech, and objectivity. The first *New York Times* article on the Sokal affair recognized the affinity and stated that the Sokal hoax "is one more skirmish in the culture wars, the battles over multiculturalism and college curriculums" (Scott 1996: A1). George Will (1996) used the occasion to disparage the academic left's "using higher education's curricula to dole out reparations to 'underrepresented cultures,'" Rush Limbaugh to launch epithets at "pseudo-history," especially as it is practiced in programs of "Afrocentric" studies (Switzer 1996). The Capital Gang even elevated Sokal to their hall of fame "for putting one over on the multiculturalists" (*Capital Gang Sunday* 1996).

Ellen Schrecker, Professor of History at Yeshiva University, cuts to the chase when she said in response to the Sokal affair:

> Besides a real physical world, there is a real political one, a world in which conservative pundits and lawmakers are attacking not just the cultural studies departments but the entire academy. The battleground here is not a text but the bottom line. The Right is fighting a broad-based campaign to demonize those sectors of the academic community that encourage critical thinking and offer an alternative perspective on the status quo.
>
> (Schrecker 1996: 61)

The opposition to liberalism is joined by the second current: anti-intellectualism. Of course, the attacks generated by the conservative movement would be ineffective except for a reasonably receptive audience. Apart from the "agenda setting" effect of the conservative publicity apparatus, the conservative agenda articulates to a prevalent anti-intellectualism in American culture. As James Carey has said: "while much of the political correctness literature is a disinformation campaign designed to discredit higher education, it could never be politically effective and the academic Left never forced into the role of a scapegoat except for one overriding fact: Public resentment against higher education is real" (quoted in Wilson 1995: 25). This anti-

intellectualism is becoming more pronounced in a context where people are now overwhelmingly preoccupied with taxes and money (Levine 1996: 64).

The third current, a scientific mistrust of the humanities, joins anti-liberalism and anti-intellectualism. The Sokal affair is so clearly an extension of the "two cultures" controversy as to make the observation seem trivial. However, what is significant is the way in which the Sokal affair is both a manifestation of and a contribution to a "heating up" of that debate and an indication of its move onto a new terrain. At one level it is readily apparent that much of Sokal's critique emanates from a scientific discomfort with the methods and practices of the humanities. Further the critique resonates with the preponderant belief that the search for objective scientific knowledge is the only legitimate path to truth – a view still held widely within the academic community (not just the scientific community), the popular press, and presumably by the public.

But the Sokal affair has done more than "breath new life" into this long-standing controversy, it registers the changing terrain that constitutes the debate. As Steve Fuller acknowledges, it is only since the early 1990s that scientists began to feel the "threat posed by the academic left critique of science," as "a frontal assault on 'civilization as we know it'" (1994: 34). The debate is moving out of the realm of the armchair reading of C. P. Snow and the philosophical musings of scientists and humanists. The debate now clearly articulates to institutional and political survival within the academy: who gets the diminishing funds? Who gets the students? Should interdisciplinary departments get supported or eliminated? Who has status within the university? Should anyone's authority be free from challenge? The stakes have become greater in an era of rising research costs and declining funding. In addition, the philosophical debates and the institutional questions are as much produced by as they are appropriated by the aggressive conservative movement in service of attacks on the liberal university (as discussed above).

Finally, the fourth current, left versus left conflict, contributes a particularly troubling trajectory to the Sokal affair. Sokal professes: "I'm a leftist" (1996b: 64). Indeed, he was assisted in writing his original hoax by at least one scholar regarded as a leftist. Ruth Rosen admits, "I helped with his exposé" (1996: A11). Sokal *et al.* make claim to the desire to rescue the left from destructive excess, by which he *means* a return to the legacy of the Enlightenment, where the strictly scientific view of evidence and logic reign:

> For most of the past two centuries, the Left has been identified with science and against obscurantism; we have believed that rational thought and the fearless analysis of objective reality (both natural and social) are incisive tools for combating the mystifications promoted by the powerful. ... I am a leftist (and a feminist) *because* of evidence and logic, not in spite of it.
>
> (Sokal 1996b: 64)

Sokal *et al.* give the conservative movement a wedge to divide and use the left. Rosen (1996) predicted that the right would use this incident to attack the left. Sokal clearly knew what he was handing the right and sought to distance himself from that effect: "My goal in writing the parody was not to give Rush Limbaugh and friends another excuse for hypocritical P.C.-bashing but to defend logic, rationality and the search for truth as the indispensable foundations of any progressive movement worth the name" (1996a: 16).

Serious intellectual and political questions constitute much of the history of debates among the left. For example, the problem and role of history is the subject of debate in *Post-Structuralism and the Question of History* (Attridge *et al.* 1987). As mentioned earlier, part of the very project of cultural studies is an ongoing debate about what constitutes cultural studies. Similarly, within feminism, there is recognition that there are many different feminisms, which involve deep philosophical and political differences on myriad issues such as essentialism versus anti-essentialism (see, for example, Chanter 1993), the relationship between "sex" and "gender" (see, for example, Butler 1990), the relationship to psychoanalysis (see, for example Brennan 1989), to postmodernism (see, for example, Nicholson 1990), to French feminism (see, for example, Jardine 1985), the merits or demerits of mainstreaming, and so forth. Outside academe proper, questions of harassment, women in politics, trade unionization, wage equity, reproductive and women's health issues, and economic development issues all figure extensively in debates among feminists. The widely cited *Conflicts in Feminism* (Hirsch and Keller 1990) covers a range of the theoretical and practical issues that figure significantly in these debates.

In the Sokal affair, however, questions taken seriously within the various academic and intellectual projects have been misappropriated and reduced, once again to the level of caricature, sound bite and epithet. So, for example, an entire left tradition is reduced to "its current fuzzy, fake-multicultural, didactic guise" (Kamiya 1996). For George Will, these are the "*lumpen* Marxists" who assert "that there are no facts, only interpretations" (1996: A31). Practitioners of feminist science studies are reduced to a "feminist-critique-of-science mafia" (Gross and Levitt 1994).

This absurd reduction again joins with the currents of anti-intellectualism and a cherished scientism to render the liberalism in higher education a grotesque perversion of intellectual life and education. Most importantly, the reduction draws together liberals and conservatives, who might otherwise disagree in virtually every other way, in alliance against the liberal university. When the voice of a united left and right is added to the currents considered above, it is difficult to see – at least in their effects – any significant difference between them. When Sokal writes, "Why should the right wing be allowed to monopolize the intellectual high ground?" (1996b: 64) it is difficult to see Sokal's project as other than "outdoing" the right on *its* terms, not the terms of responsible debate *among* the left.

The development of this emerging articulation is widely felt. The Sokal affair has already produced its share of appeals to the public to curb critical thinking in the university. Examples from the popular media include:

> If you're chuckling, but inclined to think it's just professors doing their usual angels-on-a-pinhead thing, please do think again. Tuition and fees at the priciest private universities run nearly $1,000 for each week of class. Taxpayers pick up a big chunk of the bill for public universities. Many of those classes are being taught, it appears, by professors who deny the distinction between truth and falsity and consequently can't distinguish double-talk from rational argument.
>
> (Seebach 1996: 17A)

And the controversy sparked by Alan Sokal's hoax may finally convince college deans and presidents, parents and alumni, legislators and trustees, to

take a hard look at the politicized nonsense they have been conned into subsidizing.

(Kimball 1996: A18)

Scott McConnell of the *NY Post* addresses this controversy and the pretension that exists in academia, where parents spend thousands to send their kids to be educated.

(Switzer: 1996)

As these quotes indicate, the real target is something far more fundamental than science studies, postmodernism, or even cultural studies. It should be clear by now that the opponents of postmodernism or cultural studies are not bothered as much by poor argumentation, false philosophical premises, or poor criticism of scientific methodology, as much as they are bothered by the critique of power, language, knowledge, and politics. In the absence of a significant leftist oppositional movement, the university remains a genuine voice of opposition; hence it is the university, as an idea and in practice, that represents the threat of opposition. What we are suggesting here is that in the US, the university has been the site of the proliferation of the so-called "new social movements" (feminism, multiculturalism, Afro-Americanism, environmentalism, etc.), and hence it becomes a crucial site of contestation by the conservative movement.

Although it is difficult to establish irrefutable chains of cause and effect, it appears that the Sokal affair, by contributing to a misperception of intellectual life, has and is likely to continue to have significant impact on the political and intellectual climate of the United States, particularly of US universities. At the very least a new climate of accelerated mistrust has been created within academic publishing. New hoaxes have been reported; and there is considerable unease about the authenticity of journal submissions. It isn't clear that this level of suspicion elevates the publication process. Rather, we surmise that this level of suspicion might be having a chilling effect on more exploratory research and publication.

Quite frankly, it has become a little more problematic to be identified as doing cultural studies (or, we presume, doing work in any of the constellation of practices that have come under attack). Hiring, funding, promotion and tenure, acknowledgment of merit, and program development all rely on the commitment from others that one's work is worthy of pursuit. Indeed, the legitimacy of the enterprise depends (increasingly so in the corporate university) on a reasonable degree of public support. It is difficult to know just how far administrators are willing to defend intellectual inquiry that comes under attack.

The questions remain: will administrators be interested in and committed enough to intellectual diversity to recognize the flaws in the elegant prose of the likes of Gross and Levitt and Sokal? Or will they be swayed by the status of their arguments as "science"? Will (can?) administrators stand up to the pressures brought to bear on them by parents, the public, and politicians? Will they care? Or will they (is it in their interest to?) align with the likes of Limbaugh and Will, Sokal, Gross and Levitt? More than two years after the initial hoax, we still wonder at what the effects of the pressure, all that bad press, and the growing strength of a conservative reading of political and intellectual life might be.

Intellectual and political hygiene

Ernesto Laclau, in "Totalitarianism and moral indignation," argues that the acts of violence that characterize the de Man scandal are totalitarian in nature. In a definition that is helpful to us here, Laclau explains that:

> totalitarianism drastically eliminates any difference or ambiguity and main-
> tains the myth of an absolutely transparent social organization. Precisely
> because totalitarianism presents itself as an entirely rational order, it has to
> adopt the form of an uncontaminated purity, and that which is excluded has,
> conversely, to be *essentially* impure.
>
> (Laclau 1990b: 90)

He does not reduce totalitarianism to fascism or any other form of political organiza-
tion, for "everything, even the values we most cherish, can be given a totalitarian
use" (ibid.). The distinction is important, for it is possible to advance totalitarian
projects in the name of democratic values. According to Laclau, de Man's personal
and intellectual life and the entire deconstructionist vision are collectively condemned
(in the name of anti-fascism) as an irredeemable evil that can only be cleansed by that
which is pure, i.e., a "transcendental signified,"[16] which could, as in the Sokal affair,
take the form of God, science, or transparent reality.

We maintain, with Laclau and Mouffe (1985), that the proliferation of antago-
nism, the contamination of the social by the political, and the ultimate openness of
"society," is what makes democracy possible. That is, it prevents the formation of a
totally and permanently homogeneous space, an entirely rational order, a "sutured
society" (Laclau and Mouffe 1985: 179). Ultimately the figure of the contaminating
Other is nothing more than a fantasy, a projection on to a generalized Other of the
very "impossibility of society" (Laclau and Mouffe 1985; Laclau 1990a). In other
words, a permanently sutured society is not possible; efforts to hegemonize the
openness of society are an ongoing task. Just as some of the work of de Man is seen
as contaminating de Man's *oeuvre*, the presence of the deconstructionist vision is seen
as contaminating American thought, American heritage, and the literary canon. The
demand for dismissal of de Man's work and of deconstruction constitute an impulse
to cleanse, to restore a homogeneous space, free from the contamination of context,
contradiction, compromise, and difference. It seeks to restore an oversimplified and
unreal God of the absolute: a belief in simple, superficial and transparent Truth. The
Sokal affair follows a closely aligned trajectory.

The violence committed in the Sokal affair is threefold. First, as we have argued
(using Foucault as an example), the texts are not read carefully, closely and contextu-
ally. They are read instead to garner support for what is already known, as essentially
admitted by Sokal when he says he checked out the references in Gross and Levitt to
see if they really said those things (note: *not* to read those authors to find out what
they said, but to confirm what Gross and Levitt said they said). Furthermore, Sokal *et
al.* ignore any argument that might cause them to mitigate the extreme ("there is no
such thing as reality") reading. To add to what amounts to poor scholarship, an egre-
gious disregard for either civility or professional behavior characterizes the attack.
Perhaps the glib, haughty, condescending tone works to cover over the lack of
serious scholarship. Perhaps Colinet is right when he states that "in a gangsters'
world the first to break the rules wins" (1989: 429). For example, haven't Gross and

Levitt, by their very irreverence for the scholarly project, already "won" in the struggle to make meaning, rendering impotent the measured reviews of their work by scholars such as Steve Fuller (1994)?

Second, the biographies of various authors are taken as thoroughly accounting for, explaining, and discrediting what they write. Hence, when someone such as Ross is declared to have acquired celebrity status, what he writes is reduced to nothing more than attempts to insure that status.

Third, the empirical distortion of simple facts (of, for example, the historical, institutional and intellectual differences among cultural studies, science studies, feminism, postmodernism, deconstruction, etc.) renders an "Other under attack" that resembles virtually nothing any of us actually practice. Finally, the violence is extended beyond the condemnation of the behavior of the *Social Text* collective, beyond science studies, beyond cultural studies, etc., to the vast and collective (but very real in their concrete forms) enemies of what is here God: transparent and objective Truth.

The horror of the impurity of this collective enemy is asserted and established in three ways: by reiteration, by vagary, and by the multitudinous forms of contamination that are depicted as pervasive. "[R]eiteration tries to conceal the inanity of the argument" (Laclau 1990b: 91); vagary tries to engrandize the inane argument; multiplication tries to depict the impurity as infiltrating perilously everywhere. Repeatedly in the Sokal affair we are told the same thing: that the impurity is constituted by a disregard for reality and truth. Those beliefs and the people who hold them are vaguely presented in caricatured, hyperbolic form. But they are depicted as prevalent: as threatening sacrosanct commitments to science and truth throughout the academy with an influence on culture in general. The impurity is evident first in the particular incident (the hoax), which becomes evidence of impure individual behavior (e.g., of the editorial collective of *Social Text*), which becomes evidence of impure character (e.g., of the academic celebrities or the neurotic Foucault), which becomes evidence of the corruption of entire philosophical traditions (e.g., structuralism, post-structuralism, deconstruction, postmodernism), which becomes evidence of the despicableness of a sweeping range of disciplines (e.g., feminism, science studies, cultural studies, literary studies).

What does this impure collectivity threaten to contaminate? Simply put, that safe distance between questions and insights of the humanities and the confidence, security and aloofness of the sciences and its (for some scientists anyway, as represented by the likes of Gross, Levitt and Sokal) uncompromisingly hermetic conception of reality.[17] Lee Smolin (1996), a colleague of Sokal, argues that science was once considered safe from the corruption of the humanities because the insights of the humanities and social sciences could be kept apart from the sciences, i.e., untainted, pure, at ease in its assumptions and practices. Smolin asserts that "I suspect that one thing that is going on is that you in science studies represent, for us in science, the first time we have had to confront postmodernism directly. And we don't like it." Kimball also suggests that the violation of that safe distance is what is at stake: "we could always encourage kids to study science" (Kimball 1996: A18). But, he continues, "[a]s more and more literary academics and professors of cultural studies turned their attention to the 'discourse' of science, not even the canons of scientific truth and rationality were safe from this new form of academic barbarism" (ibid.). In other words, now that nothing (not even science) is immune from the probing eye of contemporary philosophy and theory, it is time to take the offensive and cleanse all

thought (and its home in the academy) of this foul, threatening and contagious practice of questioning.

The totalitarian tendencies in Sokal *et al.*'s thought articulate remarkably well with a growing totalitarianism in the United States – regardless of any self-professed leftism on Sokal *et al.*'s parts (even if – though there is reason to doubt – his intentions are to assist the left wing).[18] Those who don't share Sokal's left-leaning nod none the less have found a totalitarian tie that binds them together far more significantly than any superficial political differences they may have. Seebach concludes her laudatory coverage of the Sokal hoax and her opprobrium for cultural studies with a disclaimer that speaks to the eviscerated distinction in this affair between left-wing and right-wing politics in the US:

> I don't remotely share Sokal's [left-wing] political views, but I agree with him that the corruption of clear thought and clear language is dangerous. And corruption has to be exposed before it can be cleaned up.
>
> (Seebach 1996: 17A)

As both the right and self-professed leftists such as Sokal call for cleaning up the contamination of reality by language and thought, the significance of the labels right and left recede along with the receding horizon of democracy.

In the end, the Sokal affair holds some important lessons. Democracy requires ambiguity, indeterminacy, undecidability. Current theorizing in the critical traditions is rich with all of these, often to the point of frustration and sometimes to the point of utter failure. But in the movement between indeterminacy, questioning, and the development of better theorizing is the distance within which democracy operates. In democracy there is no set point in the social fabric that is at once the locus of power and knowledge: not government, not science, and not some abstract conception of a universal and uncontestable Truth. The Sokal affair is useful in pointing to the very real power of our work to provide dignified, diverse, multicultural, challenging, and fundamentally democratic options to totalitarian structures. Deficiencies are inevitable but they are our only options to totalitarian structures. The magnitude of our responsibility, especially given the inevitability of its complications, warrants great care. We might take as admonishment Laclau's words: "If the word of God can no longer be heard, we can start giving our voices a new dignity" (1990a: xiv).

Notes

1 An earlier version of this chapter appeared as (1997) "Intellectual and political hygiene: 'the Sokal affair,'" *Critical Studies in Mass Communication* 14: 201–27. We would like to thank the National Communication Association (NCA) for their permission to reprint this article. We would also like to thank Anne Balsamo, Larry Grossberg, Roddey Reid and Patricia Sotirin for comments on earlier versions of this chapter.

2 The July/August issue of *Lingua Franca* included a forum on the Sokal affair. It was titled, after the television show and movie, "Mystery Science Theater," and included a black and white graphic of the two characters from that program who sit in the audience and make fun of the movies. The table of contents carried this teaser: "You've read the articles. You've slogged through the e-mail. Now tune in to Part II of the Great Social Text Hoax – starring Andrew Ross, Bruce Robbins, Alan Sokal, Evelyn Fox Keller, and more!" (*Lingua Franca* 1996).

3 Media coverage as obtained from a 17 July 1996 LEXIS-NEXIS search, using Alan Sokal as keyword, from 14–30 May 1996. The search yielded ninety stories, forty of which we assessed. Additional coverage was obtained from a variety of Internet sites, including

Sokal's Home Page: http://www.nyu.edu/gsas/dept/physics/faculty/Sokal/index.html and from http://weber.u.washington.edu/~gwalsh/sokal. Other sources of coverage consulted are cited accordingly in the References. We were able to access only a few international sources in this search, although we have been told by colleagues that international coverage was significant. We know, for example, that the issue was covered in the UK, Finland, Russia, Australia and New Zealand.

4 Gross and Levitt explicitly draw the link between these new scholars and disciplines and radicals of the 1960s (Gross and Levitt 1994: 220–4).

5 Here is one cultural studies version of this proposition which appears in the "Introduction" to a cultural studies text:

> The conception of culture that, we argue, increasingly informs the discipline of cultural studies – culture not as organic expression of a community, nor as an autonomous sphere of aesthetic forms, but as a contested and conflictual set of practices of representation bound up with the processes of formation and re-formation of social groups – depends upon a theoretical paradox, since it necessarily presupposes an opposition (between culture and society, between representations and reality) which is the condition of its existence but which it must constantly work to undo. Both the undoing of these oppositions, and the failure never completely to resolve the tension between them, are constitutive of work in cultural studies.
>
> (Frow and Morris 1993: xx)

We take the space here to quote at length from this reader in cultural studies to suggest that if Sokal *et al.* want to take issue with cultural studies, they should at least do their homework.

6 Jones attempts an inclusive list of jargon terms. He offers these "key terms" in the form of "the Times instant, self-adjusting guide to Getting Academic Articles Guaranteed Automatic Acceptance (Gaa-Gaa for short)" (Jones 1996).

7 Gross and Levitt work with a very selective bibliography of what they take to be representative works of contemporary critical intellectual thought to begin with. It is striking that so much of Sokal's bibliography – even quotations – are shared with Gross' and Levitt's *Higher Superstition*. Indeed, Sokal shares so much of their bibliography that his Reference section is more like a subset of theirs.

8 The development of the parameters of cultural studies can be traced through a series of articles that deal with the question "What is cultural studies?" Tracking the argument would take one back at least to the 1970s (Hall 1980) and include such pieces as Johnson (1986/1987); Nelson, Treichler and Grossberg (1992); Hall (1992); and Grossberg (1995). We offer none of these as either definitive or the final word. A longer (and growing) list, a sort of primer to the question, can be accessed on the Internet, thanks to Gil Rodman, through the cultural studies website: http://www.cas.usf.edu/communication/rodman/culstud/index.html.

9 We chose the example of Foucault somewhat randomly. We might just as readily have chosen other authors such as Derrida or philosophical arenas such as social constructionism.

10 For a lengthy treatment of the moralistic dismissal of Foucault by American conservatives, see Roddy Reid (1996/1997).

11 In an especially pessimistic moment which we turned into humor, it occurred to us that maybe Gross and Levitt's book is a hoax and the publishers didn't catch it.

12 Such pronouncements rely on knowledge that Sokal admits he only began to explore two years earlier (Seebach 1996: 17A), barely long enough to complete a worthwhile masters degree for a full time student.

13 See, for example, Kendrick (1988); Kimball (1988); and Wiener (1988). Roger Kimball's voice here is particularly interesting. Kimball, managing editor of *The New Criterion* magazine, has also been outspoken in the Sokal affair.

14 Derrida's relationship with de Man is noteworthy. Derrida is a Jew and was a friend of de Man. Most importantly, the work of Derrida and de Man respond seriously and positively to one another.

15 For additional treatment of the historical formation of the conservative movement as reflected in the PC debates, the Culture Wars, the Science Wars, and the attack on higher education, see Aufderheide (1992); Berman (1992), Bérubé and Nelson (1995); Bolton (1992); Newfield and Strickland (1995); Williams (1995); and Wilson (1995).

16 According to Derrida, the transcendental signified in its multiple forms includes "*eidos, arche, telos, energeia, ousia* (essence, existence, substance, subject), *aletheia*, transcendentality, consciousness, God, man, and so forth" (1978: 279–80).

17 It is important to acknowledge that not all scientists sympathize with the arguments of Gross and Levitt, Sokal and the like. This is not just a "two cultures debate," but an ethico-political-philosophical debate that cuts across both the sciences and the humanities. Especially noteworthy in this regard is a letter to the *New York Times* by Stanford University Professor of Biological Sciences, Jonathan Roughgarden, and five students from the biological sciences department that reads: "We disassociate ourselves from Alan Sokal's submission of a bogus article linking quantum mechanics with postmodern thought. … We also part company with attacks by other scientists on post-modern criticism of scientific activity, as exemplified by the book by Norman Levitt and Paul R. Gross, *Higher Superstition: The Academic Left and Its Quarrel With Science.*" They go on to "welcome the inquiry of postmodern scholars … into how science is carried out," confident that it "will not undercut scientific findings or defy common sense." Indeed, they argue that "[t]here is obviously much to study about how scientists do their work, such as what questions are allowed and what counts as an answer, the role of social interactions among scientists, and the connection of science to societal values." They conclude with a determination that "a human critique of science" is "perhaps the best approach to increasing science education with the humanities and social sciences, which is a goal of scientists themselves" (Roughgarden *et al.* 1996).

18 It is difficult to take *any* claims made by Sokal seriously. After all, with his "experiment" at the expense of *Social Text*, he has demonstrated his capacity for calculated deception. We find the lack of criticism of the ethics of Sokal's actions an especially disturbing development. If this really was an "experiment," with the possible outcome of embarrassing and discrediting people, perhaps even putting their careers in jeopardy, was it, we wonder, cleared by a Human Subjects review, as would likely be required? We have been assured, however, by the head of the Human Subjects Review Committee at our university, that Sokal's actions did not constitute an experiment. What was it then? More likely a case of "entrapment." If it was entrapment, why, we wonder, did Sokal feel the need to dignify his actions with the term "experiment"? As a scientist, he clearly knows the difference. Furthermore, if it was entrapment, would not some standards of scientific misconduct apply? By what right would it be exempt? Sokal's actions and their tacit acceptance represent the emergence of a new "ism," like racism or sexism, where, because of an unspoken agreement about the fundamental difference and inferiority of the Other, the rules do not seem to apply.

References

"All things considered" (1996) National Public Radio, transcript no. 2214–7, 15 May. LEXIS-NEXIS (17 July 1996).

Attridge, D., Bennington, G. and Young, R. (eds) (1987) *Post-Structuralism and the Question of History*, Cambridge: Cambridge University Press.

Aufderheide, P. (ed.) (1992) *Beyond PC: Toward a Politics of Understanding*, Saint Paul, MN: Graywolf Press.

Begley, S. and Rogers, A. (1996) "'Morphogenic field' day: a P.C. academic journal falls for a physicist's parody of trendy-left social theory," *Newsweek* 3 June: 37.

Berkowitz, P. (1996) "Science fiction: postmodernism exposed," *The New Republic* 1 July. Online. Available HTTP: http://weber.u.washington.edu/~gwalsh/sokal (17 July 1996).

Berman, P. (ed.) (1992) *Debating P.C.: The Controversy Over Political Correctness on College Campuses*, New York: Dell.

Bérubé, M. and Nelson, C. (eds) (1995) *Higher Education Under Fire: Politics, Economics, and the Crisis of the Humanities*, New York: Routledge.

Bolton, R. (ed.) (1992) *Culture Wars: Documents from the Recent Controversies in the Arts*, New York: New Press.

Brennan, T. (ed.) (1989) *Between Feminism and Psychoanalysis*, New York and London: Routledge.

Butler, J. (1990) *Gender Trouble: Feminism and the Subversion of Identity*, New York and London: Routledge.

Capital Gang Sunday (1996) Cable News Network, transcript no. 41, 19 May. LEXIS-NEXIS (17 July 1996).

Chanter, T. (1993) "Kristeva's politics of change: tracking essentialism with the help of a sex/gender map," in K. Oliver (ed.) *Ethics, Politics, and Difference in Julia Kristeva's Writing*, New York and London: Routledge, 179–95.

Colinet, E. (1989) "Paul de Man and the Cercle du Libre Examen," in W. Hamacher, N. Hertz and T. Keenan (eds) *Responses: On Paul de Man's Wartime Journalism*, Lincoln: University of Nebraska Press, 426–37.

de Man, P. (1989) "Letter to Professor Poggioli," 26 January 1955. Reproduced in W. Hamacher, N. Hertz and T. Keenan (eds) *Responses: On Paul de Man's Wartime Journalism*, Lincoln: University of Nebraska Press, 475–7.

Derrida, J. (1978)*Writing and Difference*, trans. A. Bass, Chicago: University of Chicago Press.

——(1989) "Like the sound of the sea deep within a shell: Paul de Man's war," trans. P. Kamuf, in W. Hamacher, N. Hertz and T. Keenan (eds) *Responses: On Paul de Man's Wartime Journalism*, Lincoln: University of Nebraska Press, 127–64.

Fish, S. (1996) "Professor Sokal's bad joke," *New York Times* 21 May: A23. LEXIS-NEXIS (17 July 1996).

Frow, J. and Morris, M. (eds) (1993) *Australian Cultural Studies: A Reader*, Urbana: University of Illinois Press.

Fuller, S. (1994) "A tale of two cultures and other higher superstitions," *Democratic Culture*, Fall: 34–5.

Gross, P. and Levitt, N. (1994) *Higher Superstition: The Academic Left and its Quarrels with Science*, Baltimore: Johns Hopkins University Press.

Grossberg, L. (1986) "History, politics and postmodernism: Stuart Hall and cultural studies," *Journal of Communication Inquiry* 10: 61–77.

——(1988) "It's a sin: politics, post-modernity and the popular," in L. Grossberg, T. Fry, A. Curthoys and P. Patton (eds) *It's a Sin: Essays on Postmodernism, Politics and Culture*, Sydney: Power Publications, 6–82.

——(1989) "The circulation of cultural studies," *Critical Studies in Mass Communication* 6(4): 413–20.

——(1995) "Cultural studies: what's in a name (one more time)," *Taboo: The Journal of Culture and Education* 1: 1–37.

Hall, S. (1980) "Cultural studies and the centre: some problematics and problems," in S. Hall, D. Hobson, A. Love and P. Willis (eds) *Culture, Media, Language: Working Papers in Cultural Studies, 1972–1979*, Boston: Unwin Hyman, 15–47, 278–88.

——(1992) "Cultural studies and its theoretical legacies," in L. Grossberg, C. Nelson and P. Treichler (eds) *Cultural Studies*. Reprinted in D. Morley and K.-H. Chen (eds) *Stuart Hall: Critical Dialogues in Cultural Studies*, London: Routledge, 262–75.

Hamacher, W., Hertz, N. and Keenan, T. (eds) (1989) *Responses: On Paul de Man's Wartime Journalism*, Lincoln: University of Nebraska Press.

Hirsch, M. and Keller, E. F. (eds) (1990)*Conflicts in Feminism*, New York and London: Routledge.

Jameson, F. (1993) "On 'cultural studies,'" *Social Text* 34: 17–52.

Jardine, A. A. (1985) *Gynesis: Configurations of Woman and Modernity*, Ithaca, NY: Cornell University Press.

Johnson, R. (1986/1987) "What is cultural studies anyway?" *Social Text* 16: 38–80.

Jones, P. (1996) "Academic jargon," *The Times* 25 May. LEXIS-NEXIS (17 July 1996).

"Journal doesn't get physicist's satire." (1996) *The Patriot Ledger* 18 May: 5. LEXIS-NEXIS (17 July 1996).

Kamiya, G. (1996) "Transgressing the transgressors: toward a transformative hermeneutics of total bullshit: physicist's slick hoax leaves egg on face of 'progressive' academic journal," *Salon, MediaCircus* June. Available HTTP: http://weber.u.washington.edu/~gwalsh/sokal (17 July 1996).

Kendrick, W. (1988) "De Man that got away: deconstructors on the barricades," *Village Voice Literary Supplement* April.

Kimball, R. (1988) "Professor Hartman reconstructs Paul de Man," *The New Criterion* May: 36–43.

——(1996) "A painful sting within the academic hive," *Wall Street Journal* 29 May: A18.

Laclau, E. (1990a) *New Reflections on the Revolution of Our Time*, London: Verso.

——(1990b) "Totalitarianism and moral indignation," *Diacritics* 20(3): 88–95.

——and Mouffe, C. (1985) *Hegemony and Socialist Strategy: Towards a Radical Democratic Politic*, London: Verso.

Levine, G. (1996) "Letter," *Lingua Franca* 6(5): 64.

McMillen, L. (1996) "The science wars: scholars who study the lab say their work has been distorted," *Chronicle of Higher Education* 28 June: A8. Available HTTP: http://weber.u.washington.edu/~gwalsh/sokal (17 July 1996).

Messer-Davidow, E. (1995) "Manufacturing the attack on liberalized higher education," in C. Newfield and R. Strickland (eds) *After Political Correctness: The Humanities and Society in the 1990s*, Boulder: Westview Press, 38–78. Originally published in (1993) *Social Text* 36: 40–80.

"Mystery science theater" (1996) *Lingua Franca* 6(5): 54–64.

Nelson, C., Treichler, P. and Grossberg, L. (1992) "Cultural studies: an introduction," in L. Grossberg, C. Nelson and P. Treichler (eds) *Cultural Studies*, New York: Routledge, 1–22.

Newfield, C. and Strickland, R. (eds) (1995) *After Political Correctness: The Humanities and Society in the 1990s*, Boulder: Westview Press.

Nicholson, L. (ed.) (1990) *Feminism/Postmodernism*, New York and London: Routledge.

Pollitt, K. (1996) "Pomolotov cocktail," *The Nation* 10 June: 9.

Reid, R. (1996/1997) "Foucault in America: biography, 'culture war' and the new consensus," *Cultural Critique* winter: 197–211.

Robbins, B. (1996) "Reality and *Social Text*," *In These Times* 8 July. Available HTTP: http://weber.u.washington.edu/~gwalsh/sokal (17 July 1996).

—— and Ross, A. (1996) "Letter" *Lingua Franca* 6(5): 54–7.

Rosen, R. (1996) "A physics prof drops a bomb on the faux left," *Los Angeles Times* 23 May: A11. LEXIS-NEXIS (17 July 1996).

Ross, A. (1996a) "Introduction," *Social Text* 46–47 14(1–2): 1–13.

——(1996b) "Letter to the Editor," *The Nation* 8 July: 2.

Roughgarden, J. et al. (1996) "Letter to the Editor," *New York Times* 3 June. Available HTTP: http://weber.u.washington.edu/~gwalsh/sokal (17 July 1996).

Schrecker, E. (1996) "Letter," *Lingua Franca* 6(5): 61.

"Science Wars" (1996) *Social Text* 46–47 14: 1–2.

Scott, J. (1996) "Postmodern gravity deconstructed, slyly," *New York Times* 18 May: A1, 22.

Seebach, L. (1996) "A bold scientist fights the tyranny of reality," *Baltimore Sun* 15 May: 17A. Carried on *New York Times* wire service, 13 May. LEXIS-NEXIS (17 July 1996).

"Serious prank in scholarly world: physicist's hoax essay attacks the field of cultural studies" (1996) *Los Angeles Times* 27 May: B4.

Slack, J. D and Mehdi Semati, M. (1997) "Intellectual and political hygiene: 'the Sokal affair,'" *Critical Studies in Mass Communication* 14(3): 201–27.

Smolin, L. (1996) "An open letter to Stanley Fish, Andrew Ross, Stanley Aronowitz, and the editorial collective of *Social Text*." Online posting. Available e-mail: smolin@phys.psu.edu (17 July 1996).

Sokal, A. (1996a) "I am a Leftist," *Newsweek* 24 June: 16. LEXIS-NEXIS (17 July 1996).

——(1996b) "A physicist experiments with cultural studies," *Lingua Franca* 6(4): 62–4.

——(1996c) "Transgressing the boundaries: toward a transformative hermeneutics of quantum gravity," *Social Text* 46/47 14(1): 217–52.

——(unpublished) "Transgressing the boundaries: an afterword," submitted to *Social Text*. Available HTTP: http://www.nyu.edu/gsas/dept/physics/faculty/Sokal/index.html (17 July 1996).

Switzer, N. (1996) "Unofficial summary of the *Rush Limbaugh Show* for Wednesday, 22 May 1996." Online posting. Available HTTP: http://weber.u.washington.edu/~gwalsh/sokal (17 July 1996).

"A wake-up call for academia" (1996) *Detroit News* 26 May: B6. LEXIS-NEXIS (17 July 1996).

Weber, S. (1989) "The monument disfigured," in W. Hamacher, N. Hertz and T. Keenan (eds) *Responses*, Lincoln: University of Nebraska Press, 404–25.

Wiener, J. (1988) "Deconstructing de Man," *The Nation* 246(1), 9 January: 22–4.

Will, G. (1996) "Smitten with gibberish," *Washington Post* 30 May: A31. (Syndicated column appeared throughout the US press under a variety of headlines.)

Williams, J. (ed.) (1995) *PC Wars: Politics and Theory in the Academy*, New York: Routledge.

Wilson, J. K. (1995) *The Myth of Political Correctness: The Conservative Attack on Higher Education*, Durham, NC: Duke University Press.

Ursula Franklin

LETTER TO A GRADUATE STUDENT

A FEW MONTHS AGO, you came to me to talk about your future. Should you, a feminist and a graduate student in science, embark on a doctoral program in a physics related field? Is not the gulf between the goals of a scientist and the goals of a feminist too great to be bridged within one person who wants to live in peace with herself?

We talked for a long time and I spoke about my friend Maggie Benston and how her life and work illuminates your questions and helps to answer them. Yet, after you had left, I felt uneasy. Did my argument for not giving up on science make sense to you? Was I able to give you an idea of the nature of Maggie's pioneering contributions and of her, a vibrant woman and an original thinker and doer?

Now that this volume on "The Legacy of Margaret Benston" has been assembled, I want to return to our conversation. In many of the papers here, you will find clarification and elaboration of the ideas we touched on. Maybe we should now pick up on three strands that ran through our talk. You asked about Maggie as a person – what made her tick? Why did she have such a strong influence on people's understanding of the technological world around us? What does her life's contribution mean for young women like yourself?

For me, the uniqueness of Maggie lies largely in the unity of her life. She wasn't a scholar and academic on Monday, Wednesday and Friday, a unionist on Tuesday and Thursday, a member of the women's movement on the weekend and an environmentalist when on vacation. She was all of these – and more – at the same time. Each of her activities was rooted in the same soil, each aspect of her life was linked to and informed by all other aspects of her being. The pattern-setting force in her life was her belief in the possibility and practicability of a feminist, egalitarian and non-oppressive society. Whatever Maggie did, as well as what she did not do, must be understood as a direct consequence of this belief.

People have often commented on how few hang-ups Maggie seemed to have. As I recall, she did not spend much time agonizing about joining a particular demonstration or supporting a struggling solidarity group – her response was quickly derived from her general standpoint, the place where her life was anchored. Once her basic position, that *patriarchy or hierarchy is not an option*, had been taken, daily hang-ups faded into the background. Much strength flows from a fundamental decision

not to accept the rules of an alien convention. There is the liberating effect of declared non-conformity, the joy of sharing and following one's own conviction, the lack of inner contradictions. A lot of creative energy becomes available, when the internal conflicts have been eliminated. Indeed, I feel that the great influence that Maggie asserted on so many people springs directly from the qualities of her own life – its inner consistency, its openness and rootedness in a feminist vision.

By the way, Marcia, don't overlook the trap here. In dress and lifestyle, demeanour and politics, Maggie stressed her ordinariness – just like everybody else. Don't let this fool you. Maggie was in many ways quite extraordinary and exceptional, not the least for her ability to integrate the ordinary and the extraordinary into one seamless life.

Maybe we should talk about Maggie's contributions to feminist theory. We can speak about her feminist practice later, when we discuss what may lie ahead for you. Just remember that for Maggie, theory and practice were inextricably linked and she would joyfully deny the existence of a tactical boundary between them.

Her two major theoretical papers were the fruits of considerable search and research. "The political economy of women's liberation" was published in 1969, "Feminism and the critique of the scientific method" appeared in 1982, and I would like to reflect on the seminal nature of the latter.

When this paper first appeared, Maggie had been at Simon Fraser University for fifteen years. At this time she held a cross-appointment in the Departments of Chemistry and Computer Science. On its initial publication, "Feminism and the critique of the scientific method" did not have the same instantaneous impact as did "The political economy of women's liberation." Maybe this was due to the fact that at the time those involved in arguments about the structure of scientific knowledge did not consult a book with the title "Feminism in Canada."

To the best of my knowledge, the paper was never translated into another language, although it became a central contribution to the debate on the nature of science and on the intrinsic limitations of the scientific method. You will be familiar with this rich discourse on the social and political structuring of knowledge, to which feminists have added so many fresh insights, and therefore, you may ask about Maggie's place in all of this …

For me, the importance of Maggie's work here is twofold. In the first place she explores, explains and illuminates the notion of science in all its aspects. Second, she draws practical consequences from what she and others found and she acts upon them in her own work.

Like a good anatomist, Maggie first dissects the concepts and practices of science, using instruments of a feminist and socialist analysis. She looks at science as a social and political structure and finds it wanting, in the same way in which she found economic systems wanting when she critiqued the political economy of women's liberation. Maggie lays bare for all to see the postulates and assumptions, the methods of work and the internal reasoning within the enterprise of science.

This *pedagogy of understanding* is embedded in all of Maggie's work. A particularly telling paragraph will illustrate what I mean. Speaking of the core assumptions of scientific progress, she writes:

These assumptions are:

1 There exists an 'objective' material reality separate from and independent of an observer. This reality is orderly.

2 The material world is knowable through rational inquiry and this knowledge is independent of the individual characteristics of the observer.

3 Knowledge of the material world is gained through measurements of natural phenomena: measurement in a scientific sense consists of quantification, i.e. reduction to some form of mathematical description.

4 The goal of scientific understanding is the ability to predict and control natural phenomena (this postulate often takes the form of equating science with power).

Interweaving her analysis with the insights of other feminist scholars, notably Ruth Hubbard and Marian Lowe, Maggie then exposes the double myth of the objectivity and neutrality of the scientific method, pointing out the inherent limitations that the methods of science place on the scope of any scientific inquiry. The impact of reductionism, this pre-ordaining of certain variables as being more important or indicative than others, becomes the next focus of her pedagogy of understanding. She quotes Ruth Hubbard in this context:

> Of necessity, we can tackle only the few limited aspects of nature of which we take sufficient notice that they arouse our interest or curiosity to the point where we examine them more closely. The scientific modes of thought and action therefore elevate some things and events to the rank of "facts," indeed of *scientific facts*, while being oblivious to the existence of others and actively relegating yet a third category to the foggy realms of suppositions or, worse yet, superstition.

Ruth Hubbard later elaborated on the role of scientists as socially sanctioned "fact-makers." You will find more on this in Ruth Hubbard's book, *The Politics of Women's Biology.*

There are other thoughts in "Feminism and the critique of the scientific method" that will be of special interest to you, Marcia. In terms of the impact of reductionism and bias in scientific practices, Maggie points to the notion of "side effects" and writes:

> In fact, there are no side effects, only effects. The definition of some of the results of the process under study as unimportant is done in terms of the intent of the investigator rather than the reality of the process. The "pill" is a good example – suppression of ovulation is one of its effects, while another is a change in blood chemistry that may make blood clotting more likely. A less distorted methodology would not dismiss this second effect as lightly as present medical science does.

Have you noticed, Marcia, that Maggie speaks throughout the papers of *present science*? She explains her terminology in a footnote, stating "I use the term 'present science' to refer to the methodology and practice of science *now*, since I believe that ultimately feminist and other critiques will lead to a quite different conception of what science can be." Maggie uses the term *present technology* in the same manner.

There are many indications throughout the paper that Maggie was not giving up on science, but was pressing for work on a different science. The paper's final section

is actually called "Towards a different science." Quoting Ruth Hubbard again, Maggie writes:

> As women and as feminists we must begin to deal with the science and technology that shape our lives and even our bodies. We have been objects of bad science; now we must become the makers of a new one.
>
> What is needed in such a new science is, first of all, a sense of the limits of the appropriateness of reductionism and the development of a methodology which can deal with complex systems "that flow so smoothly and gradually or are so profoundly interwoven in their complexities that they can not be broken up into measurable units without losing or changing their fundamental nature." Difficult as this may be in practice, its very adoption as a goal must mean a major change in scientific methodology.

And this is precisely what she did in all her own projects and studies: conducted scientific or technical studies using new and different methodologies reflecting her own different values. The fact that these studies had realistic goals and practical results – be they new designs of computer networks or a novel way of automatic clerical work – should not camouflage the emergence of radically different methodologies. Please, Marcia, don't let the down-to-earth attributes of Maggie's projects blind you to their *theoretical* importance; each one is an experience, testing the methodologies of a new contextual science.

Vividly imagining the new and cultivating constructive dreaming were important to Maggie. Did you know that she had a great deal of interest in science fiction and utopias, particularly in the feminist ones? She taught several courses on utopias, emphasizing their different sciences and knowledge structures as well as their novel social relationships. Her 1988 paper on "Feminism and systems design: questions of control" begins with reflections on Marge Piercy's utopian novel *Woman on the Edge of Time*. For Maggie, science fiction and utopian writing provided a space where the social and the scientific imagination could meet and play. Had she lived longer, she might well have written in this genre too.

But now I must return to your initial question, whether there is a place for a young feminist in science. My answer is clearly "yes," although you and other women should understand the political and social structure of present science and technology and try to become equipped to deal with this reality. However, this need for an understanding of the political and social structure of the enterprise in which one invests one's labour is not required only from those who prepare for work in science and technology. If you were to go into law or medicine, social work or architecture, the same questions about assumptions and paradigms would exist, although some disciplines might be more prepared to face such queries than is present science and its practitioners. Maggie certainly was not prepared to give up her participation in the practice of science or technology. In "Marxism, science and worker's control" she said quite explicitly: "In general, I don't want to be understood in the present practice of science." And, she could have added, do something about it.

Let me assure you, Marcia, that I know how constrained the choices for graduate students in terms of research subjects and supervisors have become in these tough times. Yet there are choices and they have to be made with care. Choose your supervisors, if you can, for their human qualities: you must be able to respect them, even

when you have to disagree with them. To me, considerations of human substance are of greater importance than the selection of a sub-discipline.

Among the research areas open to you, choose, if at all possible, one that has been neglected because of the very biases Maggie discussed. For instance, in the field of solid state physics, we both know, that the past fifty years of concentrated research have yielded a very complex and complete body of knowledge related to the interaction of solid inorganic material and radiation and currents of any kind. Without this body of knowledge, there would be no semiconductors, no microchips, no fibre optics – you name it. Now compare this situation with the very small body of uncertain information regarding the interaction between living organic solids – blood, tissue, cells or bone – and the same currents and radiation. Isn't it amazing how little research effort and attention the organic materials have attracted?

Unquestionably, the experimental context is more complicated and "messy" for organic materials, i.e. less amiable to reductionist simplification; but most problems look complicated and messy until one has a conceptual handle on them. You may want to ask yourself too whether the neglect of this research area could have a political component. The beneficiaries of the neglected sub-field would likely be, in the main, 'mere' people, while the present solid state knowledge has yielded enormous industrial and military benefits. Here is clearly an area of inquiry that is crying out for the new methodologies, for new forms of collaboration and data gathering. Try to associate yourself with those who worry about such neglected fields, as Maggie always did.

Let me also urge you not to forget how much joy the study of science can give. The world in which we live is rich and full of wonder and beauty, as Rachel Carson so often said. Can you recall the feeling of sheer joy when you grasped for the first time the underlying reasons for the regularity of the periodic table of elements or the nature of crystallographic transformations? I certainly can, and even now, some forty years after my Ph.D., I still find microscopic examination of samples a joyful and wonderful activity.

There is the joy of mastery and understanding – not at all unique to scientific studies – the pleasure of seeing patterns emerging where none were seen before, the elegance of a fresh mathematical approach – all these treasures are there, and should not become invisible because of the shadows that over-reach and over-application of *present* science and technology have cast.

Yes, you may say, all this is fine and good, but what about the "chilly climate"? Good question! I do acknowledge that the structurally and – at times – personally unfriendly environment deters young women from planning research careers in a scientific or technical field. Yet, as a feminist, you are less vulnerable than young women who have no understanding of the social and political structures of science and technology, and who might still fall for the myth of the objectivity and neutrality of science and technology.

You may think that I am joking, but let me give you my argument: first and foremost, don't check your feminism at the laboratory door, it is an important layer of the coat of inner security that will protect you from the chilly climate. As your values will be questioned constantly – implicitly and explicitly, you will depend for your sanity on an ongoing rootedness in the women's community.

Take the time to keep involved in women's issues and don't ever believe that you are "the only woman in ..." Likely you are not, just as I have never been. Wherever men work, there are women working, usually for much lower pay. You may well be

the only female doctoral student in a particular group, but what about the secretaries, the cleaning staff, the librarians or the technicians? You may link up with them and gain their support and friendship. As you watch over the safety and well-being of others, your own will take care of itself and the chilly climate will warm up a bit.

Don't become petrified by rank! Only hierarchy pulls rank; as feminists, we see rank as the institutional equivalent of a postal code, not as a figure of merit. In other words, rank or title tells of people's sphere of work and responsibility, not that – by definition – they know more or know better than those of lower rank or title.

Remember also that what is morally wrong and unjust is, in the end, also dysfunctional – a point Maggie made often. All the advanced science and technology for war has not brought peace to anyone. All the advanced systems of oppression have not brought security to their owners. As a motto for her paper on technology as language, Maggie used a line from a postcard of the International Woman's Tribune Centre: "If it's not appropriate for women, it's not appropriate" – a good phrase to remember.

And finally, when the going is tough and you feel yourself surrounded by jerks, take an anthropological approach. Take field notes (and I mean this in real and practical terms) and regard yourself as an explorer, having come upon a strange tribe. Observe and describe the tribe's customs and attitudes with keen detachment and consider publishing your field observations. It may help you and be of use to future travellers. I know from experience that the exercise works.

Please keep in touch and remember you are not alone.

Your friend,
Ursula Franklin

References

Benston, M. (1989) "The Political Economy of Women's Liberation," *Monthly Review: Independent Socialist Magazine* Sept.: 13-27.

Benston, M. (1982) "Feminism and the Critique of the Scientific Method," in Angela R. Miles and Geraldine Finn (eds) *Feminism in Canada: From Pressure to Politics*, Montreal: Black Rose Books, 47-66.

Benston, M. (1987) "Marxism, Science and Worker's Control," in Chris DeBresson, Margaret Lowe Benston, and Jesse Vorst (eds) *Work and New Technologies: Other Perspectives*, Toronto: Between the Lines, 131-42.

Benston, M. (1989) "Feminism and Systems Design: Questions of Control," in Winnie Tomm (ed.) *The Effects of Feminist Approaches on Research Methodologies*, Calgary: Wilfred Laurier University Press, 205-24.

Hubbard, R. (1980) "Introductory Essay," in H. Rose and S. Rose (eds) *Ideology of/in the Natural Sciences*, Cambridge, Mass.: Shenkman, xvii.

Hubbard, R. (1990) *The Politics of Women's Biology*, New Brunswick, New Jersey: Rutgers University Press.

Miles, A. R. and Finn G. (eds) (1982) *Feminism in Canada: From Pressure to Politics*, Montreal: Black Rose Books.

Piercy, M. (1976) *Woman on the Edge of Time*, New York: Knopf.

Index